DESIGN AND REALIZATION

A Manual for GCSE

Adrian

Lecturer in
Goldsmiths

Oxford University Press 1987

870887

5.50

Oxford University Press, Walton Street, Oxford OX2 6DP

Oxford New York Toronto
Delbi Bombay Calcutta Madras Karachi
Petaling Jaya Singapore Hong Kong Tokyo
Nairobi Dar es Salaam Cape Town
Melbourne Auckland

and associated companies in
Beirut Berlin Ibadan Nicosia

Oxford is a trade mark of Oxford University Press

© Oxford University Press 1987

First published 1987

ISBN 0 19 832732 3

Typeset by Graphicraft Typesetters Limited, Hong Kong
Printed in Hong Kong

ACKNOWLEDGEMENTS

The Publishers wish to thank the following for providing
photographic material:

Apple Computer (UK) Ltd. P.9 (bottom right);
Austin Rover Group Ltd. P.9 (middle right), P.29, P.74 (top,
centre, bottom), P.155;
British Steel Corporation P.141;
Cartier/Caroline Neville Associates P.8 (bottom left);
Complete Packaging Ltd. P.101;
Deith Leisure P.163;
Emco Maier Ltd. P.75, P.76;
Ferranti Infographics P.75 (top, centre);
Hille International Ltd. P.4;
Manchester Public Libraries P.9 (bottom left).
Mansell Collection P.10;
Philips P.156 (second from bottom, bottom);
R.D. Projects P.8;
Science Museum P.156 (top, second from top);
Jeffery Tabberner P.77;
Thorp Modelmakers P.8 (top right), p.19;
Walton Adams P.9 (top right);

Additional photography by Chris Honeywell.

Every effort has been made to trace copyright holders. If
there are any omissions the publisher will be happy to give
full acknowledgement at the first reprint.

INTRODUCTION FOR TEACHERS

This book aims to help design students to solve open-ended problems. It contains all the information needed to follow GCSE Design and Realization courses, based on the various national syllabuses, and provides material which could help Design and Technology students with their project work.

The book is divided into sections, the first of which deals with the design process, from the initial brief to the final evaluation. The remaining sections are arranged in the form of a manual, from which students can select materials, tools, processes, technologies, and drawing systems, as and when they are needed.

The book can be used in the classroom, where students may either work individually, in groups, or alongside the teacher, to develop original as well as practical solutions to problems. It can also be used as a homework study book. Material can be used as preparation for work about to be discussed in class, or to consolidate subjects already covered.

Each section is sub-divided into a number of units, which can be included or omitted as the teacher chooses. The units or the sections are concluded with questions or activities designed to check understanding and to provide practice for the skills introduced.

Information is presented throughout in both written and illustrated forms. Care has been taken to express this material in a clear and stimulating way, so that it will help students of differing abilities to achieve success.

I wish to thank the following examination groups for permission to reprint questions: Midland Examining Group (MEG), London and East Anglian Group (LEAG), Welsh Joint Education Committee (WJEC), Southern Examining Group (SEG), and Northern Examinating Association (NEA).

CONTENTS

INTRODUCTION FOR STUDENTS

Although design often gets close to invention, designers are not really inventors. Inventors look for **new** principles. This might mean the development of a new material, or a new way of using an existing one.

Designers, however, are problem solvers. They are concerned with the reorganization of **known** materials and with using **established** techniques to produce new solutions to problems.

This book has been written to help you with this process. It is not a text book to be read from cover to cover, but a manual you can refer to for information as and when it is needed.

The contents list on the previous pages will help you with general enquiries, but when you want more detailed information you will need to look at the index on pages 195–196. There is also a glossary on page 194, where you will find definitions of technical terms.

Each section of the book is divided into units. These give you both background written information and pictorial instructions. Most units end with a number of questions or activities so that you can see how well you have understood the material.

The book attempts to introduce the wide variety of design topics you are likely to need. It also aims to help you to improve your design skills and to stimulate your enjoyment of this fascinating subject.

SECTION 1
THE DESIGN PROCESS

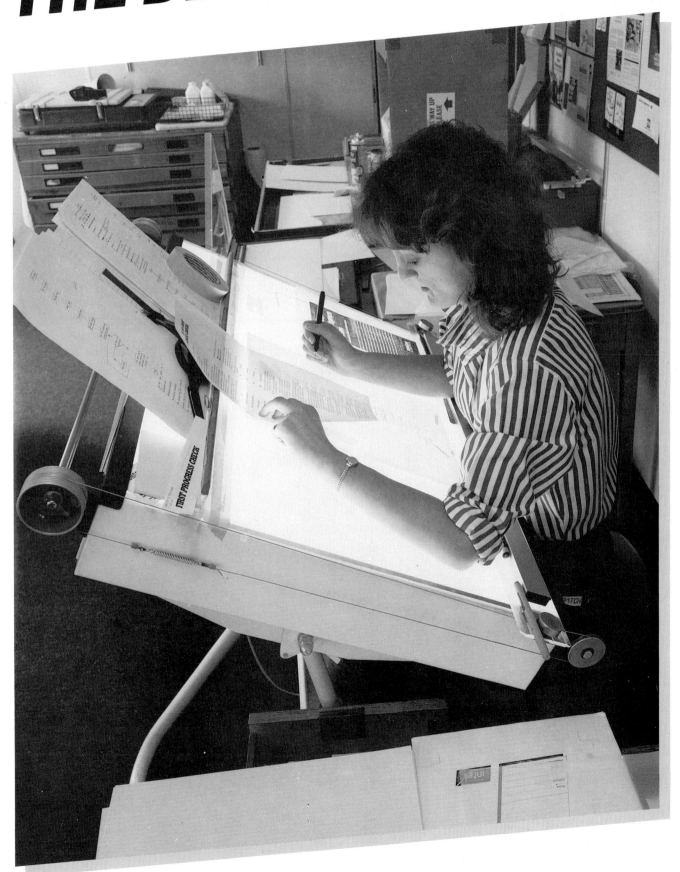

1.1 DESIGNERS DECIDE

This book, your pen, the chair or stool on which you are sitting, all of these were designed. So were the classrooms in which you spend most of your school day. Someone had to decide how to construct the walls and ceilings, and which materials to use for the floor coverings. These were design decisions and the person who made them was the designer.

Designers have been involved in every manufactured object you see around you. If you were to list the products you use, or see around you, in just one day, you would find that a vast range of design decisions are being made to create the environment in which you live.

These decisions are not made by just one sort of designer. Many different types of designer work in our modern industrial society. Each one usually specializes in the creation of one kind of product.

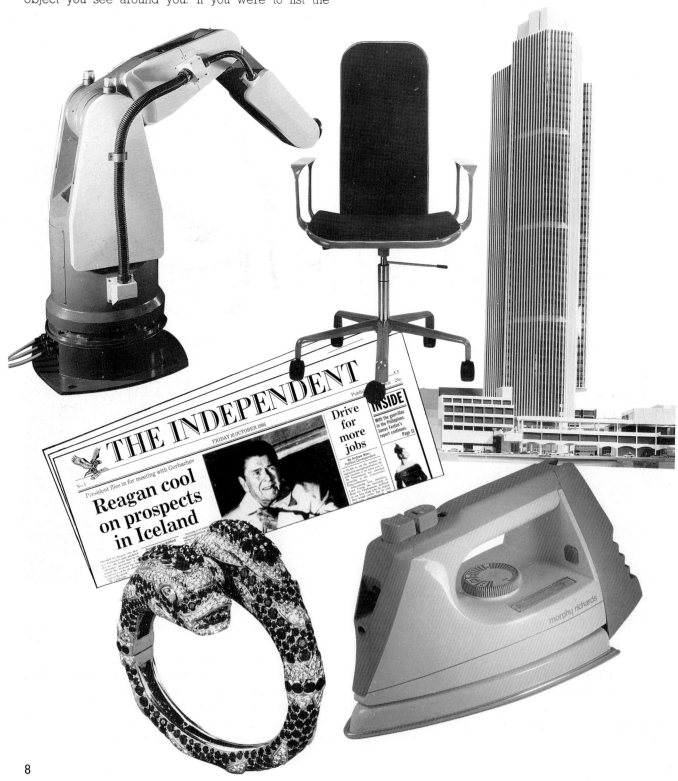

1.2 DESIGN EVOLVES

As a future designer, you should understand how products are conceived and built, and you should realize, at first hand, the effects they have on the people who use them.

From the Stone Age to modern times, the number of designed and manufactured objects and devices has increased steadily. The carpentry tools below were designed for various woodworking tasks in Roman Britain.

Generations of designers have improved and added to the range of tools and implements, making it possible for more people to spend more time thinking and planning. This, in turn, has led to the production of an increased number of designed objects.

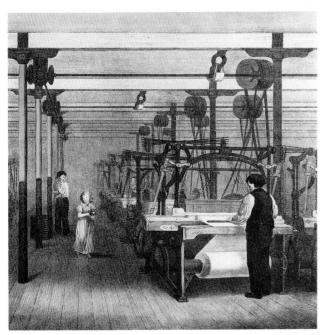

The development of new technology has helped in the production process. The design of new industrial machines, such as the weaving looms above, has had a tremendous impact on people's lives and their working conditions.

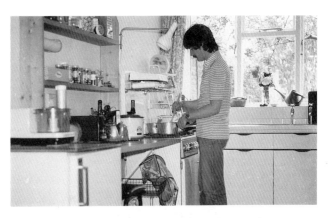

Designers have helped to improve the equipment we use in the home, making many household tasks much simpler.

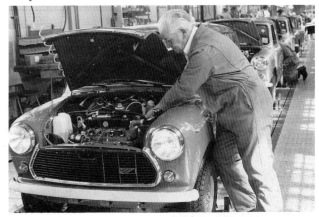

Production lines have allowed us to make complicated products such as cars relatively cheaply.

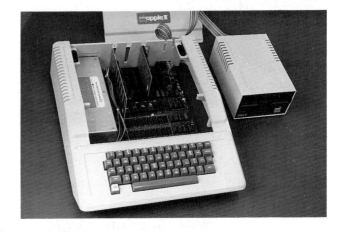

It is generally agreed that the role of design will become more important in the future, particularly as advances in science and technology make it possible to perform even more complicated tasks. Smaller and smaller electronic devices, for example, have helped to bring sophisticated machines like computers into everyday life. It therefore becomes important to understand the design process, and how particular design decisions are likely to affect people.

1.3 THE DESIGN CYCLE

Designers start the design process as **thinkers,** They analyse the problem to find out what it really means. Once this is done, they gather relevant information and set out to develop new solutions. To do this they often have to look at the problem from two aspects, viewing it both as a **technologist** and as an **artist**.

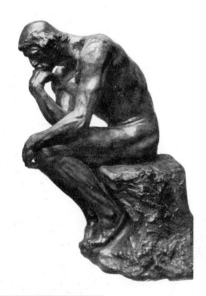

THE TECHNOLOGIST

Technologists choose the most appropriate materials and ensure that the construction is strong enough to stand up to regular use.

In fact, it is the technologist who is concerned with making sure that the object performs all its functions.

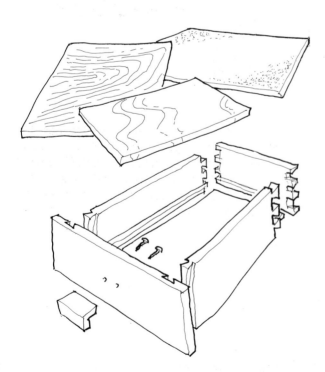

This is important, because, if an object does not work properly, it is of little use. However, this is not the only factor involved in good design.

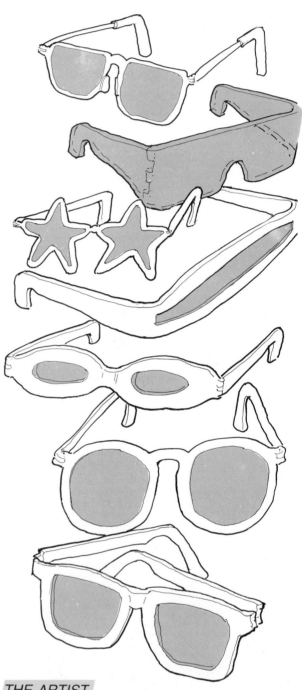

THE ARTIST

When you look at the collection of sunglasses above, you will find they are made of the same materials and use a similar construction system.

If you were asked to choose a pair, then their appearance is likely to influence your choice. The visual aspect of a design is important, and a good designer is an artist, using shapes, textures, and colours to produce 'appealing' objects.

DRAWING

Both appearance and function are important aspects of any design. But how these are emphasized will depend upon the nature of the problem and the character of the designer.

However, whether function is stressed more than appearance, or vice versa, both the 'technologist' and the 'artist' have to be able to draw. To visualize by drawing is a necessary part of sorting out ideas. Without drawing, in its many forms, the designer would not be able to work out the best solution to the problem, nor plan the detail of the design.

CRAFT SKILLS

Once these details are worked out, then the object can be manufactured. All effort can be concentrated on the important craft skills. Then, an object of good quality can be produced.

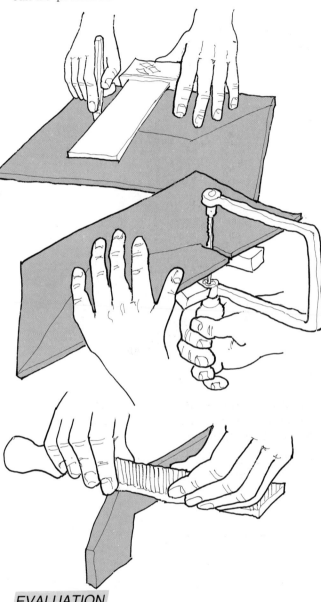

EVALUATION

On completion, the designer stands back to view the project objectively, asking the question 'How successful is this object?' The process has now gone full cycle. It started with a problem. It ends by returning to the this problem. We can now see how well the problem has been solved.

QUESTIONS

1 When is the designer a 'thinker'?
2 When is the designer a 'technologist'?
3 Why does a good designer have to be an artist?
4 Why do designers need to be able to draw?
5 Why are craft skills important?
6 Why can the design process be called a cycle?

1.4 GOOD FOUNDATIONS

Just as good foundations are very important for any building, they are also a vital part of any design project. Although foundations cannot be seen, the building would be very unsound without them. The same is true when it comes to a design project. Without the initial thinking it would be difficult to conceive and build a good product.

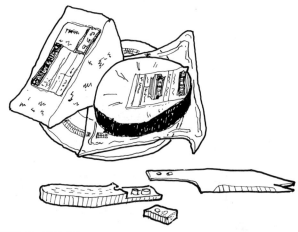

THE BRIEF

All design projects start with a brief. This is usually a short statement which sets out the basic problem. A typical brief might be 'Design and make a cheese cutter.' These words have been chosen carefully. They describe the general area of the problem without being too specific. This problem could have been written 'Design and make a cheese knife'. But this suggests that the solution would be a blade with a handle. In fact, you may find a much more interesting way to cut cheese, perhaps one that no one else has thought of yet. If you say that it is a knife, this will stop you from thinking widely enough to find possible new answers.

If you have to write your own brief, try not to make it too specific. Words like 'container' should be used instead of 'tin' or 'box'. 'Device' is a good word as it suggests many possibilities without stating how they might work.

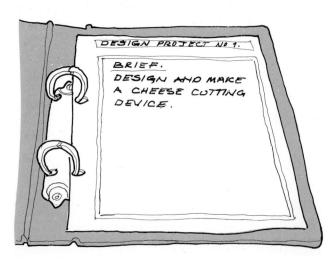

It helps sometimes to say 'could' rather than 'will'. 'Design a reading lamp that will move up and down and pivot through 360°' sounds quite reasonable. A better wording might be 'Design an adjustable lighting device that could be used at different angles and at different heights on a desk.' This leaves you room to think of new answers.

So the brief describes briefly what you are aiming to do. It should say just enough to state the problem, but it should not attempt to solve it.

ANALYSIS

Before you can say clearly and exactly what you are going to design, you need to examine the brief. This is best done by asking a series of questions and attempting answers. This process is called the **analysis**.

HOW DO I ASK QUESTIONS?

These questions start with the five '**W**s' — what, where, who, when, and why? They are:

> **What** could it do?
> **Where** could it be used?
> **Who** could use it?
> **When** could it be used?
> **Why** should it be used?

The words 'could' and 'should' permit you to find more than one answer to each question. In fact, you should try to find as many answers as possible. Set yourself about two minutes for each question, jotting down the answers, before moving on to the next. You may, while answering the 'where' question, think of another 'what' answer. A very good way to record your ideas is in the form of a **bubble chart**.

A bubble chart grows outwards from the central idea with the five questions grouped around it. Answers in bubbles can then be linked to each question. You can go on adding ideas as they occur. Do not ask 'how' questions at this stage. These will come later.

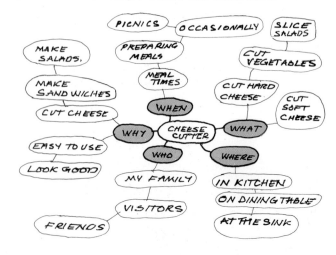

If your original problem was very general, you might try taking one idea from the chart and conducting a further analysis before carrying on. In any case, by conducting an analysis, you will probably find that there are a number of possibilities which you could design. All of them could satisfy your brief.

PROBLEM SPECIFICATION

You now need to choose one of these possibilities and to **specify** your problem. Do this by recording all the factors to be considered when you are designing a solution. Your answers to each of the questions in the analysis will make clear the product's main or **primary function.** You then need to ask the question 'What else must this product do?' because there are many hidden tasks which objects perform. These are **secondary functions** and, as a good designer, you should consider them as well as the more obvious primary ones.

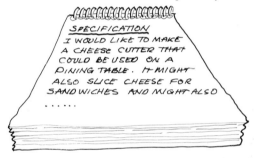

PRIMARY AND SECONDARY FUNCTIONS

The primary function of a cheese cutter, for instance, is to cut cheese. By asking what else it must do, you will discover that it should be easy to keep clean. So your design must not have sharp internal corners or grooves where cheese and germs might stick. It should stack away neatly when not in use and take up as little valuable storage space as possible. It must also be strong enough to withstand daily use, and so on and so on. . . .

SECONDARY FUNCTIONS

Secondary functions are very important. If you look at electrical goods, you will find that most of them have been well designed for their primary function. But quite often little thought has been given to the everyday use of these items.

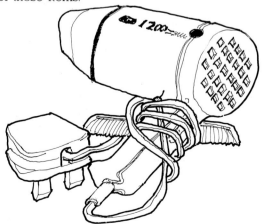

For example, hair dryers, which may have been designed to blow out hot air efficiently, will spend most of their time in storage. So the designer needs to think about this aspect. Often the design looks attractive, but there are problems when it comes to storing the dryer. For example, can the cable be wrapped up in a tidy way so that it does not get tangled with other items?

To find these secondary functions, think through a typical period in the life of your product. Ask yourself questions about storage, transport, cleaning, and maintenance. List the findings in your specification.

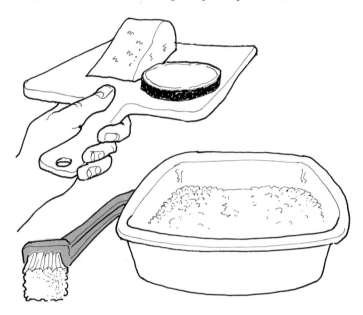

QUESTIONS

1 What is a good foundation for a design project?
2 Why should a design brief not be too specific?
3 What questions are needed to help you analyse a problem?
4 Why are 'could' and 'should' important words?
5 What is a specification?
6 What is a primary function?
7 What is a secondary function?
8 Why are secondary functions important?

1.5 GETTING THINGS RIGHT

If the object you are designing is to be worth-while, you must think it out carefully, manufacture it from the most suitable materials, and make it the right size.

THE RIGHT IDEA

To find the right idea you might need to do some experiments. You might also wish to find out how other designers have solved your problem or similar ones.

By gathering information (see page 96), you might find many different ways to solve your problem. Remember there is nothing wrong with borrowing ideas, so long as you rework them to fit your specification. It is unlikely that anyone has worked to exactly the same requirements as yourself. So other ideas, no matter how good, will need to be modified.

THE RIGHT MATERIALS

All designers are limited by the materials which are available. Some of your projects will be organized by your teachers. They will select suitable materials, making sure that there are enough of these in the school to enable each member of the class to make the object. They will also choose reasonably priced materials with the correct properties.

When you have to choose a material for yourself you will have to think about **availability, properties,** and **price.**

AVAILABILITY

Availability is a prime factor. There is no point in designing something to be made of brass sheet if there is none available. This may seem obvious, but it is often forgotten. So check the storeroom before you commit yourself.

EXPERIMENTS

Experiments should be used to find key pieces of information. This might mean finding the weight of a certain amount of wet clothes for a project concerned with clothes drying. Similarly, you might experiment to identify various ways of cutting cheese for a cheese-cutter project. Whatever you do, you should write it up in the same manner as a scientific experiment using these headings:

Aim — why I did the experiment
Apparatus — equipment and materials used
Method — how the experiment was done
Result — what was discovered.

INFORMATION

Information is anything that can be related to the specification. You could take cuttings from magazines and newspapers of similar products, or copy diagrams and notes from books, as well as writing to manufacturers for trade literature.

PROPERTIES

Each material has good and bad points. Mild steel is strong, but it rusts. Plastics are waterproof, but will not stand too much heat. Chipboard is cheap, but it cannot be used in wet situations. When you know your design problem you should be able to specify the properties

you need from your materials. To help you select the best materials for your project you will find some information on pages 102–111.

PRICE

Price is always important. Different materials can be just as good for a particular job, but one material might be much cheaper than the rest. You can find a table of materials, with approximate prices and common stock sizes on pages 110–111. This will give you some indication of cost and will help you to decide, at the design stage, whether or not to make changes.

THE RIGHT SIZE

Most people are not tall enough to sit at a table 1.5 metres high nor short enough to be comfortable with one only 300 mm from the ground. There may be one or two people who would be suited to these tables, but most of us would not.

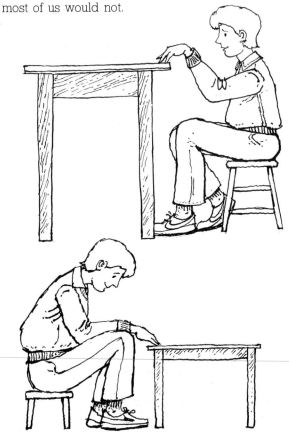

To help designers make things the right size for most people, scientists have studied human bodies and gathered information which is called **anthropometric data**. There is a summary of this information in Section 3. This data will provide you with key human dimensions which will enable you to work out the overall sizes of tables and chairs, for example. These facts will also help you with less obvious projects. If, for instance, you were designing a tool rack, then to know the size of the average hand would help you to space the tools so that they could be removed easily. Using anthropometric data in this way to make products the right size is called **ergonomics**.

The data, however, is quite general. If you were involved in a particular task aimed at a particular person, then you should set up some experiments to gather your own anthropometric data. You might be trying to develop a tin opener for someone with arthritis. You would need to look carefully at the capabilities of arthritic people. You might also need to measure and record the length, width, and thickness of the average tin can.

In fact, if your design involves the use of any other object, then you will need to know its exact dimensions as well.

QUESTIONS

1 When are experiments useful?

2 What must you do when 'borrowing' design ideas?

3 What are the three factors you should consider when selecting a material?

4 Why are availability, properties, and price important?

5 What is anthropometric data?

6 What other data is important to designers?

1.6 APPEARANCES MATTER

The two tables below have both been produced in response to the same brief. They are both large enough to provide room for a tea tray, and high enough to be reached easily from a sofa. In functional terms, there is little difference between them. But there are few situations in which the 'orange box' could be considered a satisfactory solution. That is because appearances matter.

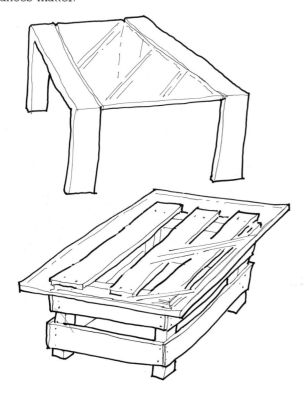

FORM FOLLOWS FUNCTION

What your design will look like is often a matter of personal preference. It is sometimes thought that the shapes and forms chosen may depend only on the function of the object. To find out if this is true you need to look more closely at a particular design problem.

One of the primary functional requirements of a table is that it should stand firmly on a flat, level floor with the top horizontal. This tells you that you must design a structure with a number of supports, or legs, all of which must be the same length. This function, however, does not tell you the size of these 'legs', their number, their shape, or even the material to be used.

A secondary requirement is that the materials used should be treated in some way so that they will be easy to clean and will stand up to regular use. It does not tell you what the treatment should be, nor what colour or type of finish you should use.

The shape, texture, colour, and finish are important. These features of your design are the things that will be seen and will give it visual appeal.

AESTHETICS

Aesthetics is the study of visual qualities. It is concerned with 'beauty'. It is a difficult subject because there are no fixed ideas about beauty or what makes something attractive.

For instance, what you consider a good shape for a pair of shoes probably differs from your parents' view. Their ideas will not necessarily be the same as people living in New Guinea. And your ideas now are unlikely to be the same as they were two years ago.

We call these ever changing ideas about appearance **fashion.**

FASHION AND STYLE

As you know, fashions for clothes are always being changed and updated. But so are fashions for other manufactured objects.

Different styles can be created with different shapes, colours, or textures. **Style**, in fact, is the way in which all of the visual elements are blended together.

WHICH STYLE?

Just as there are various styles of 'fashionable' clothes, there are also different ideas about what makes an acceptable product design.

None of the tables below is wrong. The one which appeals to you depends upon your taste and the environment in which it is to be used.

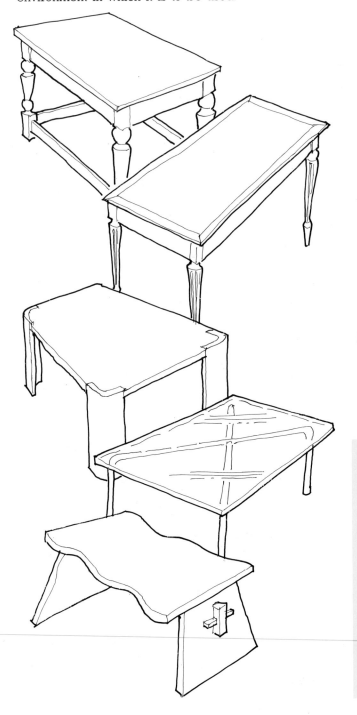

DESIGN RULES

Because ideas about what is attractive vary so much there are no definite rules which must be followed to ensure a design is aesthetically pleasing. A good designer, however, must be aware of the visual elements that can be used in any design problem. A suitable product can then be produced.

You need to find a style which will 'fit' with its intended environment. Also, as the designer, you need to make sure that the style is suited to the problem. You should build up visual awareness. Look at the objects around you. Think about your likes and dislikes. Analyse the ways in which the visual elements have been used.

SKETCH BOOK

Start to compile a sketch book where you can collect ideas. Paste in photographs and leaflets of products and analyse what it is that interests you. In this way, you will increase your visual vocabulary. This will help you to develop better design solutions.

QUESTIONS

1 Do you agree that the orange box is not a good solution to the table problem?
 Give reasons for your answer.
2 What is meant by the statement 'form follows function'?
3 Is it true to say that form depends on function?
4 What is aesthetics?
5 How do ideas about beauty vary?
6 What is style?
7 Why are there no definite design rules related to appearance?

1.7 SKETCHING AND PROTOTYPING

When you have defined what the problem really is, and you have found the information and data you need, you are ready to start working out design ideas. The best way of doing this is to sketch them.

This means asking the questions 'What might it look like?' and 'How might it work?' You can answer these by making a series of drawings and notes to try out ideas. It is a good idea to tackle this part of the project in the spirit of 'What would happen if. . .?'

THINK ON PAPER

You should try to think of as many ideas as you can. With a wide variety of possibilities, you will stand a better chance of finding a really good solution.

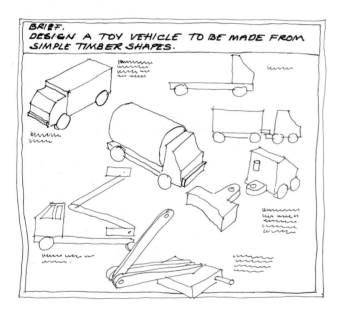

Try not to be too critical of your initial ideas or think that one notion is all you can manage. Once you have something down on paper, you should be able to think about it more carefully or discuss it with other people. You can then modify and improve it.

Keep asking yourself questions, as it is very unlikely that your first scheme will be the best one. You should try to think of at least three possibilities.

One idea could suggest another idea or a change to the first.

DESIGNERS' SKETCH BOOKS

If you look at other designers' sketch books you wil see that the various possibilities are recorded in different ways. Some of the drawings are finished, solid looking three-dimensional objects; some are part drawings; some are exploded views; and some are flat plans and elevations.

These various types of drawing (discussed on pages 30–69) explain different aspects of the solution. The three-dimensional drawings give some idea of how the completed object will look. Use the cut aways and exploded drawings to work out how the parts might fit together, and flat drawings to refine shapes.

NOTES ARE IMPORTANT

You will also notice that sketch sheets are a series of both drawings and notes. These notes are important. They are there to remind you of ideas, things that you perhaps could not draw. They might suggest a change to the design which only occured to you as you finished sketching it. Or they might indicate which materials could be used.

You will need to write a least one note per drawing. When you return to the problem, refer to your sketch book and you will be reminded of your initial ideas.

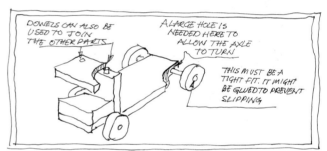

DO NOT WASTE IDEAS

When sketching, you should always remember that the next time you look at the problem you may see it differently. A poor idea today might suggest something better next time. Do not waste any possibility — record it in your sketch book.

PROTOTYPING

Because it is possible to draw things that may not actually work as solid shapes, you must not trust sketches too much.

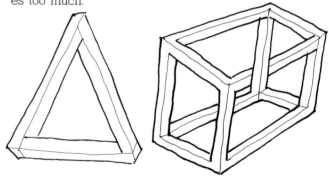

Look carefully at the triangle and cube above.

They appear solid enough, but what would they look like from the end view?

Your drawings will probably be less misleading than these, but the sketch is only one view. When it is made, the object will be seen from every angle.

BUILDING CONFIDENCE

Sometimes it is difficult to get sizes and proportions just right using only a drawing. It is not worth spending time making the actual object, without more evidence.

To be sure that your sketch is worth the effort of manufacture, you need to build **prototypes.** This means taking your best sketches and modelling them quickly with simple materials.

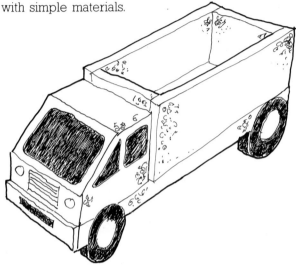

SCALE MODELS

Try to make models full-size if you can. You can then see the details of the design as they will actually be. But if this is not possible, you should attempt a scale model. If the model is one half the finished size, 10 mm on your model will equal 20 mm in reality. This proportion is expressed as 1:2.

A larger object, like a piece of furniture, might be modelled at 1:10, where 10 mm on the model is equal to 100 mm on the final object.

The furniture designer will often build a small prototype to view the object from all angles. The design can then be modified before building a full-size 'mock up'.

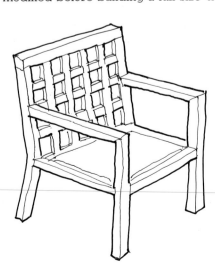

Architects have to work to very small scales, such as 1:2500, to model their building schemes. These models are carefully made, because full-size prototypes are not possible. They must be very accurate in order to check out details and make sure that the scheme meets the specification.

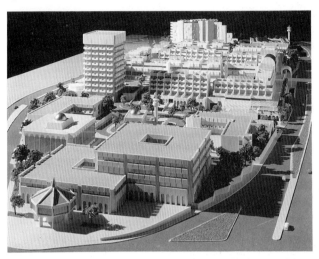

TESTING IDEAS

Car designers may start by making scale models of new vehicles. As soon as they are confident of a shape, they will build full-size prototypes to test them under realistic conditions.

The point of the prototype is to try out ideas. With this in mind, you should be ready to modify models if you find a fault in the original design. This might mean adding an extra piece to make it more functional or changing the shape to improve the appearance. Most designers will sketch ideas, then build prototypes. They may then return to the drawing board, having learned more about the problem. This may happen a number of times.

If your design is complicated, you may have to go through this process more than once before you are happy with your solution.

QUESTIONS

1 What questions should you ask when you are sketching?
2 Why do you need more than one possible solution to your problem?
3 Why are written notes on sketch sheets important?
4 Different types of drawing are used to sketch out ideas.
 What are they and why are they used?
5 Drawings are useful but why should you be wary of them?
6 What should models be made from?
7 Why is it best to make models full-size?
8 What is the point of a prototype?

1.8 A MATTER OF CHOICE

When you have decided on the appearance of your design, you will need to work out exactly how to construct it. This will involve you in a matter of choice.

At this stage of the design process you need to be practical. When you are considering construction it is best to keep two factors firmly in mind. These are **time** and **skill.**

HOW MUCH TIME?

Start by asking yourself 'How much time do I have to manufacture this object?' If it has to be made quickly, you must attempt a simple, straightforward construction. If you have more time you can afford to be adventurous.

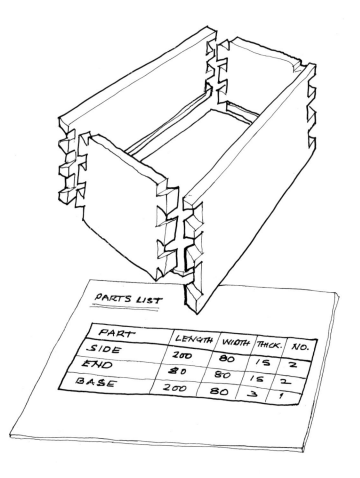

PARTS LIST

PART	LENGTH	WIDTH	THICK.	NO.
SIDE	200	80	15	2
END	80	80	15	2
BASE	200	80	3	1

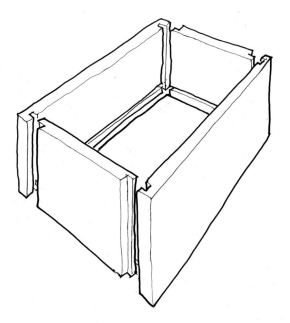

Both of the boxes above are made from five pieces of material, and each has four joints. The box on the left uses only grooves, or rebates. These are much simpler than the dovetails in the second construction. Each of the dovetail joints must be carefully cut out and fitted together. So this box will take longer to make.

PARTS LIST

PART	LENGTH	WIDTH	THICK	NO.
SIDE	200	80	15	2
END	80	80	15	2
BASE	200	80	3	1

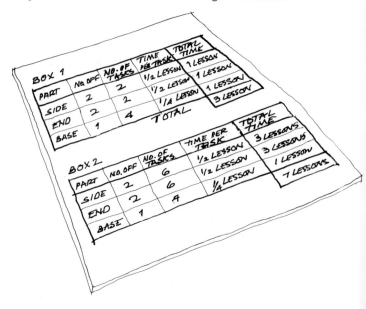

BOX 1				
PART	No OFF	NO. OF TASKS	TIME PER TASKS	TOTAL TIME
SIDE	2	2	1/2 LESSON	1 LESSON
END	2	2	1/4 LESSON	1 LESSON
BASE	1	4	TOTAL	3 LESSON

BOX 2				
PART	NO. OFF	NO. OF TASKS	TIME PER TASK	TOTAL TIME
SIDE	2	6	1/2 LESSON	3 LESSONS
END	2	6	1/2 LESSON	3 LESSONS
BASE	1	4	1/4 LESSON	1 LESSON
				7 LESSONS

It is sound practice to count up the number of parts of your construction. Then list how many joints or shaping operations there will be for each piece. This will help you to estimate the time needed for the whole construction.

WHAT SKILL IS NEEDED?

Your own ability is important at this stage. If you work with care and precision, then complicated constructions are going to provide you with an ideal challenge. If you are not confident with your workmanship, you should concentrate on simpler shapes and straightforward constructions until your skills improve.

The steel framed coffee tables both look fairly simple. The round tube system is based on a connector which would need to be carefully designed and manufactured. Once this was done, the eight tubes which make up the frame would simply be cut to length, squared off, and drilled before the table was assembled.

The bent tube table has only four frame members. At first, this table might look simpler. But each tube would have to be carefully formed into right angles at exactly the correct place, with no twisting or crushing of the tube. Then, the tubes would have to be fastened together and the 'glass support' brackets formed and fitted. These are operations which need skill and precision.

Neither of these designs is the right or wrong one. Both would 'work' equally well. The skill and time involved depends on the choice you make. You, as the designer, must make that choice.

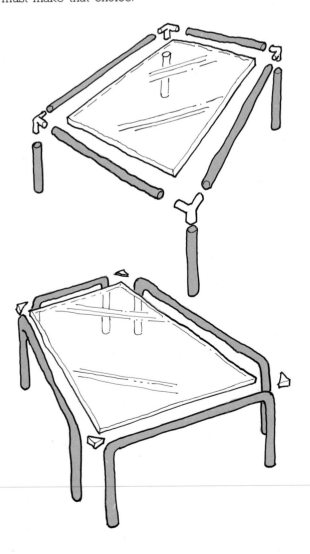

EXACT DETAILS

Once you have made a decision, you need to prepare the product for manufacture. This involves working out exactly what sort of material should be used, how many pieces are needed, and the exact sizes required. This is best done by preparing a set of working drawings in what is called **orthographic projection**. You will find more information on this on pages 62–69.

Draw at least three flat views of the object from different directions. You should then be able to work out the exact details of each piece of your design and see how they fit together. These components should be listed on a parts list, where their overall dimensions can be found quickly.

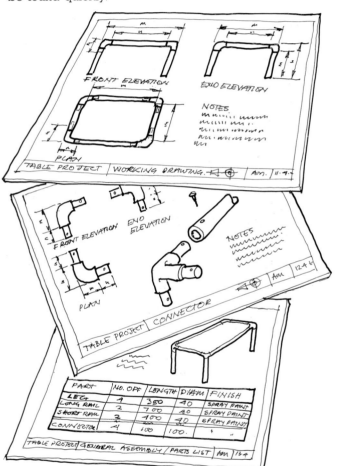

QUESTIONS

1 What effect does time have on the construction of your design?

2 Why should you consider your own skills when planning your construction?

3 How would you estimate the time needed to manufacture two alternative constructions?

4 How could you reduce the amount of skill needed to manufacture an object?

5 What is the best way to work out the exact details of your design?

6 What is the function of a parts list?

1.9 MANUFACTURING

Before you manufacture your design you should discuss your ideas with your teacher to ensure a practical manufacturing plan. It is a good idea to sketch a project network chart (see page 157). This will allow both of you to see the whole plan at a glance.

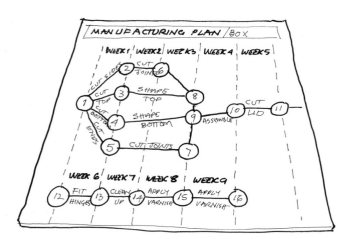

At this time, you should also decide on the best order for the cutting and shaping operation involved. Careful thought at this stage will often save a lot of time in the workshop.

SPECIAL TOOLS AND MATERIALS

Planning will enable you to arrange for any special tools and materials you might need. It will also help you to decide if the manufacture of **jigs, templets,** or **formers** would be right for the number of operations involved.

JIGS

A jig is something which will allow you to repeat an operation accurately every time. For instance, perhaps you would need to drill twenty strips of metal with a hole 10 mm from each end. If you measure and make each one separately, you might get twenty different results. Instead, you could make a 'holder' into which the metal is placed for centre punching and then held for drilling. This holder is called a jig.

TEMPLETS

By making a shape from a durable material which you can draw around, you have made a templet. This can be used to reproduce the original outline, or a feature, any number of times with accuracy.

FORMERS

A former is a construction which will help you with shaping operations. If, for example, you were bending a number of plastic sheets to make holders for a notice-board, then a former would make sure that each sheet is shaped correctly.

PATTERNS

If you were intending to make a moulding in aluminium or polyester resin, then you would need to make a pattern before making the mould. A pattern is an exact

replica of the object. It is made in timber, and has all of the features of the final object.

MOULDS

In the school workshop, moulds are chiefly used for metals and plastics. They have to be accurate and well finished because every detail of the final moulding depends on them. If you wanted to make a ball, the mould would be two hollow cups. You should take care with the design of moulds. You need to be able to remove the object when it is completed. Also, the joint lines between the parts should be in the least noticeable places.

In the lower school, jigs, templets, formers, patterns, and moulds will probably have been made for you. Now you must decide if they are worth your effort. Will they save you time in the long run? Will they enable you to produce a better product? If you decide that they are worthwhile, then they must be allowed for in the plan.

DESIGN ALTERATIONS

The design process does not end when you start to make something. As the physical object grows in front of you, you will often see where you can make improvements. There is nothing wrong with making these, if they are minor changes to your scheme. But do not change too many features without first checking your drawings. You may have forgotten why you made a particular decision. By changing part of it, the object may no longer function properly.

CHECK REGULARLY

The manufacturing plan should be consulted regularly to see if you are meeting your deadline. It is best to put in the extra effort as it is needed. Don't leave all the catching up to the last minute. Sometimes rushing cannot be avoided. It is very difficult to foresee every problem and plan for it. But having to do things quickly usually leads to inferior work.

MANUFACTURING

All this planning is intended to make the manufacturing process as easy as possible. When you are making something, you need to concentrate your efforts into getting the pieces correctly shaped and fitting together as exactly as you can. This will not happen easily. It will take a lot of thought, skill, patience, and common sense.

Some people are naturally good with their hands and eyes. They can see immediately if something is not square and can easily put it right. The rest of us have to battle to achieve these things. For instance, to make a competent woodwork joint you would have to make sure that the work was firmly held in the vice with a minimum of material projecting from it. The sawing operation should be undertaken slowly and carefully, and the saw should be square and in the wood that is to be removed.

When chiselling, constant checking is needed so that too much material is not removed and an accurate shape is produced. Eventually, with care, you should achieve a good fit.

Each workshop operation has a set of procedures and needs a range of tools for different purposes. These have been established over many years and both the procedures and tools are summarized in sections 6 and 7. Do remember that they have not been drawn up to slow you down or to hamper your efforts in any way. They really are the best way of achieving good results.

LOG BOOK

To improve your skill and judgement it is a good idea to keep a manufacturing log book. Here you can record your plan and match it against the reality. The problems which you meet can be noted and their solutions recorded.

In this way you can learn from your mistakes, so that you can improve your next manufacturing plan.

QUESTIONS

1 Why is it a good idea to discuss your plans before you start to manufacture your design?

2 What is a jig?

3 What is a templet used for?

4 When would you use a pattern?

5 Why must moulds be well finished?

6 Why should you check your drawings before making major adjustments to your design during manufacture.

7 Why should you check your progress against your plan?

8 Why should you use established tools and procedures?

9 How can a log book help you?

1.10 TESTING AND EVALUATION

When you have finished the manufacture of your product, you will need to **test** and **evaluate** it before you can say that the project is completed.

This means analysing your efforts, and if you do this effectively it will help you to become a better designer.

Design and manufacture demands a great variety of skills. It is very unlikely that you will be excellent at all of them. The skills you need are:

thinking — analysing and developing solutions to problems

technology — deciding how the design will work

art — choosing the most appropriate visual elements

drawing — sketching ideas and presenting detailed and accurate drawings

modelling — 'shaping' ideas and selecting the final form

planning — evolving the most practical manufacturing programme

manufacturing — using the practical skills and techniques to make the object

You can be your own best teacher here. By asking yourself questions and answering them honestly, you will be able to build on your strengths and learn from your weaknesses.

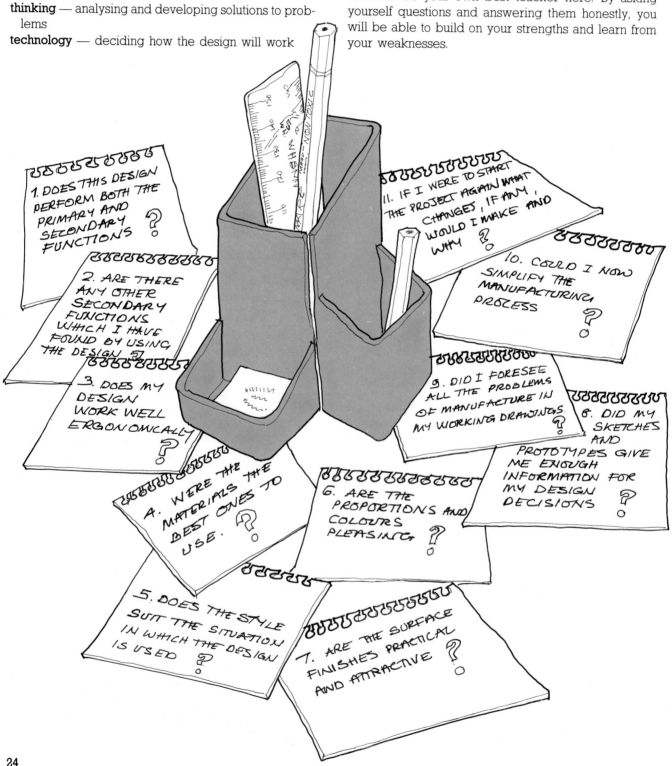

1. DOES THIS DESIGN PERFORM BOTH THE PRIMARY AND SECONDARY FUNCTIONS ?

2. ARE THERE ANY OTHER SECONDARY FUNCTIONS WHICH I HAVE FOUND BY USING THE DESIGN ?

3. DOES MY DESIGN WORK WELL ERGONOMICALLY ?

4. WERE THE MATERIALS THE BEST ONES TO USE.?

5. DOES THE STYLE SUIT THE SITUATION IN WHICH THE DESIGN IS USED ?

6. ARE THE PROPORTIONS AND COLOURS PLEASING ?

7. ARE THE SURFACE FINISHES PRACTICAL AND ATTRACTIVE ?

8. DID MY SKETCHES AND PROTOTYPES GIVE ME ENOUGH INFORMATION FOR MY DESIGN DECISIONS ?

9. DID I FORESEE ALL THE PROBLEMS OF MANUFACTURE IN MY WORKING DRAWINGS ?

10. COULD I NOW SIMPLIFY THE MANUFACTURING PROCESS ?

11. IF I WERE TO START THE PROJECT AGAIN WHAT CHANGES, IF ANY, WOULD I MAKE AND WHY ?

TESTING

The tests which you use will depend upon the type of product you have designed. If your 'design' is intended for domestic use you might simply live with it to **test** that it meets all the requirements of the design brief and the problem specification. It is also a good idea to ask someone else to use it if you can. You can then get a more objective assessment. For instance, if it is a project aimed at office use, you might ask a local company to test it out under real conditions.

SIMULATION

Alternatively, you might set up a **simulation**, putting the product under conditions similar to the real situation. The designer of a new door handle might set up a machine to simulate its use. This machine could turn the handle repeatedly, and so he or she can get an idea of how long the handle would last in ordinary use. In both cases make sure you have checked the primary and secondary functions. You should also make sure that your test period is long enough for you to get a fair picture.

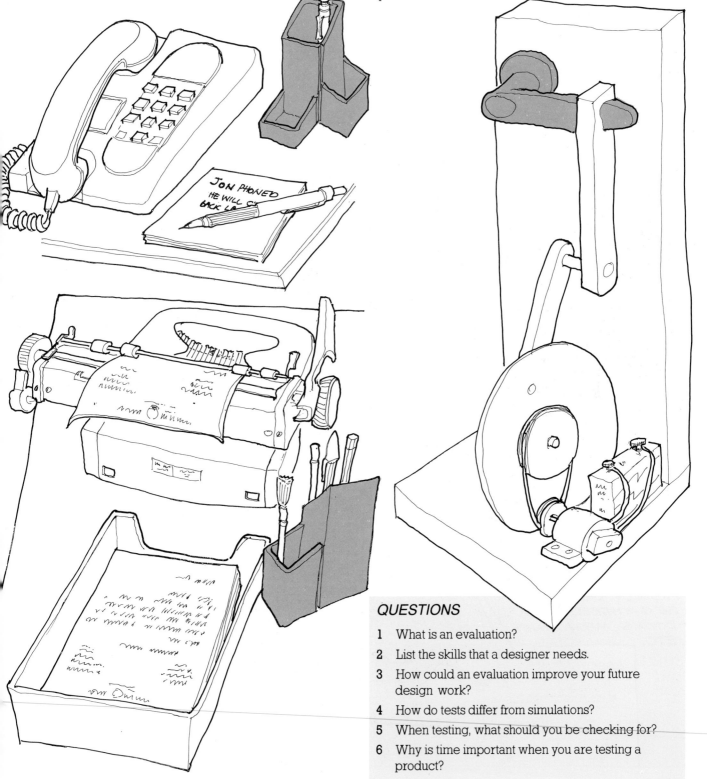

QUESTIONS

1 What is an evaluation?

2 List the skills that a designer needs.

3 How could an evaluation improve your future design work?

4 How do tests differ from simulations?

5 When testing, what should you be checking for?

6 Why is time important when you are testing a product?

1.11 THE DESIGN PROCESS

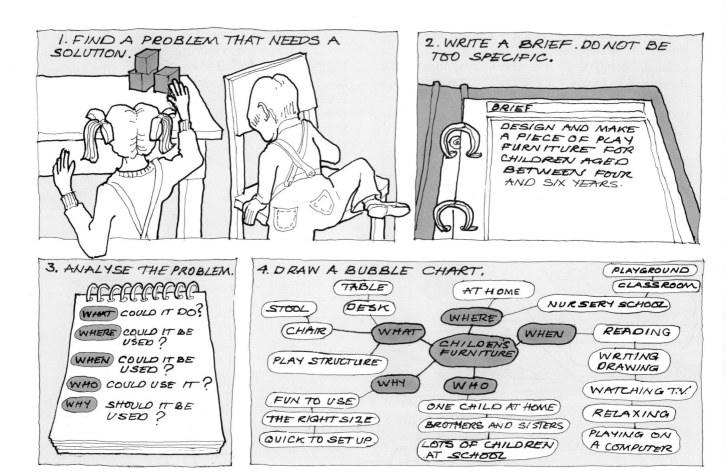

1. FIND A PROBLEM THAT NEEDS A SOLUTION.

2. WRITE A BRIEF. DO NOT BE TOO SPECIFIC.

BRIEF
DESIGN AND MAKE A PIECE OF PLAY FURNITURE FOR CHILDREN AGED BETWEEN FOUR AND SIX YEARS.

3. ANALYSE THE PROBLEM.

WHAT COULD IT DO?
WHERE COULD IT BE USED?
WHEN COULD IT BE USED?
WHO COULD USE IT?
WHY SHOULD IT BE USED?

4. DRAW A BUBBLE CHART.

CHILDRENS FURNITURE
WHAT — TABLE, DESK, STOOL, CHAIR, PLAY STRUCTURE
WHERE — AT HOME, PLAYGROUND, CLASSROOM, NURSERY SCHOOL
WHEN — READING, WRITING DRAWING, WATCHING T.V., RELAXING, PLAYING ON A COMPUTER
WHY — FUN TO USE, THE RIGHT SIZE, QUICK TO SET UP
WHO — ONE CHILD AT HOME, BROTHERS AND SISTERS, LOTS OF CHILDREN AT SCHOOL

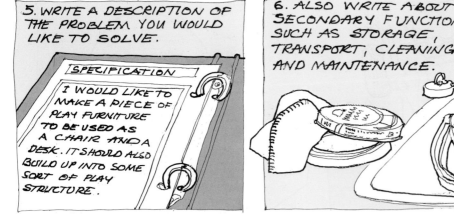

5. WRITE A DESCRIPTION OF THE PROBLEM YOU WOULD LIKE TO SOLVE.

SPECIFICATION
I WOULD LIKE TO MAKE A PIECE OF PLAY FURNITURE TO BE USED AS A CHAIR AND A DESK. IT SHOULD ALSO BUILD UP INTO SOME SORT OF PLAY STRUCTURE.

6. ALSO WRITE ABOUT THE SECONDARY FUNCTIONS SUCH AS STORAGE, TRANSPORT, CLEANING, AND MAINTENANCE.

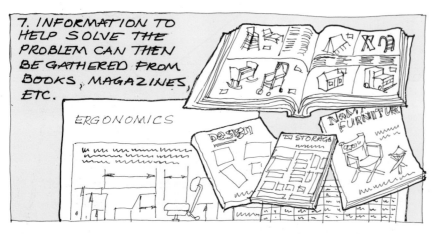

7. INFORMATION TO HELP SOLVE THE PROBLEM CAN THEN BE GATHERED FROM BOOKS, MAGAZINES, ETC.

ERGONOMICS

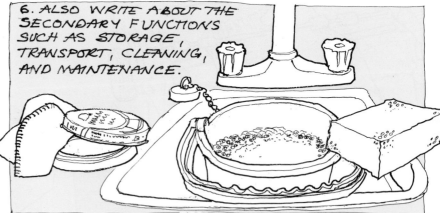

8. LETTERS CAN BE WRITTEN TO MANUFACTURERS OF INTERESTING PRODUCTS.

41 ROSEDALE
WELWYN GARDEN
HERTS AL7 1DW
21ST MAR 1994.

FUN FURNITURE
13 CENTRE WAY
LONDON N4.

DEAR SIRS,
I AM A PUPIL AT MONKS WALK SCHOOL IN WELWYN GARDEN CITY AND AM STUDYING FOR MY GCSE EXAM IN DESIGN AND REALIZATION. I AM INTERESTED IN CHILDREN'S FURNITURE AND WOULD WELCOME A COPY OF YOUR SCHOOL FURNITURE CATALOGUE. YOUR SINCERELY,

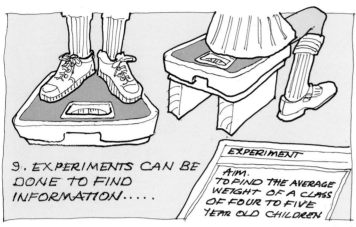
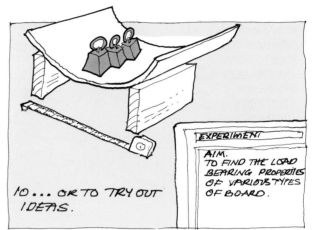

9. EXPERIMENTS CAN BE DONE TO FIND INFORMATION.....

EXPERIMENT

AIM.
TO FIND THE AVERAGE WEIGHT OF A CLASS OF FOUR TO FIVE YEAR OLD CHILDREN

10...OR TO TRY OUT IDEAS.

EXPERIMENT

AIM.
TO FIND THE LOAD BEARING PROPERTIES OF VARIOUS TYPES OF BOARD.

11. ALTERNATIVE SOLUTIONS CAN BE EXPLORED BY SKETCHING.

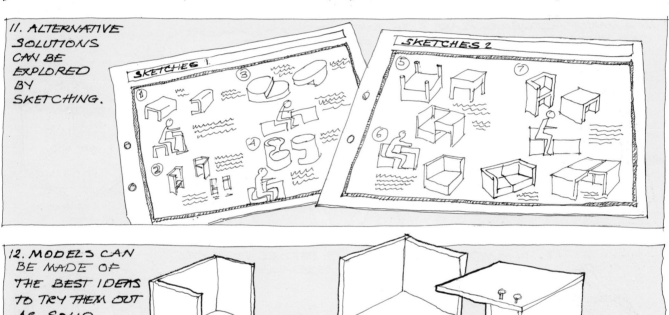

SKETCHES 1

SKETCHES 2

12. MODELS CAN BE MADE OF THE BEST IDEAS TO TRY THEM OUT AS SOLID OBJECTS.

clear adhesive Britfix

13. THE IDEAS CAN THEN BE IMPROVED BY FURTHER SKETCHING BEFORE A SOLUTION IS SELECTED.

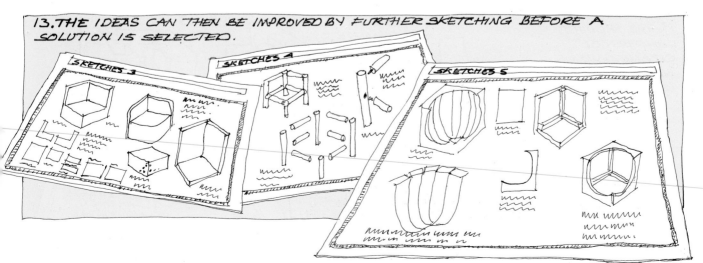

SKETCHES 3

SKETCHES 4

SKETCHES 5

14. WORKING DRAWINGS ARE THEN PREPARED TO WORK OUT THE DETAILS OF THE DESIGN.

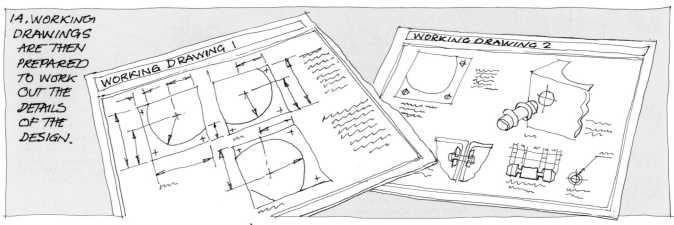

WORKING DRAWING 1

WORKING DRAWING 2

15. A MANUFACTURING PLAN CAN THEN BE DRAWN UP.

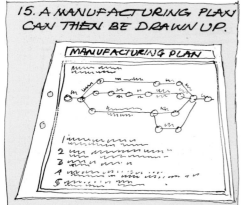

MANUFACTURING PLAN

16. MATERIALS CAN BE CUT....

17. ... AND SHAPED

18. BEFORE THEY ARE ASSEMBLED.

19. THE PRODUCT CAN THEN BE CLEANED UP BEFORE IT IS FINISHED.

20. WHEN COMPLETE, THE DESIGN CAN BE TESTED AND AN EVALUATION WRITTEN.

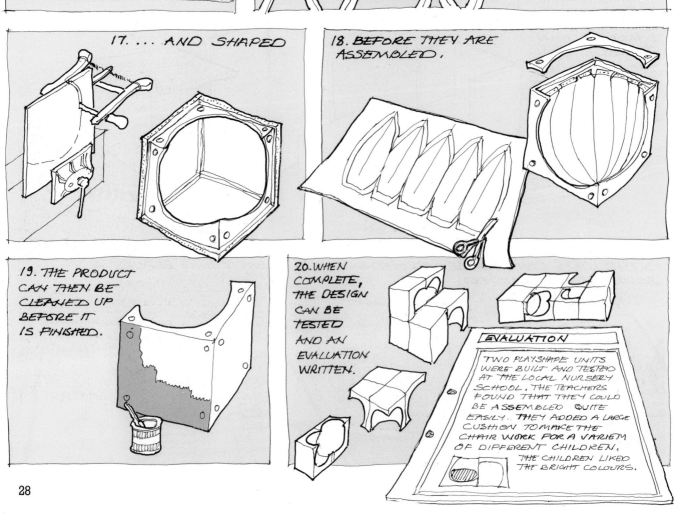

EVALUATION

TWO PLAYSHAPE UNITS WERE BUILT AND TESTED AT THE LOCAL NURSERY SCHOOL. THE TEACHERS FOUND THAT THEY COULD BE ASSEMBLED QUITE EASILY. THEY ADDED A LARGE CUSHION TO MAKE THE CHAIR WORK FOR A VARIETY OF DIFFERENT CHILDREN. THE CHILDREN LIKED THE BRIGHT COLOURS.

SECTION 2
DESIGN GRAPHICS

2.1 DRAUGHTING EQUIPMENT

Designers sketch to try out ideas. Sketching only requires a soft pencil and an eraser. More accurate drawings are used to work out precise details and need to be drawn with instruments on a drawing board.

1. GOOD DRAWING BOARDS ARE EDGED, BUT ANY FLAT SQUARE BOARD CAN BE USED.

2. THE BOARD NEEDS TO BE ANGLED. THIS CAN BE ACHIEVED BY A NUMBER OF SYSTEMS. WEDGES, LEGS, AND STANDS ARE THE MOST COMMON.

3. TEE SQUARES ARE USED TO DRAW PARALLEL HORIZONTAL LINES. THERE ARE A NUMBER OF DIFFERENT FORMS BUT EACH PERFORMS THE SAME TASK.

BOARD AND TEE SQUARE DRAUGHTING TABLET PARALLEL MOTION

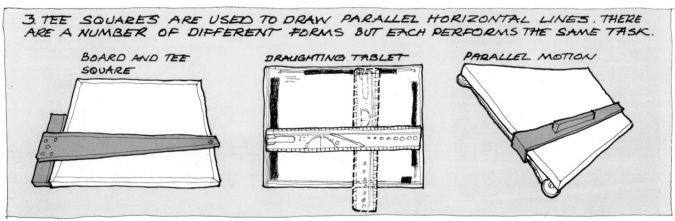

4. CARTRIDGE, LAYOUT, AND TRACING PAPERS ARE ALL AVAILABLE IN STANDARD 'A' SIZES.
A2 IS TWICE A3
A3 IS TWICE A4.

CARTRIDGE IS WHITE AND OPAQUE AND IS FOR GENERAL DRAWING.
LAYOUT IS TRANSLUCENT. IT WORKS WELL WITH UNDERLAY SHEETS.
TRACING IS USED IN DRAWING OFFICES. CORRECTIONS CAN BE MADE EASILY AND PRINTS TAKEN.

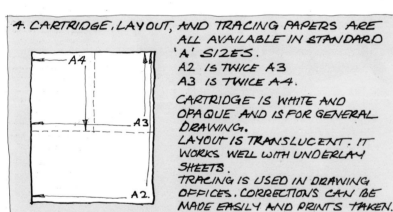

5. PAPER HAS TO BE HELD SQUARE AND FIRMLY IN PLACE. DRAWING PINS, DRAUGHTING TAPE OR BOARD CLIPS CAN BE USED.

6. DRAWING PENCILS ARE GRADED FROM 6B TO 9H.

B ARE SOFT GRADES; H ARE HARD.

FOR SKETCHING USE HB OR 2B AND FOR DRAUGHTING ON CARTRIDGE 4H AND H. DRAWING ON TRACING WILL NEED 6H AND 2H PENCILS.

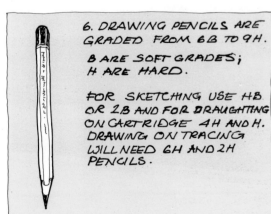

7. POINTED OR CHISEL SHAPED LEADS CAN BE USED.

8. TRANSPARENT PLASTIC RULES ARE USEFUL FOR GENERAL DRAUGHTING PURPOSES. SCALE RULES REPRESENT MEASUREMENTS AT VARIOUS SCALES.

2.2 LINES AND ANGLES

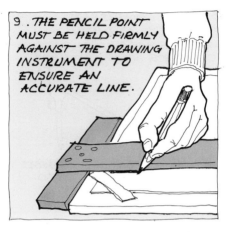

9. THE PENCIL POINT MUST BE HELD FIRMLY AGAINST THE DRAWING INSTRUMENT TO ENSURE AN ACCURATE LINE.

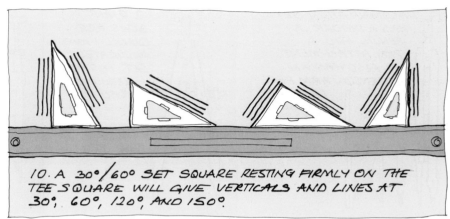

10. A 30°/60° SET SQUARE RESTING FIRMLY ON THE TEE SQUARE WILL GIVE VERTICALS AND LINES AT 30°, 60°, 120°, AND 150°.

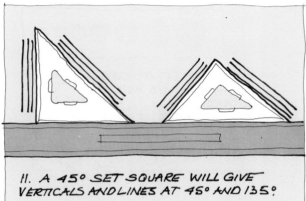

11. A 45° SET SQUARE WILL GIVE VERTICALS AND LINES AT 45° AND 135°.

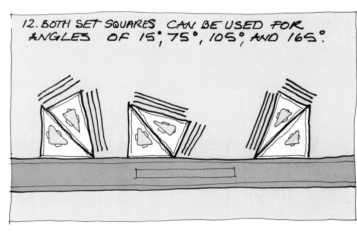

12. BOTH SET SQUARES CAN BE USED FOR ANGLES OF 15°, 75°, 105°, AND 165°.

13. OTHER ANGLES CAN BE DRAWN WITH A PROTRACTOR.

TO DRAW PARALLEL LINES,
A. PLACE ONE SET SQUARE ON THE LINE.
B. MOVE THE OTHER ONE TO TOUCH THE FIRST
C. HOLD THE SECOND SQUARE FIRMLY IN PLACE
D. SLIDE THE FIRST SQUARE, EITHER TO THE LEFT OR RIGHT, FOR PARALLEL LINES.

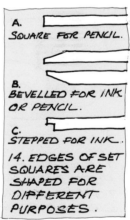

A. SQUARE FOR PENCIL.

B. BEVELLED FOR INK OR PENCIL.

C. STEPPED FOR INK.

14. EDGES OF SET SQUARES ARE SHAPED FOR DIFFERENT PURPOSES.

15. AN ADJUSTABLE SET SQUARE CAN BE SET TO ANY ANGLE.

16. A DRAUGHTING HEAD CAN ALSO BE ADJUSTED TO ANY ANGLE.

Activity

Design a name plate for yourself.
Draw the letters of your name using only vertical, horizontal, and angled lines.

31

2.3 CIRCLES AND CURVES

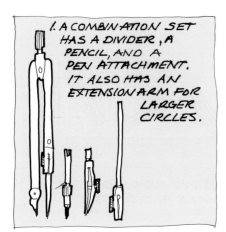

1. A COMBINATION SET HAS A DIVIDER, A PENCIL, AND A PEN ATTACHMENT. IT ALSO HAS AN EXTENSION ARM FOR LARGER CIRCLES.

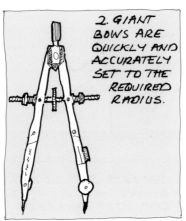

2. GIANT BOWS ARE QUICKLY AND ACCURATELY SET TO THE REQUIRED RADIUS.

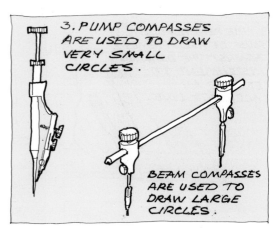

3. PUMP COMPASSES ARE USED TO DRAW VERY SMALL CIRCLES.

BEAM COMPASSES ARE USED TO DRAW LARGE CIRCLES.

4. THE LEAD SHOULD BE GIVEN A CHISEL POINT.

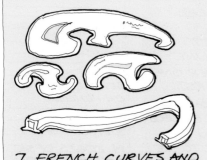

5. THE POINT AND THE LEAD MUST ALWAYS BE KEPT LEVEL.

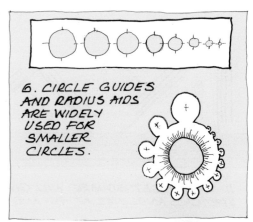

6. CIRCLE GUIDES AND RADIUS AIDS ARE WIDELY USED FOR SMALLER CIRCLES.

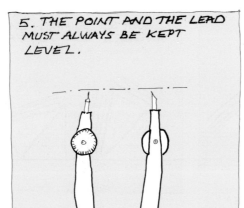

7. FRENCH CURVES AND FLEXIBLES ARE USED TO DRAW NON CIRCULAR CURVES.

A. FIRST DRAW THE SHAPE FREE HAND.

B. THEN USE VARIOUS PARTS OF THE CURVE TO TIDY UP THE LINE.

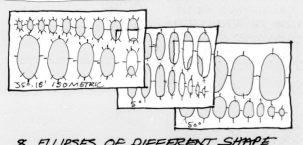

8. ELLIPSES OF DIFFERENT SHAPE AND SIZE CAN BE DRAWN WITH GUIDES. THESE REPRESENT CIRCLES VIEWED FROM DIFFERENT ANGLES.

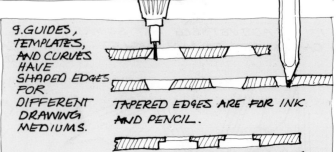

9. GUIDES, TEMPLATES, AND CURVES HAVE SHAPED EDGES FOR DIFFERENT DRAWING MEDIUMS.

TAPERED EDGES ARE FOR INK AND PENCIL.

STEPPED EDGES ARE FOR INK.

STRAIGHT EDGES ARE FOR PENCIL.

2.4 LETTERING

10. NOTES ON DRAWINGS NEED TO BE CLEAR. THEY SHOULD BE DRAWN BETWEEN FAINT GUIDE LINES.

HEADINGS ARE 5MM HIGH

THEY CAN SLOPE IN

EITHER DIRECTION

NOTES
SHOULD BE 3MM HIGH WITH A 3MM GAP BETWEEN EACH LINE

THEY CAN ALSO BE SLOPING

or in script.

11. WRITING ON A RULE WILL HELP TO KEEP NOTES TIDY.

12. STENCILS ARE AVAILABLE IN DIFFERENT LETTERING STYLES.
THEY CAN BE USED WITH FELT OR TECHNICAL PENS.

ADAPTOR JOINTS ANGLE THE PEN FOR EASIER USE.

13. STENCILS ARE AVAILABLE IN SIZES FROM 1·4MM HIGH TO 25MM HIGH.

aabcdeefghijklmn
aabcde
aabc
a

EACH SIZE NEEDS A SPECIAL PEN.

14. A STEPPED EDGE OR 'Z' PROFILE WILL STOP THE INK FROM SMUDGING.

15. MANY DIFFERENT STYLES OF LETTERING ARE AVAILABLE ON DRY TRANSFER SHEETS.

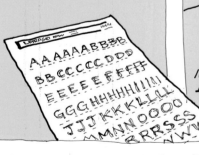

16. DRAW GUIDE LINES BELOW THE LINE OF THE LETTERING REQUIRED. LINE UP THE GUIDE LINE ON THE SHEET.

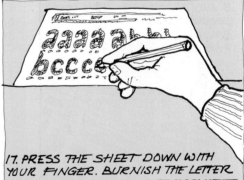

17. PRESS THE SHEET DOWN WITH YOUR FINGER. BURNISH THE LETTER WITH AN OLD BALL PEN TO TRANSFER IT TO THE PAPER.

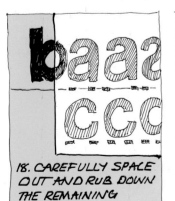

18. CAREFULLY SPACE OUT AND RUB DOWN THE REMAINING LETTERS.

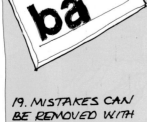

19. MISTAKES CAN BE REMOVED WITH AN ERASER.

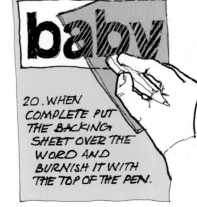

20. WHEN COMPLETE PUT THE BACKING SHEET OVER THE WORD AND BURNISH IT WITH THE TOP OF THE PEN.

Activity

Design a title sheet for your design folder using hand drawn, stencil, or dry transfer lettering. Also introduce some form of circular or curved decorative motif.

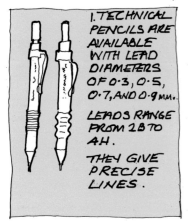

1. TECHNICAL PENCILS ARE AVAILABLE WITH LEAD DIAMETERS OF 0.3, 0.5, 0.7, AND 0.9 MM.

LEADS RANGE FROM 2B TO 4H.

THEY GIVE PRECISE LINES.

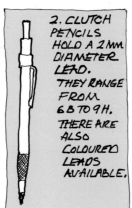

2. CLUTCH PENCILS HOLD A 2MM DIAMETER LEAD. THEY RANGE FROM 6B TO 9H. THERE ARE ALSO COLOURED LEADS AVAILABLE.

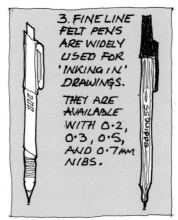

3. FINE LINE FELT PENS ARE WIDELY USED FOR 'INKING IN' DRAWINGS. THEY ARE AVAILABLE WITH 0.2, 0.3, 0.5, AND 0.7MM NIBS.

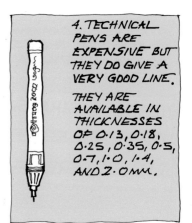

4. TECHNICAL PENS ARE EXPENSIVE BUT THEY DO GIVE A VERY GOOD LINE.

THEY ARE AVAILABLE IN THICKNESSES OF 0.13, 0.18, 0.25, 0.35, 0.5, 0.7, 1.0, 1.4, AND 2.0 MM.

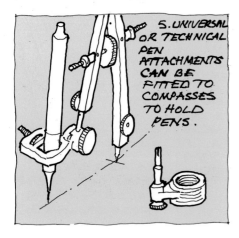

5. UNIVERSAL OR TECHNICAL PEN ATTACHMENTS CAN BE FITTED TO COMPASSES TO HOLD PENS.

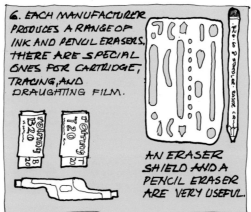

6. EACH MANUFACTURER PRODUCES A RANGE OF INK AND PENCIL ERASERS. THERE ARE SPECIAL ONES FOR CARTRIDGE, TRACING, AND DRAUGHTING FILM.

AN ERASER SHIELD AND A PENCIL ERASER ARE VERY USEFUL.

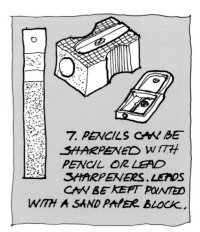

7. PENCILS CAN BE SHARPENED WITH PENCIL OR LEAD SHARPENERS. LEADS CAN BE KEPT POINTED WITH A SAND PAPER BLOCK.

8. DRY TRANSFER TONE AND COLOUR SHEETS ARE AVAILABLE IN MANY DIFFERENT FORMS.

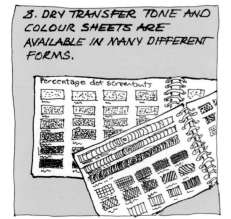

Percentage dot screentints

9. THEY ARE EXPENSIVE BUT MAKE DRAWINGS LOOK VERY GOOD.

Letratone

10. LAY THE SHEET OVER THE DRAWING AND CUT OUT A ROUGH SHAPE.

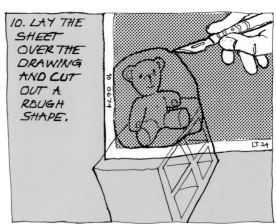

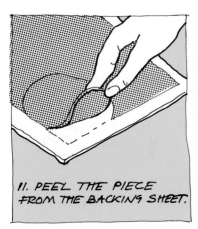

11. PEEL THE PIECE FROM THE BACKING SHEET.

12. PRESS ON TO THE DRAWING AND CUT OUT THE EXACT SHAPE.

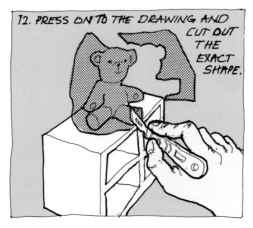

13. PRESS THE FILM DOWN TO MAKE SURE THAT IT HAS STUCK.

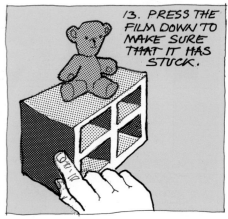

2.6 DESIGN FOLDER

To keep all the information about your projects, including drawings, in one place, you will need a **design folder**.

This will be seen by the examiner at the end of your course and will contribute to your final examination mark. Therefore, the folder should be well organized, full of useful information, and well presented.

The most practical way of keeping the pages together would be to use a folder, with a hard cover to protect your work. A folder of this sort is easy to carry around and allows you to add and remove pages as and when you require.

1. A LOOSE LEAF FOLDER IS THE MOST PRACTICAL FORM OF DESIGN FOLDER.

DESIGN FOLDER. 1

2. A4 IS THE MOST CONVENIENT SIZE. ALL 'A' SIZED PAPERS CAN BE FOLDED INTO A4 SIZE.

A3 PAPER CAN BE FOLDED ONCE.

FOLD IN

FOLD UP

3. A2 PAPER IS FOLDED TWICE.

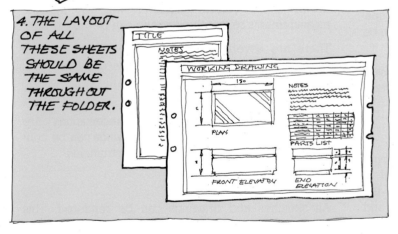

4. THE LAYOUT OF ALL THESE SHEETS SHOULD BE THE SAME THROUGHOUT THE FOLDER.

TITLE

NOTES

WORKING DRAWING

150

PLAN

NOTES

PARTS LIST

FRONT ELEVATION

END ELEVATION

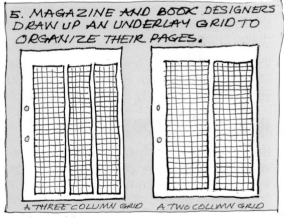

5. MAGAZINE AND BOOK DESIGNERS DRAW UP AN UNDERLAY GRID TO ORGANIZE THEIR PAGES.

A THREE COLUMN GRID A TWO COLUMN GRID

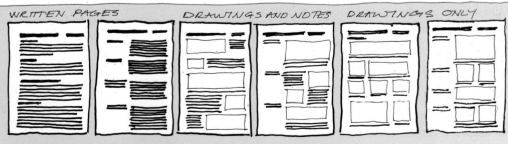

6. A GRID LIKE THIS CAN BE PLACED UNDER ANY PLAIN PAPER TO GIVE GUIDE LINES FOR WRITING AND FOR ILLUSTRATIONS IT WILL ENSURE THAT EACH PAGE HAS A SIMILAR APPEARANCE.

WRITTEN PAGES DRAWINGS AND NOTES DRAWINGS ONLY

THESE GRIDS CAN BE USED IN MANY WAYS. DIFFERENT SORTS OF PAGE, BASED ON A THREE COLUMN GRID, ARE SHOWN ABOVE.

2.7 THREE DIMENSIONAL DRAWING

1. CAVALIER OBLIQUE

2. CABINET OBLIQUE

3. PLANOMETRIC OBLIQUE

4. DIMETRIC PROJECTION

5. ISOMETRIC PROJECTION

6. TRIMETRIC PROJECTION

7. SINGLE POINT PERSPECTIVE

8. TWO POINT PERSPECTIVE

9. THREE POINT PERSPECTIVE

Designers need to be able to draw objects that appear three dimensional. In this way, they can begin to establish the appearance and function of the object.

NINE DIFFERENT WAYS

There are three groups of three dimensional drawing designers can use to try out ideas. These are **Obliques, Axonometrics,** and **Perspectives.**

There are three variations within each of these groups. So, in all, there are nine different ways an object can be drawn in three dimensions.

The nine views above are all of the same tape player. They have been drawn to the same scale. From these you can see the variety of effects produced.

WHICH SYSTEM DO I CHOOSE?

Each system has its strengths and weaknesses. Some are more suited to working out how things will fit together; others will give a better idea of how the finished item might look. Some are easy to draw and others are more difficult.

Which you use for a particular task will often be a matter of choice. Each system is explained and discussed on pages 37–56 to help you make this decision.

SKETCHING

At an early stage in the design process this drawing might be free hand sketching, using only a pencil and an eraser. It can be carried out purely by eye, drawing as an artist, adjusting the shape until it looks right.

However, at some point, the designer needs a more accurate representation of the object. So, as the idea develops, measured drawings are needed.

GRIDS

At first this might involve the use of a grid, which is placed under the drawing sheet. A grid is rather like graph paper and will help to ensure that the lines are drawn to the correct angles. It will also indicate measurements so that the drawing can be kept to size.

There are several grids on pages 190–193, which you can use to produce more precise drawings.

MEASURED DRAWINGS

When even more accurate representations are needed, measured or projected drawings can be constructed on a drawing board with instruments.

RENDERING

All sketches and drawings can be rendered. This means applying shade or colour to represent forms, textures, and so on. In this way materials with various surface qualities can be represented. Consequently, a clearer idea of the design can be achieved. (See pages 57–61 and 90–91)

QUESTIONS

1 What are the names of the three groups of three dimensional drawing?
2 When are free hand sketches used?
3 What are grids used for?
4 How are very accurate drawings made?
5 What is rendering?

2.8 OBLIQUE PROJECTION

Obliques are some of the earliest recorded three dimensional drawings. They consist of one view drawn as a true shape and the others projected from it, usually at 45°.

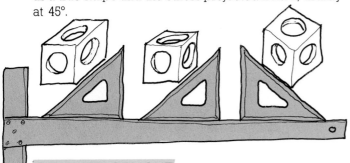

CAVALIER OBLIQUE

The front face of the object is drawn true shape and size. The receding edges are drawn to the same scale, but projected back at 45°.

The details on the surfaces are also drawn to the same rules. In the diagram of the cube below, the circles on the front face are drawn as circles. On the other faces they become ellipses and have to be constructed. (See page 39.)

The resultant drawing is awkward looking, but it can be made very quickly and measurements can be taken from it easily.

CABINET OBLIQUE

The front face is drawn true shape and size but the receding faces, still drawn at 45°, are at half true length. This makes the object look more natural, but it is harder to draw.

Details are treated in the same manner as in cavalier oblique. But they are more condensed on the 'top' and 'side', or more correctly, **plan** and **end** views.

Care has to be taken with complex cabinet oblique drawings to make sure that the correct scale is being used in the right direction.

PLANOMETRIC OBLIQUE

By rotating the plan around, so that it is at an angle of 45°/45°, or 60°/30°, and projecting the front and end views down from it, a planometric oblique is produced.

Details on the plan are drawn as true shapes, becoming distorted on the front and end elevations.

This type of drawing is frequently used by architects and is becoming increasingly popular because it is relatively easy to construct.

It appears more three dimensional than cavalier, but, like the cavalier, both the vertical and horizontal dimensions can be measured directly from the drawing.

WHY USE OBLIQUES?

Obliques are useful when planning in three dimensions, especially cavalier and planometric, where all the measurements are true lengths.

However, they both give a distorted appearance. So, cabinet oblique is best used when a quick assessment of appearance is required.

Both cabinet and cavalier can be used to view the object from either side, from above, or from below.

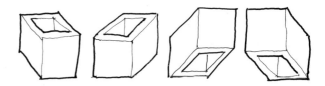

OBLIQUE RULES

There are general rules regarding the use of obliques which might help in producing good drawings.

The first is that care should be taken to place the object the right way round. It is always best to arrange it so that the complex face is the one drawn as a true shape. Not only will this make the drawing easier to construct, but it will also look less distorted.

In this position circles can be drawn as circles, rather than the more complex ellipses they become on the receding faces.

Also, to avoid too much distortion, the longest part of the object should always be placed so that it is a true shape.

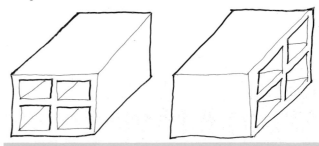

QUESTIONS

1 Describe the way in which a cavalier oblique drawing is constructed.
2 How does cabinet oblique differ from cavalier?
3 What happens to the details in both of these drawing systems?
4 How is planometric oblique constructed?
5 What happens to the details on planometric drawings?
6 What are the good and bad features of oblique projection?

2.9 DRAWING OBLIQUES

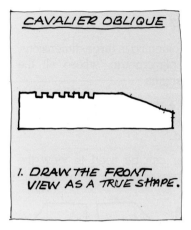

CAVALIER OBLIQUE

1. DRAW THE FRONT VIEW AS A TRUE SHAPE.

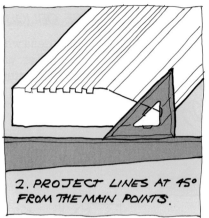

2. PROJECT LINES AT 45° FROM THE MAIN POINTS.

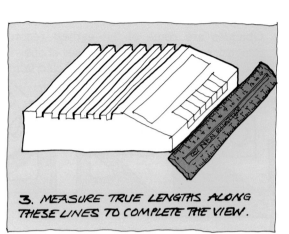

3. MEASURE TRUE LENGTHS ALONG THESE LINES TO COMPLETE THE VIEW.

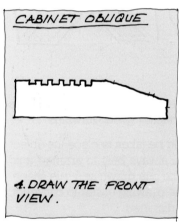

CABINET OBLIQUE

4. DRAW THE FRONT VIEW.

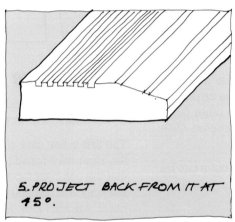

5. PROJECT BACK FROM IT AT 45°.

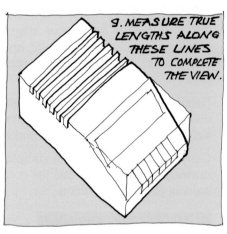

6. MEASURE BACK HALF THE TRUE LENGTH TO COMPLETE THE VIEW.

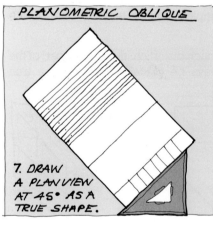

PLANOMETRIC OBLIQUE

7. DRAW A PLAN VIEW AT 45° AS A TRUE SHAPE.

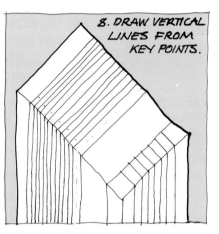

8. DRAW VERTICAL LINES FROM KEY POINTS.

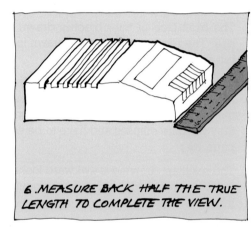

9. MEASURE TRUE LENGTHS ALONG THESE LINES TO COMPLETE THE VIEW.

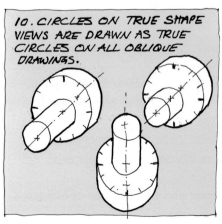

10. CIRCLES ON TRUE SHAPE VIEWS ARE DRAWN AS TRUE CIRCLES ON ALL OBLIQUE DRAWINGS.

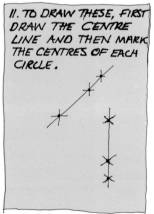

11. TO DRAW THESE, FIRST DRAW THE CENTRE LINE AND THEN MARK THE CENTRES OF EACH CIRCLE.

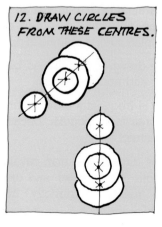

12. DRAW CIRCLES FROM THESE CENTRES.

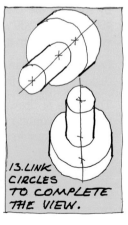

13. LINK CIRCLES TO COMPLETE THE VIEW.

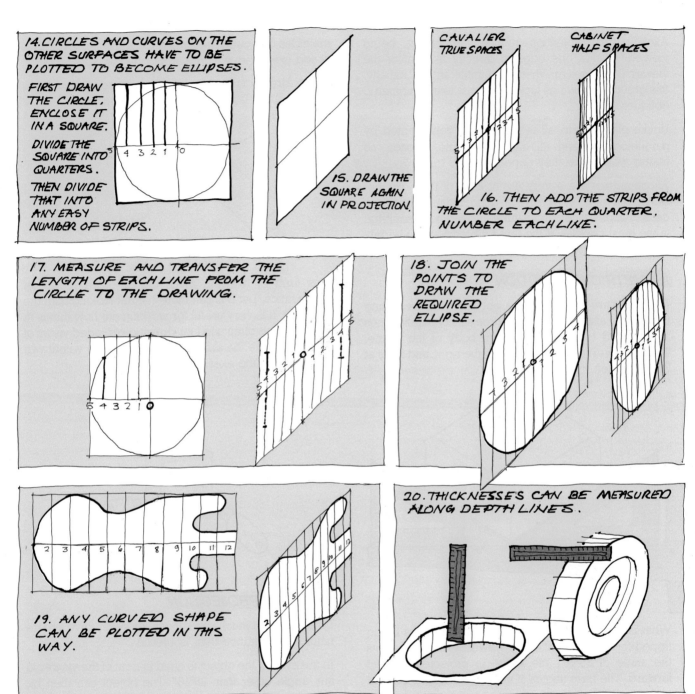

14. CIRCLES AND CURVES ON THE OTHER SURFACES HAVE TO BE PLOTTED TO BECOME ELLIPSES.

FIRST DRAW THE CIRCLE. ENCLOSE IT IN A SQUARE.

DIVIDE THE SQUARE INTO QUARTERS.

THEN DIVIDE THAT INTO ANY EASY NUMBER OF STRIPS.

15. DRAW THE SQUARE AGAIN IN PROJECTION.

CAVALIER TRUE SPACES

CABINET HALF SPACES

16. THEN ADD THE STRIPS FROM THE CIRCLE TO EACH QUARTER. NUMBER EACH LINE.

17. MEASURE AND TRANSFER THE LENGTH OF EACH LINE FROM THE CIRCLE TO THE DRAWING.

18. JOIN THE POINTS TO DRAW THE REQUIRED ELLIPSE.

19. ANY CURVED SHAPE CAN BE PLOTTED IN THIS WAY.

20. THICKNESSES CAN BE MEASURED ALONG DEPTH LINES.

21. SMALL CURVES CAN BE PLOTTED WITHOUT A GRID.

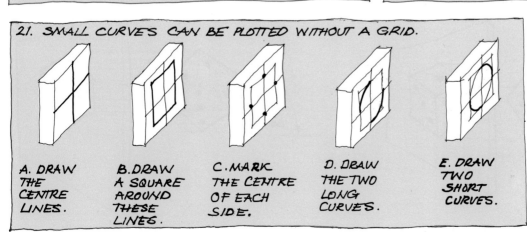

A. DRAW THE CENTRE LINES.

B. DRAW A SQUARE AROUND THESE LINES.

C. MARK THE CENTRE OF EACH SIDE.

D. DRAW THE TWO LONG CURVES.

E. DRAW TWO SHORT CURVES.

Activity

Draw some designs for a cassette player. Present your drawings in oblique projection.

2.10 AXONOMETRIC PROJECTION

Axonometric projection rotates the object being viewed, so that one edge is directly in front of the viewer. The faces are then at an angle and so, initially, this group of drawings look somewhat like planometric obliques.

Unlike planometric, all rectangles are represented by parallelograms and all circles become ellipses, no matter which face they appear on.

Axonometrics are a very useful form of three dimensional drawing. They give a good balance between ease of construction and natural appearance. Isometric is the most popular of the three systems and is widely used by all kinds of designer.

ISOMETRIC PROJECTION

Isometrics are in frequent use, not only because scaling is easy, but also because only three sets of parallel lines are needed to set out the main body of the shape. These are verticals, lines at 30° to the right, and lines at 30° to the left.

What is actually happening is that the object is being tipped forward in front of the viewer. When it reaches the angle of 35°16′, the shape is projected straight forward. The base angles of the shape become 30° and

the sides of a cube are drawn the same length. This is called isometric, which means 'one measure'.

These drawings should be made to isometric scale, which is 0.816:1. However, they are often drawn 1:1, i.e. true length.

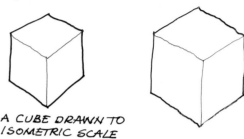

A CUBE DRAWN TO ISOMETRIC SCALE

This form of drawing gives the object a rather fat appearance, but it is still more natural looking than the obliques. It is very useful for working out how things fit together. It is often used for drawing exploded views of objects, where the assembled parts can be withdrawn along any of the axes. (See pages 45–46.)

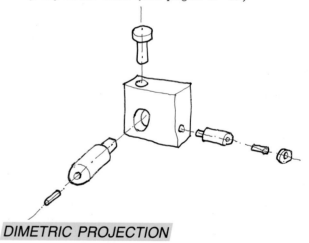

DIMETRIC PROJECTION

Dimetric is not much used. It can, however, give a more natural appearance than isometric.

In this system the object is tilted in front of the viewer to any angle other than 35°16′. The object can then be

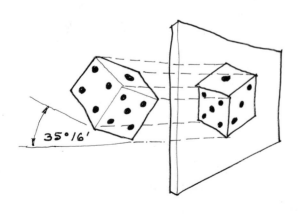

35°16′

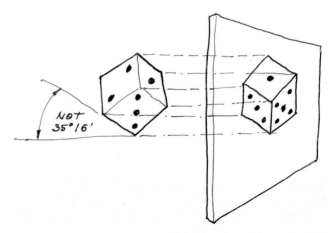

NOT 35°16′

angled up to show more of the plan view, or tilted back to give more emphasis to the front and end elevations.

However, this does mean that the vertical scale is different from receding scales. This is called dimetric, which means 'two measures'.

In the cubes below, the amount that the base angles varies depends on the angle through which the object is tipped. In each case the two base angles are the same. Lines, parallel to the base, form the edges of rectangular shapes.

LOW BASE ANGLE

LARGE BASE ANGLE

Dimetric projection is useful for drawing objects which cannot be distinguished clearly in isometric.

The 45° tapered shape below, drawn in isometric, is difficult to understand. The same shape, drawn in dimetric, becomes much clearer.

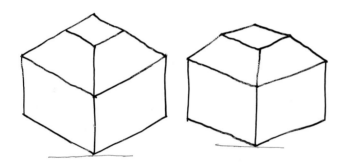

The same shape, turned up the other way in isometric, is misleading. In dimetric, taking a lower angle, a much clearer picture can be achieved.

TRIMETRIC PROJECTION

Trimetric is rarely used because it is more complicated to draw. However, of all the axonometrics, it gives the most natural appearance. Fortunately, it is not quite as difficult to construct as it looks.

The object is tilted in front of the viewer, as in the other axonometrics, but in this case it can also be rotated so that more, or less, of the front elevation can be seen.

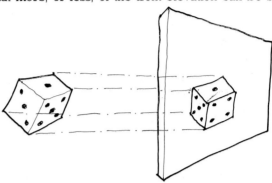

In the drawing of the cube below, you will see that the base angles at A and B are different. Also, the sides are not drawn to the same scale, which is why this system is called trimetric or 'three measures'.

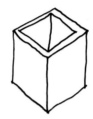
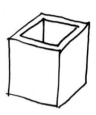

Once this system has been mastered, trimetric overcomes the drawbacks of the other two axonometrics, as objects can be rotated to give a clearer view.

The hollow cube in isometric and dimetric projection looks misleading. It could be a box with a lid. In trimetric, however, it does appear hollow.

The metal bracket below is very hard to understand in isometric. By rotating it in trimetric, it becomes much clearer.

QUESTIONS

1 Why are isometric drawings widely used?
2 How is an isometric cube drawn?
3 What does isometric mean?
4 How is an object viewed in dimetric projection?
5 What does dimetric mean?
6 What happens to the object in trimetric projection?
7 What does trimetric mean?

2.11 ISOMETRICS

The main lines on an isometric projection are either vertical or at 30° to the left or right. This means that all squares are drawn as parallelograms and all circles as ellipses. There is an underlay grid on page 192 which can be placed under your drawing paper. The lines on this can be traced to make sure that they are at the right angle. There are also some isometric ellipses on page 193. These can be traced to give the correctly shaped ellipse.

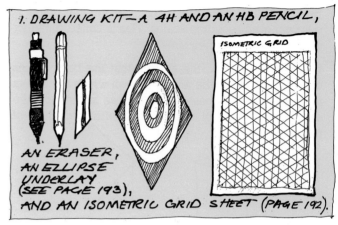

1. DRAWING KIT — A 4H AND AN HB PENCIL, AN ERASER, AN ELLIPSE UNDERLAY (SEE PAGE 193), AND AN ISOMETRIC GRID SHEET (PAGE 192).

ISOMETRIC GRID

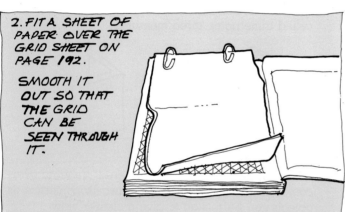

2. FIT A SHEET OF PAPER OVER THE GRID SHEET ON PAGE 192.

SMOOTH IT OUT SO THAT THE GRID CAN BE SEEN THROUGH IT.

3. COUNT THE GRID TO PLOT YOUR DRAWING AND FOLLOW THE LINES TO GET THE RIGHT ANGLES.

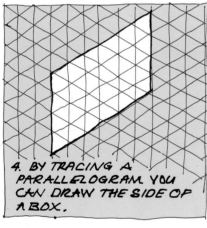

4. BY TRACING A PARALLELOGRAM YOU CAN DRAW THE SIDE OF A BOX.

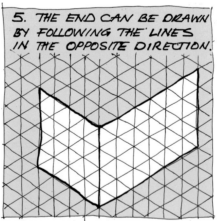

5. THE END CAN BE DRAWN BY FOLLOWING THE LINES IN THE OPPOSITE DIRECTION.

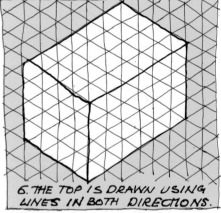

6. THE TOP IS DRAWN USING LINES IN BOTH DIRECTIONS.

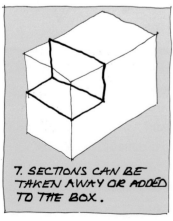

7. SECTIONS CAN BE TAKEN AWAY OR ADDED TO THE BOX.

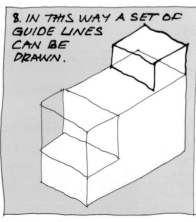

8. IN THIS WAY A SET OF GUIDE LINES CAN BE DRAWN.

9. THE REQUIRED SHAPE CAN BE DRAWN FROM THESE WITH AN HB PENCIL.

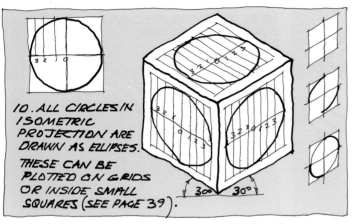

10. ALL CIRCLES IN ISOMETRIC PROJECTION ARE DRAWN AS ELLIPSES.

THESE CAN BE PLOTTED ON GRIDS OR INSIDE SMALL SQUARES (SEE PAGE 39).

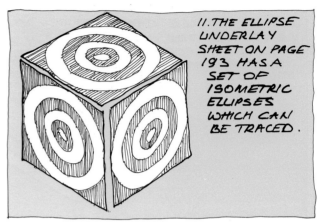

11. THE ELLIPSE UNDERLAY SHEET ON PAGE 193 HAS A SET OF ISOMETRIC ELLIPSES WHICH CAN BE TRACED.

12. TO DRAW A VERTICAL CYLINDER, FIRST DRAW A CENTRE LINE AND LOCATE THE CENTRE OF EACH ELLIPSE.

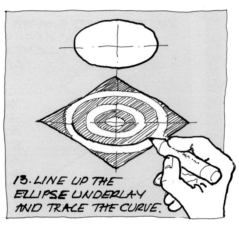

13. LINE UP THE ELLIPSE UNDERLAY AND TRACE THE CURVE.

14. COMPLETE THE DRAWING BY ADDING THE VERTICAL SIDES AND THE RIM.

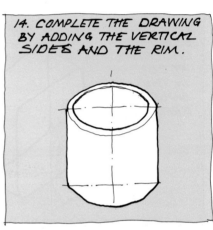

15. TO DRAW A CYLINDER FACING TO THE RIGHT FIRST DRAW THE CENTRE LINE AT 30°. THEN ADD THE ELLIPSES.

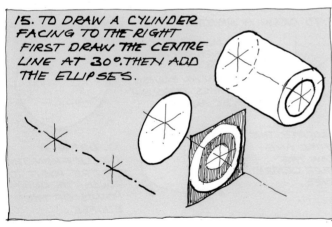

16. LEFT FACING CYLINDERS ARE DRAWN ON A CENTRE LINE AT 30° IN THE OPPOSITE DIRECTION.

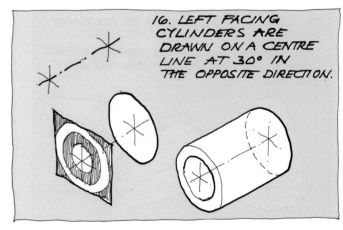

17. VERTICAL HOLES ARE DRAWN IN THE SAME WAY AS VERTICAL CYLINDERS.

18. CENTRE LINES ARE DRAWN AND ELLIPSES ARE TRACED.

19. ONLY THE PART OF THE BOTTOM ELLIPSE WHICH FALLS INSIDE THE TOP ONE IS DRAWN.

20. HOLES FACING LEFT AND RIGHT ARE DRAWN IN THE SAME WAY.

43

21. PART CURVES CAN BE DRAWN BUT THE UNDERLAY MUST BE PLACED THE RIGHT WAY ROUND.

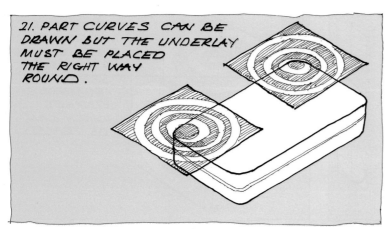

22. CURVES FACING RIGHT USE THE UNDERLAY AT 30°.

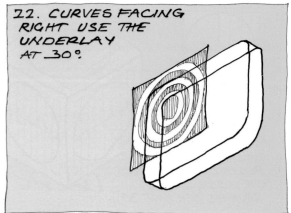

23. CURVES FACING LEFT USE THE UNDERLAY AT 30° IN THE OPPOSITE DIRECTION.

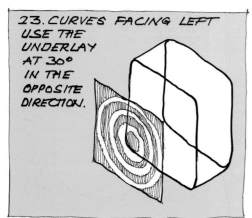

24. TAPERED SHAPES ARE DRAWN AROUND A CENTRE LINE.

THE TOP AND BOTTOM SHAPES ARE DRAWN FIRST.

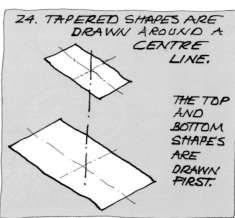

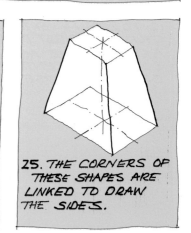

25. THE CORNERS OF THESE SHAPES ARE LINKED TO DRAW THE SIDES.

26. CONES ARE DRAWN IN THE SAME WAY.

THE CENTRE LINES ARE DRAWN EITHER VERTICALLY OR AT 30° FACING LEFT OR RIGHT.

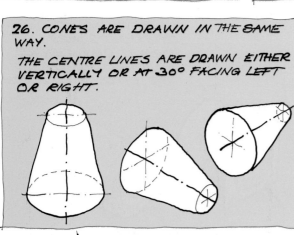

27. TO DRAW A SPHERE —

B. MARK THE OUTER POINTS ON THESE LINES.
DRAW AN ELLIPSE TO PASS THROUGH A, B, C, AND D.

A. LOCATE THE CENTRE AND DRAW THE THREE CENTRE LINES.

C. DRAW A CIRCLE FROM THE CENTRE POINT TO TOUCH THE OUTER POINTS OF THE ELLIPSE.

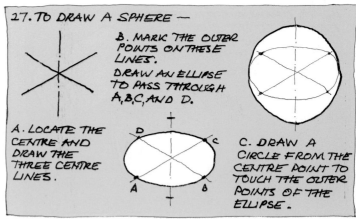

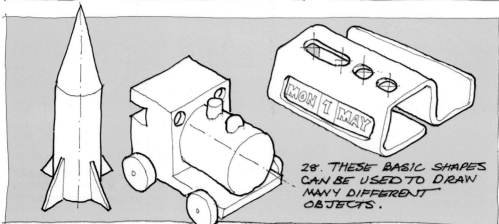

28. THESE BASIC SHAPES CAN BE USED TO DRAW MANY DIFFERENT OBJECTS.

Activity

Design a range of simple wooden vehicles which could be used by a small child. They should be easy to make and safe to use.

2.12 MEASURED ISOMETRICS

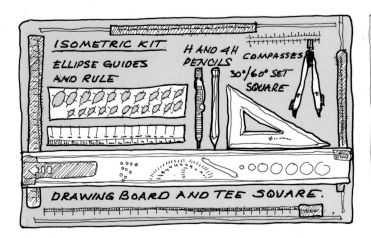

ISOMETRIC KIT
ELLIPSE GUIDES AND RULE
H AND 4H PENCILS
COMPASSES
30°/60° SET SQUARE
DRAWING BOARD AND TEE SQUARE.

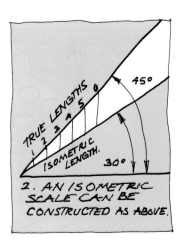

1. MEASURED ISOMETRICS ARE DRAWN WITH INSTRUMENTS.

THEY SHOULD REALLY BE DRAWN TO SCALE (0·816 : 1) BUT THEY ARE OFTEN DRAWN FULL SIZE (1:1).

TRUE LENGTHS
1 2 3 4 5 6
ISOMETRIC LENGTH.
45°
30°

2. AN ISOMETRIC SCALE CAN BE CONSTRUCTED AS ABOVE.

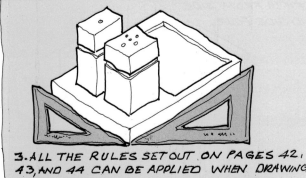

3. ALL THE RULES SET OUT ON PAGES 42, 43, AND 44 CAN BE APPLIED WHEN DRAWING ISOMETRICS WITH INSTRUMENTS.

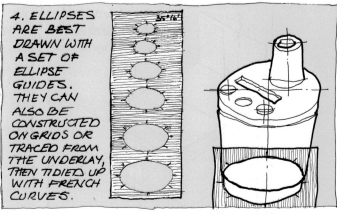

4. ELLIPSES ARE BEST DRAWN WITH A SET OF ELLIPSE GUIDES. THEY CAN ALSO BE CONSTRUCTED ON GRIDS OR TRACED FROM THE UNDERLAY, THEN TIDIED UP WITH FRENCH CURVES.

35°16'

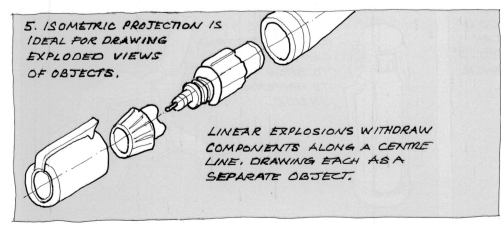

5. ISOMETRIC PROJECTION IS IDEAL FOR DRAWING EXPLODED VIEWS OF OBJECTS.

LINEAR EXPLOSIONS WITHDRAW COMPONENTS ALONG A CENTRE LINE, DRAWING EACH AS A SEPARATE OBJECT.

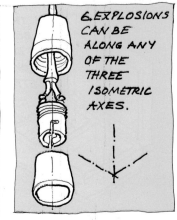

6. EXPLOSIONS CAN BE ALONG ANY OF THE THREE ISOMETRIC AXES.

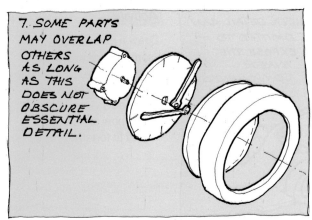

7. SOME PARTS MAY OVERLAP OTHERS AS LONG AS THIS DOES NOT OBSCURE ESSENTIAL DETAIL.

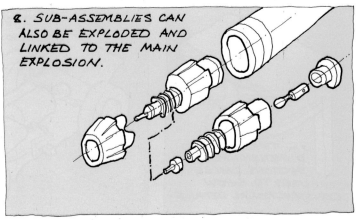

8. SUB-ASSEMBLIES CAN ALSO BE EXPLODED AND LINKED TO THE MAIN EXPLOSION.

9. EXPLOSIONS CAN BE DRAWN IN MORE THAN ONE DIRECTION.

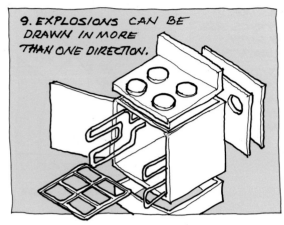

10. TO DRAW A FOUR WAY EXPLOSION, FIRST DRAW THE CENTRAL COMPONENT, THEN PROJECT THE POSITION OF THE SECOND.

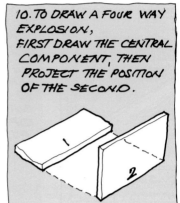

11. THE THIRD CAN BE POSITIONED FROM THE FIRST TWO.

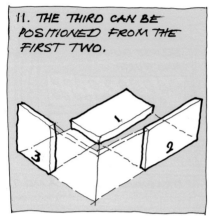

12. THE FOURTH SIDE IS PROJECTED FROM SIDES ONE AND THREE.

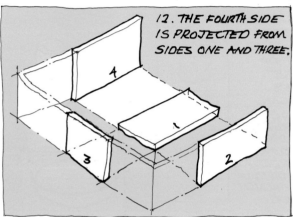

13. THE FIFTH FROM SIDE ONE AND SIDE FOUR.

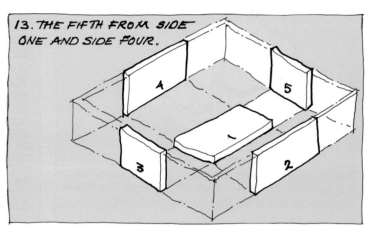

14. THE LID OF A BOX CAN BE LIFTED TO SHOW INNER DETAIL.

15. IF THIS IS NOT POSSIBLE THE WALLS CAN BE 'CUT AWAY' TO SHOW WHAT IS HAPPENING INSIDE.

16. THREE DIMENSIONAL SECTIONS CAN BE USED TO SHOW CONSTRUCTIONAL DETAILS.

17. THE OUTER DETAIL CAN ALSO BE OMITTED TO EXPOSE THE INNER COMPONENTS.

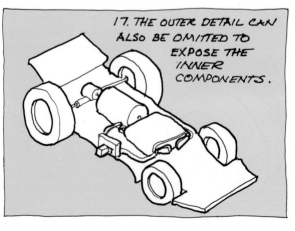

Activity

Draw a measured isometric view of a kitchen table. Then construct an exploded view of it to show how all the parts could fit together.

DIMETRIC PROJECTION

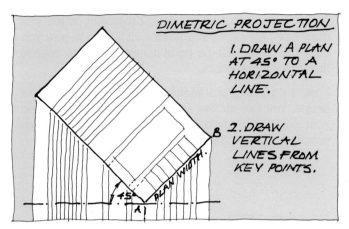

1. DRAW A PLAN AT 45° TO A HORIZONTAL LINE.

2. DRAW VERTICAL LINES FROM KEY POINTS.

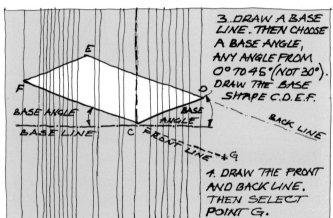

3. DRAW A BASE LINE. THEN CHOOSE A BASE ANGLE, ANY ANGLE FROM 0° TO 45° (NOT 30°). DRAW THE BASE SHAPE C.D.E.F.

4. DRAW THE FRONT AND BACK LINE. THEN SELECT POINT G.

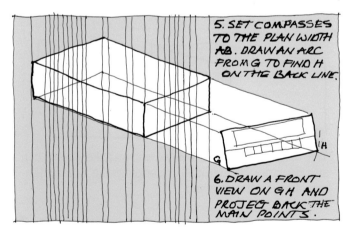

5. SET COMPASSES TO THE PLAN WIDTH AB. DRAW AN ARC FROM G TO FIND H ON THE BACK LINE.

6. DRAW A FRONT VIEW ON GH AND PROJECT BACK THE MAIN POINTS.

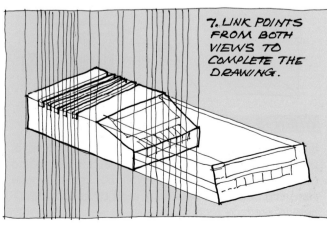

7. LINK POINTS FROM BOTH VIEWS TO COMPLETE THE DRAWING.

TRIMETRIC PROJECTION

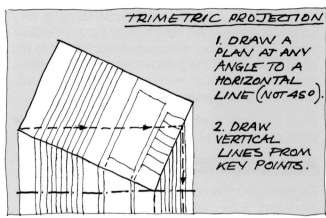

1. DRAW A PLAN AT ANY ANGLE TO A HORIZONTAL LINE (NOT 45°).

2. DRAW VERTICAL LINES FROM KEY POINTS.

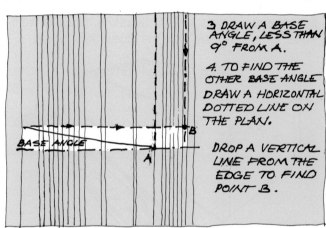

3. DRAW A BASE ANGLE, LESS THAN 9° FROM A.

4. TO FIND THE OTHER BASE ANGLE DRAW A HORIZONTAL DOTTED LINE ON THE PLAN.

DROP A VERTICAL LINE FROM THE EDGE TO FIND POINT B.

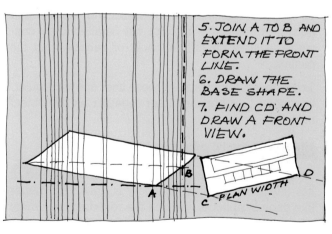

5. JOIN A TO B AND EXTEND IT TO FORM THE FRONT LINE.

6. DRAW THE BASE SHAPE.

7. FIND CD AND DRAW A FRONT VIEW.

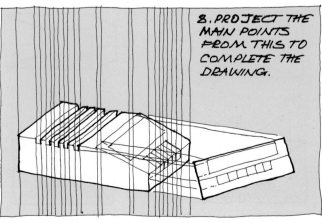

8. PROJECT THE MAIN POINTS FROM THIS TO COMPLETE THE DRAWING.

If your design is one in which appearance is very important, then you will need to work out more exactly what it might look like when completed. To do this you should use one of the perspective drawing systems. These produce a more realistic appearance than obliques and axonometrics.

There are three types of perspective. These are **single point, two point,** and **three point.**

PERSPECTIVE SCALE

Perspectives attempt to reproduce the effect of foreshortening. This means that a distant object looks smaller than the same thing when viewed close to. The far edge of a box is shorter, therefore, than the front edge, as you can see from the illustrations below.

To achieve this, the lines representing the top and bottom edges of the box are not parallel. They converge as they go further back, or recede, into the picture.

'Equal' measurements along these lines are not regularly spaced, but appear closer together as the object recedes.

SINGLE POINT PERSPECTIVE

Single point is the simplest perspective to construct. It has this name because one view is drawn flat, rather like cabinet oblique, while all the receding lines meet at one distant point, called a vanishing point.

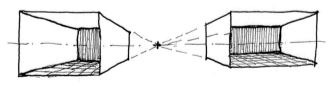

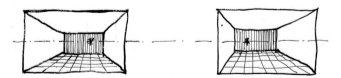

As with dimetric and trimetric projection, when you draw in single point, you have a choice as to how you view the object. Single point allows you more options than the axonometrics.

First, by placing the vanishing point at the required height, you can choose the angle from which you see your design. Secondly, you can vary the viewing position from left to right, as you please.

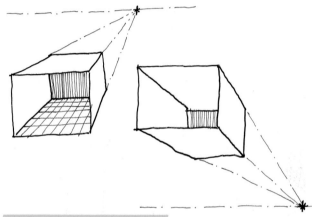

THE VANISHING POINT

The distance between the object and the vanishing point can be changed to give more, or less, of a converging effect.

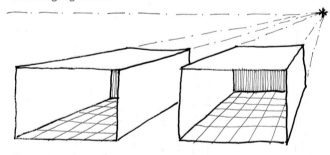

The distance between the viewer and the object can also be varied, to increase or decrease the foreshortening effect in the drawing.

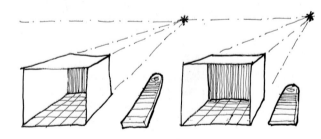

WHEN IS SINGLE POINT USED?

Single point is a relatively quick method of drawing in perspective. It is particularly useful for illustrating groups of objects which can all be linked to one vanishing point. It is frequently used by interior designers to produce room plans.

TWO POINT PERSPECTIVE

When people talk about perspective drawing they are usually refering to 'two point'. It is easier to construct than three point. It is an adaptable system which can be used for a wide variety of projects of vastly different size.

Industrial designers use it to portray various solutions to briefs and architects often draw impressions of their buildings in two point.

TWO VANISHING POINTS

In two point, the uprights are always drawn as true verticals. The other lines recede to two vanishing points, either to the left or the right of the object. This is why the name 'two point' perspective is used. These points lie on a straight horizontal line which is at eye level.

VARIOUS VIEWS

Choosing the position of the object in relation to the eye level line allows the designer to view the design from any height.

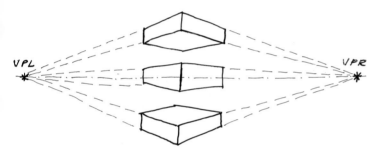

The object can also be partially rotated in front of the viewer.

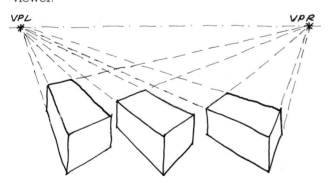

Grids can be used for two point perspectives. Or, these drawings can be constructed on a drawing board, using either an approximate or measured system. The choice depends upon how accurate the drawing needs to be.

MEASURED POINT

There are a number of ways of producing measured two point perspectives. The system illustrated on pages 54–55 is called **measured point**. It will enable you to draw accurate perspectives of a good size, even on A3 paper.

WHEN IS TWO POINT USED?

Two point perspective is a versatile drawing system. You should keep the vanishing points as far apart as possible, and arrange the drawing so that neither the top nor the bottom of the object is close to the eye level line. This allows you to produce drawings of objects ranging in size from small pieces of jewellery to large items of furniture.

THREE POINT PERSPECTIVE

Unlike two point there are no parallel vertical lines in three point perspective. All lines recede to one of three vanishing points.

Three point is sometimes called aerial perspective because it gives the impression of looking down on the

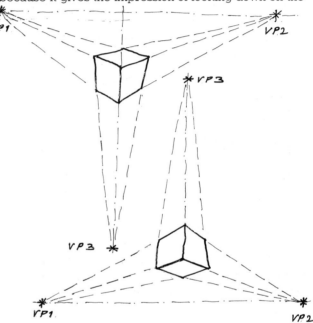

object. The system can also be used upside down to produce a worm's eye view.

You will find a method of construction for three point on page 56. It is time consuming to construct and requires a large sheet of paper, most of which will be taken up by the construction system.

QUESTIONS

1. When are perspectives used?
2. How many different types of perspective are there and what are they called?
3. What is foreshortening?
4. Why is single point perspective so named?
5. What options does single point allow you?
6. When would you use single point?
7. Why is two point perspective widely used?
8. Why is two point perspective so called?
9. What options does two point perspective give the designer?
10. Why is three point perspective given this name?

2.15 SINGLE POINT PERSPECTIVE

1. DRAW A FRONT ELEVATION.

MARK OFF EQUAL LENGTHS ALONG THE BASE.

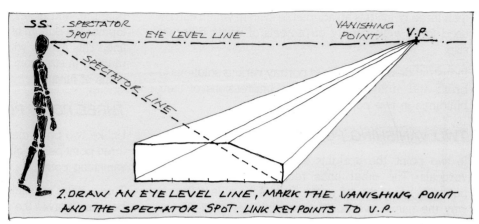

S.S. SPECTATOR SPOT EYE LEVEL LINE VANISHING POINT V.P.

SPECTATOR LINE

2. DRAW AN EYE LEVEL LINE, MARK THE VANISHING POINT AND THE SPECTATOR SPOT. LINK KEY POINTS TO U.P.

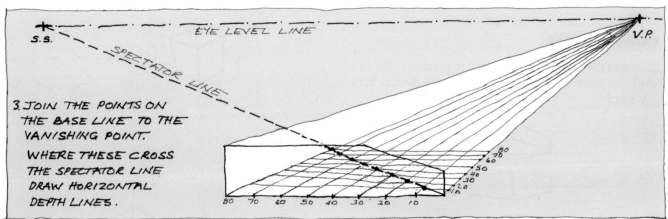

EYE LEVEL LINE

S.S. SPECTATOR LINE V.P.

3. JOIN THE POINTS ON THE BASE LINE TO THE VANISHING POINT.

WHERE THESE CROSS THE SPECTATOR LINE DRAW HORIZONTAL DEPTH LINES.

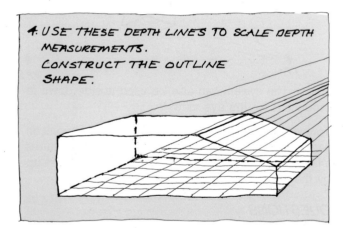

4. USE THESE DEPTH LINES TO SCALE DEPTH MEASUREMENTS.
CONSTRUCT THE OUTLINE SHAPE.

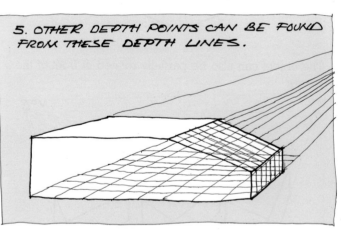

5. OTHER DEPTH POINTS CAN BE FOUND FROM THESE DEPTH LINES.

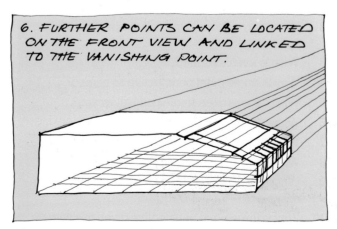

6. FURTHER POINTS CAN BE LOCATED ON THE FRONT VIEW AND LINKED TO THE VANISHING POINT.

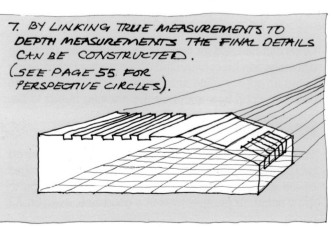

7. BY LINKING TRUE MEASUREMENTS TO DEPTH MEASUREMENTS THE FINAL DETAILS CAN BE CONSTRUCTED.
(SEE PAGE 55 FOR PERSPECTIVE CIRCLES).

1. TO DRAW A ROOM INTERIOR IN SINGLE POINT FIRST DRAW A ROOM PLAN.

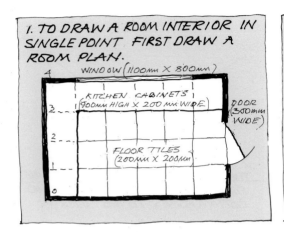

WINDOW (1100mm X 800mm)

KITCHEN CABINETS (900mm HIGH X 200mm WIDE)

DOOR (800mm WIDE)

FLOOR TILES (200mm X 200mm)

2. DRAW AN OUTLINE OF THE ROOM VIEWED FROM THE FRONT. ADD THE MAIN HEIGHT AND WIDTH MEASUREMENTS ALONG THE EDGES OF THIS OUTLINE.

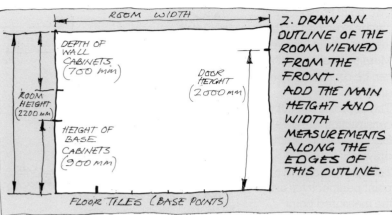

ROOM WIDTH

DEPTH OF WALL CABINETS (700 mm)

DOOR HEIGHT (2000 mm)

ROOM HEIGHT (2200 mm)

HEIGHT OF BASE CABINETS (900 mm)

FLOOR TILES (BASE POINTS)

3. SELECT AN EYE LEVEL LINE AND A VANISHING POINT (NOT IN THE CENTRE, NOR TOO CLOSE TO EITHER WALL).

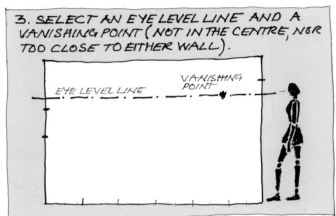

EYE LEVEL LINE

VANISHING POINT

4. LINK THE CORNERS OF THE ROOM TO THE VANISHING POINT. ALSO DRAW LINES FROM THE BASE POINTS.

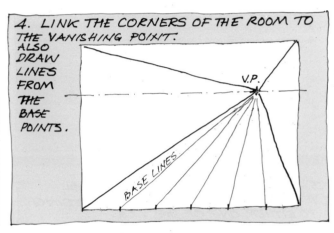

V.P.

BASE LINES

5. SELECT A SPECTATOR SPOT. DRAW SPECTATOR LINE TO CORNER OF BOX.

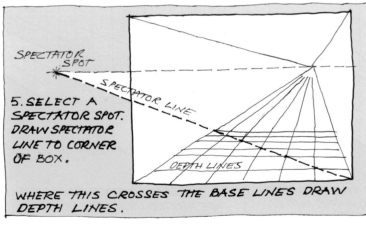

SPECTATOR SPOT

SPECTATOR LINE

DEPTH LINES

WHERE THIS CROSSES THE BASE LINES DRAW DEPTH LINES.

6. COUNT FLOOR SQUARES TO FIND ROOM DEPTH. DRAW WALLS AND CEILING.

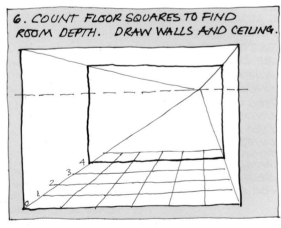

7. DRAW END VIEWS OF FURNITURE. LINK CORNERS TO V.P.

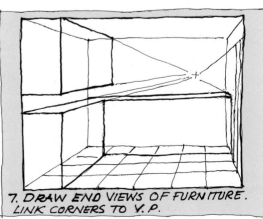

8. ADD DETAILS.

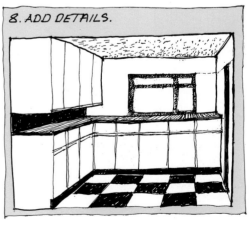

Activity

Draw a single point view of the room above.
Draw it to a scale of 1:10, so that 1 mm on your drawing represents 10 mm in the room.

Two point perspectives can be sketched so that they look right 'by eye'. More accurate sketches can be constructed on a grid (page 191).

The approximate cube construction will give fast, reasonably precise drawings (page 53).

The most precise two point perspectives use the measured point system (pages 54, 55)

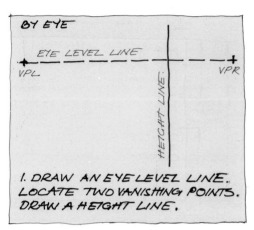

1. DRAW AN EYE LEVEL LINE. LOCATE TWO VANISHING POINTS. DRAW A HEIGHT LINE.

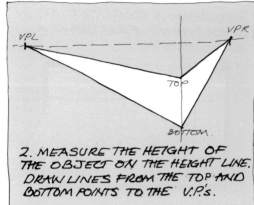

2. MEASURE THE HEIGHT OF THE OBJECT ON THE HEIGHT LINE. DRAW LINES FROM THE TOP AND BOTTOM POINTS TO THE V.P's.

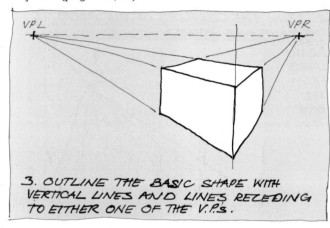

3. OUTLINE THE BASIC SHAPE WITH VERTICAL LINES AND LINES RECEDING TO EITHER ONE OF THE V.P's.

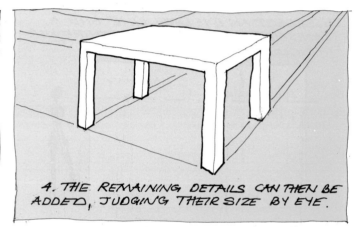

4. THE REMAINING DETAILS CAN THEN BE ADDED, JUDGING THEIR SIZE BY EYE.

5. MORE ACCURATE PERSPECTIVE SKETCHES CAN BE DRAWN USING A PERSPECTIVE UNDERLAY (PAGE 191). THIS CAN BE PLACED UNDER YOUR DRAWING SHEET. LINES CAN BE TRACED TO GIVE THE RIGHT ANGLES AND THE SQUARES COUNTED FOR MEASUREMENTS.

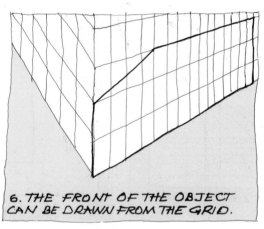

6. THE FRONT OF THE OBJECT CAN BE DRAWN FROM THE GRID.

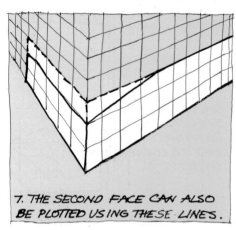

7. THE SECOND FACE CAN ALSO BE PLOTTED USING THESE LINES.

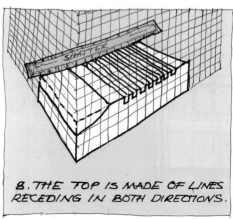

8. THE TOP IS MADE OF LINES RECEDING IN BOTH DIRECTIONS.

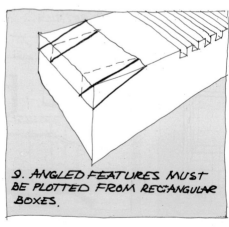

9. ANGLED FEATURES MUST BE PLOTTED FROM RECTANGULAR BOXES.

10. THESE DRAWINGS CAN BE PLACED ON ANY PART OF THE GRID.

An approximate perspective can be drawn from a cube. This has to be drawn by eye, but from it relatively accurate drawings can be made.

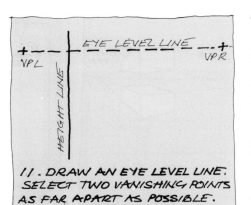

11. DRAW AN EYE LEVEL LINE. SELECT TWO VANISHING POINTS AS FAR APART AS POSSIBLE. DRAW A HEIGHT LINE.

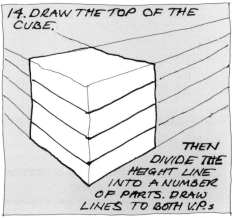

12. MEASURE THE HEIGHT OF THE CUBE ON THE HEIGHT LINE. DRAW LINES FROM THE TOP AND BOTTOM TO THE TWO VANISHING POINTS.

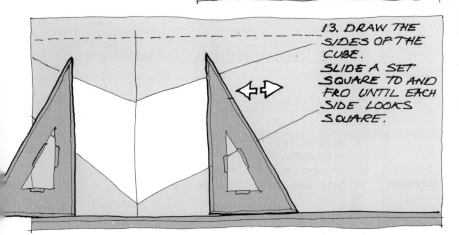

13. DRAW THE SIDES OF THE CUBE. SLIDE A SET SQUARE TO AND FRO UNTIL EACH SIDE LOOKS SQUARE.

14. DRAW THE TOP OF THE CUBE.

THEN DIVIDE THE HEIGHT LINE INTO A NUMBER OF PARTS. DRAW LINES TO BOTH V.P.s

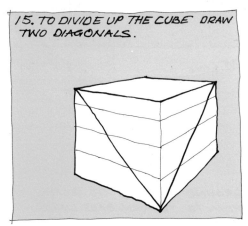

15. TO DIVIDE UP THE CUBE DRAW TWO DIAGONALS.

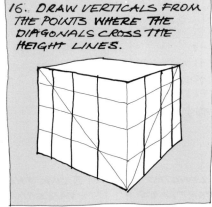

16. DRAW VERTICALS FROM THE POINTS WHERE THE DIAGONALS CROSS THE HEIGHT LINES.

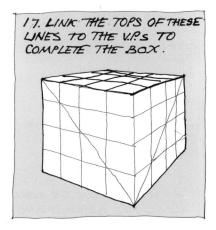

17. LINK THE TOPS OF THESE LINES TO THE V.P.s TO COMPLETE THE BOX.

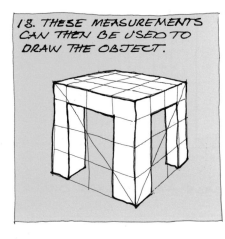

18. THESE MEASUREMENTS CAN THEN BE USED TO DRAW THE OBJECT.

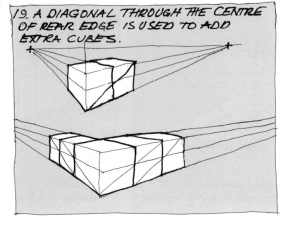

19. A DIAGONAL THROUGH THE CENTRE OF REAR EDGE IS USED TO ADD EXTRA CUBES.

Activity

Draw a coffee table of your own design in each of the three perspective drawing systems illustrated here.

Draw a view:

1. By eye
2. On a grid (see page 191)
3. An approximate 'cube' perspective.

Measured point

There are a number of different methods of constructing measured two point perspective. The system shown here is called 'measured point'. It is easy to construct and will give good sized drawings even on A3 paper.

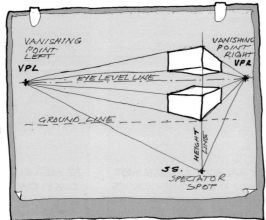

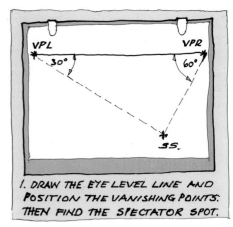

1. DRAW THE EYE LEVEL LINE AND POSITION THE VANISHING POINTS. THEN FIND THE SPECTATOR SPOT.

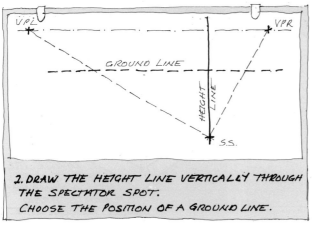

2. DRAW THE HEIGHT LINE VERTICALLY THROUGH THE SPECTATOR SPOT. CHOOSE THE POSITION OF A GROUND LINE.

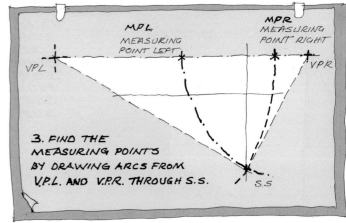

3. FIND THE MEASURING POINTS BY DRAWING ARCS FROM V.P.L. AND V.P.R. THROUGH S.S.

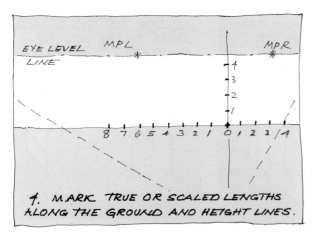

4. MARK TRUE OR SCALED LENGTHS ALONG THE GROUND AND HEIGHT LINES.

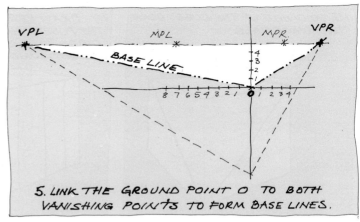

5. LINK THE GROUND POINT O TO BOTH VANISHING POINTS TO FORM BASE LINES.

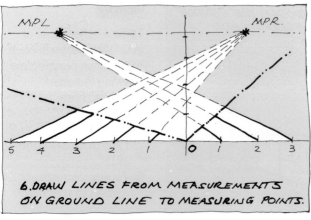

6. DRAW LINES FROM MEASUREMENTS ON GROUND LINE TO MEASURING POINTS.

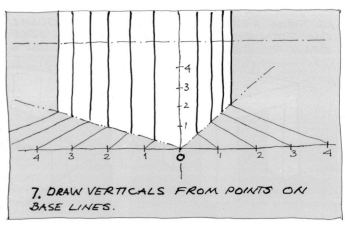

7. DRAW VERTICALS FROM POINTS ON BASE LINES.

54

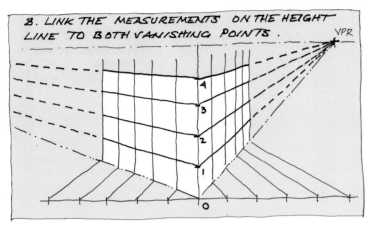

8. LINK THE MEASUREMENTS ON THE HEIGHT LINE TO BOTH VANISHING POINTS.

VPR

4
3
2
1
0

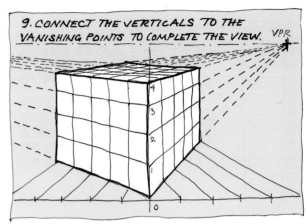

9. CONNECT THE VERTICALS TO THE VANISHING POINTS TO COMPLETE THE VIEW.

VPR

4
3
2
1
0

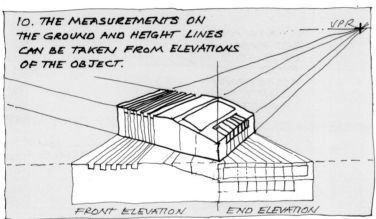

10. THE MEASUREMENTS ON THE GROUND AND HEIGHT LINES CAN BE TAKEN FROM ELEVATIONS OF THE OBJECT.

VPR

FRONT ELEVATION END ELEVATION

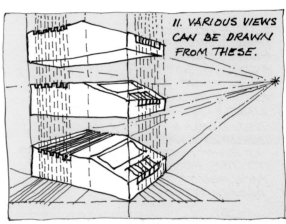

11. VARIOUS VIEWS CAN BE DRAWN FROM THESE.

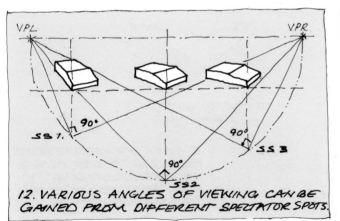

VPL VPR

90° 90°
SS1 SS3
90°
SS2

12. VARIOUS ANGLES OF VIEWING CAN BE GAINED FROM DIFFERENT SPECTATOR SPOTS.

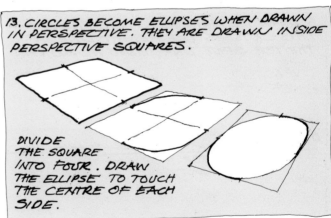

13. CIRCLES BECOME ELLIPSES WHEN DRAWN IN PERSPECTIVE. THEY ARE DRAWN INSIDE PERSPECTIVE SQUARES.

DIVIDE THE SQUARE INTO FOUR. DRAW THE ELLIPSE TO TOUCH THE CENTRE OF EACH SIDE.

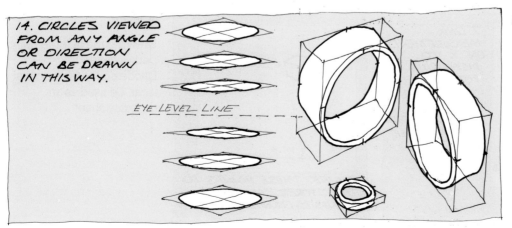

14. CIRCLES VIEWED FROM ANY ANGLE OR DIRECTION CAN BE DRAWN IN THIS WAY.

EYE LEVEL LINE

Activity

Draw a two point perspective grid using the measured point system. Ink this in or use a soft pencil to make a dark line so that this can be used as an underlay for perspective sketching.

2.17 THREE POINT PERSPECTIVE

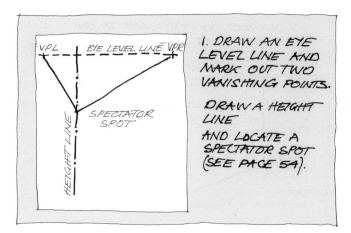

1. DRAW AN EYE LEVEL LINE AND MARK OUT TWO VANISHING POINTS.

DRAW A HEIGHT LINE

AND LOCATE A SPECTATOR SPOT (SEE PAGE 54).

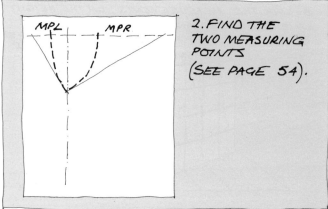

2. FIND THE TWO MEASURING POINTS (SEE PAGE 54).

3. TO FIND THE THIRD VANISHING POINT DRAW A LINE AT 30° FROM POINT A ON THE HEIGHT LINE.

THEN DRAW A SECOND LINE AT RIGHT ANGLES TO THIS FROM ANY POINT ALONG IT.

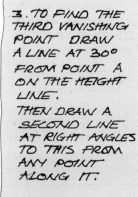
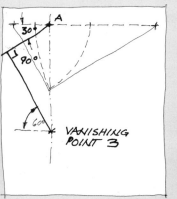

4. DRAW AN ARC FROM VP 3 TO FIND MEASURING POINT THREE.

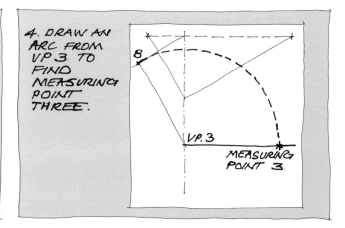

5. DRAW THE MEASURING LINE FROM B. THIS CROSSES THE HEIGHT LINE AT THE TOP SPOT. LINK THIS TO VPL AND VPR.

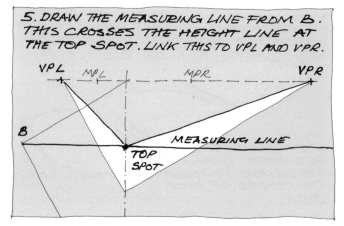

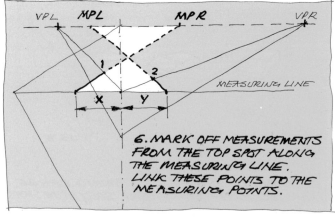

6. MARK OFF MEASUREMENTS FROM THE TOP SPOT ALONG THE MEASURING LINE. LINK THESE POINTS TO THE MEASURING POINTS.

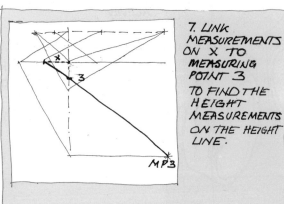

7. LINK MEASUREMENTS ON X TO MEASURING POINT 3 TO FIND THE HEIGHT MEASUREMENTS ON THE HEIGHT LINE.

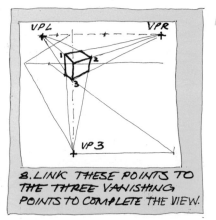

8. LINK THESE POINTS TO THE THREE VANISHING POINTS TO COMPLETE THE VIEW.

Activity

Draw a cube in three point perspective.
Divide up the faces so that it can be used as an underlay sheet.

2.18 RENDERING

When you have established the main framework of the drawing in oblique, axonometric, or perspective, then you can render it so that each surface appears more realistic. Rendering means applying shade or colour to increase the sense of three dimensions. There are a number of different methods of achieving this and you can find some examples on pages 58–61 and 90–91.

SHADOW LINE

Shadow line is a system of thick and thin lines which can be used to emphasize the forms involved in a drawing. It is a simple, but effective, method of making an object appear to stand out from the page.

TONE SHADING

Areas of light and dark on an object can be represented by light and dark pencil shading. This is called tone shading.

LINE SHADING

Lines drawn at different distances from each other can be used to represent light and dark areas. For example, lines spaced wide apart appear lighter than lines drawn close together. This technique is called line shading.

TEXTURE SHADING

Line shading can be combined with a variety of marks to represent the texture of different surfaces. With practice, a number of formulae for various materials can be built up.

COLOUR

Colour is a very effective way to render drawings. There are many colour mediums to choose from. Chalks, coloured pencils, water and poster colours, felt pens, and felt markers are some of the most common.

Most industrial designers use felt markers, which are an expensive range of special felt pens. Although they are costly they can be used quickly and, in skilled hands, can produce some dramatic effects.

This method of rendering can be practised with slower and cheaper mediums, such as pencils and chalks. These are easier to use than wet mediums and, with some care, can produce professional results. You will find some information about applying colour to drawings on pages 90–91.

QUESTIONS

1 What is rendering?
2 List the types of rendering and write a short explanation of each.

1. LINES ON DRAWINGS REPRESENT THE EDGES OF SHAPES. THEY INDICATE A CHANGE OF ANGLE BETWEEN TWO OR MORE SURFACES. THE LINES THAT MAKE UP THE CUBE TELL US THAT THERE ARE THREE SQUARE FACES AT RIGHT ANGLES TO EACH OTHER.

2. THERE ARE TWO TYPES OF LINE ON THIS DRAWING.

THE INNER LINE TELLS YOU THAT THERE IS A CHANGE OF ANGLE BETWEEN TWO SURFACES THAT YOU CAN SEE.

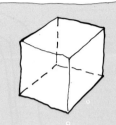

3. THE OUTLINE REPRESENTS A CHANGE OF PLANE BETWEEN TWO SURFACES THAT YOU CANNOT SEE.

4. SHADOW LINE TECHNIQUE DISTINGUISHES BETWEEN THESE LINES. WHERE BOTH SURFACES CAN BE SEEN YOU DRAW A THIN LINE. WHERE ONLY ONE CAN BE SEEN YOU DRAW A THICK LINE.

5. THE THICKER LINE CASTS A SHADOW AND MAKES THE EDGE STAND OUT.

6. SEEN FROM THE OTHER SIDE THE SHADOW IS DIFFERENT.

7. CURVES CAN BE THICKENED TO MAKE A SHADOW.

8. HOLES ARE DRAWN WITH THICK LINES TO THE FRONT AND THIN TO THE BACK OF THE TOP EDGE.

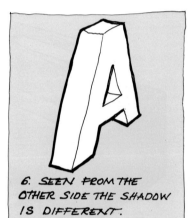

9. THE THICK CURVE TAPERS INTO THE THIN CURVE ON THE EDGE OF ALL HOLES.

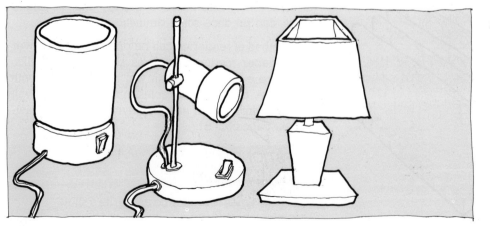

Activity

Use shadow line shading to render some designs of the lighting units on the left. You may start by copying the ones opposite noting carefully the line thicknesses.

2.20 TONE SHADING

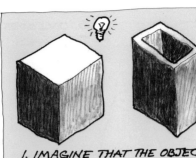

THE INNER-FACES OF HOLLOW SHAPES ARE TREATED IN THE SAME MANNER.

1. IMAGINE THAT THE OBJECT IS LIT FROM ONE BULB.
THE TOP IS LIGHT. THE END IS DARK. THE FRONT IS A HALFTONE.

2. A MORE THREE DIMENSIONAL EFFECT CAN BE ACHIEVED BY ADDING REFLECTED LIGHT.

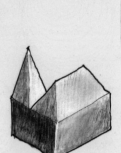

3. ANGLED FACES NEED MORE TONES, RANGING FROM LIGHT TO DARK.

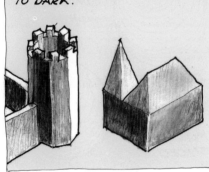

A. DRAW BANDS OF DARK TONE FROM THE EDGES.

B. MAKE THIS FADE TO WHITE JUST PAST THE CENTRE LINE.

C. THE TONE AT THE EDGES FADES IN OR OUT TO INCREASE THE SOLID LOOK.

4. THE TONE ON CYLINDERS CHANGES SLOWLY FROM DARK TO LIGHT.

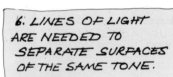

6. LINES OF LIGHT ARE NEEDED TO SEPARATE SURFACES OF THE SAME TONE.

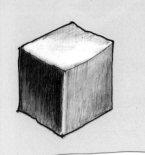

7. TRIANGULAR BANDS OF TONE POINT TOWARDS THE APEX OF THE CONE.

5. THE TONE ON HORIZONTAL CYLINDERS RUNS IN BANDS THAT ARE PARALLEL TO THE EDGES.

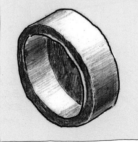

8. TO APPLY TONE TO A SPHERE —

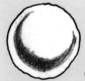

B. THEN FADE THE TONE AT THE TOP INTO A LIGHT CIRCLE.

A. SHADE A CRESCENT OF DARK TONE.

C. THE OUTER RING FADES TOWARDS THE EDGE.

9. THESE BASIC SHAPES CAN BE ASSEMBLED INTO MORE COMPLEX FORMS.

Activity

Draw two or three wooden toys which could be made from the simple geometric forms that are shown on this page. Render these drawings with tone shading.

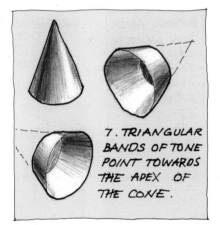

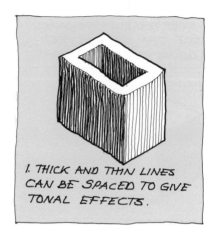

1. THICK AND THIN LINES CAN BE SPACED TO GIVE TONAL EFFECTS.

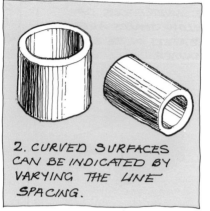

2. CURVED SURFACES CAN BE INDICATED BY VARYING THE LINE SPACING.

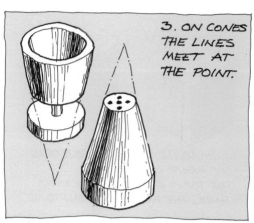

3. ON CONES THE LINES MEET AT THE POINT.

4. ON PERSPECTIVE DRAWINGS THE LINES RECEDE TOWARDS THE VANISHING POINTS.

B. ABOVE THE CENTRE LINE THE CURVES GET CLOSER TOGETHER AT THE TOP AND BACK.

D. RUB AWAY TOP LINES TO SIMULATE LIGHT.

5. TO LINE SHADE SPHERES A. LOCATE THE TOP AND CENTRE LINES.

C. BENEATH THE CENTRE LINE THEY ARE ALSO MORE CLOSELY SPACED.

6. THICK AND THIN LINES CAN BE USED TO REPRESENT MORE DRAMATIC EFFECTS OF LIGHT AND SHADE.

7. THE REFLECTIONS ON POLISHED SURFACES CAN BE IMITATED WITH LINE SHADING.

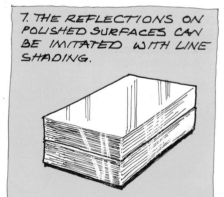

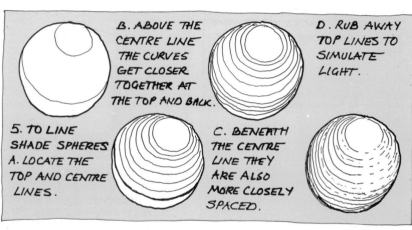

'SHINE LINES' ON THE TOP SURFACE ARE LONG IRREGULARLY SPACED AND AT A SLIGHT ANGLE.

8. LINES ON THE SIDES CAN BE BROKEN WITH AN ERASER OR WHITE PAINT.

9. THICK BLACK BANDS CAN BE USED TO SHOW THE DARK REFLECTIONS ON POLISHED SURFACES

10. BRIGHT SHINING 'HIGH LIGHTS' CAN BE OUTLINED.

11. BRIGHT EDGES AND SHADOWS ARE ALSO IMPORTANT ON SHINY OBJECTS.

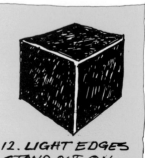

12. LIGHT EDGES STAND OUT ON DARK OBJECTS.

13. LIGHT REFLECTIONS ARE USED ON DARK SHINY OBJECTS.

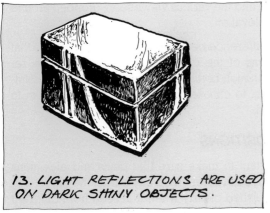

14. THERE ARE NO REFLECTIONS ON DARK MATT SURFACES.

15. BROKEN SURFACES WILL INDICATE TEXTURE.

16. TO DRAW TRANSPARENT OBJECTS FIRST DRAW THE OUTLINE.

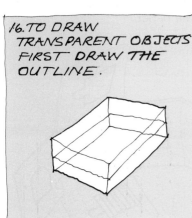

17. ADD 'SHINE LINES' TO THE TOP AND SIDES.

BREAK THE INTERNAL DETAILS AT THE EDGES AND UNDER 'SHINE LINES!'

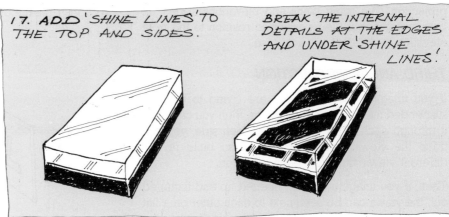

18. FABRICS CAN BE REPRESENTED BY LINE TEXTURES.

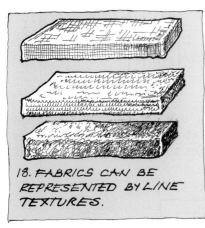

19. ON TIMBER USE DIFFERENT GRAIN PATTERNS ON ADJACENT SURFACES.

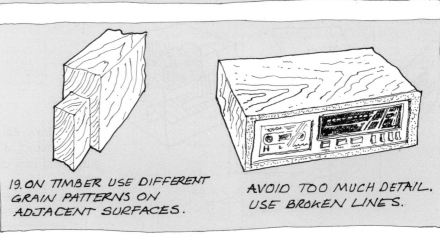

AVOID TOO MUCH DETAIL. USE BROKEN LINES.

20. VARIOUS TYPES OF LINES AND MARKS CAN BE USED TO SUGGEST DIFFERENT MATERIALS. THESE CAN ALSO BE IN COLOUR (PAGES 90-91).

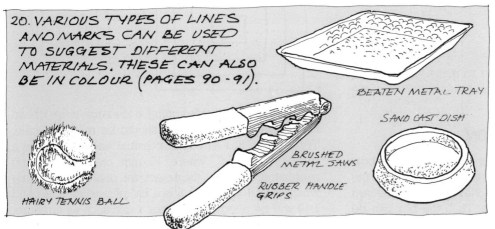

BEATEN METAL TRAY

SAND CAST DISH

BRUSHED METAL JAWS

RUBBER HANDLE GRIPS

HAIRY TENNIS BALL

Activity

Draw some designs for a hi-fi system. The system should include a record deck, a tape player, an amplifier, a radio, and speakers.
Render your best drawing using line and texture shading.

2.22 WORKING DRAWINGS

The best method of working out the exact measurements for each piece of your design is to produce a set of working drawings. These consist of views from various sides of the object, drawn looking straight at it. In this way, the object can be seen as a series of flat shapes with no hint of it being solid.

This process is called **orthographic projection**. The views from the front and ends of the object are called **elevations**. The view from above is called a **plan**.

THIRD AND FIRST ANGLE PROJECTION

There are two methods in general use for producing these views. These are called **third** and **first angle projection**. The same plans and elevations appear in both systems, but their position in relation to the front elevation is different in each case.

THIRD ANGLE PROJECTION

If you imagine the object you are trying to draw is suspended inside a transparent box, then you can view it through each of six faces. On to each side, you can trace the view you have of it and so build up six different views, one from each direction.

Then, if you imagine the box opened up and flattened out, the views can be seen next to each other on a flat piece of paper. This is a **third angle** projection of your object.

It is unlikely that you will need so many views. Three will usually be sufficient, the front elevation, one of the end elevations, and the plan.

FIRST ANGLE PROJECTION

Now imagine the object floating inside an opaque box. Look at the object and project what you see on to the wall behind. In this way the six views can be collected on the inner faces of the cube. Then the box can be

opened up and the various views seen, grouped around the front elevation.

The only difference between this and third angle is that the positions of the end elevations and plan are reversed. Although both systems can be used successfully, it is best to choose the method you find easiest to understand.

VIEW POSITIONS

It is important to make sure that plans and elevations line up with each other. Then any part of the object can be distinguished clearly when it is seen from different positions. Views should be drawn on graph paper or with instruments on plain paper.

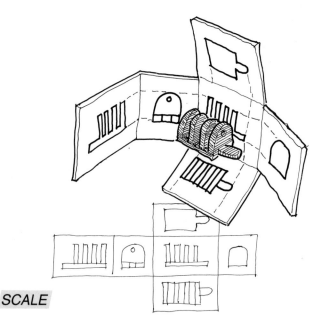

SCALE

Try to draw full size, if that is possible. The actual relationship of all the elements can then be seen. It is surprising how different an object can look at half full size.

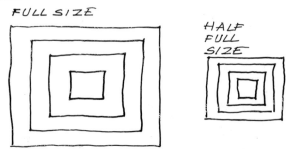

If the object you are designing is too large to be drawn full size, then your drawing should be made to scale. Try to keep this as big as possible and always use a simple scale. 1:2, where 10 mm on your drawing represents 20 mm on the object, will give you a drawing which is half full size. 1:5 is a useful smaller scale and 1:10 will be needed for larger items such as furniture.

DETAILS

If your drawing is too small to enable you to sort out a particular feature, you may choose to enlarge just part of it. This is called a **detail**.

Engineers and designers, concerned with precise measurements such as those needed to snap fit a plastic lid on to a box, will draw details at 10:1; that is 10 times larger than the object. They do this to ensure that the parts will fit together properly. The scale you use will depend upon how complicated the design is. 2:1, which is twice full size, and 5:1, where 5 mm on the drawing represents 1 mm on the object, are useful for most occasions.

HIDDEN DETAIL

Sometimes you will need to work out what the object looks like inside. To plan out these unseen parts you can use one of two systems, either **hidden detail** or a **section**.

If the inside is simple you can show the hidden detail as a series of dashed lines on any of the orthographic views.

SECTIONS

If the inner parts are complicated, hidden detail will only confuse the drawing. In these cases a section will show what is happening. This is like an imaginary saw cut through the object. The surfaces cut by this plane are hatched on engineering drawings. This means they are shaded with lines at 45°. Each material is represented by lines in different directions as below.

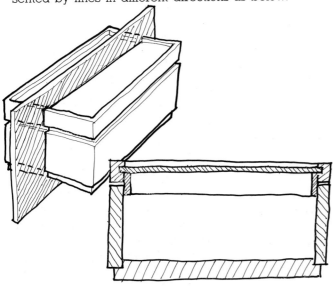

Smaller parts are covered with close hatching, and larger parts with wider hatching. Architects use various sets of symbols for the variety of different materials they use. A selection of these is shown on page 69.

DIMENSION LINES

To complete the drawing, you will need to work out the dimensions of the various component parts. They can then be read clearly. They should be placed well clear of the drawing and connected to it by projection lines.

There is more information about dimensioning on pages 67 and 69.

ABBREVIATIONS

Rather than writing the same word over and over again on a drawing, designers use a series of abbreviations and symbols for commonly occuring terms. Radius becomes r, diameter is either *dia.* or ϕ. You will find some more of these on page 69.

PARTS LIST

Finally, you will need to draw up a table in which you can list all the components and materials needed to make the object you have designed. This is called a **parts list**. You can make up your own style of table, but it should contain the key information which should always be easy to find.

PART	MATERIAL	LENGTH	WIDTH	THICKNESS	FINISH	NUMBER REQUIRED
BOX TOP	ACRYLIC SHEET	150	60	3	POLISH	1
BOX SIDES	HARDWOOD	175	50	15	STAIN AND POLISH	2
BOX ENDS	HARDWOOD	80	50	15	STAIN AND POLISH	2
SIDE LINING	ACRYLIC SHEET	150	20	3	POLISH	2
END LINING	ACRYLIC SHEET	60	20	3	POLISH	2
BOX BASE	HARDWOOD	140	80	15	STAIN AND POLISH	1

QUESTIONS

1 What are working drawings used for?
2 What is orthographic projection?
3 Describe how plans and elevations are arrived at in third angle projection.
4 Which three views are usually sufficient?
5 What is the difference between first and third angle projection?
6 Why is it best to draw full size?
7 What do 1:2 and 1:5 mean?
8 When would you use a detail and what sort of scale would you use?
9 What is hidden detail?
10 When is it better to use a section rather than hidden detail?
11 Why do designers use abbreviations and symbols?
12 What is a parts list?

2.23 SIMPLE WORKING DRAWINGS

Working drawings are the best way of establishing the exact details of your designs. They can be made in either first or third angle projection. Usually only three views are needed. These are a plan, an end, and a front elevation.

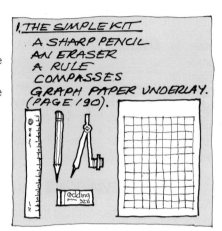

1. THE SIMPLE KIT
 A SHARP PENCIL
 AN ERASER
 A RULE
 COMPASSES
 GRAPH PAPER UNDERLAY.
 (PAGE 190).

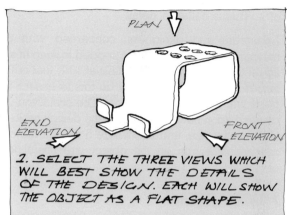

2. SELECT THE THREE VIEWS WHICH WILL BEST SHOW THE DETAILS OF THE DESIGN. EACH WILL SHOW THE OBJECT AS A FLAT SHAPE.

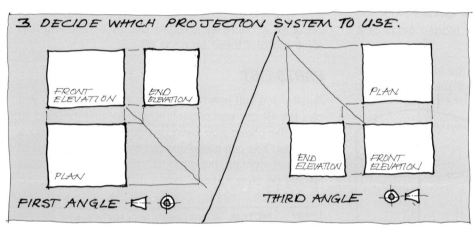

3. DECIDE WHICH PROJECTION SYSTEM TO USE.

FIRST ANGLE

THIRD ANGLE

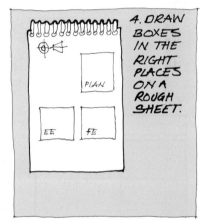

4. DRAW BOXES IN THE RIGHT PLACES ON A ROUGH SHEET.

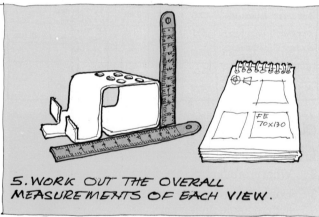

5. WORK OUT THE OVERALL MEASUREMENTS OF EACH VIEW.

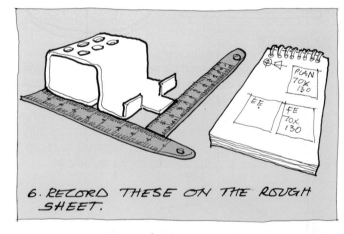

6. RECORD THESE ON THE ROUGH SHEET.

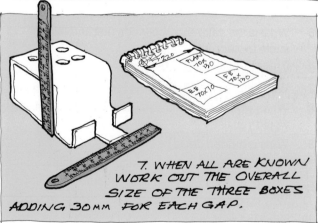

7. WHEN ALL ARE KNOWN WORK OUT THE OVERALL SIZE OF THE THREE BOXES ADDING 30MM FOR EACH GAP.

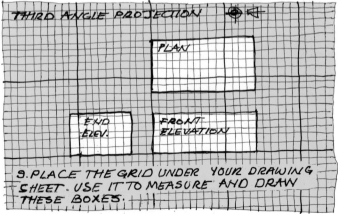

THIRD ANGLE PROJECTION

9. PLACE THE GRID UNDER YOUR DRAWING SHEET. USE IT TO MEASURE AND DRAW THESE BOXES.

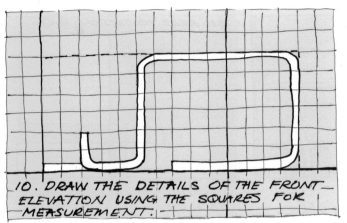

10. DRAW THE DETAILS OF THE FRONT ELEVATION USING THE SQUARES FOR MEASUREMENT.

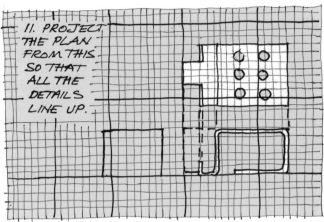

11. PROJECT THE PLAN FROM THIS SO THAT ALL THE DETAILS LINE UP.

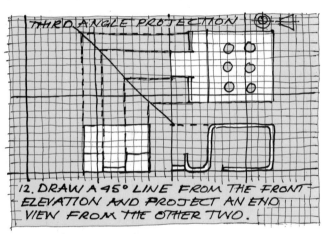

THIRD ANGLE PROJECTION

12. DRAW A 45° LINE FROM THE FRONT ELEVATION AND PROJECT AN END VIEW FROM THE OTHER TWO.

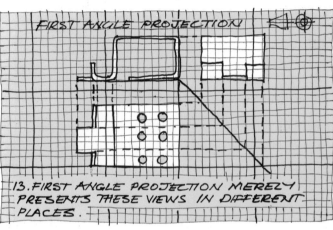

FIRST ANGLE PROJECTION

13. FIRST ANGLE PROJECTION MERELY PRESENTS THESE VIEWS IN DIFFERENT PLACES.

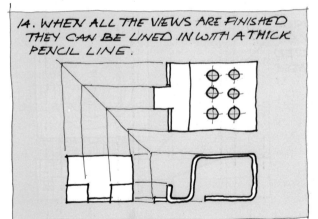

14. WHEN ALL THE VIEWS ARE FINISHED THEY CAN BE LINED IN WITH A THICK PENCIL LINE.

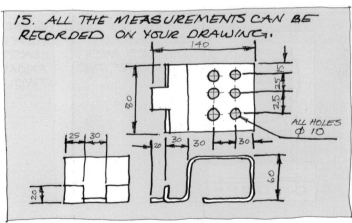

15. ALL THE MEASUREMENTS CAN BE RECORDED ON YOUR DRAWING.

ALL HOLES Ø 10

PART No.	PART NAME	LENGTH	WIDTH	THICKNESS	NOTES	NO. REQD.
1	BOX LID	120	80	12	HARDWOOD	1
2	LONG BOX SIDE	130	60	12	HARDWOOD	2
3	SHORT BOX SIDE	80	60	12	HARDWOOD	2
4	BOX BASE	125	75	3	PLYWOOD	1

16. WHEN SEVERAL COMPONENTS ARE NEEDED A PARTS LIST SHOULD BE DRAWN UP.

Activity

Sketch some designs for a desk tidy to be made from one piece of acrylic sheet. Produce a set of working drawings in either first or third angle projection. Use the graph paper underlay on page 190.

More complex drawings will have to be drawn with instruments on a drawing board. Equipment list: 2 pencils, 4H or 2H technical pencil and an H pencil; 30°/60° and 45° set squares; an eraser; a rule; a pair of compasses; circle guides; a drawing board; and a tee square with a block and some board clips.

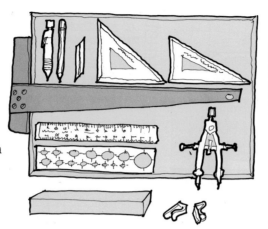

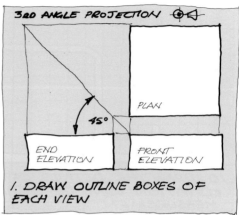

3RD ANGLE PROJECTION

PLAN

END ELEVATION

FRONT ELEVATION

45°

1. DRAW OUTLINE BOXES OF EACH VIEW

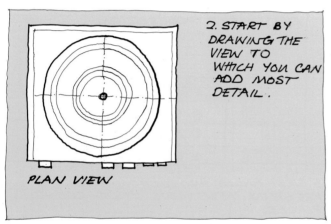

PLAN VIEW

2. START BY DRAWING THE VIEW TO WHICH YOU CAN ADD MOST DETAIL.

3. PROJECT THE POSITION OF THESE DETAILS ON TO A SECOND VIEW.

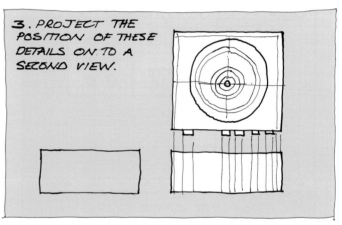

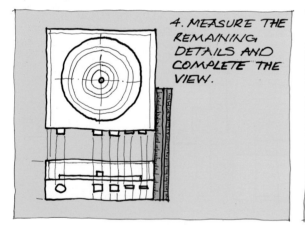

4. MEASURE THE REMAINING DETAILS AND COMPLETE THE VIEW.

5. THE THIRD VIEW CAN BE CONSTRUCTED FROM THESE TWO.

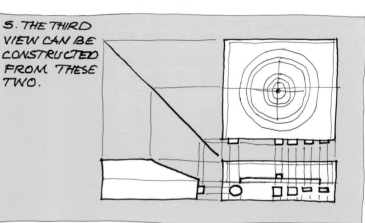

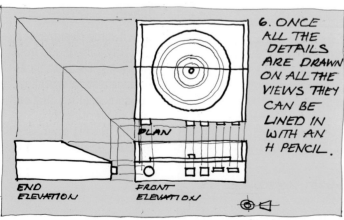

PLAN

END ELEVATION

FRONT ELEVATION

6. ONCE ALL THE DETAILS ARE DRAWN ON ALL THE VIEWS THEY CAN BE LINED IN WITH AN H PENCIL.

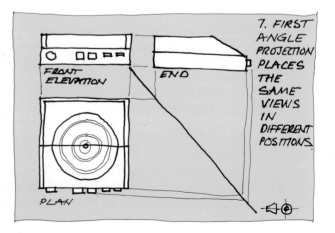

FRONT ELEVATION

END

PLAN

7. FIRST ANGLE PROJECTION PLACES THE SAME VIEWS IN DIFFERENT POSITIONS.

8. ONE VIEW CAN BE TREATED AS A SECTION TO SHOW THE INNER DETAIL.

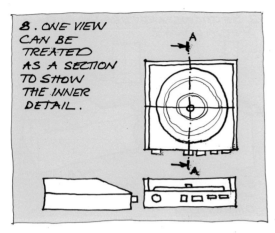

9. EACH PART OF THE CONSTRUCTION CAN THEN BE SEEN CLEARLY.

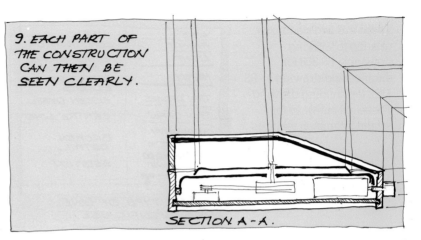

SECTION A-A.

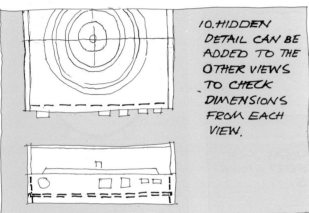

10. HIDDEN DETAIL CAN BE ADDED TO THE OTHER VIEWS TO CHECK DIMENSIONS FROM EACH VIEW.

11. EACH VIEW CAN THEN BE DIMENSIONED. KEEP THE DIMENSION ARROWS WELL AWAY FROM THE DRAWINGS.

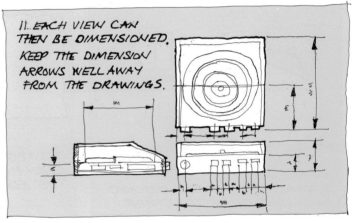

12. ARROWHEADS SHOULD BE SMALL AND BLACK.

DIMENSIONS CAN BE ADDED ON THE ARROWS OR PLACED BETWEEN THE ARROW HEADS.

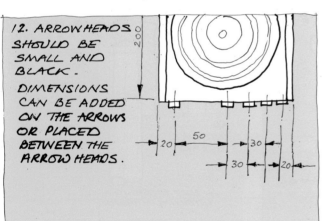

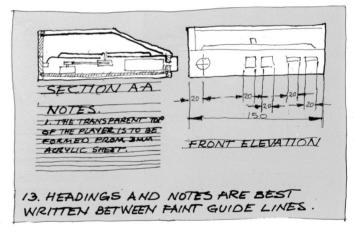

SECTION AA

NOTES.

1. THE TRANSPARENT TOP OF THE PLAYER IS TO BE FORMED FROM 3MM ACRYLIC SHEET.

FRONT ELEVATION

13. HEADINGS AND NOTES ARE BEST WRITTEN BETWEEN FAINT GUIDE LINES.

Activity

Sketch some designs for a record player.
Draw a set of working drawings in either first or third angle projection.
Add dimensions and a parts list.

NAME	MATERIAL	L	W	T	FINISH	NO. RQD.	APPROX PRICE
BACK	HARDWOOD	150	80	12	STAIN AND LACQUER	1	30P
SIDE	"	200	80	12	"	2	35P
FRONT	"	150	50	12	"	1	25P
BASE	PLYWOOD	200	150	3	"	1	20P
GLUE BLOCKS	SOFTWOOD	200	20	20	NO FINISH	4	5P
TOP	ACRYLIC	200	180	3	POLISH	1	1.50
					TOTAL PRICE		2.65P

14. A PARTS LIST CAN THEN BE DRAWN UP TO RECORD THE DETAILS OF EACH COMPONENT OF THE DESIGN.

2.25 SYMBOLS AND CONVENTIONS

There are two standards relating to working drawings: BS 308 for engineering drawing or BS 1192 for building drawing. These set out ways for treating common features.

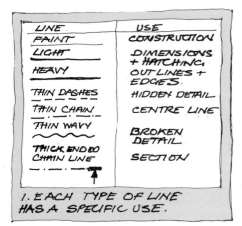

LINE	USE
FAINT	CONSTRUCTION
LIGHT	DIMENSIONS + HATCHING
HEAVY	OUT LINES + EDGES
THIN DASHES	HIDDEN DETAIL
THIN CHAIN	CENTRE LINE
THIN WAVY	BROKEN DETAIL
THICK ENDED CHAIN LINE	SECTION

1. EACH TYPE OF LINE HAS A SPECIFIC USE.

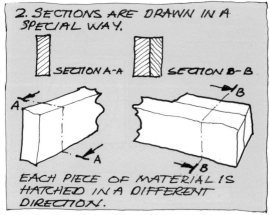

2. SECTIONS ARE DRAWN IN A SPECIAL WAY.

SECTION A-A SECTION B-B

EACH PIECE OF MATERIAL IS HATCHED IN A DIFFERENT DIRECTION.

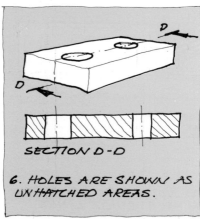

SECTION C-C.

3. SMALL PARTS ARE HATCHED WITH LINES CLOSE TOGETHER.

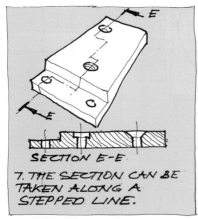

4. LARGE AREAS ARE ONLY HATCHED AROUND THE EDGES.

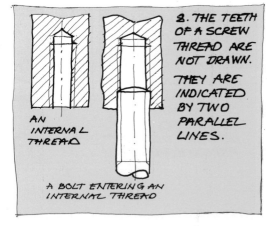

5. THIN MATERIALS ARE SHOWN AS A THICK BLACK LINE ON A SECTION.

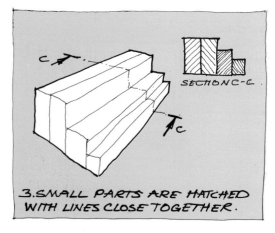

SECTION D-D

6. HOLES ARE SHOWN AS UNHATCHED AREAS.

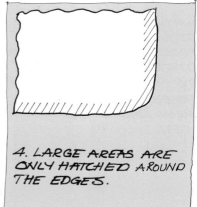

SECTION E-E

7. THE SECTION CAN BE TAKEN ALONG A STEPPED LINE.

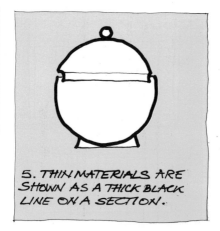

AN INTERNAL THREAD

A BOLT ENTERING AN INTERNAL THREAD

8. THE TEETH OF A SCREW THREAD ARE NOT DRAWN.

THEY ARE INDICATED BY TWO PARALLEL LINES.

9. SOME COMPONENTS ARE NOT HATCHED IN SECTION. THEY ARE DRAWN AS IF VIEWED IN FRONT ELEVATION.

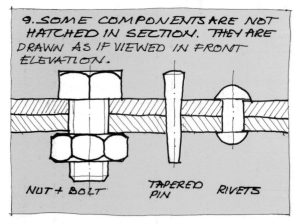

NUT + BOLT TAPERED PIN RIVETS

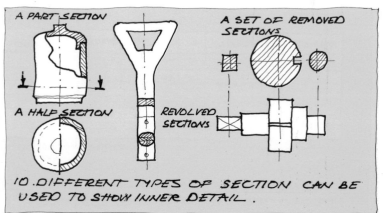

A PART SECTION

A SET OF REMOVED SECTIONS

A HALF SECTION REVOLVED SECTIONS

10. DIFFERENT TYPES OF SECTION CAN BE USED TO SHOW INNER DETAIL.

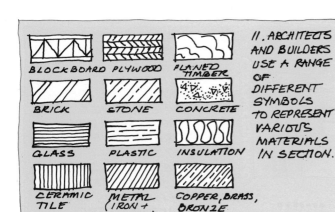

BLOCKBOARD PLYWOOD PLANED TIMBER

BRICK STONE CONCRETE

GLASS PLASTIC INSULATION

CERAMIC TILE METAL (IRON + STEEL) COPPER, BRASS, BRONZE

11. ARCHITECTS AND BUILDERS USE A RANGE OF DIFFERENT SYMBOLS TO REPRESENT VARIOUS MATERIALS IN SECTION.

12. ON OTHER VIEWS ENGINEERS OFTEN USE FORMS OF SHORTHAND TO SAVE DRAWING TIME.

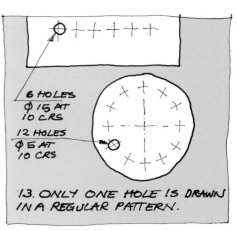

6 HOLES Ø 15 AT 10 CRS

12 HOLES Ø 5 AT 10 CRS

13. ONLY ONE HOLE IS DRAWN IN A REGULAR PATTERN.

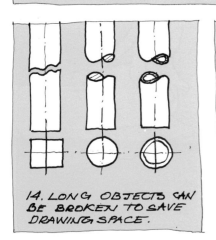

14. LONG OBJECTS CAN BE BROKEN TO SAVE DRAWING SPACE.

15. ONLY PART OF THE KNURLING TEXTURE IS DRAWN.

16. PARALLEL LINES ARE USED TO REPRESENT SCREW THREADS.

17. A PART DRAWING OR A SYMBOL IS USED TO INDICATE A SPRING.

18. ABBREVIATIONS ARE USED FOR COMMON TERMS TO SAVE TIME AND SPACE ON DRAWINGS.

R	RADIUS
Ø	DIAMETER
□	SQUARE
CRS	CENTRES
₵ or CL	CENTRE LINE
M.	METRIC THREAD
CHAM.	CHAMFER.
L.H.	LEFT HAND
R.H.	RIGHT HAND
A/F	ACROSS FLATS
I.D.	INTERNAL DIAMETER
O.D.	OVERALL DIAMETER

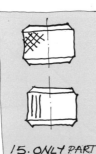

Ø 15

Ø 7

19. WHOLE CIRCLES ARE DIMENSIONED BY RECORDING THEIR DIAMETERS.

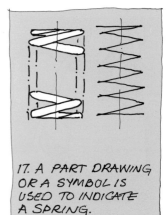

R 10 R 14

R 5

20. RADII OF PART CIRCLES CAN BE WRITTEN ON THE RADIUS ARROW OR ON LEAD LINES.

21. DIMENSIONING RULES —
A. THERE SHOULD BE A SMALL GAP AT THE END OF THE PROJECTION LINE.

B. NUMERALS SHOULD ALWAYS BE PLACED IN THE CENTRE OF THE DIMENSION ARROW.

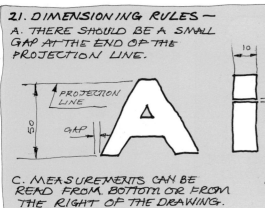

PROJECTION LINE

GAP

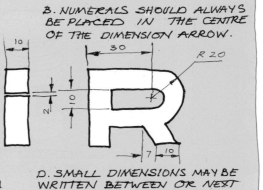

C. MEASUREMENTS CAN BE READ FROM BOTTOM OR FROM THE RIGHT OF THE DRAWING.

D. SMALL DIMENSIONS MAY BE WRITTEN BETWEEN OR NEXT TO DIMENSION ARROWS.

Activity

Draw a section through a record deck.
Make the drawing using the conventions and symbols recommended by the British Standards.

69

2.26 BUILDING PROTOTYPES

Prototypes are used to test design ideas in three dimensions before designers commit themselves to the lengthy process of manufacture. Balsawood, card, expanded polystyrene, plasticine, and paper straws can be used to make quick models of design ideas.

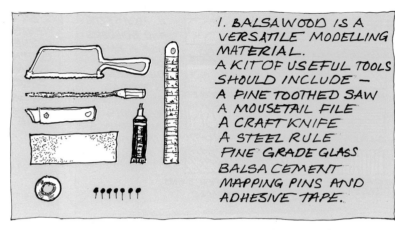

1. BALSAWOOD IS A VERSATILE MODELLING MATERIAL. A KIT OF USEFUL TOOLS SHOULD INCLUDE —
A PINE TOOTHED SAW
A MOUSETAIL FILE
A CRAFT KNIFE
A STEEL RULE
FINE GRADE GLASS
BALSA CEMENT
MAPPING PINS AND
ADHESIVE TAPE.

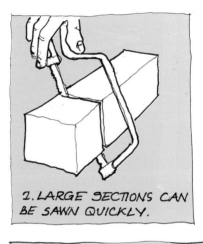

2. LARGE SECTIONS CAN BE SAWN QUICKLY.

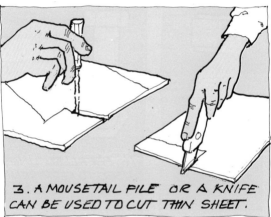

3. A MOUSETAIL FILE OR A KNIFE CAN BE USED TO CUT THIN SHEET.

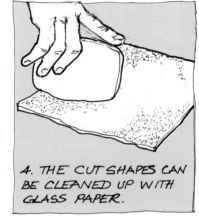

4. THE CUT SHAPES CAN BE CLEANED UP WITH GLASS PAPER.

5. OLD METALWORK FILES OR TIMBER SECTIONS COVERED IN GLASS PAPER CAN BE USED TO SHAPE FINE DETAIL.

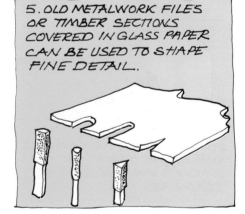

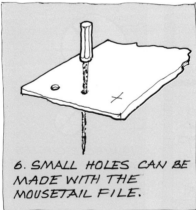

6. SMALL HOLES CAN BE MADE WITH THE MOUSETAIL FILE.

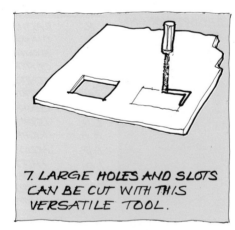

7. LARGE HOLES AND SLOTS CAN BE CUT WITH THIS VERSATILE TOOL.

8. TURNED SHAPES CAN BE BUILT UP FROM PRE-SHAPED BLOCKS OR SHEETS.

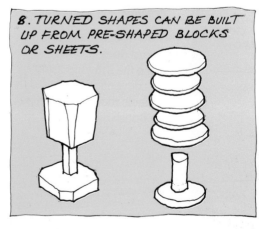

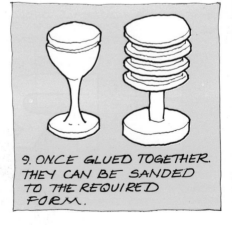

9. ONCE GLUED TOGETHER. THEY CAN BE SANDED TO THE REQUIRED FORM.

10. THE FINISHED SHAPE CAN BE PAINTED WITH BALSA PAINT.

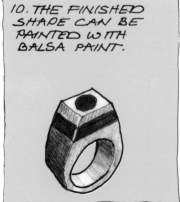

11. CARD CAN BE EASILY CUT, FOLDED AND CURVED. IT CAN BE USED ON A WIDE RANGE OF PROJECTS.

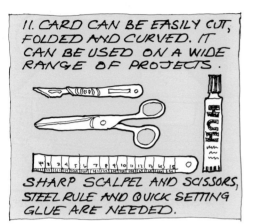

SHARP SCALPEL AND SCISSORS, STEEL RULE AND QUICK SETTING GLUE ARE NEEDED.

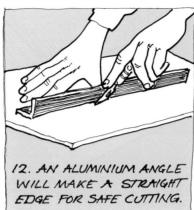

12. AN ALUMINIUM ANGLE WILL MAKE A STRAIGHT EDGE FOR SAFE CUTTING.

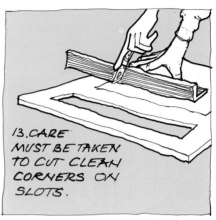

13. CARE MUST BE TAKEN TO CUT CLEAN CORNERS ON SLOTS.

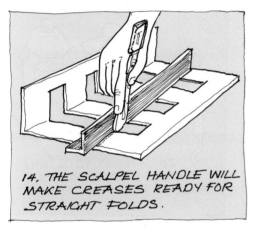

14. THE SCALPEL HANDLE WILL MAKE CREASES READY FOR STRAIGHT FOLDS.

15. CURVES ON THIN CARD ARE BEST CUT WITH SCISSORS.

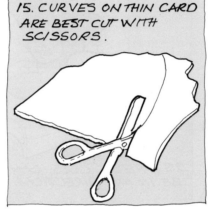

16. SMALL HOLES CAN BE MADE FROM A SERIES OF PIERCINGS.

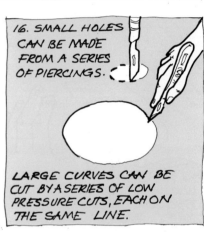

LARGE CURVES CAN BE CUT BY A SERIES OF LOW PRESSURE CUTS, EACH ON THE SAME LINE.

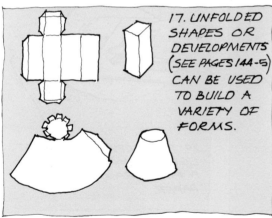

17. UNFOLDED SHAPES OR DEVELOPMENTS (SEE PAGES 144-5) CAN BE USED TO BUILD A VARIETY OF FORMS.

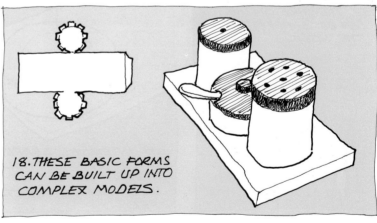

18. THESE BASIC FORMS CAN BE BUILT UP INTO COMPLEX MODELS.

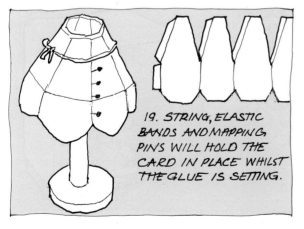

19. STRING, ELASTIC BANDS AND MAPPING PINS WILL HOLD THE CARD IN PLACE WHILST THE GLUE IS SETTING.

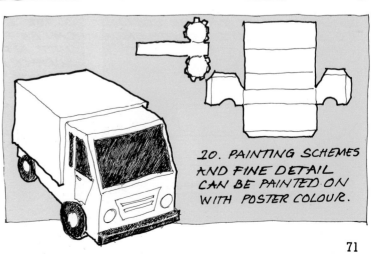

20. PAINTING SCHEMES AND FINE DETAIL CAN BE PAINTED ON WITH POSTER COLOUR.

21. EXPANDED POLYSTYRENE CAN BE USED TO MODEL THICK SECTIONS AND LARGE OBJECTS.

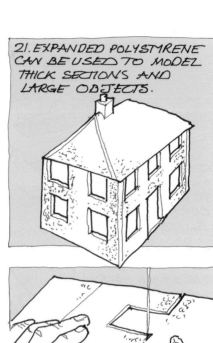

22. CEILING TILES, BUILDING BLOCKS AND OLD PACKAGES CAN BE USED.

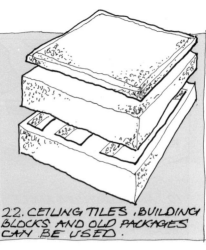

23. THESE CAN BE CUT WITH A HOT WIRE OR A SHARP HACK SAW BLADE.

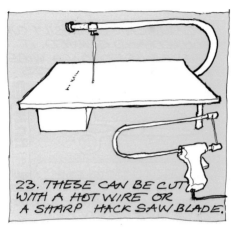

24. THE HOT WIRE WILL CUT A THICK OR THIN BLOCK VERY QUICKLY.

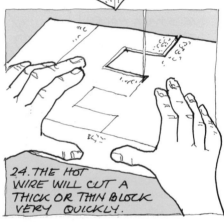

25. THESE CUTS CAN BE IN ANY DIRECTION.

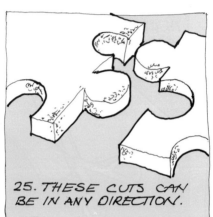

26. A HAND TOOL WILL CARVE OUT SHAPES FROM THE MAIN FORM.

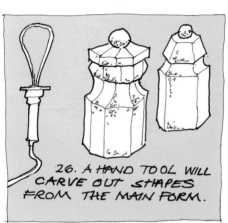

27. THE WIRE ON THIS TOOL CAN BE SHAPED TO SUIT THE WORK.

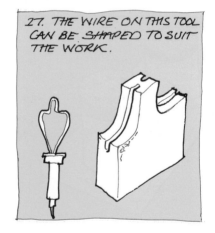

28. INTERNAL SHAPES ARE CUT FROM A HOLE THROUGH WHICH THE DISCONNECTED WIRE IS FED.

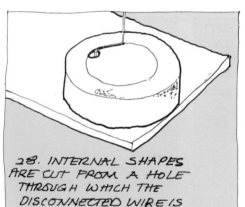

29. THE SURFACES CAN BE LIGHTLY SANDED WITH A FINE GRAIN GLASS PAPER.

30. LATEX GLUE MAY BE USED TO STICK PARTS TOGETHER.

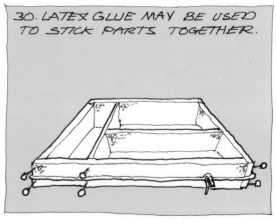

31. THE SURFACES CAN BE FILLED WITH A FINE SURFACE FILLER TO MAKE THEM SMOOTH. AFTER SANDING THEY CAN BE PAINTED WITH EMULSION PAINT.

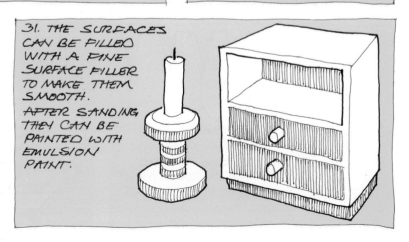

32. PLASTICINE CAN BE FORMED INTO COMPLEX SHAPES. IT IS THEREFORE GOOD FOR MODELS OF BEATEN METALWORK, MOULDED, AND CARVED FORMS.

33. LONG COILS CAN BE WOUND INTO HOLLOW SHAPES SUCH AS BOWLS AND CUPS.

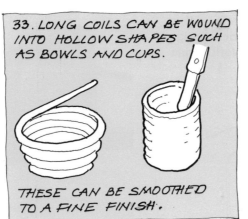

THESE CAN BE SMOOTHED TO A FINE FINISH.

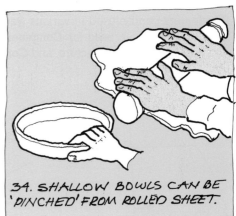

34. SHALLOW BOWLS CAN BE 'PINCHED' FROM ROLLED SHEET.

35. LARGE AND COMPLICATED FORMS MAY NEED AN 'ARMATURE' MADE FROM BENT WIRE.

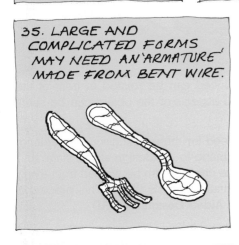

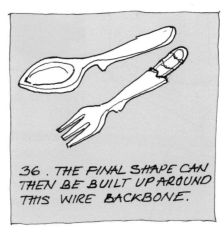

36. THE FINAL SHAPE CAN THEN BE BUILT UP AROUND THIS WIRE BACKBONE.

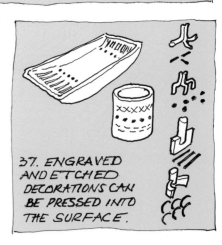

37. ENGRAVED AND ETCHED DECORATIONS CAN BE PRESSED INTO THE SURFACE.

38. PAPER OR PLASTIC STRAWS ARE USED TO MODEL TUBE AND WIRE STRUCTURES.

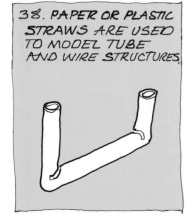

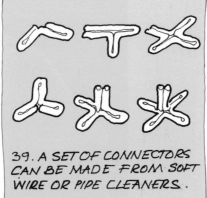

39. A SET OF CONNECTORS CAN BE MADE FROM SOFT WIRE OR PIPE CLEANERS.

40. THESE CONNECTORS CAN BE USED TO JOINT CUT STRAWS.

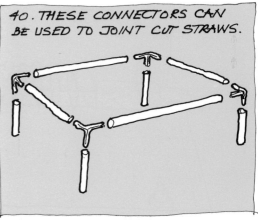

41. THE VARIOUS CONFIGURATIONS WILL ALLOW A VARIETY OF STRUCTURES TO BE BUILT.

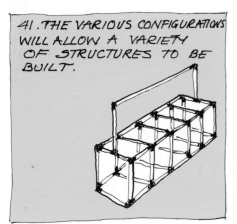

42. WIRE-CORED STRAWS CAN BE BENT INTO A VARIETY OF SHAPES.

Activity

Describe two projects that could be modelled in each of the materials illustrated on these pages.
Explain why each project is suited to the material used.

2.27 DESIGN WITH COMPUTERS

Computers can be used in various ways in the design process. They can used for **Computer Aided Design**, **Computer Aided Manufacture**, and **Computer Draughting**.

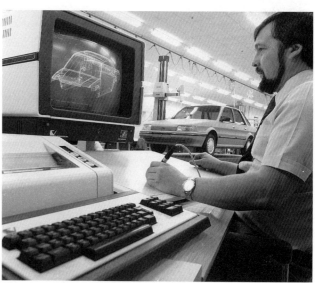

The images produced can be rotated in front of the viewer so that all aspects of the object can be seen. clearly.

This avoids the need for three dimensional modelling. Changes can be made to the design at this stage and the results of these changes can be viewed from every angle, before a final choice is made. This process is called **Computer Aided Design**, or **CAD**.

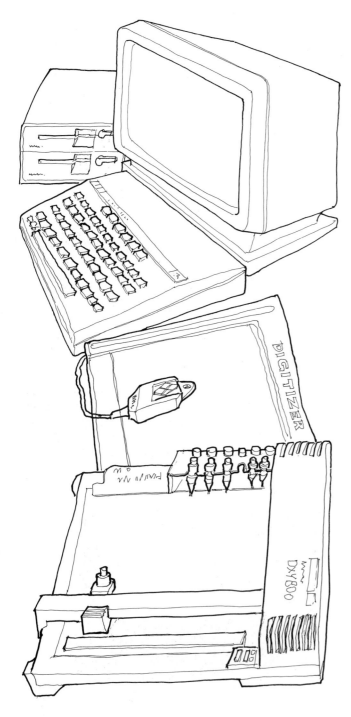

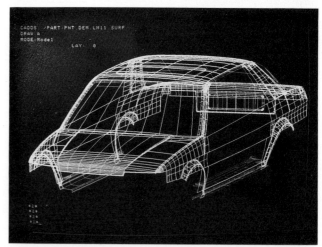

COMPUTER AIDED DESIGN

Computer Aided Design programs will handle objects in three dimensions. They will help you to produce images of the design which can be drawn in perspective projection.

Some programmes will render three dimensional images in tone and colour. Others can also add texture, so that various materials can be distinguished.

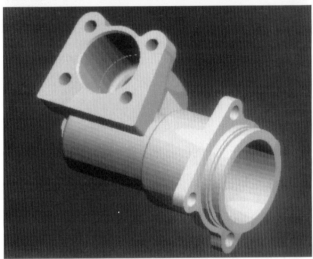

COMPUTERIZED ENGINEERING ANALYSIS

With more advanced programmes, the same image can be subjected to tests and the results anticipated by the computer. This is called **Computerized Engineering Analysis**, or **CEA**.

COMPUTER AIDED MANUFACTURE

With computers you can look at the profiles of proposed components and work out the most suitable cutting and shaping techniques. These can be demonstrated on a screen before they are relayed to the manufacturing machines.

The numerical data is then transmitted directly to computer controlled manufacturing machines. This is **NC**, which is short for **Numerical Control**. The machines will then cut and shape the materials and manufacture the object with no further instructions from the designer. This is called **Computer Aided Manufacture**, or **CAM**.

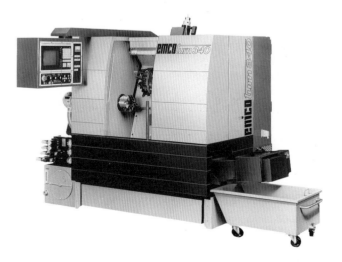

These programmes, and their associated hardware, are expensive, but they are not science fiction. There are programmes for school computers which allow you to visualize a turned object and then proceed to model it on a special lathe. This is a full CAD/CAM process.

75

COMPUTER DRAUGHTING

The smaller microcomputers, however, are used more widely for computer draughting, sometimes called **CD** or **2D**. These systems are now widely used in small design offices and are available to schools.

Some of them are keyboard based, some use a joystick, and others use a digitizer pad, or a 'mouse', to input information. Most of the systems use a menu from which the designer can select functions, such as lines, circles, or arcs. These can be drawn between any selected points. Thick or thin lines can be produced, and they can be dotted or dashed in a range of colours.

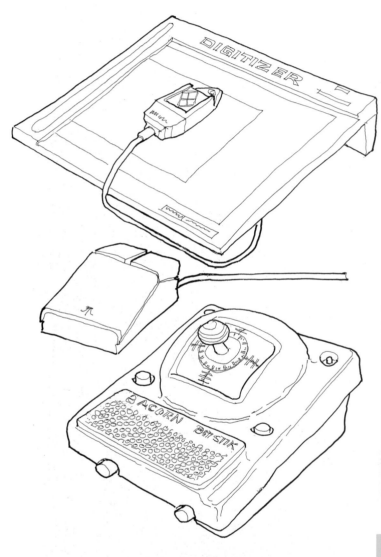

Text is usually confined to one type face, but unlike handwritten notes it is always clear and can be enlarged or reduced, as required. Some programmes will help with dimensioning, measuring, and checking the sizes of parts as you draw the dimension lines.

Squared and isometric grid sheets usually form part of the menu. These can be used in the same manner as underlay sheets to produce accurate three dimensional drawings. The images constructed using 2D programmes cannot be viewed from other angles.

INFORMATION STORAGE

There are library discs of useful information which can be incorporated into your work. Also, the images you produce can be stored on a disc and then retrieved, rotated, magnified, or reduced as desired, all without losing the original drawing. In this way parts can be drawn, saved, brought back when they are needed, and incorporated into the final drawing.

IMAGE PLOTTING

Once this is done the images can be relayed to a **plotter**. This will reproduce your drawing as many times as you like and at whatever size you choose.

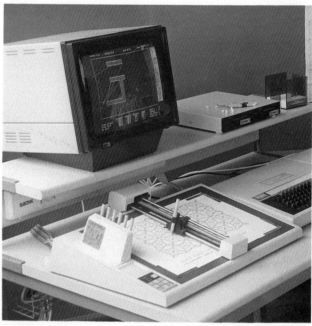

QUESTIONS

1 What is Computer Aided Design?
2 What is CEA and how does it help the designer?
3 There are two processes involved in CAM. Name and describe them.
4 What does computer rendering do?
5 Describe the main functions of a typical CD or 2D programme.
6 How can this information be stored?
7 What is a plotter and what does it do?

SECTION 3
AESTHETICS

3.1 THE VISUAL FACTOR

Although a design needs to function effectively, it is also important for it to be visually pleasing. Therefore, designers need to consider **aesthetics**.

In design, aesthetics is concerned mostly with visual qualities. It includes such factors as **shape, proportion, pattern, texture,** and **colour**. These can be combined in a number of ways to create particular **styles**, which will project different **images**.

As a designer, you need to be aware of how different images are achieved. To do this, you should start by looking at the cups below.

SHAPE

The most obvious difference between them is their shape. You can choose the shape to give a heavy or delicate look to the cup. The wider, fatter shapes look more solid than the slimmer shapes.

PROPORTION

Now compare two similarly shaped cups and you will see that it is not just the overall shape that suggests their style.

Both cups are curved and are based on a circle of the same radius. However, they do not have the same image because they are made up from different amounts of that circle. There is a different relationship between the width and the depth of each cup.

The shallower shape looks more delicate than the deeper one. This has been enhanced by the handle and the base. Smaller, thinner parts have been added to the first cup to make it appear lighter. Larger, thicker parts have been used on the other so that it has a stronger appearance. The relative size and position of the parts of a design is called **proportion**.

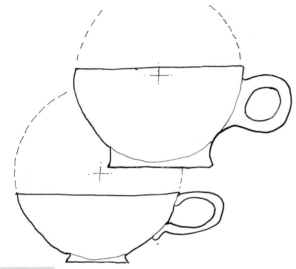

PATTERN

The designer may decide to decorate the object with a **pattern**, making sure that it is appropriate.

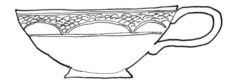

On the cups above a fine, detailed pattern has been introduced to the first. This makes it look more refined. The image of strength and simplicity of the other is reinforced by the bold and simple bands placed carefully near the top.

TEXTURE

Texture can also be part of the image of an object. If the same rough texture were to be applied to the two cups below, it might disturb the delicate appearance of the shallow cup. But the same texture on the mug-like shape may be right for its tougher image.

COLOUR

Designers can change and adjust the image of an object by using colour.

For example, if any one of the cups were coloured bright red or fluorescent green, then it would have a different image from the same shaped cup with a pale pink or pastel green colouring.

STYLE

Each of these visual factors is discussed in more detail in this section. As the designer, it is you who will have to decide which shapes to use, how to proportion them, whether to add pattern, which textures to apply, and which colours to introduce. In fact, it is you who will give your designs their style.

QUESTIONS

1 What visual factors should be considered by designers?
2 Look at the six cups on the page opposite. How has shape affected their appearance?
3 Look at the two cups which are based on a circle. How has the shallow cup been made to appear more delicate than the deeper one?
4 Look at the two decorated cups. Why did the designer choose a fine detailed pattern for the lighter cup?
5 Look at the textured cups. Why could the rough texture be thought more appropriate for the mug-like shape?
6 What effect can colour have on a design?

ACTIVITIES

A Draw two boxes, one heavy and the other lighter in appearance.
Add an appropriate decoration.

B Sketch some delicately shaped wine glasses.

3.2 SHAPE AND FORM

Shape and form are sometimes confused in everyday speech. But, in general terms, a shape is flat and a form is solid. A circle drawn on a piece of paper is a circular shape, but a ball is a circular form. Shapes and forms divide into two types, being either **organic** or **geometric**.

ORGANIC AND GEOMETRIC SHAPES AND FORMS

Organic shapes and forms are the naturally occuring ones, such as leaves, fruit, and shells. Geometric shapes and forms are those which can be constructed, such as squares, circles, and cubes. Organic *and* geometric shapes and forms can be used as a basis for design work.

ORGANIC SHAPES AND FORMS

The shapes and forms in nature are many and various. Some objects have a strong geometric basis. The honeycomb of bees, for example, is a set of hexagons. And the shell of a snail forms a beautiful spiral. But others have little geometric basis, such as the patterns of tree bark and the patterns on pebbles.

ORGANIC DESIGN

Natural objects can be excellent inspiration for shapes, forms, and decorations. You can either **simplify** or **stylize** to use them effectively.

SIMPLIFYING

Simplifying means making things simpler. You can do this by replacing complicated outlines with straight lines or curves. Work from a drawing or photograph of the original object. You can trace over this using a rule, curves, or a compass. This allows you to produce a new, simplified outline. (See page 143.)

STYLIZING

Stylizing also simplifies the object. After careful observation, draw the main pattern, or theme of the shape. You can then modify the shape further by taking a series of tracings, each one becoming more stylized than the one before.

This Art Nouveau plant drawing has been stretched, slimmed in some places, and thickened in others. Then the curves have been made more curly to emphasize the plant shape.

GEOMETRIC SHAPES

There are two basic types of geometric shape. These are **regular** and **irregular**. Regular shapes are usually symmetrical, but irregular are not.

There are four main groups of both regular and irregular geometric shapes:

triangles, which have three sides

quadrilaterals, with four sides

polygons, which have many sides

curved shapes, with no straight sides at all

GEOMETRIC FORMS

Each type of geometric shape can be the basis of a 'solid', three-dimensional form. There are three types:

prisms, with parallel sides

pyramids, which are pointed

solids, which are either curved (spheres and ellipsoids) or many faced (polyhedra)

You can cut any of these forms along a straight or curved line to produce a new shape. This process can be repeated many times. Consequently, there are a vast number of basic geometric shapes and forms from which design work can start.

GEOMETRIC DESIGN

The choice of a shape or form will often depend upon the nature of the problem. 'Design a school signposting system', for example, might indicate the need for a pointed shape. This could be a triangle, an irregular polygon, or the sector of a circle.

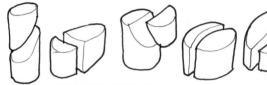

'Design a stool to be used by itself, or grouped with others of the same type to make some sort of bench seat' could suggest a tessellating or interlocking form. You might use a rectangular, a triangular, or a hexagonal prism.

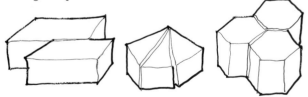

Sometimes the manufacturing process could dictate the shape. 'Design a timber container, with a lid, to be turned on the lathe' would probably involve the use of a cylinder, a cone, or part of a sphere. However, with just these three basic forms, you would still have a wide range of possibilities from which to make your choice.

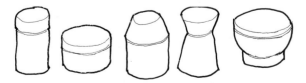

At other times you may simply *feel* that a particular shape or form would project the required visual image or that it would help the object to function effectively. For example, you might feel that a wedge shaped form could make an ideal desk tidy, either because it would look attractive or because the wedge would angle the pens and pencils, making them easy to select.

THE STARTING POINT

Whatever your starting point might be, remember to detail the shape or form carefully. Make sure that each element you add does not alter the overall effect which you are trying to achieve.

QUESTIONS

1 What is the difference between shape and form?
2 How do organic shapes and forms differ from geometric shapes and forms?
3 How can an organic shape be simplified?
4 How does stylizing differ from simplifying?
5 What is the difference between a regular and an irregular geometric shape?
6 How many groups of regular and irregular geometric shapes are there?
7 What are the differences between prisms, pyramids and solids?
8 What are the three main starting points for the selection of a shape or form?

ACTIVITIES

A Refer to pages 142–3.
Stylize or simplify the horse chestnut leaf to make a design for a badge or a brooch.

B Sketch some geometric shapes and forms that could be used for a school signposting system.
Select one and explain your choice.

3.3 PROPORTION, BALANCE, AND SYMMETRY

Proportion is concerned with relative size. If the legs of a table are too big or too small, it could be said that they are out of proportion, or that they do not look right. However, what is right is difficult to define.

THE GOLDEN MEAN

In about 650 BC, some people in Greece throught they had an answer to this problem. They thought that a rectangle with sides in the ratio of 1:1.62 was a perfect shape. The method by which they constructed these rectangles is known as the **golden mean** and the Greeks used this method to decide on the dimensions for their buildings.

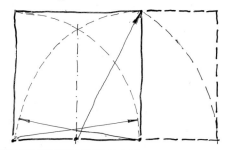

THE FIBONACCI SERIES

Eighteen hundred years later an Italian mathematician, called Leonardo Fibonacci, worked out a useful series of numbers. This series was calculated by adding two consecutive numbers to find the next in the sequence, and is known as the **Fibonacci series**. It begins 1,1,2,3,5,8,13,21,34,55,89... and continues according to the above rule. After 13, any number divided by the previous one will give the value 1.62, the same number which appears in the golden mean.

USING FIBONACCI NUMBERS

You can use these numbers in your design work. For example, if you were designing a round topped container, then the height could be 89 mm and the dia-

meter 55 mm, the previous number on the list. The dimensions of the lid and of the decorations could also be determined using the Fibonacci series.

USING YOUR EYE

Although these numbers can be useful, they are not the only method of proportioning a design. Many people rely purely on proportioning an object by eye. They sketch and build models, adjusting the proportions until they look just right.

BALANCE

However, proportion is not the only factor in making an object look right.

Designers also take account of the relative positions of parts within a design. This helps them create a visual **balance**.

POSITIVE AND NEGATIVE SHAPES

Imagine you are designing a frame for a photograph. You have decided to explore the possibilities of an oval picture within a rectangular frame.

The shape, size, and position of the picture within that rectangle will change the look of the whole.

The picture is called a **positive** shape because it is doing something. The spaces around it are the **negative** shapes. Although they may not be performing a function they are important to the appearance.

By placing the picture at the top or bottom of the rectangle, you could make the whole shape appear top heavy. The relationship between the positive and negative shapes would be poor.

SYMMETRY

With the picture in the centre, the whole shape would become **symmetrical**. This means that if you were to

divide the rectangle in half, along either the vertical or horizontal centre line, the shapes on either side would become mirror images of each other.

Many products are symmetrical. For example, most chairs have four legs and a back rest, and when divided in half vertically they are usually the same both sides.

If your design is to be symmetrical, then you must take great care to make sure that it is accurate.

ASYMMETRY

When something is not symmetrical it is said to be **asymmetrical**. Quite often asymmetrical objects are more visually interesting than symmetrical ones. But the elements which make up an asymmetrical design must be carefully balanced.

A teapot, for example, has a handle on one side and a spout on the other. These two elements are not usually the same shape or size, but they must be designed so that they balance visually.

If a design has a large number of elements, then getting a balance is more difficult. One way of achieving this is to organize the features so that they line up.

For example, the keys and display on the calculator have been carefully positioned to create a **linear balance**.

GETTING IT RIGHT

To balance the photograph frame, which has a limited number of elements, is a fairly simple task. So an asymmetrical solution might be a possibility.

By placing the picture towards the top of the rectangle, an interesting relationship begins to develop, but it is still too top heavy.

As the picture is moved down towards the centre of the rectangle, the relationship between the negative base shape, the positive picture shape, and the negative top shape changes.

To obtain the *best* relationship, the design would have to be drawn carefully and accurately a number of times, changing the position of the picture, until the delicate balance was just right.

QUESTIONS

1 What is proportion?
2 What is the golden mean, and what was it used for?
3 What is the significance of the series of numbers discovered by Fibonacci?
4 How can a design be proportioned without using Fibonacci numbers?
5 What is the difference between a positive and a negative shape?
6 How does symmetry differ from asymmetry?
7 What is linear balance?
8 How would you get the balance of a design just right?

ACTIVITIES

A Design a square picture frame.
Consider the relationship between the size of the frame and the shape of the picture.
Balance the shape and position of the picture within the frame.

B Draw up a balanced design for a television set which incorporates the following elements:

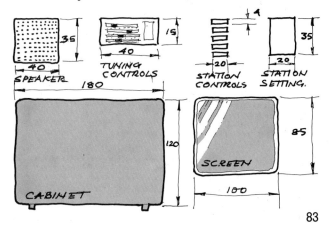

3.4 PATTERN

Patterns can be used to add visual attraction to what otherwise would be a plain surface. They can be a useful decorative factor in your design work.

MOTIFS

The basic element of a pattern is a **motif**.

The motif may be a simplified or stylized organic shape or it might be some form of regular or irregular geometric shape.

Building motifs into a pattern will mean that you need to set out your design carefully.

GRIDS

If you are planning to apply a pattern to a surface, you will need to draw up a **grid**. This will help you to position each motif accurately. Alternatively, you may decide to use the grid as a pattern in its own right.

There are many different types of grid. Some examples are shown below.

REPEATING PATTERNS

Each type of grid can be used in a number of ways. Using one might indicate how the others could be used. Take, for instance, one square on a square grid. The pattern may be made up of a motif placed centrally inside this square and repeated a number of times. With any repeating pattern, the spaces around and between the motifs are important.

Look at the sequence above. When the square motif is seen alone, it is a black square. In a repeating situation there is a pattern of dark squares, and *also* a number of light squares made up from the spaces between the main motif. In this case the motif has been placed centrally. However, if the motif is not fixed, then it can be turned in different directions throughout the grid to produce a greater variety of patterns.

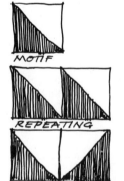

The motif can be reflected either vertically or horizontally to produce a mirror image of itself. By reflecting it in this manner, on both axes, four alternative motifs can be produced.

If these four alternative motifs are each given a number, then these numbers can be arranged in a variety of sequences within four adjacent squares.

In this way they will combine to make up six possible patterns. This can best be seen by repeating the four squares a number of times.

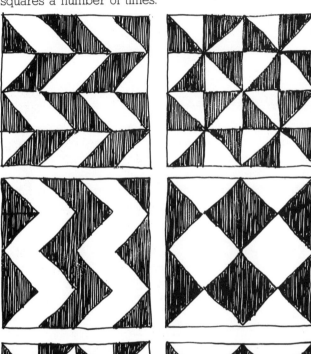

RANDOM PATTERNS

The four numbers do not necessarily have to be arranged in any particular order. You could choose a random sequence instead.

OTHER POSSIBILITIES

The motif may be made up from more than one element within the square. It might be composed of thick or thin lines or a combination of the two.

Not every square need be filled with the same motif. A different motif could be used in adjacent squares.

There are many different types of motif and grid, each of which gives a range of patterns. In fact, there is a wide range of possibilities.

CHOOSING PATTERNS

If you want to see whether you should use a particular pattern, then draw it in a sketch book. As a general rule, anything that is difficult to draw will be time consuming to make. However, all patterns should be set out carefully and constructed accurately, if the effect is to be convincing.

QUESTIONS

1 Why are patterns used?
2 What is a motif?
3 How can grids help?
4 Why are the spaces as important as the motif in a pattern?
5 How do repeating and random patterns differ?
6 List the ways by which you can construct a vast number of possible patterns.
7 What is the best method of choosing a pattern?

ACTIVITIES

A Draw a square grid made up of sixteen squares. Design a motif which is not fixed centrally, and draw the six possible repeating patterns.

B Design a pattern, for the lid of a box, based on a triangular grid.

3.5 TEXTURE AND FINISH

When discussing the appearance of an object, it is difficult to do so without mentioning texture and finish. Texture and finish are closely related and both describe the surface of a material.

Unplaned timber has a rough or coarse texture, but the paper in this book has a smooth or fine texture. Finishes are either **matt** (non-shiny) or **glossy** (shiny). Both texture and finish are widely used when designing consumer products to aid function and to add visual interest.

TEXTURE

Textures can be **random** or **regular**. Random textures occur naturally, such as tree bark, or can be found on surfaces like those of most housebricks. With such textures, there is no definite pattern.

Regular textures have some kind of repeating basis. This may be the closely spaced grooves around the cap of a bottle, or the continuous surface of a fine pile carpet.

Textures can be used to help perform a particular function or as a decorative feature.

FUNCTIONAL TEXTURES

Areas of coarse texture will provide grip, for example around the lens and film winder of a camera. The finer,

more random texture on the body panels will give the user a non-slip surface. This texture will also help to disguise any marks or scratches.

DECORATIVE TEXTURES

Texture can also be used as a decorative element in a design. This watch has an area of coarse texture around its face. This has no obvious task to perform, other than to make the product more visually interesting. Here, it might be seen as an area of roughness encircling the smooth face, so that the face stands out.

Texture is often used in this way to create a visual contrast. For example, rough and smooth areas can be placed next to each other to make the adjacent parts look different. This treatment has been used on the rear of the camera to emphasize the forms involved.

Texture can also be used to link different parts of a design to hold it together visually. The film winder and the surrounding camera top have been given the same fine texture to help 'join' them.

PATTERNS

Areas of texture can be used to create patterns and decorations on surfaces. If applied well, they can brighten a surface without breaking up the overall form.

SYNTHETIC TEXTURES

Textures are sometimes applied so as to suggest other materials.

The plastic briefcase has a **synthetic**, or false, 'leather look'. This makes it appear as if it is made from a more expensive material.

APPLYING TEXTURE

In the school workshop, you will probably be restricted to either natural surfaces or textures that are relatively easy to apply. Before you commit yourself to one of these, try out ideas on a test piece of scrap material. A convincing texture takes skill and patience to apply properly.

FINISH

A highly polished finish is glossy and can emphasize textures. The minute edges catch the light making features stand out.

Matt finishes will dull these edges and so help to disguise fine textures.

Some plastics and metals can be treated with polishes or abrasives. This builds up gloss finish which is part of the material.

Other materials, for instance timber and mild steel, need some form of protective coating. This will seal the surface, and prevent it from being attacked by environmental conditions. These varnishes and paints can be either matt or gloss.

GLOSS AND MATT FINISHES

In general terms, glossy surfaces tend to attract attention. They reflect their evironment but show dust and marks. So they need careful cleaning at regular intervals. Matt surfaces attract less attention. They do not show marks and fingerprints so readily and therefore need less cleaning.

QUESTIONS

1 What is the difference between a random and a regular texture?
2 What functions can textures perform?
3 How can textures be used decoratively?
4 What is the function of a synthetic texture?
5 How do gloss and matt finishes differ?

ACTIVITIES

A Design a picture for a blind person using textures.

B Design a set of textured controls for a radio cassette player so that you can tell them apart in the dark.

3.6 COLOUR

Colour is an important factor in design. If you imagine your television set coloured fluorescent purple with green controls, you will realize what a difference colour can make. Televisions are not often brightly coloured, because they need to fit into or blend with a variety of surroundings. Unlike televisions, many childrens' toys are brightly coloured, so that they attract attention.

In your design work, you should be aware of which objects need to blend with their surroundings, and which need to attract attention. You should therefore use colour with caution.

WHAT IS COLOUR?

The colours you see around you are reflected light. White light, which falls on everything, is a combination of red, orange, yellow, green, blue, indigo, and violet, and these colours make up the **spectrum**. Each coloured object absorbs some colours and reflects others. A blue object reflects the blue and absorbs the remaining spectrum. A white object reflects the complete spectrum to appear white. A black object reflects no light.

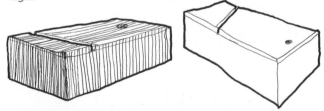

PRIMARY, SECONDARY, AND TERTIARY COLOURS

Many colours can be made from just three **primary** colours. These are particular shades of red, yellow, and blue. By mixing them in equal quantities, **secondary** colours can be obtained. Red and yellow will give orange. Yellow and blue produce green. A mixture of blue and red will give violet. These secondaries can be mixed with the primaries to give the **tertiary** colours.

This process can continue many times until a vast range of colours, or **hues**, is produced.

TINTS AND SHADES

These hues can be made either darker, by mixing them with black, or lighter by adding white.

Darkened hues are called **shades**, and the lightened hues are called **tints**.

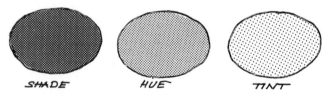

THE COLOUR CIRCLE

Hues, tints, and shades can be grouped into a colour circle. You will see one on page 89.

Each sector, based on one hue, has been shaded towards the centre and tinted towards the circumference.

HARMONIOUS AND COMPLEMENTARY COLOURS

Adjacent sectors of the circle are said to be **harmonious** colours. They are supposed to blend well together to produce pleasing relationships.

Those exactly opposite on the circle are **complementary**. They are very different. When used together, they will give a lively contrast.

BOLD COLOURS

Bold colours are the bright hues around the centre of the colour circle. They are strong and attract attention.

WARM AND COLD COLOURS

The reds and oranges at the top of the colour circle are thought to be 'warm' colours, but the blues and blue-greens around the bottom are 'cool'.

This is particularly true of the tints of blue-greens, which are very 'cold' colours.

Cold blues can be made 'warmer' by mixing them with red. Oranges can be made 'cooler' by adding small quantities of pale green.

BLACK AND WHITE

Although black and white are not really colours and do not appear on the colour circle, they can be used with bold colours and with each other to produce some striking relationships.

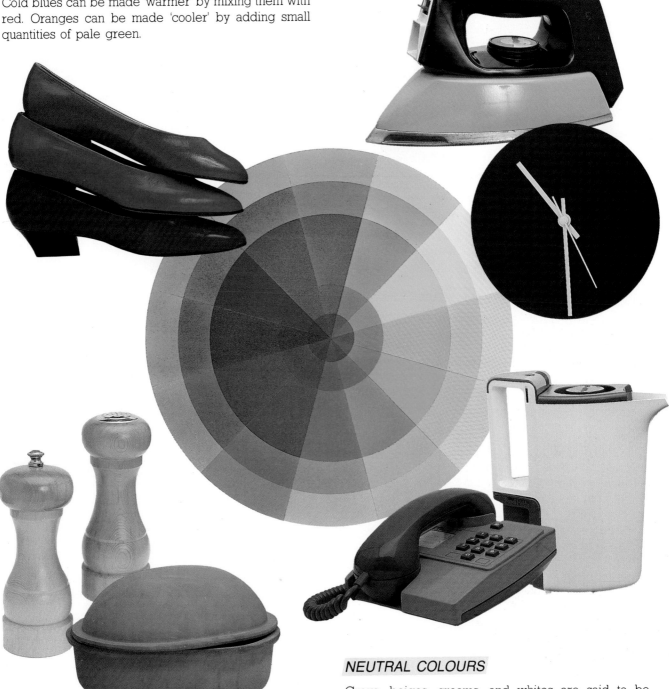

NATURAL COLOURS

The browns, greens, and yellows, which are **natural** colours, are generally thought of as being restful. However, this depends upon the strength of the colours. It is usually only true of their shades and tints.

NEUTRAL COLOURS

Greys, beiges, creams, and whites are said to be **neutral**.

When using neutral colours, one colour, combined with its shades and tints, can often create interesting variations within a design.

Small quantities of white or black can be mixed with the basic colour to create the shades or tints. These can be used to give emphasis or to provide contrasts.

3.7 APPLYING COLOUR

1. THERE ARE MANY COLOURING MEDIUMS WHICH THE DESIGNER CAN USE.
COLOURED PENCILS

GOUACHE OR POSTER COLOURS

COLOURED PAPER

FELT PENS

2. ALL OF THESE CAN BE IMPORTANT SKETCHING AIDS.

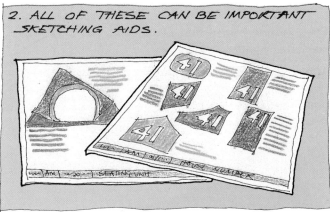

3. FLAT AREAS OF COLOUR CAN BE USED TO GOOD EFFECT ON ALL SORTS OF DESIGN DRAWING

SALT + PEPPER SET

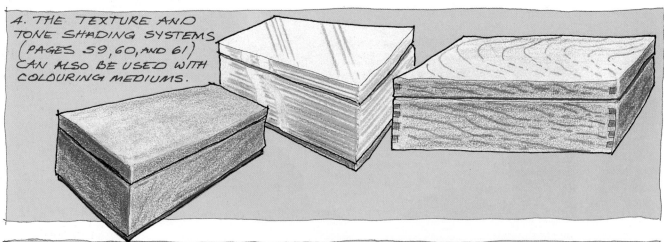

4. THE TEXTURE AND TONE SHADING SYSTEMS (PAGES 59, 60, AND 61) CAN ALSO BE USED WITH COLOURING MEDIUMS.

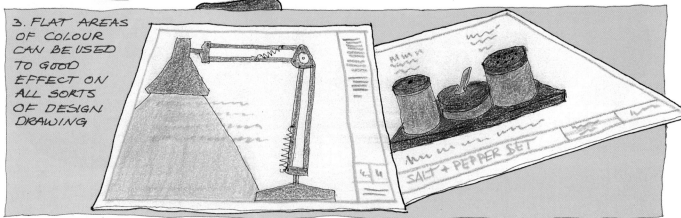

DULL

GLOSSY

SHINY

5. THE WAY IN WHICH THE COLOUR IS APPLIED WILL SUGGEST THE SURFACE TEXTURE.

TEXTURED

TRANSPARENT

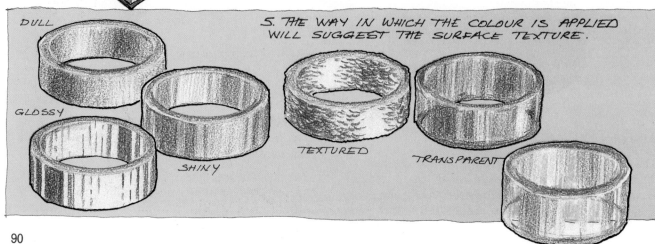

6. TO PRODUCE A COLOUR RENDERING, FIRST DRAW THE SHAPE IN PENCIL.

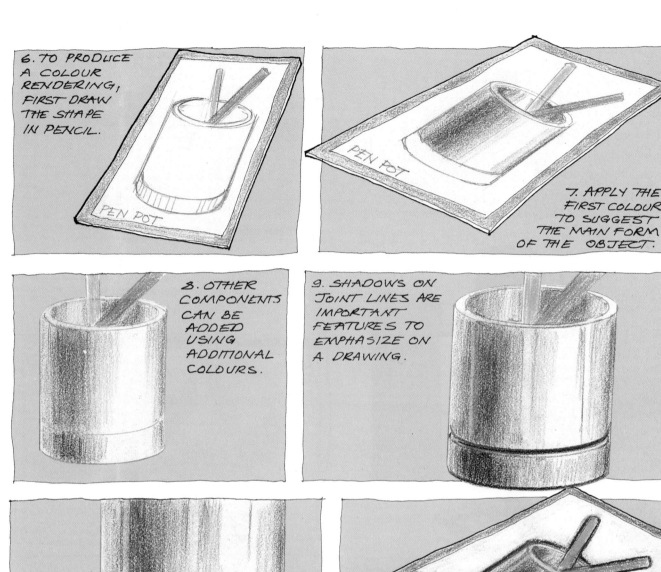

7. APPLY THE FIRST COLOUR TO SUGGEST THE MAIN FORM OF THE OBJECT.

8. OTHER COMPONENTS CAN BE ADDED USING ADDITIONAL COLOURS.

9. SHADOWS ON JOINT LINES ARE IMPORTANT FEATURES TO EMPHASIZE ON A DRAWING.

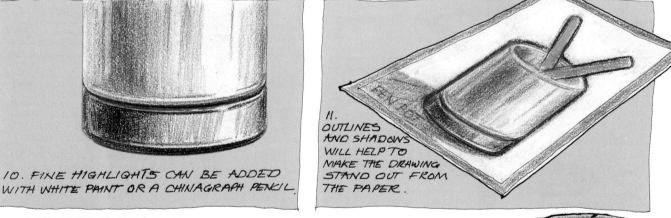

10. FINE HIGHLIGHTS CAN BE ADDED WITH WHITE PAINT OR A CHINAGRAPH PENCIL.

11. OUTLINES AND SHADOWS WILL HELP TO MAKE THE DRAWING STAND OUT FROM THE PAPER.

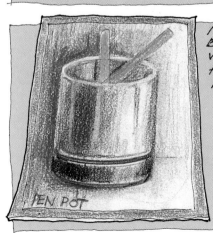

12. COLOURED BACKGROUNDS WILL ALSO HELP THE DRAWING.

13. DRAWINGS OFTEN LOOK BETTER BRIGHTLY COLOURED. THEREFORE IT IS BEST TO TRY OUT YOUR COLOUR SCHEMES ON MODELS BEFORE MAKING DECISIONS.

3.8 COLOUR PRACTICE

USING COLOUR

The colours you use in your design work will often be those of the materials you have chosen.

Therefore, you need to think about your colour scheme at an early stage in the project.

First of all you should decide if your design is to blend with, or stand out from, its environment.

Blending will usually require a low key colour scheme, but if a design is to stand out, it will need stronger or bolder colours.

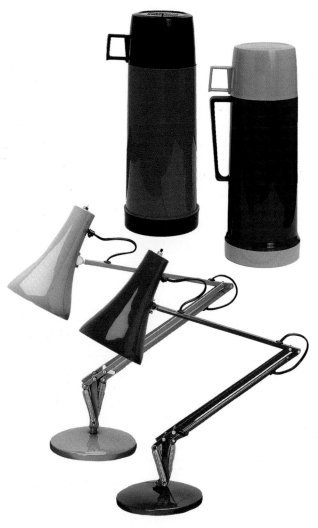

In low key schemes, natural and neutral colours are often recommended. In objects designed to attract attention bold colours are called for. However, even in bold schemes, you should choose only one or two colours.

Bold colours can be difficult to use. So, you should restrict them to small areas or features, unless there is a good reason for not doing this.

Paler colours tend to emphasize the forms within a design. This allows you to see the subtle shades and tints formed by different amounts of light falling on to the object.

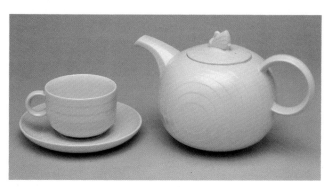

When choosing colours, you need to take your time and explore various possibilities. A rash choice could ruin your design. A careful choice should enhance it.

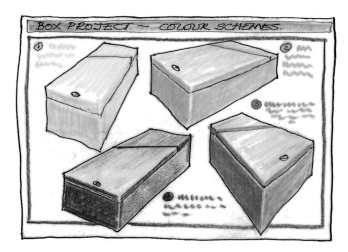

QUESTIONS

1 Why does a white object appear white?
2 What are the primary colours?
3 How are secondary and tertiary colours made?
4 What is the difference between the shade and the tint of a colour?
5 How is the colour circle constructed?
6 How do harmonious and complementary colours differ?
7 What are the warm and cold colours?
8 How do natural and neutral colours differ?

ACTIVITIES

A Draw a box with the patterned lid.
Colour it to produce a low key effect.
Repeat the drawing and colour it using bold colours.

B Make two drawings of a tiled coffee table. Colour one to produce a natural effect, and the other to appear cold.

3.9 STYLE

If ten designers were asked to design a box, then ten different solutions might be expected. This is because the visual factors of shape, proportion, pattern, texture, and colour can be used in individual ways to create different styles.

INDIVIDUAL STYLES

Most designers develop their own style. Some people are experienced enough to look at a design and to recognize the designer. They can do this because they know how particular designers or design groups use the various visual elements. They know, in fact, their style.

SOCIAL STYLES

As you know, style is closely related to fashion, and fashion depends upon people, places, and time. If you look through history and geography books at houses, for instance, you will see how different styles have been used in different places and at different times. These styles may relate to the availability of materials. However, most result from ideas of what is acceptable and appealing.

MODERN STYLES

When you read magazines and catalogues, you will see that there is no one style of today. Rather, there are a number of possible styles that designers could adopt for their design work.

Each of these styles will limit the selection and use of the visual factors. That is, if you wish to design an object to fit into a particular style, then shape, proportion, pattern, texture, and colour should be used in a certain way.

CLASSIFYING STYLES

Designers, therefore, need to be able to classify styles. In books about the history of design you will see that there have been many styles this century. These have been grouped under headings such as Art Nouveau, Bauhaus, Fifties and so on.

However, to keep things simple, a good starting point is to use more general classifications, such as traditional, classical, functional, and technical.

Each is listed below, with an analysis of some of the ways in which certain visual factors are used. These should be seen as generalizations. They are starting points for a wider study which you should continue as you increase your visual awareness.

TRADITIONAL

Traditional designs tend to be solidly constructed. Heavily proportioned components are often linked with curved forms which act as decorative elements.

Dark colours are used frequently. However, bleached pine can sometimes be used. Timbers are treated with wax polishes. Ferrous metals, like mild steel, are often painted black and given a beaten 'wrought-iron' appearance.

CLASSICAL

Classical design is based on precise proportion and carefully planned shapes and forms. A greater range of naturally coloured hardwoods are used. These are protected beneath many layers of wax polish. Non-ferrous metals like brass are also given a high gloss finish and are skillfully shaped.

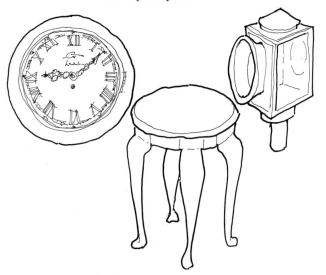

Both traditional and classical styles, when used for furniture, are often called 'reproduction'. They take a high degree of skill to construct.

FUNCTIONAL

Many modern designs fall into this group. It uses relatively simple geometric shapes and forms. These are carefully proportioned and detailed. The materials and joints between them form their own decorations. The overall appearance is, therefore, one of simplicity, in which only the functioning elements remain.

Developments in materials technology, especially the introduction of plastics in the 1930s, allowed for the moulding of complicated forms.

However, most consumer products today which use plastics, such as vacuum cleaners and torches, have been given simple forms. Manufactured items are more colourful, and patterns are usually kept to a minimum. Company 'logos' and product names can be used as decorative features.

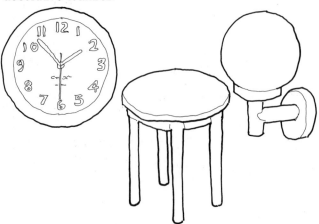

TECHNICAL

With the introduction of more and more machines into our everyday lives, there is a growing liking for things technical. This has led to radios and hi-fis emphasizing their working parts, rather than hiding them inside the casing.

Similarly, many domestic items use readily available fixings and fasteners to join materials, (see pages 118–120). These are often exposed and the designs are painted black or a bright primary colour. This style is often called 'hi tech'. Fasteners and wire meshes are the usual forms of decoration.

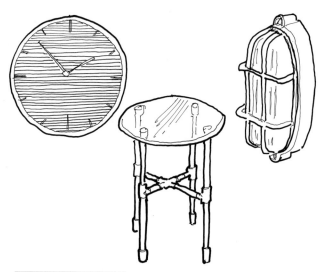

FINAL QUALITY

Whichever style you choose, the detail of your design is always very important. The character of the materials you use, the proportion of the joints in relation to the rest of the object, and your skill, in shaping and fitting the components together, will all affect the final appearance. There is a certain quality that good design gives to the appearance of an object. This quality is essential, no matter what the style.

QUESTIONS

1 How can different styles be created?
2 How can individual style be recognised?
3 What factors does fashion depend upon?
4 Why do designers need to be able to classify styles?
5 How does the traditional style differ from the classical?
6 What are the main features of the functional style?
7 How can hi tech be distinguished?
8 Why are the details of a design important?

ACTIVITIES

A Sketch some designs for a set of house numerals in traditional, classical, functional, and technical styles.

B Design a shelf light in one style, and then explain why it fits into that category.

SECTION 4
GATHERING INFORMATION

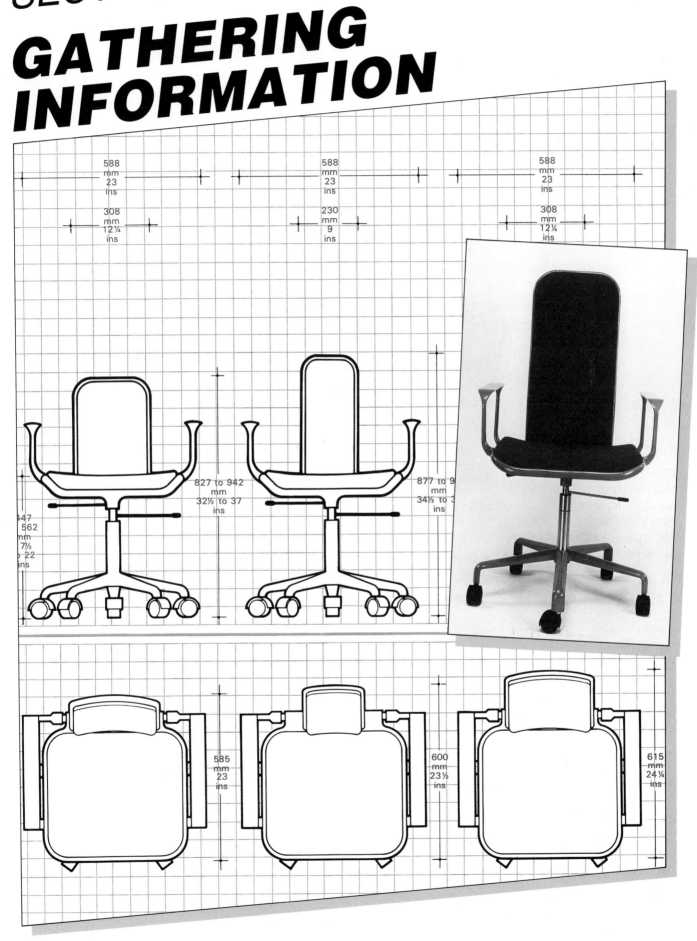

4.1 GATHERING INFORMATION

To write a problem specification, or to find alternative solutions to a design brief, designers need information.

Information usually has to be collected. It should be recorded in your design folder, where it can be found easily and referred to throughout the design process.

MEASUREMENTS

Gathering information might simply mean measuring or weighing objects to be included in the design solution.

Work on a desk tidy, for example, might involve taking measurements of pens, pencils, rulers, or erasers. This helps you to make sure that any slots or holes in the eventual design are the correct size.

MATERIALS, TOOLS AND TECHNIQUES

All designers are limited by the materials available, by their properties, and by the ways in which they can be shaped and formed. Designers therefore need information to help them in the selection of materials, tools, and processes. Sections 5, 6, and 7 have been written to help with this selection. You may also wish to refer to other books, as well as discussing practical problems with your teachers.

EXPERIMENTS

Some projects will require experiments in order to find information. You might need to find the right place to support a record in a storage system, so that it will not bend, or to determine the temperature at various distances from a light bulb, when designing a lamp-shade, so that it will not burn.

No matter how simple or complicated experiments are, results should always be recorded in your design folder.

ANTHROPOMETRIC DATA

Designers often need to consider data on human measurements, or **anthropometric** data.

You can select relevant information from the data on pages 98–100 when you are working on a product intended for use by a number of people. If your work is related to a specific individual, then you will need to collect and record your own data.

SIMILAR PRODUCTS

Looking at similar products can often help to give you ideas for designs. This could mean visiting shops to inspect manufactured goods, or looking at books in the school library. A visit to a local library will enable you to look through a wider selection of books and also to browse through the magazines on display.

MANUFACTURER'S LITERATURE

If you require detailed information about a particular product you might try writing to the manufacturer. You can get names and addresses from advertisements or from reference books such as 'Kompass' or 'Kelly's Directory'. These are kept in the reference section of local libraries. The 'Yellow Pages' or your 'Thomson Local Directory' will give you the names and addresses of companies involved in particular businesses in your area.

When you write to manufacturers you should explain who you are, what you are doing in connection with your design work, and what specific information you need. You will usually find most manufacturers only too pleased to help.

HALF WAY

Gathering information not only gives the designer time to think around a problem before formulating a solution, but is part of understanding the design brief.

It has been said of design that 'to know the problem is half way towards finding the solution'. Gathering information helps the designer to reach this half way stage.

4.2 GRAPHS, CHARTS, AND DIAGRAMS

Designers often need to analyse information found in the form of numerical data. One of the best ways of doing this is to plot the data on a graph.

There are four different types of graph. The choice will depend upon the sort of information to be analysed. **Bar charts** provide comparisons of relative sizes of categories of data. **Line graphs** show trends, and **block** and **pie charts** demonstrate proportions.

BAR CHARTS

By looking at the bar chart below you will be able to see how easy it is to compare the recommended seat heights for children of different ages.

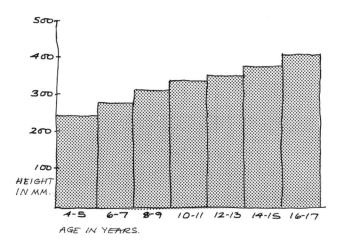

RECOMMENDED SEAT HEIGHT RELATED TO AGE.

LINE GRAPHS

The line graph above shows how the weight of children increases from age 4 to 16 years. The graph gives a clear picture of the amount of this increase. It also allows you to take readings at any point on either scale.

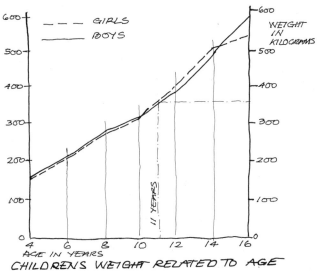

CHILDRENS WEIGHT RELATED TO AGE

BLOCK CHARTS

To compare the numbers of children of different ages throughout the country you might draw a block chart.

NUMBER OF CHILDREN 5-16 YEARS.

This is somewhat similar to a bar chart except that each category is drawn to scale and placed in one long block. On this, the length of each of the parts can be easily compared with each other and with the total length of the block.

PIE CHARTS

A pie chart is more complicated to construct than a block chart. Each category of data has to be converted into a fraction of the total. Then it is multiplied by 360 to find the angle of the slice of the pie which is to represent it.

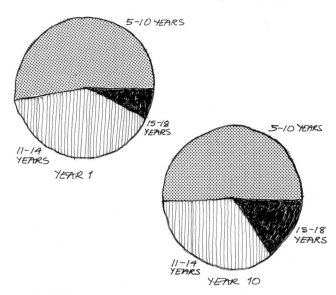

A COMPARISON OF CHILDREN IN SCHOOL

Two pie charts allow you to compare two sets of data.

QUESTIONS

1 What is the purpose of a bar chart?
2 What are the advantages of a line graph?
3 How does a block chart differ from a bar chart?
4 What sort of information is best analysed on a block chart?
5 When would a number of pie charts be used?

4.3 ANTHROPOMETRIC DATA

The length of an arm or a leg will vary according to the age, sex, and physique of the person being measured. Anthopometric data has been gathered from large numbers of people and average figures for various measurements have been established.

Designs based on these average values will suit most people. However they may not work for short or tall people.

F = Female

M = Male

All dimensions are in millimetres

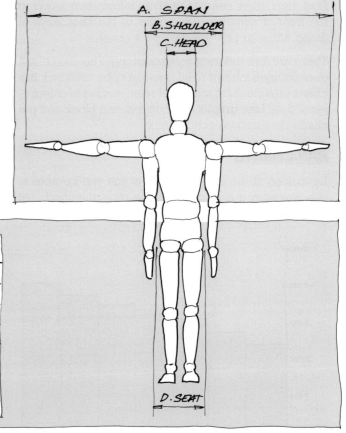

		4 YEARS	8 YEARS	12 YEARS	14 YEARS	ADULT
A. SPAN	F.	1035	1312	1580	1742	1643
	M.	1049	1296	1560	1838	1798
B. SHOULDER	F.	246	282	330	363	399
	M.	239	290	330	386	455
C. HEAD	F.	137	142	145	147	147
	M.	142	145	147	152	155
D. SEAT	F.	196	231	285	325	363
	M.	188	229	269	323	335

		4 YEARS	8 YEARS	12 YEARS	14 YEARS	ADULT
E. STANDING	F.	1039	1270	1478	1613	1605
	M.	1039	1270	1499	1709	1755
F. EYE HEIGHT	F.	937	1168	1376	1511	1506
	M.	937	1178	1397	1607	1643
G. SHOULDER	F.	772	1008	1240	1326	1265
	M.	775	1011	1204	1410	1387
H. KNEE HEIGHT	F.	272	351	422	445	452
	M.	269	351	417	478	503

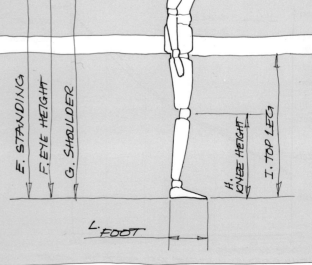

		4 YEARS	8 YEARS	12 YEARS	16 YEARS	ADULT
I. TOP LEG	F.	437	577	696	734	732
	M.	437	577	693	800	833
J. ARM LENGTH	F.	417	539	653	706	666
	M.	424	546	643	754	729
K. BODY WIDTH	F.	132	137	160	175	—
	M.	132	145	163	188	229
L. FOOT	F.	165	196	216	239	244
	M.	168	196	218	249	267

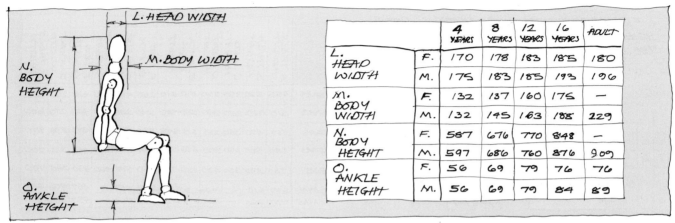

		4 YEARS	8 YEARS	12 YEARS	16 YEARS	ADULT
L. HEAD WIDTH	F.	170	178	183	185	180
	M.	175	183	185	193	196
M. BODY WIDTH	F.	132	137	160	175	—
	M.	132	145	163	188	229
N. BODY HEIGHT	F.	587	676	770	848	—
	M.	597	686	760	876	909
O. ANKLE HEIGHT	F.	56	69	79	76	76
	M.	56	69	79	84	89

P. THE HEAD OF AN ADULT MALE

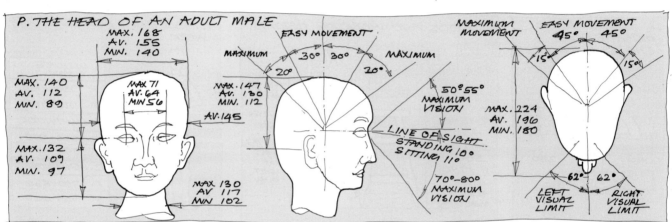

Q. HAND BREADTH

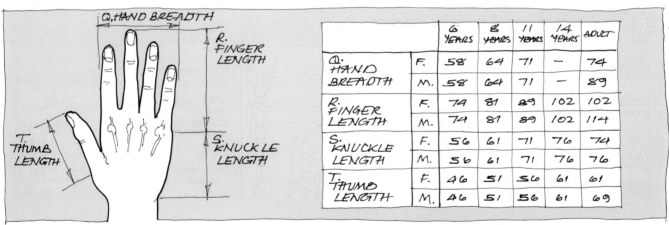

		6 YEARS	8 YEARS	11 YEARS	14 YEARS	ADULT
Q. HAND BREADTH	F.	58	64	71	—	74
	M.	58	64	71	—	89
R. FINGER LENGTH	F.	74	81	89	102	102
	M.	74	81	89	102	114
S. KNUCKLE LENGTH	F.	56	61	71	76	74
	M.	56	61	71	76	76
T. THUMB LENGTH	F.	46	51	56	61	61
	M.	46	51	56	61	69

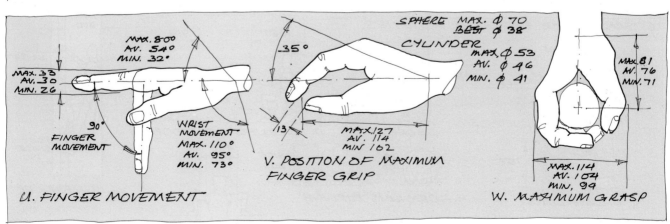

U. FINGER MOVEMENT

V. POSITION OF MAXIMUM FINGER GRIP

W. MAXIMUM GRASP

4.4 ERGONOMICS

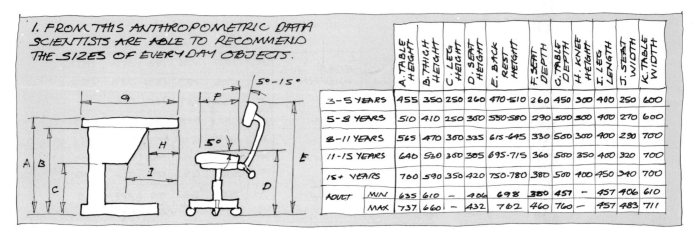

1. FROM THIS ANTHROPOMETRIC DATA SCIENTISTS ARE ABLE TO RECOMMEND THE SIZES OF EVERYDAY OBJECTS.

		A. TABLE HEIGHT	B. THIGH HEIGHT	C. LEG HEIGHT	D. SEAT HEIGHT	E. BACK REST HEIGHT	F. SEAT DEPTH	G. TABLE DEPTH	H. KNEE HEIGHT	I. LEG LENGTH	J. SEAT WIDTH	K. TABLE WIDTH
3-5 YEARS		455	350	250	260	470-510	260	450	300	400	250	600
5-8 YEARS		510	410	250	300	550-580	290	500	300	400	270	600
8-11 YEARS		565	470	300	335	615-645	330	500	300	400	290	700
11-15 YEARS		640	530	360	385	695-715	360	500	350	400	320	700
15+ YEARS		700	590	350	420	750-780	380	500	400	450	340	700
ADULT	MIN	635	610	—	406	698	380	457	—	457	406	610
	MAX	737	660	—	432	762	460	760	—	457	483	711

2. SUGGESTED HEIGHTS FOR CHAIRS WITH ARMS.

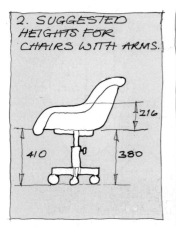

216
410
380

3. STOOL AND WORKTOP HEIGHTS.

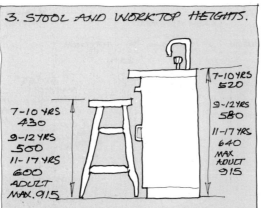

7-10 YRS 430
9-12 YRS 500
11-17 YRS 600
ADULT MAX. 915

7-10 YRS 520
9-12 YRS 580
11-17 YRS 640
MAX ADULT 915

4. TABLE TOPS FOR STANDING WORK.

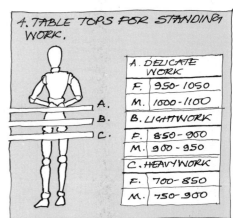

A. DELICATE WORK	
F.	950-1050
M.	1000-1100
B. LIGHTWORK	
F.	850-900
M.	900-950
C. HEAVYWORK	
F.	700-850
M.	750-900

5. SHELVING FOR VARIOUS AGE GROUPS.

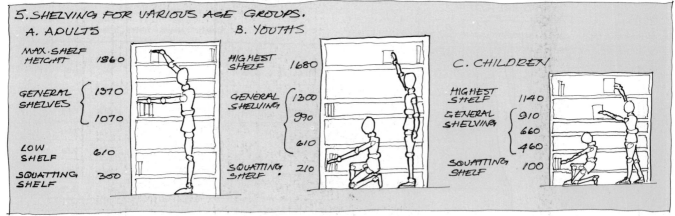

A. ADULTS

MAX. SHELF HEIGHT 1860
GENERAL SHELVES { 1370 / 1070 }
LOW SHELF 610
SQUATTING SHELF 300

B. YOUTHS

HIGHEST SHELF 1680
GENERAL SHELVING { 1300 / 990 / 610 }
SQUATTING SHELF 210

C. CHILDREN

HIGHEST SHELF 1140
GENERAL SHELVING { 910 / 660 / 460 }
SQUATTING SHELF 100

6. SPACES FOR DIFFERENT ACTIVITIES.

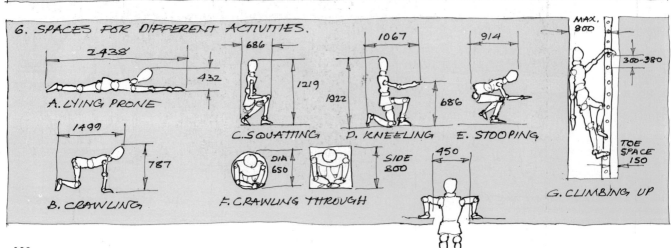

2438
432
A. LYING PRONE

1499
787
B. CRAWLING

686
1219
C. SQUATTING

1067
1922
D. KNEELING

914
686
E. STOOPING

MAX. 800
300-380
TOE SPACE 150
G. CLIMBING UP

DIA 650
SIDE 800
450
F. CRAWLING THROUGH

SECTION 5
MATERIALS

5.1 INTRODUCING MATERIALS

There are many natural and synthetic materials which the designer can use, for instance fabrics, foams, ceramics, concrete, and glass.

Craft, Design, and Technology, however, is usually concerned with shaping the three most versatile rigid materials. These are **metal**, **plastic**, and **timber**. Metals can be either ferrous or non-ferrous; there are two kinds of plastics: thermoplastics and thermosets; and timbers are either softwoods or hardwoods.

METALS

Ferrous metals contain iron. Wrought iron and mild steel are ferrous metals. Non-ferrous metals contain no iron. Copper and aluminium are non-ferrous metals.

Metals can also be mixed together to form alloys. Bronze is an alloy of copper and tin; brass is an alloy of copper and zinc.

TIMBER

The names 'softwood' and 'hardwood' do not describe the properties of the timber, but refer to the types of trees from which the woods come.

Softwoods come from trees with needle-like leaves. Pine, spruce, and yew are softwoods, but the timber from yew is much harder than most hardwoods.

Hardwoods come from broad-leaved deciduous trees. Mahogany, oak, and balsa are hardwoods, but balsa wood is very soft.

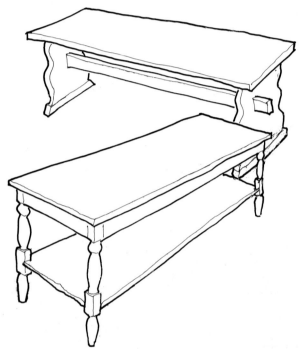

Both softwoods and hardwoods can be formed into manufactured boards such as plywood, blockboard, and chipboard. These are available in large sheets from which a range of products can be made easily.

PLASTICS

Thermoplastics will soften when they are heated, and harden as they cool. There are many different types, all of which have long chemical names and are usually referred to by their initials. PVC is polyvinyl chloride, ABS is acrylonitrile butadiene styrene. Ps is polystyrene and Pe polyethylene, which is often called polythene.

Some retain their original trade names. for instance, polyamide is called nylon, and polymethyl methacrylate is usually called perspex.

Thermosets will not soften with heat. Once they set hard they retain their form. GRP (glass reinforced polyester) is the most common thermoset, but MF or UF (melamine and urea formaldehyde) are also widely used.

PROPERTIES OF MATERIALS

Each material has a set of properties which might make it suitable for one particular function but not necessarily for another. Some are hard, others soft. Some wear well, while others break easily.

Designers use the following terms to enable them to discuss and select materials for their projects.

Strength This is the ability to withstand deformation. Strong materials will keep their shape under load. Therefore very strong materials will be difficult to work.

Toughness Tough materials will absorb a lot of energy. Steel is tough.

Hardness Hard materials will not wear or scratch easily. Ferrous metals are harder than plastics.

Ductility A ductile material will change shape and deform easily. Aluminium is a relatively ductile metal and can be formed into deep saucepans.

Elasticity Elastic materials will return to their original shape once a load has been removed.

Plasticity Plastic materials will remain deformed even when the load has been removed.

Conductivity A material which allows heat to pass through it has a high thermal conductivity. Timber has low thermal conductivity. High electrical conductivity means that a material will allow electricity to pass through it easily.

1. THE SYMBOLS BELOW ARE USED TO SHOW HOW EACH METAL CAN BE WORKED

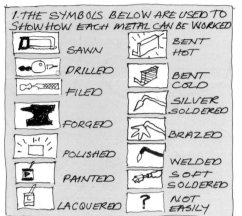

	SAWN		BENT HOT
	DRILLED		BENT COLD
	FILED		SILVER SOLDERED
	FORGED		BRAZED
	POLISHED		WELDED
	PAINTED		SOFT SOLDERED
	LACQUERED	?	NOT EASILY

2. CAST IRON HAS A GREY GRANULAR SURFACE WHEN BROKEN. IT CAN BE POLISHED TO A BRIGHT FINISH.

IT IS MADE FROM 93% IRON, 3% CARBON AND SMALL AMOUNTS OF SILICON, MANGANESE AND PHOSPHORUS.

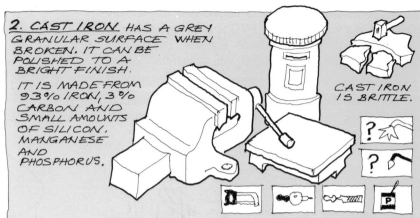

CAST IRON IS BRITTLE.

3. WROUGHT IRON HAS A GOOD RESISTANCE TO RUSTING.

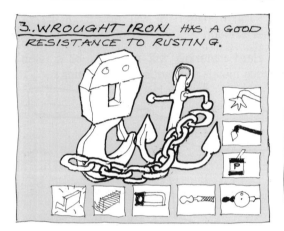

4. THERE ARE TWO MAIN TYPES OF STEEL

A. ALLOY STEELS

A MIXTURE OF IRON, CARBON AND ANOTHER METAL. STAINLESS AND HIGH SPEED STEELS ARE ALLOY STEELS

B. PLAIN CARBON STEEL

A MIXTURE OF IRON AND CARBON. TOOL AND MILD STEELS ARE BOTH PLAIN CARBON STEELS.

5. HIGH SPEED STEEL

THIS IS CARBON STEEL WITH 14 TO 18% TUNGSTEN, CHROMIUM AND VANADIUM.

THIS METAL WILL WITHSTAND RED HEAT AND STILL RETAIN ITS SHARP EDGE.

ONCE HARDENED IT CAN ONLY BE SHARPENED BY A GRINDSTONE.

6. STAINLESS STEEL IS A CARBON STEEL WITH 12% CHROMIUM AND NICKEL. IT HAS A BRIGHT SURFACE.

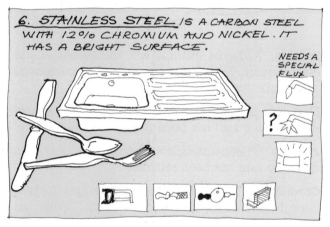

NEEDS A SPECIAL FLUX

7. TOOL STEEL HAS A HIGH CARBON CONTENT (0.6 TO 1.5%). IT HAS A SMOOTH SKIN OR BLACK OXIDE FINISH.

IT CAN BE DIFFICULT TO WORK BUT WHEN HARDENED AND TEMPERED IT WILL GIVE A STRONG CUTTING EDGE.

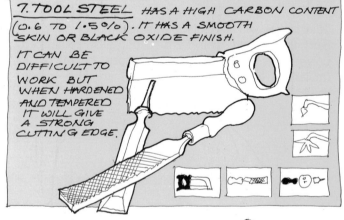

8. MILD STEEL IS IRON WITH 0.15 TO 0.25% CARBON. THERE ARE TWO MAIN TYPES —

A. BRIGHT DRAWN. (BDMS)

THIS HAS A SMOOTH SILVER GREY SURFACE.

B. BLACK MILD

THIS IS COVERED IN A BLUE BLACK OXIDE.

BOTH ARE WIDELY USED IN THE WORKSHOP. THEY RUST EASILY AND NEED SOME TYPE OF SURFACE PROTECTION

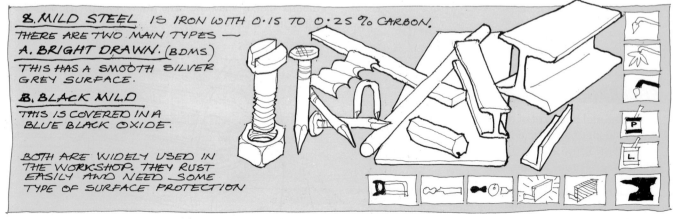

9. COPPER IS A BROWNISH PINK METAL.

IT CAN BE BENT AND SHAPED EASILY. IT BECOMES HARDENED AS IT IS WORKED AND HAS TO BE ANNEALED REGULARLY.

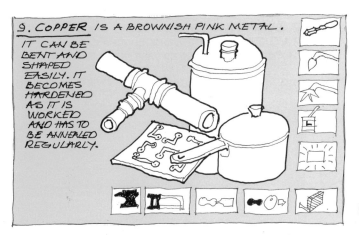

10. GILDING METAL

HAS A GOLDEN COLOUR. AN ALLOY OR 90% COPPER AND 10% ZINC.

IT IS EASILY WORKED AND JOINED.

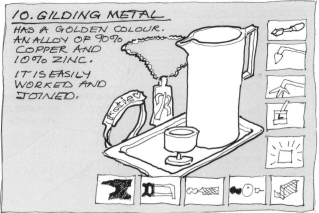

11. BRASS IS A YELLOW METAL. IT IS AN ALLOY OF COPPER AND ZINC.

BRASS, WITH LESS THAN 37% ZINC, CAN BE WORKED COLD.
37% TO 42% ZINC CAN BE WORKED HOT.

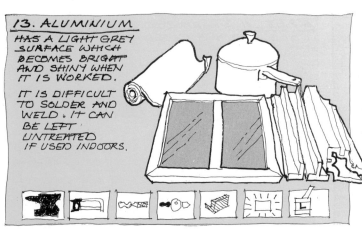

12. BRONZE IS A DARK MUDDY YELLOW. IT IS AN ALLOY OF COPPER WITH 10% TIN.

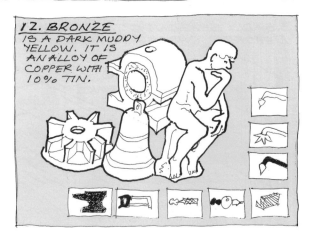

13. ALUMINIUM

HAS A LIGHT GREY SURFACE WHICH BECOMES BRIGHT AND SHINY WHEN IT IS WORKED.

IT IS DIFFICULT TO SOLDER AND WELD. IT CAN BE LEFT UNTREATED IF USED INDOORS.

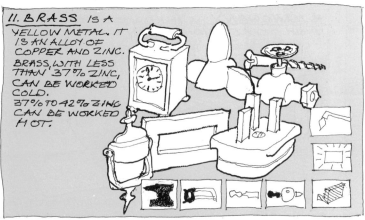

14. DURALAMIN

IS A ALLOY OF ALUMINIUM COPPER AND MANGANESE.

IT IS STRONG AND LIGHT BUT IT CANNOT BE SOLDERED BY NORMAL METHODS.

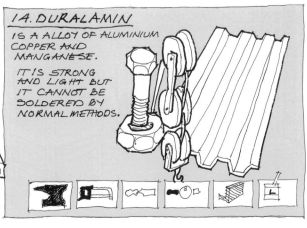

15. TIN HAS A BRIGHT SILVER FINISH. IT IS RARELY USED ON ITS OWN. IT IS USED AS A COATING ON STEEL CALLED TINPLATE.

IT IS ALSO IN ALLOYS SUCH AS BRONZE AND LEAD IN SOFT SOLDER.

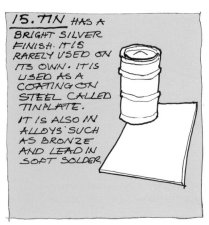

16. ZINC HAS A BLUISH WHITE APPEARANCE. IT IS SOFT AND EASILY WORKED. IT APPEARS AS A COATING ON MILD STEEL CALLED GALVENIZING.

IT IS OFTEN ALLOYED WITH OTHER METALS FOR DIE CASTING.

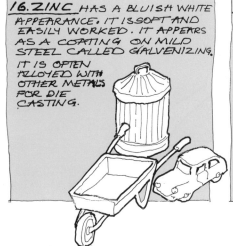

17. LEAD HAS A BLUE GREY COLOUR.

IT IS SOFT AND VERY HEAVY. IT HAS A HIGH RESISTANCE TO WEATHER AND ALSO APPEARS IN SOFT SOLDER.

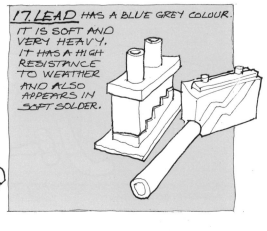

1. TREES ARE SAWN INTO BOARDS IN A SAW MILL.

THIS CAN BE DONE IN A NUMBER OF WAYS.

MOST COMMON IS SLASH SAWN.

RADIAL SAWN TIMBER IS MORE STABLE BUT IS EXPENSIVE.

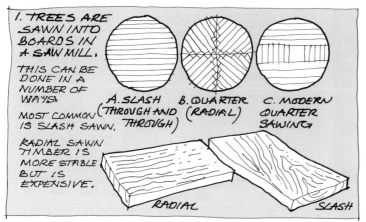

A. SLASH (THROUGH AND THROUGH) B. QUARTER (RADIAL) C. MODERN QUARTER SAWING

RADIAL SLASH

2. BOTH THE HARDWOODS ON THIS PAGE AND THE SOFTWOODS OPPOSITE ARE SEASONED AFTER SAWING.

THEY ARE STACKED TO DRY IN THE OPEN AIR OR IN AN OVEN.

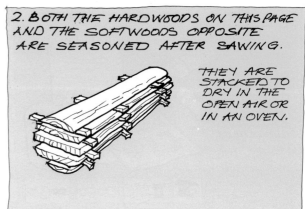

3. BADLY SEASONED TIMBER WILL DEFORM. CHECK FOR THESE FAULTS—

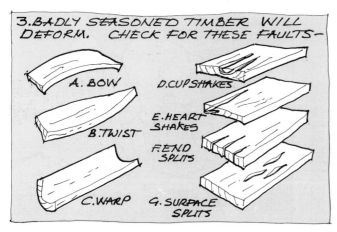

A. BOW
B. TWIST
C. WARP
D. CUP SHAKES
E. HEART SHAKES
F. END SPLITS
G. SURFACE SPLITS

4. MAHOGANY A HARDWOOD, DARK PINK TO REDDISH BROWN COLOUR.

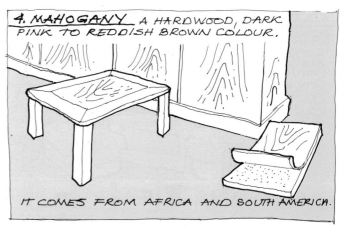

IT COMES FROM AFRICA AND SOUTH AMERICA.

5. OAK A HARDWOOD, PALE STRAW COLOUR IT SOMETIMES HAS A SILVER GRAIN.

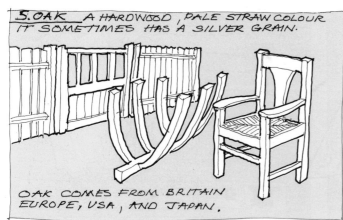

OAK COMES FROM BRITAIN EUROPE, USA, AND JAPAN.

6. BEECH A HARDWOOD, A VERY PALE PINK COLOUR WITH A CLOSE GRAIN.

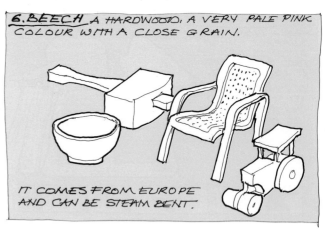

IT COMES FROM EUROPE AND CAN BE STEAM BENT.

7. ASH A HARDWOOD, CREAM TO PALE BROWN COLOUR.

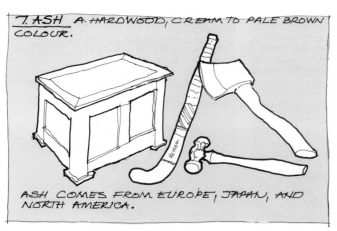

ASH COMES FROM EUROPE, JAPAN, AND NORTH AMERICA.

8. TEAK A HARDWOOD, MID BROWN IN COLOUR.

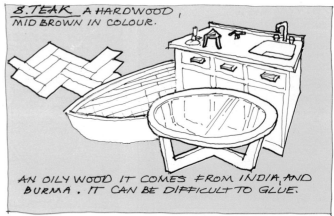

AN OILY WOOD IT COMES FROM INDIA AND BURMA. IT CAN BE DIFFICULT TO GLUE.

... AND SOFTWOODS

9. RED BALTIC PINE A SOFTWOOD WITH A CREAM TO REDDISH BROWN COLOUR.

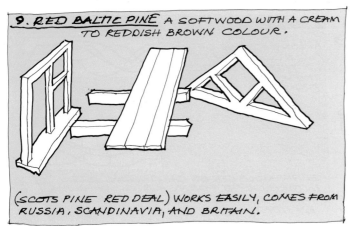

(SCOTS PINE RED DEAL) WORKS EASILY, COMES FROM RUSSIA, SCANDINAVIA, AND BRITAIN.

10. DOUGLAS FIR A SOFTWOOD, REDDISH BROWN COLOUR.

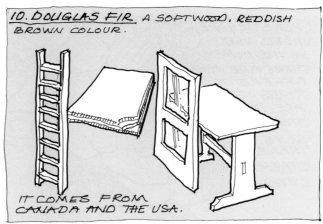

IT COMES FROM CANADA AND THE USA.

11. SPRUCE (WHITEWOOD) A SOFTWOOD WITH A CREAMY YELLOW COLOUR.

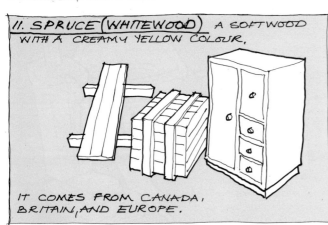

IT COMES FROM CANADA, BRITAIN, AND EUROPE.

12. WESTERN RED CEDAR A SOFTWOOD, REDDISH BROWN WITH A STRONG OILY SMELL.

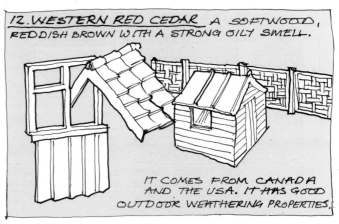

IT COMES FROM CANADA AND THE USA. IT HAS GOOD OUTDOOR WEATHERING PROPERTIES.

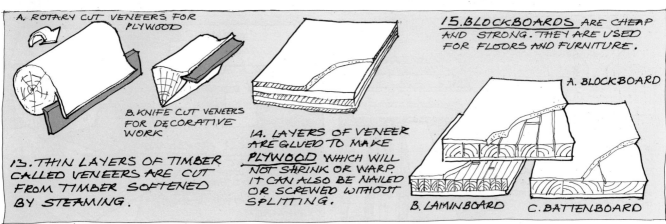

A. ROTARY CUT VENEERS FOR PLYWOOD

B. KNIFE CUT VENEERS FOR DECORATIVE WORK

13. THIN LAYERS OF TIMBER CALLED VENEERS ARE CUT FROM TIMBER SOFTENED BY STEAMING.

14. LAYERS OF VENEER ARE GLUED TO MAKE PLYWOOD WHICH WILL NOT SHRINK OR WARP IT CAN ALSO BE NAILED OR SCREWED WITHOUT SPLITTING.

15. BLOCKBOARDS ARE CHEAP AND STRONG. THEY ARE USED FOR FLOORS AND FURNITURE.

A. BLOCKBOARD

B. LAMINBOARD

C. BATTENBOARD

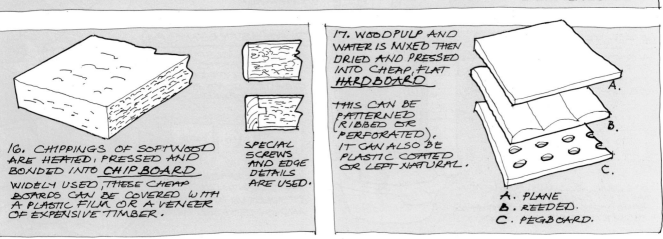

16. CHIPPINGS OF SOFTWOOD ARE HEATED, PRESSED AND BONDED INTO CHIPBOARD WIDELY USED, THESE CHEAP BOARDS CAN BE COVERED WITH A PLASTIC FILM OR A VENEER OF EXPENSIVE TIMBER.

SPECIAL SCREWS AND EDGE DETAILS ARE USED.

17. WOODPULP AND WATER IS MIXED THEN DRIED AND PRESSED INTO CHEAP, FLAT HARDBOARD

THIS CAN BE PATTERNED (RIBBED OR PERFORATED). IT CAN ALSO BE PLASTIC COATED OR LEFT NATURAL.

A. PLANE
B. REEDED.
C. PEGBOARD.

5.4 PLASTICS

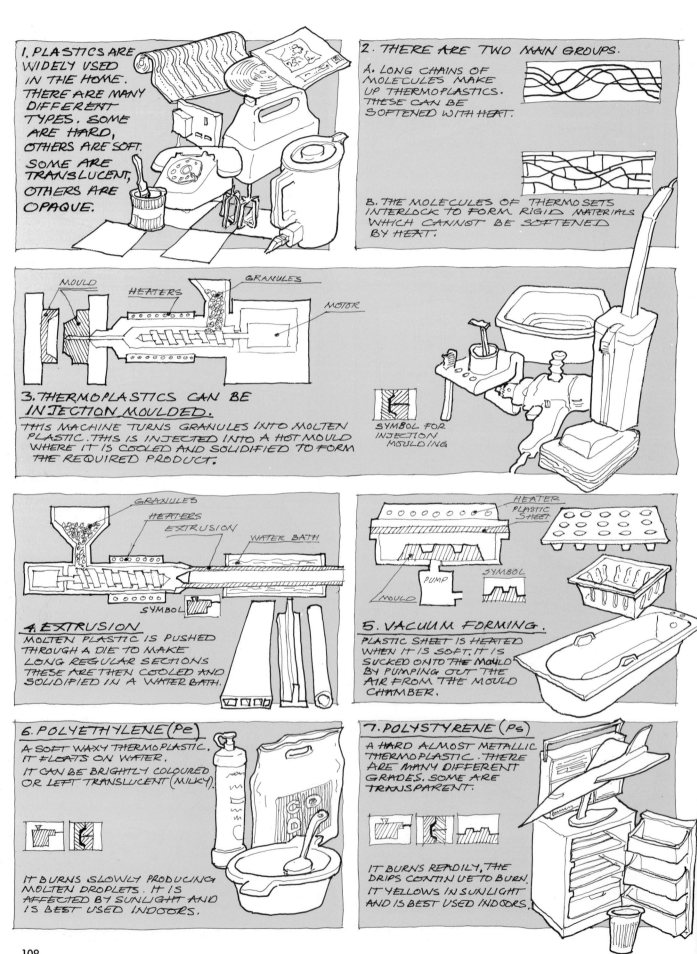

1. PLASTICS ARE WIDELY USED IN THE HOME. THERE ARE MANY DIFFERENT TYPES. SOME ARE HARD, OTHERS ARE SOFT. SOME ARE TRANSLUCENT, OTHERS ARE OPAQUE.

2. THERE ARE TWO MAIN GROUPS.

A. LONG CHAINS OF MOLECULES MAKE UP THERMOPLASTICS. THESE CAN BE SOFTENED WITH HEAT.

B. THE MOLECULES OF THERMOSETS INTERLOCK TO FORM RIGID MATERIALS WHICH CANNOT BE SOFTENED BY HEAT.

MOULD HEATERS GRANULES MOTOR

3. THERMOPLASTICS CAN BE INJECTION MOULDED.
THIS MACHINE TURNS GRANULES INTO MOLTEN PLASTIC. THIS IS INJECTED INTO A HOT MOULD WHERE IT IS COOLED AND SOLIDIFIED TO FORM THE REQUIRED PRODUCT.

SYMBOL FOR INJECTION MOULDING

GRANULES HEATERS EXTRUSION WATER BATH

SYMBOL

4. EXTRUSION
MOLTEN PLASTIC IS PUSHED THROUGH A DIE TO MAKE LONG REGULAR SECTIONS THESE ARE THEN COOLED AND SOLIDIFIED IN A WATER BATH.

HEATER PLASTIC SHEET

PUMP SYMBOL MOULD

5. VACUUM FORMING.
PLASTIC SHEET IS HEATED WHEN IT IS SOFT, IT IS SUCKED ONTO THE MOULD BY PUMPING OUT THE AIR FROM THE MOULD CHAMBER.

6. POLYETHYLENE (Pe)
A SOFT WAXY THERMOPLASTIC. IT FLOATS ON WATER. IT CAN BE BRIGHTLY COLOURED OR LEFT TRANSLUCENT (MILKY).

IT BURNS SLOWLY PRODUCING MOLTEN DROPLETS. IT IS AFFECTED BY SUNLIGHT AND IS BEST USED INDOORS.

7. POLYSTYRENE (Ps)
A HARD ALMOST METALLIC THERMOPLASTIC. THERE ARE MANY DIFFERENT GRADES. SOME ARE TRANSPARENT.

IT BURNS READILY, THE DRIPS CONTINUE TO BURN. IT YELLOWS IN SUNLIGHT AND IS BEST USED INDOORS.

8. POLYVINYL CHLORIDE (PVC)

A DENSE, TOUGH, RUBBERY THERMOPLASTIC. IT CAN BE ALMOST TRANSPARENT.

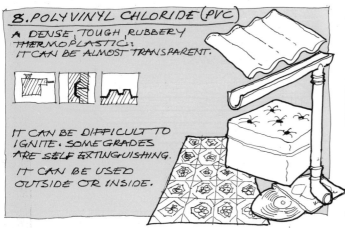

IT CAN BE DIFFICULT TO IGNITE. SOME GRADES ARE SELF EXTINGUISHING.

IT CAN BE USED OUTSIDE OR INSIDE.

9. POLYAMIDE (NYLON)

A WAXY RESILIENT THERMOPLASTIC.

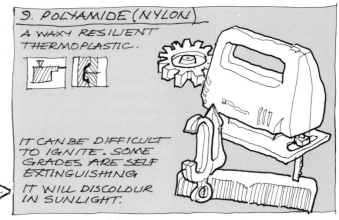

IT CAN BE DIFFICULT TO IGNITE. SOME GRADES ARE SELF EXTINGUISHING

IT WILL DISCOLOUR IN SUNLIGHT.

10. ACRYLONITRILE BUTADIENE STYRENE

(ABS) A STRONG SLIGHTLY RUBBERY THERMOPLASTIC.

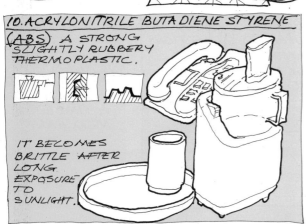

IT BECOMES BRITTLE AFTER LONG EXPOSURE TO SUNLIGHT.

11. POLYMETHYL METHACRYLATE (ACRYLIC OR PMMA)

(OFTEN CALLED PERSPEX)

IT HAS A HARD SURFACE AND CAN BE A CRYSTAL CLEAR THERMOPLASTIC.

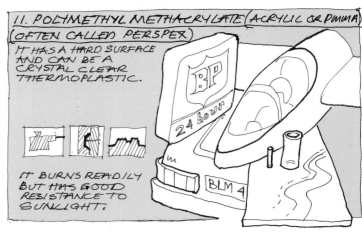

IT BURNS READILY BUT HAS GOOD RESISTANCE TO SUNLIGHT.

12. THERE ARE THREE MAIN MANUFACTURING PROCESSES FOR THERMOSETS.

A. COMPRESSION MOULDING

A PREFORM IS PLACED IN A HEATED MOULD. THE HOT PRESS IS THEN CLOSED AND HELD SHUT UNTIL THE MOULDING SETS.

B. HAND LAY UP

C. SPRAY LAY UP

GLASS FIBRES ARE MIXED WITH A LIQUID RESIN WHICH SLOWLY SETS HARD.

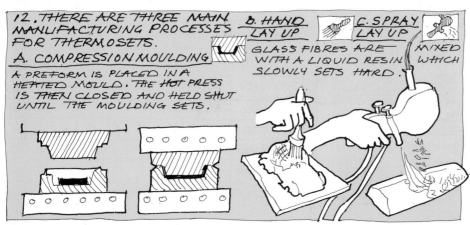

13. UREA FORMALDEHYDE

(UF) THIS HAS A HARD HEAVY FEEL. IT IS USUALLY WHITE.

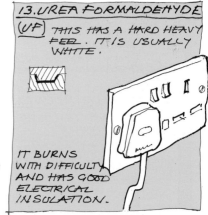

IT BURNS WITH DIFFICULTY AND HAS GOOD ELECTRICAL INSULATION.

14. POLYESTER (GRP) (OFTEN CALLED FIBREGLASS)

IT HAS A SOLID HARD FEEL. IT BURNS READILY AND CAN BE USED INDOORS AND OUTDOORS.

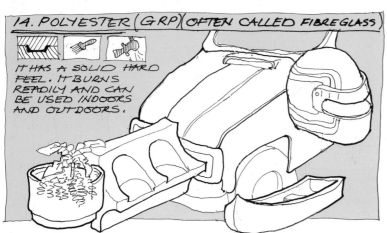

15. MELAMINE FORMALDEHYDE (MF)

IT HAS A HEAVY HARD FEEL AND IS TOUGH AND SCUFF RESISTANT.

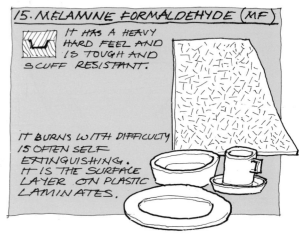

IT BURNS WITH DIFFICULTY IS OFTEN SELF EXTINGUISHING. IT IS THE SURFACE LAYER ON PLASTIC LAMINATES.

5.5 AVAILABILITY OF MATERIALS

The metal, timber, and plastics industries each produce their materials in a range of standard shapes and sizes. A good designer will take account of these 'stock' sizes, as they are called.

Manufactures' and suppliers' catalogues are therefore essential for detailed design work. However, you will find some general information on these two pages about the common forms and relative prices of these materials. This should allow you to check the feasibility of your design work.

1. TIMBER IS SUPPLIED BY MERCHANTS IN LENGTHS FROM 1·8 TO 6·3 METRES IN 300mm INCREMENTS.

2. TIMBER IS SOLD EITHER SAWN OR PLANED.

SAWN HAS A ROUGH SURFACE
PLANED IS SMOOTH

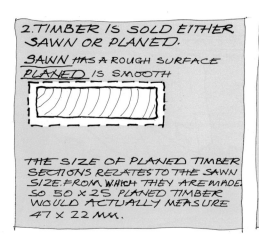

THE SIZE OF PLANED TIMBER SECTIONS RELATES TO THE SAWN SIZE FROM WHICH THEY ARE MADE. SO 50 X 25 PLANED TIMBER WOULD ACTUALLY MEASURE 47 X 22 MM.

3. PLANING CAN BE P.A.R.
PLANED ALL ROUND.
OR:-
P.B.S.
PLANED BOTH SIDES.

4. SOFTWOODS ARE SUPPLIED IN SECTIONS RANGING FROM 12 X 12 MM TO 100 X 200 MM.

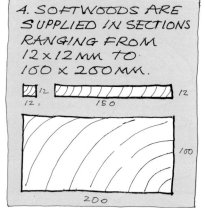

5. HARDWOODS CAN USUALLY BE SAWN OR PLANED TO ANY REQUIRED SIZE BY A TIMBER MERCHANT.

6. HARDWOODS ARE ALSO STOCKED IN THE FORM OF MOULDINGS.

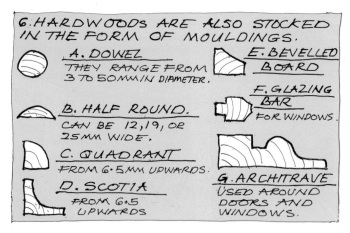

A. DOWEL
THEY RANGE FROM 3 TO 50MM IN DIAMETER.

B. HALF ROUND.
CAN BE 12, 19, OR 25MM WIDE.

C. QUADRANT
FROM 6·5MM UPWARDS.

D. SCOTIA
FROM 6.5 UPWARDS

E. BEVELLED BOARD

F. GLAZING BAR
FOR WINDOWS.

G. ARCHITRAVE
USED AROUND DOORS AND WINDOWS.

7. MANUFACTURED BOARDS ARE AVAILABLE IN SHEETS RANGING 610 X 1220 MM TO 1220 X 2240 MM.

THICKNESS IN MM	3	4	6	6·5	9	12	18	25	45
HARBOARD	H	—	H	—	—	—	—	—	—
PLYWOOD	-	P	P	P	P	P	P	P	—
BLOCKBOARD	—	—	—	—	—	B	B	B	B
CHIPBOARD	—	—	—	—	—	C	C	C	—

READILY AVAILABLE THICKNESSES.

5. PLASTICS ARE SUPPLIED TO MOULDING COMPANIES AS POWDERS, OR GRANULES.

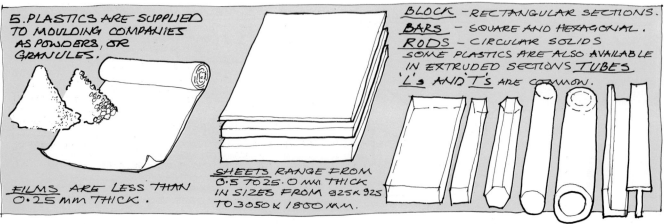

FILMS ARE LESS THAN 0·25 MM THICK.

SHEETS RANGE FROM 0·5 TO 25·0 MM THICK IN SIZES FROM 925 X 925 TO 3050 X 1800 MM.

BLOCK - RECTANGULAR SECTIONS.
BARS - SQUARE AND HEXAGONAL.
RODS - CIRCULAR SOLIDS
SOME PLASTICS ARE ALSO AVAILABLE IN EXTRUDED SECTIONS TUBES 'L's AND 'T's ARE COMMON.

6.
SOME PLASTICS ARE AVAILABLE IN RESIN FORM.

7. AVAILABILITY OF PARTICULAR PLASTICS

		POWDER	GRANULES	FOAM	FILM	SHEET	BLOCK	HEXAGONAL BAR	ROD	EXTRUSION	RESIN
− NOT READILY AVAILABLE											
✗ READILY AVAILABLE											
POLYETHYLENE (Pe)		X	X	−	X	−	−	−	−	PIPE	−
ACRYLIC (PMMA)		−	X	−	−	X	X	−	X	TUBE	X
NYLON		X	X	−	−	−	X	X	X	PIPE	−
PVC		X	X	X	−	−	−	−	−	X	−
POLYSTYRENE (PS)		X	X	X	−	−	−	−	−	−	−
POLYESTER		−	−	−	−	−	−	−	−	−	X

8.
BOTH FERROUS AND NON-FERROUS METALS ARE AVAILABLE IN SHEET FORM. COMMON SIZES ARE 600 × 1200 AND 915 × 1830 MM. THICKNESSES ARE MEASURED IN GAUGE NUMBERS (SWG).

SWG	MM
10	3.25
12	2.6
14	2.0
16	1.6
18	1.2
20	0.9
22	0.7
24	0.6

9. FERROUS METALS ~
A. SHEET
B. CORRUGATED SHEET
C. CHEQUER PLATE
D. EXPANDED MESH
E. PERFORATED SHEET
F. PLATE ~ FROM 6 TO 150MM THICK
G. STRIP ~ LESS THAN 6MM THICK
H, I, AND J. THICK WALLS ARE CALLED HOLLOW SECTIONS. THIN WALLS ARE CALLED TUBES.

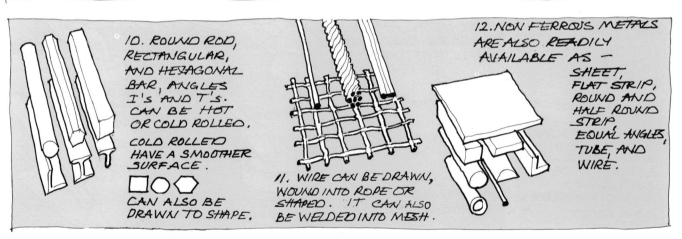

10.
ROUND ROD, RECTANGULAR, AND HEXAGONAL BAR, ANGLES I's AND T's. CAN BE HOT OR COLD ROLLED.

COLD ROLLED HAVE A SMOOTHER SURFACE.

CAN ALSO BE DRAWN TO SHAPE.

11.
WIRE CAN BE DRAWN, WOUND INTO ROPE OR SHAPED. IT CAN ALSO BE WELDED INTO MESH.

12.
NON FERROUS METALS ARE ALSO READILY AVAILABLE AS ─

SHEET, FLAT STRIP, ROUND AND HALF ROUND STRIP, EQUAL ANGLES, TUBE, AND WIRE.

13.
PRICES OF MATERIALS CHANGE REGULARLY. HOWEVER THIS TABLE GIVES SOME INFORMATION FROM WHICH COMPARISONS CAN BE MADE. MANUFACTURERS' PRICE LISTS SHOULD BE CONSULTED FOR ACCURATE DATA.

ALL PRICES ARE IN £.00

− NOT READILY AVAILABLE

	ALUMINIUM	BRASS	COPPER	MILD STEEL	HARDWOOD	SOFTWOOD	PLYWOOD	ACRYLIC
1MM THICK SHEET, PER SQUARE METRE	5.50	26.60	24.80	5.15	−	−	−	20.10
3MM THICK SHEET, PER SQUARE METRE	21.80	29.00	−	−	−	−	1.90	18.15
18MM THICK SHEET, PER SQUARE METRE	−	−	−	−	−	−	8.90	108.00
10MM DIAMETER ROD, PER METRE	0.65	1.70	10.65	0.45	0.14	−	−	1.27
50 × 22 MM SECTION, PER METRE	−	−	−	−	1.55	0.30	−	−

5.6 METAL JOINTS

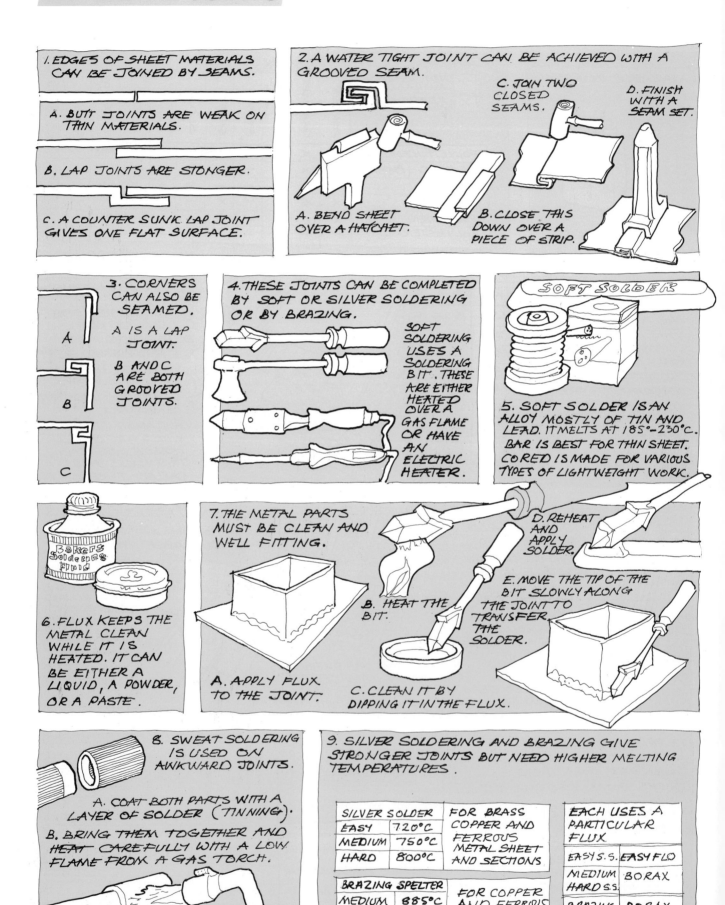

1. EDGES OF SHEET MATERIALS CAN BE JOINED BY SEAMS.

A. BUTT JOINTS ARE WEAK ON THIN MATERIALS.

B. LAP JOINTS ARE STONGER.

C. A COUNTER SUNK LAP JOINT GIVES ONE FLAT SURFACE.

2. A WATER TIGHT JOINT CAN BE ACHIEVED WITH A GROOVED SEAM.

C. JOIN TWO CLOSED SEAMS.

D. FINISH WITH A SEAM SET.

A. BEND SHEET OVER A HATCHET.

B. CLOSE THIS DOWN OVER A PIECE OF STRIP.

3. CORNERS CAN ALSO BE SEAMED.

A IS A LAP JOINT.

B AND C ARE BOTH GROOVED JOINTS.

4. THESE JOINTS CAN BE COMPLETED BY SOFT OR SILVER SOLDERING OR BY BRAZING.

SOFT SOLDERING USES A SOLDERING BIT. THESE ARE EITHER HEATED OVER A GAS FLAME OR HAVE AN ELECTRIC HEATER.

SOFT SOLDER

5. SOFT SOLDER IS AN ALLOY MOSTLY OF TIN AND LEAD. IT MELTS AT 185°–230°C. BAR IS BEST FOR THIN SHEET. CORED IS MADE FOR VARIOUS TYPES OF LIGHTWEIGHT WORK.

Bakers Soldering Fluid

6. FLUX KEEPS THE METAL CLEAN WHILE IT IS HEATED. IT CAN BE EITHER A LIQUID, A POWDER, OR A PASTE.

7. THE METAL PARTS MUST BE CLEAN AND WELL FITTING.

A. APPLY FLUX TO THE JOINT.

B. HEAT THE BIT.

C. CLEAN IT BY DIPPING IT IN THE FLUX.

D. REHEAT AND APPLY SOLDER.

E. MOVE THE TIP OF THE BIT SLOWLY ALONG THE JOINT TO TRANSFER THE SOLDER.

8. SWEAT SOLDERING IS USED ON AWKWARD JOINTS.

A. COAT BOTH PARTS WITH A LAYER OF SOLDER (TINNING).

B. BRING THEM TOGETHER AND HEAT CAREFULLY WITH A LOW FLAME FROM A GAS TORCH.

9. SILVER SOLDERING AND BRAZING GIVE STRONGER JOINTS BUT NEED HIGHER MELTING TEMPERATURES.

SILVER SOLDER		FOR BRASS COPPER AND FERROUS METAL SHEET AND SECTIONS	EACH USES A PARTICULAR FLUX	
EASY	720°C			
MEDIUM	750°C		EASY S.S.	EASY FLO
HARD	800°C		MEDIUM HARD S.S.	BORAX
BRAZING SPELTER		FOR COPPER AND FERROUS METAL		
MEDIUM	885°C		BRAZING	BORAX
HARD	900°C			

10. A BRAZING HEARTH AND A GAS TORCH ARE NEEDED TO REACH THESE HIGH TEMPERATURES.

11. BRAZING AND SILVER SOLDERING PROCEDURES ARE SIMILAR.

A. CLEAN THE JOINT AND WIRE TOGETHER WITH SOFT BINDING WIRE.

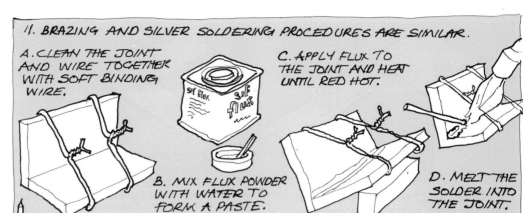

B. MIX FLUX POWDER WITH WATER TO FORM A PASTE.

C. APPLY FLUX TO THE JOINT AND HEAT UNTIL RED HOT.

D. MELT THE SOLDER INTO THE JOINT.

12. RIVETS ARE AN EFFECTIVE COLD JOINTING SYSTEM.

A. SNAP HEAD – VISIBLE
B. FLAT HEAD – DECORATIVE
C. COUNTERSUNK – INVISIBLE
D. BIFURCATED – QUICK FIX
E. POP RIVET – QUICKER FIX
F. RIVET SET + SNAP. – SHAPES RIVETS.

13. A. MATCH RIVET TO MATERIAL
B. CUT RIVET TO LENGTH
C. SPREAD RIVET TO FILL DRILLED HOLE.

D. ROUND WITH A BALL PEIN HAMMER
E. FINISH WITH A RIVET SNAP IF NECESSARY.

SNAP SNAP IN VICE SNAP

14. BLIND RIVETS ARE FITTED WITH A SPECIAL TOOL. THEY ARE USEFUL WHEN ONE SIDE IS SEEN.

15. A DIE IS USED TO CUT A THREAD ON METAL AND PLASTIC ROD.

IT IS HELD IN A DIE HOLDER.

THE SIZE OF THE THREAD IS MARKED ON THE DIE (FOR EXAMPLE, M10 x 1.5 WILL THREAD A DIAMETER 10mm ROD WITH A PITCH OF 1.5 mm).

A. CHAMFER THE ROD AND PLACE UPRIGHT IN A VICE.

B. TURN THE DIE HOLDER OVER SO THAT THE DIE FACES THE WORK. MAKE SURE THAT IT IS SQUARE.

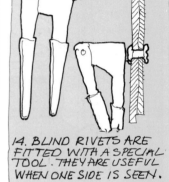

C. APPLY CUTTING PASTE. CUT ONE TURN CLOCKWISE, HALF A TURN ANTI-CLOCKWISE.

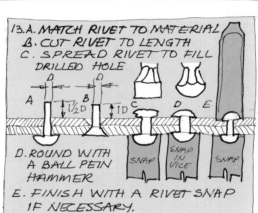

16. TAPS CUT INTERNAL THREADS. THEY COME IN SETS OF THREE.

A. TAPER
B. SECOND
C. PLUG

THEY ARE HELD IN A TAP WRENCH.

THREAD SIZE	TAPPING DRILL SIZE
M3	2.5
M4	3.3
M5	4.2
M6	5.0
M8	6.8
M10	8.5
M12	10.2

A. DRILL PILOT HOLE TO 'TAPPING DRILL SIZE'
B. APPLY CUTTING PASTE
C. USE TAPER TO START
D. CUT CLOCKWISE WITH A HALF TURN
E. RELEASE SWARF WITH A QUARTER TURN ANTI-CLOCKWISE
F. REPEAT WITH THE SECOND AND THEN THE PLUG FOR BLIND (STOPPED) HOLES.

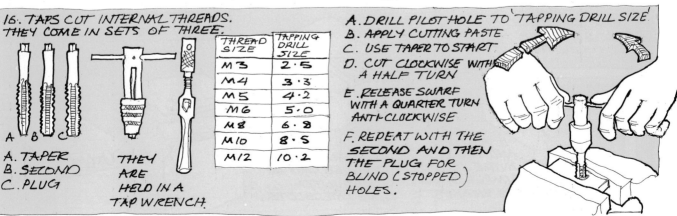

5.7 TIMBER JOINTS

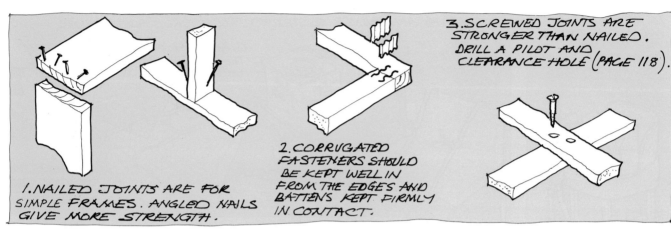

3. SCREWED JOINTS ARE STRONGER THAN NAILED. DRILL A PILOT AND CLEARANCE HOLE (PAGE 118).

1. NAILED JOINTS ARE FOR SIMPLE FRAMES. ANGLED NAILS GIVE MORE STRENGTH.

2. CORRUGATED FASTENERS SHOULD BE KEPT WELL IN FROM THE EDGES AND BATTENS KEPT FIRMLY IN CONTACT.

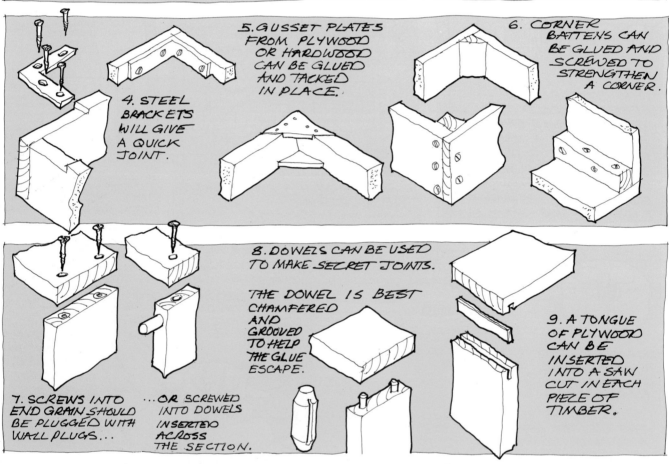

4. STEEL BRACKETS WILL GIVE A QUICK JOINT.

5. GUSSET PLATES FROM PLYWOOD OR HARDWOOD CAN BE GLUED AND TACKED IN PLACE.

6. CORNER BATTENS CAN BE GLUED AND SCREWED TO STRENGTHEN A CORNER.

7. SCREWS INTO END GRAIN SHOULD BE PLUGGED WITH WALL PLUGS...

...OR SCREWED INTO DOWELS INSERTED ACROSS THE SECTION.

8. DOWELS CAN BE USED TO MAKE SECRET JOINTS.

THE DOWEL IS BEST CHAMFERED AND GROOVED TO HELP THE GLUE ESCAPE.

9. A TONGUE OF PLYWOOD CAN BE INSERTED INTO A SAW CUT IN EACH PIECE OF TIMBER.

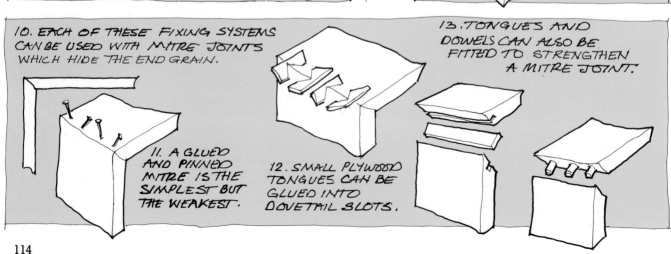

10. EACH OF THESE FIXING SYSTEMS CAN BE USED WITH MITRE JOINTS WHICH HIDE THE END GRAIN.

11. A GLUED AND PINNED MITRE IS THE SIMPLEST BUT THE WEAKEST.

12. SMALL PLYWOOD TONGUES CAN BE GLUED INTO DOVETAIL SLOTS.

13. TONGUES AND DOWELS CAN ALSO BE FITTED TO STRENGTHEN A MITRE JOINT.

14. REBATED JOINTS GIVE MORE CONTACT BETWEEN THE TWO PIECES OF MATERIAL. THEY ARE THEREFORE STRONGER THAN BUTT JOINTS AND MITRES. THERE ARE A NUMBER OF DIFFERENT CONFIGURATIONS —

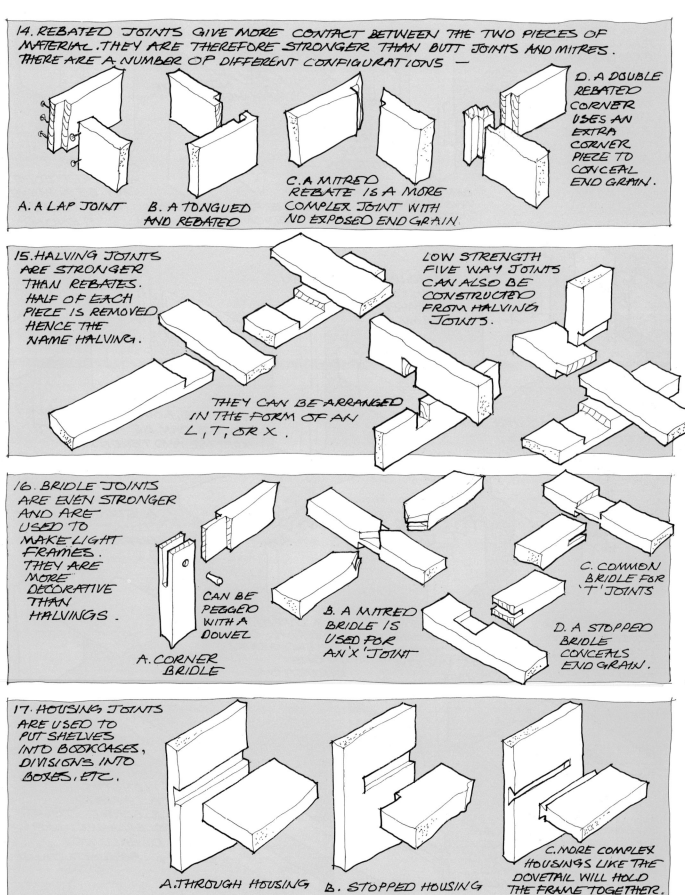

D. A DOUBLE REBATED CORNER USES AN EXTRA CORNER PIECE TO CONCEAL END GRAIN.

A. A LAP JOINT

B. A TONGUED AND REBATED

C. A MITRED REBATE IS A MORE COMPLEX JOINT WITH NO EXPOSED END GRAIN.

15. HALVING JOINTS ARE STRONGER THAN REBATES. HALF OF EACH PIECE IS REMOVED HENCE THE NAME HALVING.

THEY CAN BE ARRANGED IN THE FORM OF AN L, T, OR X.

LOW STRENGTH FIVE WAY JOINTS CAN ALSO BE CONSTRUCTED FROM HALVING JOINTS.

16. BRIDLE JOINTS ARE EVEN STRONGER AND ARE USED TO MAKE LIGHT FRAMES. THEY ARE MORE DECORATIVE THAN HALVINGS.

CAN BE PEGGED WITH A DOWEL

A. CORNER BRIDLE

B. A MITRED BRIDLE IS USED FOR AN 'X' JOINT

C. COMMON BRIDLE FOR 'T' JOINTS

D. A STOPPED BRIDLE CONCEALS END GRAIN.

17. HOUSING JOINTS ARE USED TO PUT SHELVES INTO BOOKCASES, DIVISIONS INTO BOXES, ETC.

A. THROUGH HOUSING

B. STOPPED HOUSING

C. MORE COMPLEX HOUSINGS LIKE THE DOVETAIL WILL HOLD THE FRAME TOGETHER.

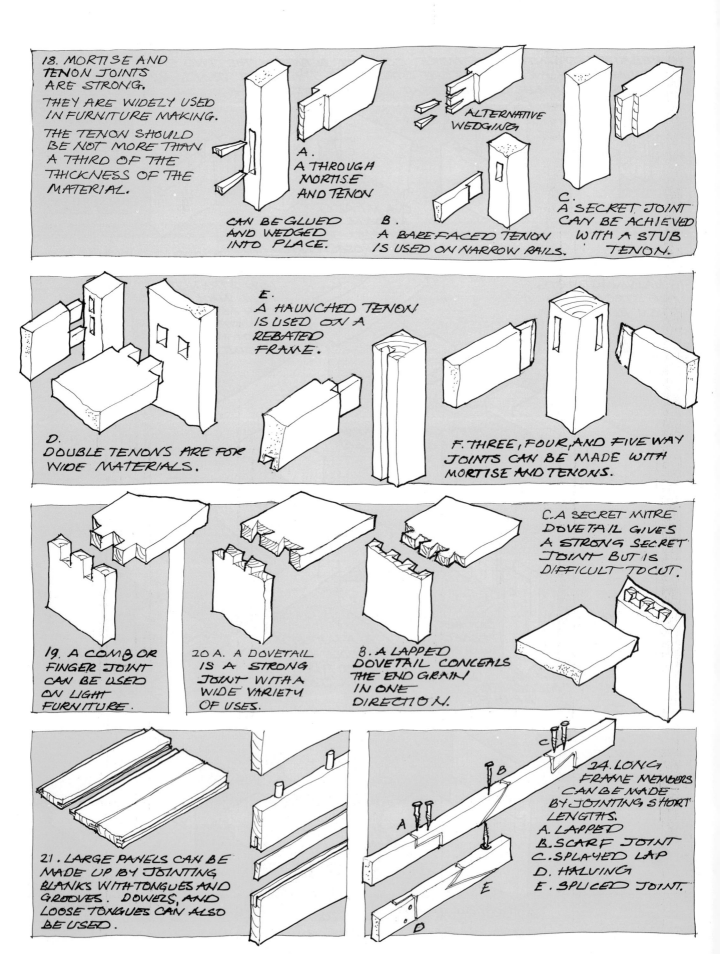

18. MORTISE AND TENON JOINTS ARE STRONG.

THEY ARE WIDELY USED IN FURNITURE MAKING.

THE TENON SHOULD BE NOT MORE THAN A THIRD OF THE THICKNESS OF THE MATERIAL.

CAN BE GLUED AND WEDGED INTO PLACE.

A. A THROUGH MORTISE AND TENON

ALTERNATIVE WEDGING

B. A BAREFACED TENON IS USED ON NARROW RAILS.

C. A SECRET JOINT CAN BE ACHIEVED WITH A STUB TENON.

E. A HAUNCHED TENON IS USED ON A REBATED FRAME.

D. DOUBLE TENONS ARE FOR WIDE MATERIALS.

F. THREE, FOUR, AND FIVE WAY JOINTS CAN BE MADE WITH MORTISE AND TENONS.

19. A COMB OR FINGER JOINT CAN BE USED ON LIGHT FURNITURE.

20 A. A DOVETAIL IS A STRONG JOINT WITH A WIDE VARIETY OF USES.

B. A LAPPED DOVETAIL CONCEALS THE END GRAIN IN ONE DIRECTION.

C. A SECRET MITRE DOVETAIL GIVES A STRONG SECRET JOINT BUT IS DIFFICULT TO CUT.

21. LARGE PANELS CAN BE MADE UP BY JOINTING BLANKS WITH TONGUES AND GROOVES. DOWELS, AND LOOSE TONGUES CAN ALSO BE USED.

24. LONG FRAME MEMBERS CAN BE MADE BY JOINTING SHORT LENGTHS.
A. LAPPED
B. SCARF JOINT
C. SPLAYED LAP
D. HALVING
E. SPLICED JOINT.

5.8 PLASTIC JOINTS

Thermoplastics can be glued using either a solvent or a cement for a fine joint. They can be welded with hot air to make rough joints. They can also be threaded to make moveable joints.

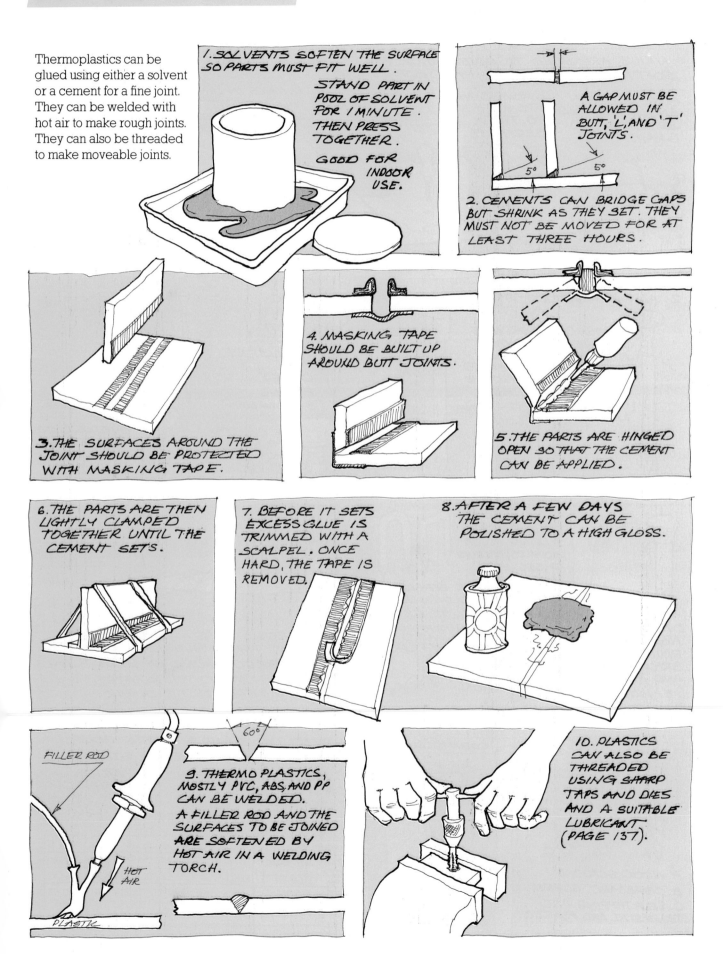

1. SOLVENTS SOFTEN THE SURFACE SO PARTS MUST FIT WELL.

STAND PART IN POOL OF SOLVENT FOR 1 MINUTE. THEN PRESS TOGETHER.

GOOD FOR INDOOR USE.

A GAP MUST BE ALLOWED IN BUTT, 'L', AND 'T' JOINTS.

2. CEMENTS CAN BRIDGE GAPS BUT SHRINK AS THEY SET. THEY MUST NOT BE MOVED FOR AT LEAST THREE HOURS.

3. THE SURFACES AROUND THE JOINT SHOULD BE PROTECTED WITH MASKING TAPE.

4. MASKING TAPE SHOULD BE BUILT UP AROUND BUTT JOINTS.

5. THE PARTS ARE HINGED OPEN SO THAT THE CEMENT CAN BE APPLIED.

6. THE PARTS ARE THEN LIGHTLY CLAMPED TOGETHER UNTIL THE CEMENT SETS.

7. BEFORE IT SETS EXCESS GLUE IS TRIMMED WITH A SCALPEL. ONCE HARD, THE TAPE IS REMOVED.

8. AFTER A FEW DAYS THE CEMENT CAN BE POLISHED TO A HIGH GLOSS.

FILLER ROD

HOT AIR

PLASTIC

9. THERMO PLASTICS, MOSTLY PVC, ABS, AND PP CAN BE WELDED. A FILLER ROD AND THE SURFACES TO BE JOINED ARE SOFTENED BY HOT AIR IN A WELDING TORCH.

10. PLASTICS CAN ALSO BE THREADED USING SHARP TAPS AND DIES AND A SUITABLE LUBRICANT (PAGE 137).

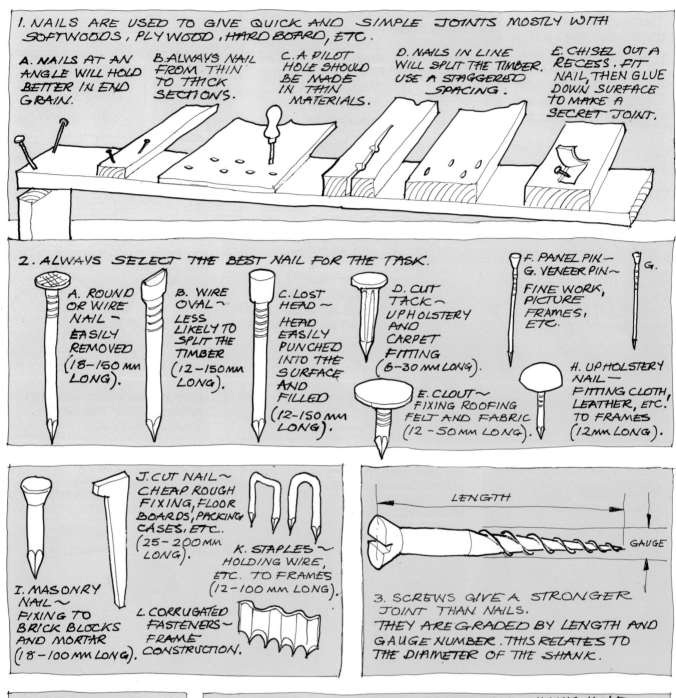

1. NAILS ARE USED TO GIVE QUICK AND SIMPLE JOINTS MOSTLY WITH SOFTWOODS, PLYWOOD, HARDBOARD, ETC.

A. NAILS AT AN ANGLE WILL HOLD BETTER IN END GRAIN.

B. ALWAYS NAIL FROM THIN TO THICK SECTIONS.

C. A PILOT HOLE SHOULD BE MADE IN THIN MATERIALS.

D. NAILS IN LINE WILL SPLIT THE TIMBER. USE A STAGGERED SPACING.

E. CHISEL OUT A RECESS. FIT NAIL, THEN GLUE DOWN SURFACE TO MAKE A SECRET JOINT.

2. ALWAYS SELECT THE BEST NAIL FOR THE TASK.

A. ROUND OR WIRE NAIL ~ EASILY REMOVED (18-150 MM LONG).

B. WIRE OVAL ~ LESS LIKELY TO SPLIT THE TIMBER (12-150MM LONG).

C. LOST HEAD ~ HEAD EASILY PUNCHED INTO THE SURFACE AND FILLED (12-150 MM LONG).

D. CUT TACK ~ UPHOLSTERY AND CARPET FITTING (6-30 MM LONG).

E. CLOUT ~ FIXING ROOFING FELT AND FABRIC (12-50 MM LONG).

F. PANEL PIN ~
G. VENEER PIN ~ FINE WORK, PICTURE FRAMES, ETC.

H. UPHOLSTERY NAIL ~ FITTING CLOTH, LEATHER, ETC.! TO FRAMES (12MM LONG).

I. MASONRY NAIL ~ FIXING TO BRICK BLOCKS AND MORTAR (18-100 MM LONG).

J. CUT NAIL ~ CHEAP ROUGH FIXING, FLOOR BOARDS, PACKING CASES, ETC. (25-200MM LONG).

K. STAPLES ~ HOLDING WIRE, ETC. TO FRAMES (12-100 MM LONG).

L. CORRUGATED FASTENERS ~ FRAME CONSTRUCTION.

LENGTH

GAUGE

3. SCREWS GIVE A STRONGER JOINT THAN NAILS. THEY ARE GRADED BY LENGTH AND GAUGE NUMBER. THIS RELATES TO THE DIAMETER OF THE SHANK.

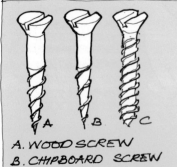

A. WOOD SCREW
B. CHIPBOARD SCREW
C. SELF TAPPING INTO THIN METAL AND PLASTIC.

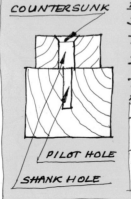

COUNTERSUNK

PILOT HOLE

SHANK HOLE

5. A PILOT HOLE AND A SHANK HOLE SHOULD BE DRILLED FOR EACH SCREW.

THE SIZES OF THESE HOLES VARIES ACCORDING TO THE GAUGE NUMBER OF THE SCREW.

THE MOST COMMON GAUGE NUMBERS ARE 6, 8, AND 10.

GAUGE NO.		1	2	3	4	5	6	8	10	12	14	16
HARD WOOD	SHANK	2	2.5	3	3.5	3.5	4	5	5.75	6.5	6.5	7.25
	PILOT	1.25	1.5	1.5	2	2	2	2.5	3.5	3.5	4	5
SOFT WOOD	SHANK	USE A BRADAWL						2.5	4	4	5.75	5.75
	PILOT	USE A BRADAWL						1.5	2	2	3	3

VARIOUS SLOTS ARE ALSO AVAILABLE.

D. STRAIGHT ~ MOST COMMON

E. POSIDRIV ~ MORE DECORATIVE.

6. THE HEAD SHAPE IS MATCHED TO THE TASK.

A. COUNTERSINK ~ RECESSED INTO WORK

B. RAISED HEAD ~ DECORATIVE

C. ROUNDHEAD ~ EXPOSED

7. SCREW HEADS CAN BE FEATURED IN MANY WAYS.

A. MIRROR SCREWS ~ HAVE METAL DOMES

B. PLASTIC SNAP FITTING COVERS

C. INSERT CAPS ~ PUSH INTO A DRILLED HOLE.

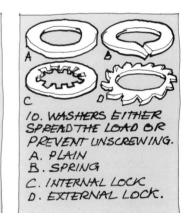

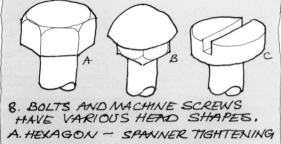

8. BOLTS AND MACHINE SCREWS HAVE VARIOUS HEAD SHAPES.

A. HEXAGON ~ SPANNER TIGHTENING

B. COACH BOLT ~ WOODWORK

C. CHEESEHEAD ~ SCREWDRIVER FITTING.

9. THERE IS A VARIETY OF DIFFERENT THREAD FORMS, 'UNF,' 'BSW,' 'BSF,' ETC. THE MOST COMMON IN SCHOOL IS 'ISO' WHERE THE THREAD SIZE IS BASED ON THE BOLT DIAMETER.

M8 BOLT ⌀ 8 MM

10. WASHERS EITHER SPREAD THE LOAD OR PREVENT UNSCREWING.

A. PLAIN

B. SPRING

C. INTERNAL LOCK

D. EXTERNAL LOCK.

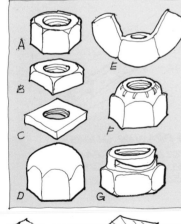

11. NUTS PERFORM A TASK.

A. HEXAGON ~ SPANNER TIGHTENING

B. SQUARE ~ LOAD SPREADING

C. FLAT ~ CHEAP

D. DOME ~ DECORATIVE

E. WING NUT ~ FINGER TIGHTENING

F. LOCKNUT ~ PLASTIC INSERT LOCKS BOLT

G. AEROTIGHT ~ ALSO LOCKS ONTO BOLT.

12. SET SCREWS CAN HAVE A SLOT OR HEXAGON SOCKET FOR A WRENCH. THEY CAN BE RECESSED INTO THE WORK.

13. ANY ROUND BAR CAN BE THREADED TO FORM A STUD.

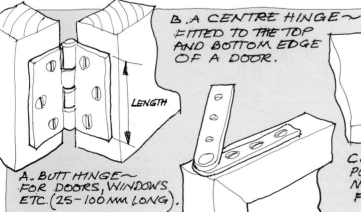

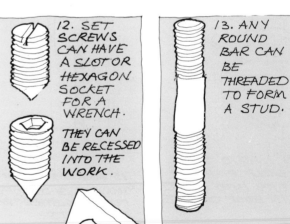

B. A CENTRE HINGE ~ FITTED TO THE TOP AND BOTTOM EDGE OF A DOOR.

D. PIANO HINGE ~ THIS IS SOLD IN A CONTINUOUS LENGTH UP TO 1830 MM.

LENGTH

A. BUTT HINGE ~ FOR DOORS, WINDOWS ETC. (25-100 MM LONG).

C. CONCEALED HINGE ~ POPULAR WITH FURNITURE MANUFACTURERS. THEY FIT INSIDE THE CABINET.

119

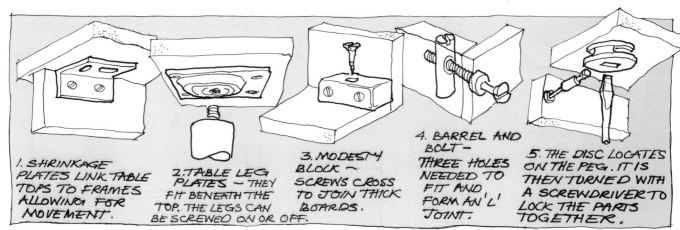

1. SHRINKAGE PLATES LINK TABLE TOPS TO FRAMES ALLOWING FOR MOVEMENT.

2. TABLE LEG PLATES — THEY FIT BENEATH THE TOP. THE LEGS CAN BE SCREWED ON OR OFF.

3. MODESTY BLOCK — SCREWS CROSS TO JOIN THICK BOARDS.

4. BARREL AND BOLT — THREE HOLES NEEDED TO FIT AND FORM AN 'L' JOINT.

5. THE DISC LOCATES ON THE PEG. IT IS THEN TURNED WITH A SCREWDRIVER TO LOCK THE PARTS TOGETHER.

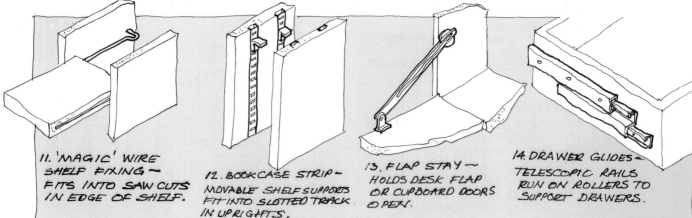

6. CORNER PLATES — INTERLOCK TO HOLD PANELS AT RIGHT ANGLES.

7. FLUSHMOUNTS — FIT ONE PIECE TO WALL, ONE TO CUPBOARD.

8. K.D. PLATES — PULL BOARDS TOGETHER AS PLATE IS PUSHED ON TO RAISED SREWS.

9. CAPTIVE NUT — HAMMERED INTO A DRILLED HOLE TO ACCEPT A BOLT.

10. CORNER PLATE — JOINS THREE BOARDS TO FORM A CORNER.

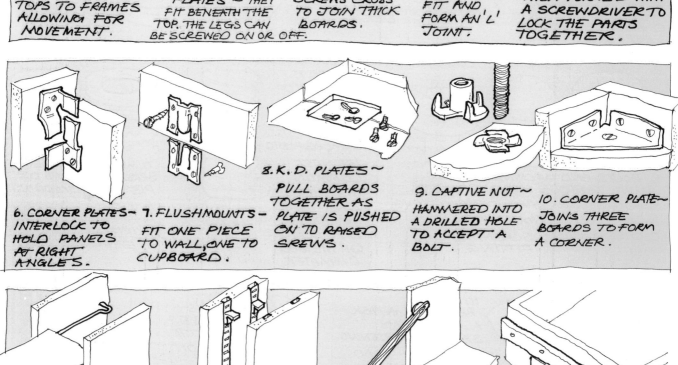

11. 'MAGIC' WIRE SHELF FIXING — FITS INTO SAW CUTS IN EDGE OF SHELF.

12. BOOKCASE STRIP — MOVABLE SHELF SUPPORTS FIT INTO SLOTTED TRACK IN UPRIGHTS.

13. FLAP STAY — HOLDS DESK FLAP OR CUPBOARD DOORS OPEN.

14. DRAWER GLIDES — TELESCOPIC RAILS RUN ON ROLLERS TO SUPPORT DRAWERS.

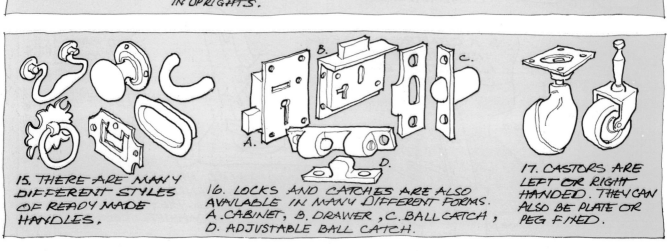

15. THERE ARE MANY DIFFERENT STYLES OF READY MADE HANDLES.

16. LOCKS AND CATCHES ARE ALSO AVAILABLE IN MANY DIFFERENT FORMS. A. CABINET, B. DRAWER, C. BALL CATCH, D. ADJUSTABLE BALL CATCH.

17. CASTORS ARE LEFT OR RIGHT HANDED. THEY CAN ALSO BE PLATE OR PEG FIXED.

5.10 ADHESIVES

1. THERE ARE MANY DIFFERENT GLUES. EACH IS DESIGNED TO PERFORM A PARTICULAR TASK.

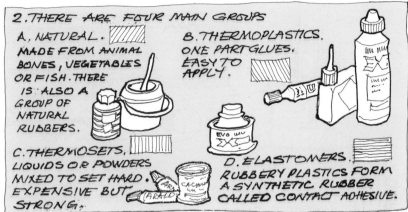

2. THERE ARE FOUR MAIN GROUPS

A. NATURAL. MADE FROM ANIMAL BONES, VEGETABLES OR FISH. THERE IS ALSO A GROUP OF NATURAL RUBBERS.

B. THERMOPLASTICS. ONE PART GLUES. EASY TO APPLY.

C. THERMOSETS. LIQUIDS OR POWDERS MIXED TO SET HARD. EXPENSIVE BUT STRONG.

D. ELASTOMERS. RUBBERY PLASTICS FORM A SYNTHETIC RUBBER CALLED CONTACT ADHESIVE.

3. TYPES	BRAND NAMES	FORM	CLAMPING	CURE TIME	WEATHERING	WATER RES.	GAP FILLING	NO.
1. SCOTCH ANIMAL	CROID, AERO, LEPAGE	GRANULES	YES	4-6 HRS	FAIR	POOR	POOR	1
2. LATEX	COPYDEX, GLOY	LIQUID	LIGHT PRESSURE	15-30 MINS	GOOD	GOOD	GOOD	2
3. PVA	RESIN W, UNI BOND	LIQUID	YES	20-60 MINS	GOOD	POOR	FAIR	3
4. CEMENTS	TENSOL (ACRYLIC), PVC, POLYSTYRENE	LIQUID	LIGHT PRESSURE	3 HRS	FAIR	FAIR	FAIR	4
5. CELLULOSE	BOSTIC, UHU	LIQUID	LIGHT	10-15 MINS	FAIR	GOOD	FAIR	5
6. EPOXY	ARALDITE RAPID, DUNLOP EPOXY	LIQUID TWO PART	YES	20-60 MINS	EXCELLENT	EXCELLENT	EXCELLENT	6
7. UREA FORMALDEHYDE	AEROLITE 306, CASCAMITE	POWDER TWO PART	YES	4-6 HOURS	EXCELLENT	GOOD	EXCELLENT	7
8. CONTACT	BOSTIC 3, EVO STIK CONTACT	LIQUID	LIGHT PRESSURE	IMMEDIATE	GOOD	GOOD	POOR	8

4. VARIOUS GLUES CAN BE USED TO BOND PARTICULAR MATERIALS TOGETHER.

TO SELECT A GLUE, MATCH A MATERIAL FROM THE TWO COLUMNS. THE NUMBERS REFER TO TABLE 3 ABOVE.

	ACRYLICS	TIMBERS	METALS	TEXTILES
ACRYLICS	4, 6, 8	8, 4, 2	8, 2	8, 2
TIMBERS	8, 4	1, 7, 3, 5, 8	6, 8, 2	8, 5, 2, 3
METALS	8, 2	6, 8, 2	6, 8, 2	8, 2, 3
TEXTILES	8, 2	8, 5, 2, 3	8, 2, 3	2, 5, 8

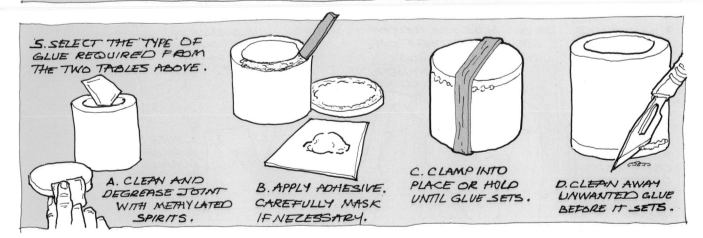

5. SELECT THE TYPE OF GLUE REQUIRED FROM THE TWO TABLES ABOVE.

A. CLEAN AND DEGREASE JOINT WITH METHYLATED SPIRITS.

B. APPLY ADHESIVE. CAREFULLY MASK IF NECESSARY.

C. CLAMP INTO PLACE OR HOLD UNTIL GLUE SETS.

D. CLEAN AWAY UNWANTED GLUE BEFORE IT SETS.

5.11 FILLERS AND FINISHES

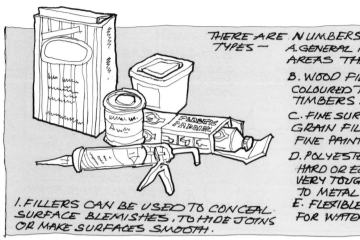

THERE ARE NUMBERS OF DIFFERENT TYPES —
A. GENERAL PURPOSE — LARGE AREAS THAT DO NOT MOVE.
B. WOOD FILLER — COLOURED TO SUIT VARIOUS TIMBERS.
C. FINE SURFACE — GRAIN FILLING OR FOR FINE PAINT FINISH.
D. POLYESTER — HARD OR ELASTIC GRADES. VERY TOUGH, WILL BOND TO METAL.
E. FLEXIBLE FILLER — FOR WATERPROOF JOINTS.

1. FILLERS CAN BE USED TO CONCEAL SURFACE BLEMISHES, TO HIDE JOINS OR MAKE SURFACES SMOOTH.

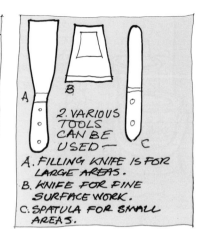

2. VARIOUS TOOLS CAN BE USED —
A. FILLING KNIFE IS FOR LARGE AREAS.
B. KNIFE FOR FINE SURFACE WORK.
C. SPATULA FOR SMALL AREAS.

3. TO FINISH NON-FERROUS METALS FIRST CLEAN THEM IN AN ACID PICKLE BATH.

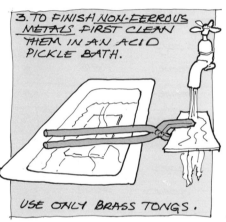

USE ONLY BRASS TONGS.

4. CLEAN WITH PUMICE POWDER AND A DAMP CLOTH.

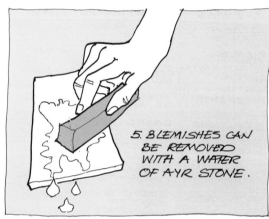

5. BLEMISHES CAN BE REMOVED WITH A WATER OF AYR STONE.

6. POLISHING CAN THEN BE UNDERTAKEN EITHER ON A BUFFING MACHINE OR WITH A SOFT CLOTH AND METAL POLISH.

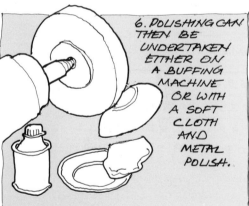

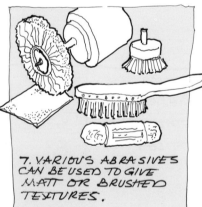

7. VARIOUS ABRASIVES CAN BE USED TO GIVE MATT OR BRUSHED TEXTURES.

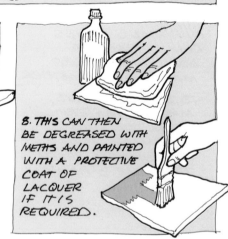

8. THIS CAN THEN BE DEGREASED WITH METHS AND PAINTED WITH A PROTECTIVE COAT OF LACQUER IF IT IS REQUIRED.

9. BRIGHT MILD STEEL CAN BE CLEANED UP WITH EMERY PAPER PROGRESSING FROM ROUGH TO FINE GRADES. THIS CAN BE PROTECTED WITH A LIGHT COATING OF GREASE OR VASELINE FOR INDOOR USE.

10. OIL BLUE IS A POPULAR SURFACE TREATMENT ON MILD STEEL TOOLS.
A. HEAT METAL TO DULL RED.
B. QUENCH IN OIL. (OLD CAR OIL IS BEST).
C. WHEN COOL WIPE OFF SURPLUS AND POLISH WITH BLACK SHOE POLISH.

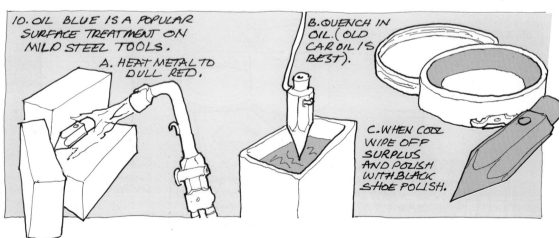

11. TIMBER CAN BE CLEANED UP WITH ABRASIVE PAPERS (SEE PAGE 139). THESE SHOULD BE WRAPPED TIGHTLY AROUND A CORK SANDING BLOCK.

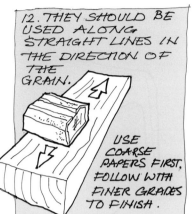

12. THEY SHOULD BE USED ALONG STRAIGHT LINES IN THE DIRECTION OF THE GRAIN.

USE COARSE PAPERS FIRST. FOLLOW WITH FINER GRADES TO FINISH.

13. KNOTS SHOULD BE TREATED WITH A STOPPER.

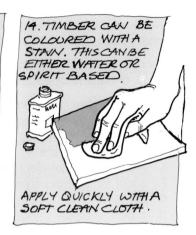

14. TIMBER CAN BE COLOURED WITH A STAIN. THIS CAN BE EITHER WATER OR SPIRIT BASED.

APPLY QUICKLY WITH A SOFT CLEAN CLOTH.

15. THE TIMBER CAN BE FINISHED IN A NUMBER OF WAYS —

A. TEAK OIL — APPLY A THIN COAT WITH A SOFT DRY CLOTH. WORK INTO GRAIN. APPLY A SECOND COAT AND FINISH WITH WIRE WOOL THE NEXT DAY.

B. WAX POLISH — SEAL THE SURFACE. SAND LIGHTLY. APPLY A HEAVY COAT OF POLISH. LEAVE FOR SEVERAL HOURS. BUFF WITH A SOFT CLOTH ALONG THE GRAIN.

C. POLYURATHANE VARNISH — STAIN IF REQUIRED. APPLY SEALING COAT WITH A PAD OF CLOTH. ALLOW TO DRY FOR SIX HOURS. APPLY FURTHER COATS WITH A BRUSH.

D. FRENCH POLISH — MAKE A PAD OF COTTON WOOL COVERED WITH COTTON CLOTH. APPLY THIN LAYERS IN CIRCULAR MOVEMENTS. ALLOW TO DRY FOR 8 HOURS. REPEAT WITH CLEAN CLOTH, THEN POLISH WITH METHYLATED SPIRITS.

16. PLASTIC LAMINATES CAN BE CUT AND STUCK WITH CONTACT ADHESIVE TO VARIOUS TYPES OF BOARD.

17. MOST SURFACES CAN BE PAINTED.

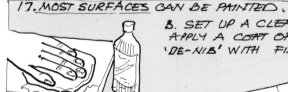

A. FIRST CLEAN AND DEGREASE THE SURFACE. USE METHS ON METAL, WHITE SPIRIT ON TIMBER.

B. SET UP A CLEAN SPACE TO WORK IN. APPLY A COAT OF PRIMER. ALLOW TO DRY. 'DE-NIB' WITH FINE GLASS-PAPER.

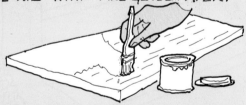

C. APPLY THE TOP COAT BRUSHING IN THE OPPOSITE DIRECTION TO THE PRIMER COAT. 'DE-NIB' AND ADD FURTHER COATS AS NECESSARY.

18. AFTER THEY HAVE BEEN FILED, PLASTICS CAN BE SCRAPED WITH A SHARP EDGE.

19. AFTER SMOOTHING WITH WET AND DRY PAPER (PAGE 139) THE PLASTIC CAN BE POLISHED WITH METAL POLISH....

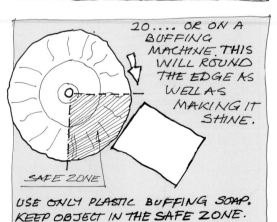

20..... OR ON A BUFFING MACHINE. THIS WILL ROUND THE EDGE AS WELL AS MAKING IT SHINE.

SAFE ZONE

USE ONLY PLASTIC BUFFING SOAP. KEEP OBJECT IN THE SAFE ZONE.

5.12 ACTIVITIES FOR MATERIALS

These activities should be attempted, one product at a time, over a number of sessions.

Choose the most appropriate raw material (plastic, metal, or timber) for each of the products listed below:

A a decorative container
B a kitchen chopping board
C a bath toy for a young child
D a garden tool rack
E a stand for a hot electric iron
F a tool for clearing snow from paths
G a coffee table
H a picture frame

Sketch a design for each product.
Then answer the following questions explaining the reasons for your choices.

1 Which raw material did you choose?
2 Which specific type of that material would you select? (Pages 102–109.)
3 From which form of that material would you begin to manufacture your product? (Pages 110–111.)
4 Which joints would you use? (Pages 112–117.)
5 Which fixtures and fittings would you incorporate into your design? (Pages 118–120.)
6 What type of adhesive would you use to join your materials? (Page 121.)
7 Which finishes would you apply? (Pages 122–123.)

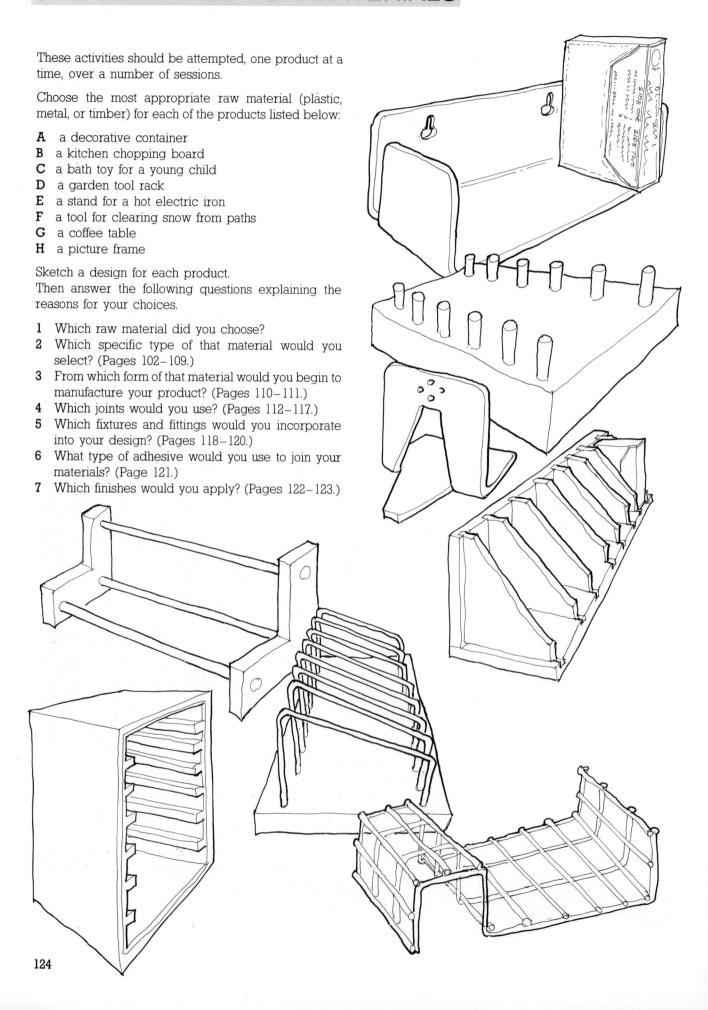

SECTION 6
TOOLS AND MACHINES

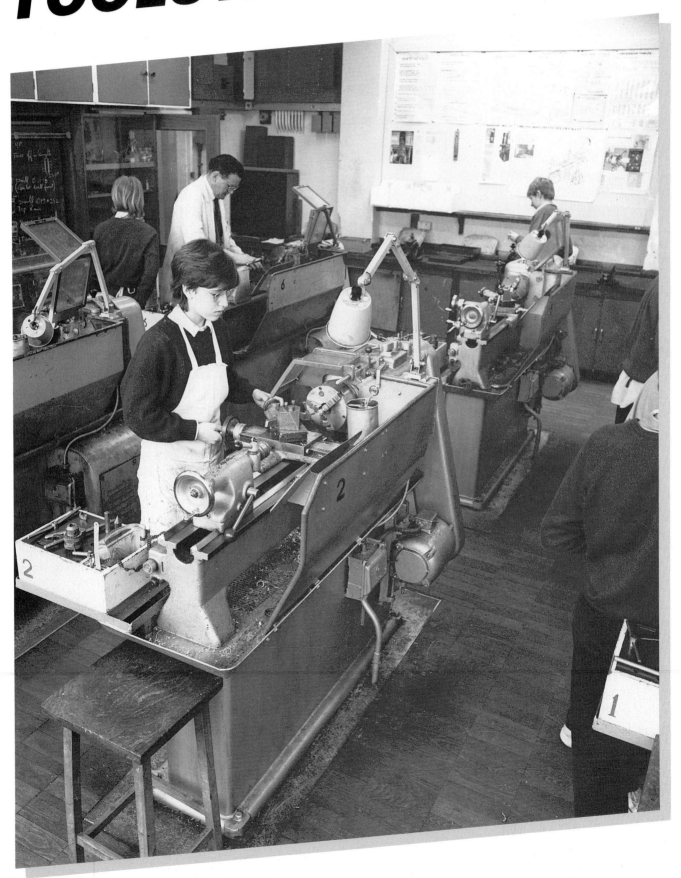

6.1 SAFETY

Similar tools and machines are grouped together on the following pages. They are presented in pictorial form with a brief explanation of their use. By consulting these pages, you should be able to select the correct tool or machine for each particular task.

These tools and machines have been designed and developed over many years to help produce a good product. They should be kept in good condition and used with care.

Tools and machines can be dangerous. When you are in the workshop you should always observe the safety rules. These refer to you, your actions, and the use of tools, machines, and materials.

YOU

1 Wear an overall to protect your clothes.
2 Roll up long sleeves and tuck in loose clothing.
3 Wear stout shoes.
4 Remove jewellery and watches.
5 Tie back long hair.
6 Wear special safety clothing and equipment when necessary.

YOUR ACTIONS

1 Never work alone or without permission in the workshop.
2 Never run or act irresponsibly in the workshop.
3 Always keep your work area clean and tidy.

MATERIALS

1 Heated work should be handled with care.
2 Plastics should be kept away from naked flames.
3 Chemicals, resins, and catalysts must be used with caution, and in well ventilated conditions.
4 Materials, which give off fumes or a fine dust when worked, should be used with ventilators and extractors switched on. Dust masks, eye protection, and barrier creams should be used.

TOOLS

1 Make sure that tools are in good condition.
2 Never use tools for anything other than their intended purpose.
3 Do not be careless with sharp tools.
4 Always place tools so as to protect their cutting edge.
5 Always follow correct procedures for particular operations.
6 Replace tools carefully in the racks provided, when they are no longer needed.

MACHINES

1 Machines should never be used without permission.
2 Only one person should operate a machine at any one time.
3 Eye protection must be worn, and guards lowered, *before* machines are turned on.
4 Work should always be held securely before it is machined.
5 Do not adjust machines without first switching off the power at the isolator.

Remember: the safety rules have been compiled to help **prevent accidents**. So, in the workshop, it is always better to **be safe** rather than sorry.

6.2 MARKING OUT

Marking out must be undertaken with care. A steel rule is essential because it is accurate and can be used to measure. Mark out and check flatness. A tri square is also important. It is set to 90° and is used to mark out and to check squareness.

Metals are often painted with a fast drying coat of engineer's blue, so that scriber marks can be clearly seen. The key below indicates the materials that can be worked with the tools on this page.

Metal Timber Plastic

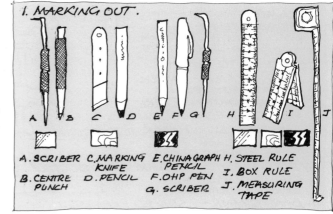

1. MARKING OUT.

A. SCRIBER C. MARKING KNIFE E. CHINAGRAPH PENCIL H. STEEL RULE
B. CENTRE PUNCH D. PENCIL F. OHP PEN I. BOX RULE
G. SCRIBER J. MEASURING TAPE

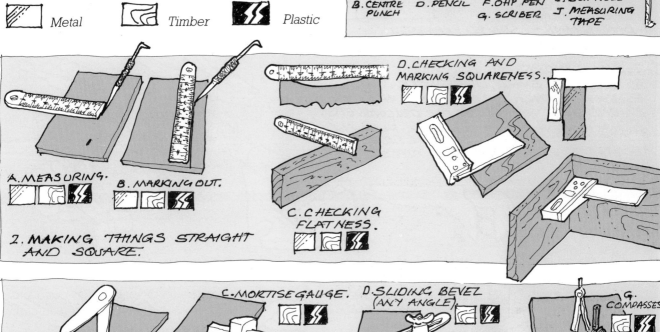

A. MEASURING.

B. MARKING OUT.

C. CHECKING FLATNESS.

D. CHECKING AND MARKING SQUARENESS.

2. MAKING THINGS STRAIGHT AND SQUARE.

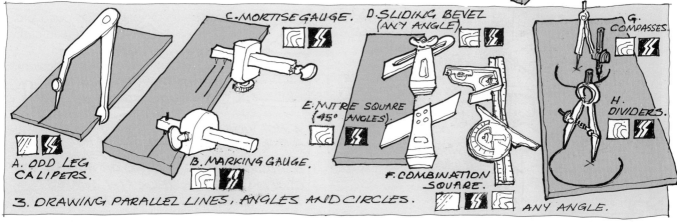

A. ODD LEG CALIPERS.

B. MARKING GAUGE.

C. MORTISE GAUGE.

D. SLIDING BEVEL (ANY ANGLE).

E. MITRE SQUARE (45° ANGLES).

F. COMBINATION SQUARE.

ANY ANGLE.

G. COMPASSES.

H. DIVIDERS.

3. DRAWING PARALLEL LINES, ANGLES AND CIRCLES.

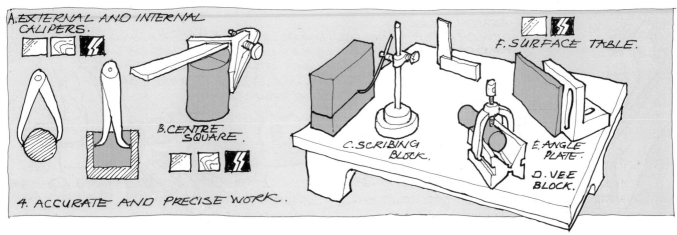

A. EXTERNAL AND INTERNAL CALIPERS.

B. CENTRE SQUARE.

C. SCRIBING BLOCK.

D. VEE BLOCK.

E. ANGLE PLATE.

F. SURFACE TABLE.

4. ACCURATE AND PRECISE WORK.

127

6.3 HOLDING DEVICES

1. CLAMPS.
A. THUMBSCREW. ~ SMALL WORK UP TO 100 mm
B. G CRAMP ~ VARIOUS SIZES UP TO 300 mm
C. RACK CLAMP ~ WORK FROM 140 — 1830 mm
D. SASH CRAMP ~ LARGE FRAMES UP TO 2000 mm
E. HANDSCREW ~ TIMBER UP TO 300 mm
F. TOOLMAKERS CLAMP ~ METAL + PLASTICS TO 90 mm
G. STRING CLAMP ~ LARGE FRAMES
H. BAND CLAMP ~ SHAPED FRAMES.

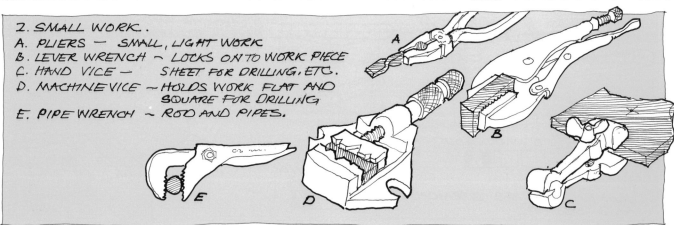

2. SMALL WORK.
A. PLIERS — SMALL, LIGHT WORK
B. LEVER WRENCH ~ LOCKS ON TO WORK PIECE
C. HAND VICE — SHEET FOR DRILLING, ETC.
D. MACHINE VICE ~ HOLDS WORK FLAT AND SQUARE FOR DRILLING
E. PIPE WRENCH ~ ROD AND PIPES.

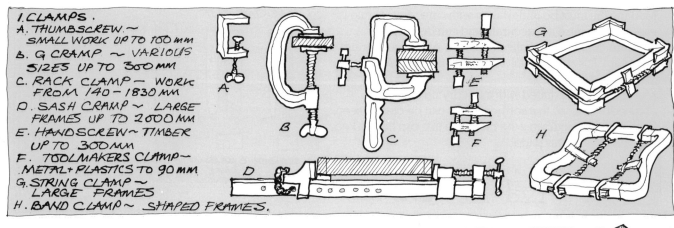

3. VICES ARE THE MOST VERSATILE OF HOLDING DEVICES.
THEY WILL SECURE LONG, SHORT, FAT, AND THIN OBJECTS AS REQUIRED.

A. WOODWORKER'S VICE
B. ENGINEER'S VICE

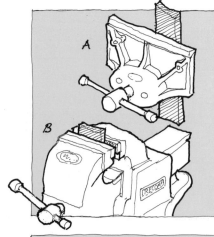

4. HOT WORK.
A. PICK UP TONGS — PICKING UP HOT WORK NOT FOR FORGING
B. HOLLOW BIT — ROUND OR SQUARE WORK
C. OPEN MOUTH — THICK FLAT SHAPES
D. CLOSE MOUTH — THIN MATERIALS.

5. BENCH WORK.
A. BENCH STOP — HOLDS TIMBER STEADY FOR PLANING
B. HOLDFAST — HOLDS LONG, LARGE PIECES OF WORK
C. BENCH HOOK — HOLDS TIMBER STEADY FOR CROSS SAWING
D. MITRE CLAMP — FOR CUTTING AND GLUEING MITRE CORNERS
E. FOLDING BARS — FOR BENDING THIN SHEET.

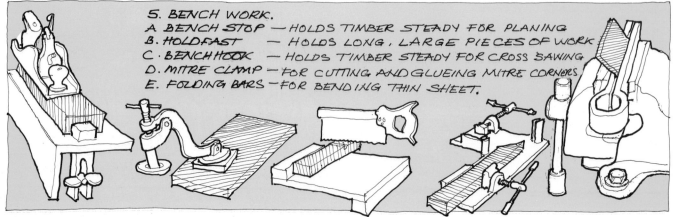

6.4 SAWS

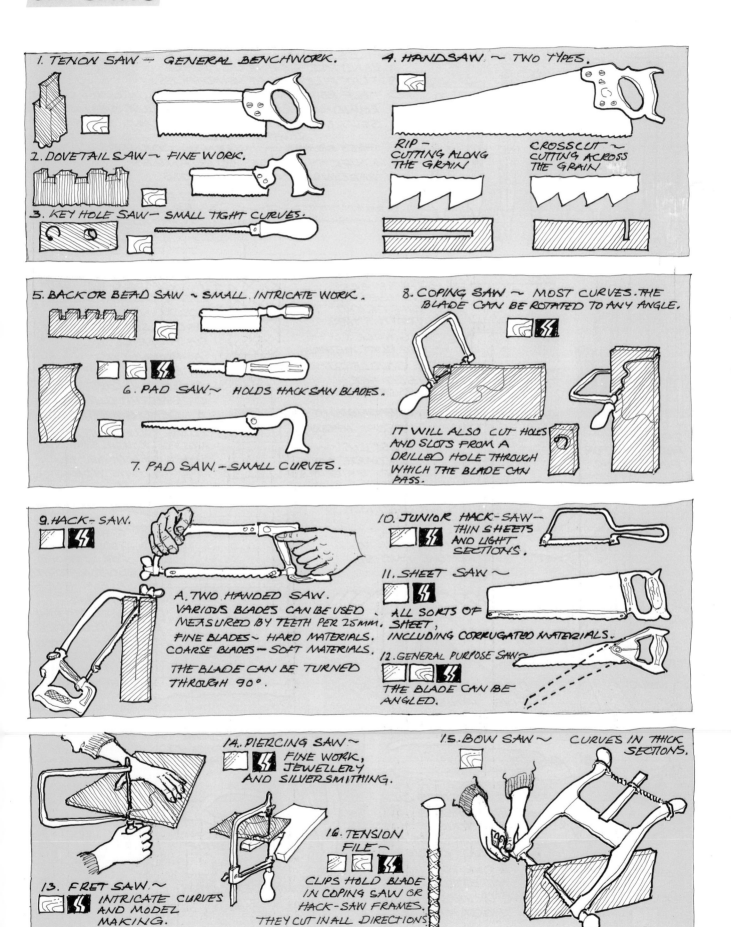

1. TENON SAW ~ GENERAL BENCHWORK.

2. DOVETAIL SAW ~ FINE WORK.

3. KEY HOLE SAW ~ SMALL TIGHT CURVES.

4. HANDSAW ~ TWO TYPES.

RIP ~ CUTTING ALONG THE GRAIN

CROSSCUT ~ CUTTING ACROSS THE GRAIN

5. BACK OR BEAD SAW ~ SMALL, INTRICATE WORK.

6. PAD SAW ~ HOLDS HACK SAW BLADES.

7. PAD SAW ~ SMALL CURVES.

8. COPING SAW ~ MOST CURVES. THE BLADE CAN BE ROTATED TO ANY ANGLE.

IT WILL ALSO CUT HOLES AND SLOTS FROM A DRILLED HOLE THROUGH WHICH THE BLADE CAN PASS.

9. HACK-SAW.

A. TWO HANDED SAW. VARIOUS BLADES CAN BE USED. MEASURED BY TEETH PER 25mm. FINE BLADES ~ HARD MATERIALS. COARSE BLADES ~ SOFT MATERIALS.

THE BLADE CAN BE TURNED THROUGH 90°.

10. JUNIOR HACK-SAW ~ THIN SHEETS AND LIGHT SECTIONS.

11. SHEET SAW ~ ALL SORTS OF SHEET, INCLUDING CORRUGATED MATERIALS.

12. GENERAL PURPOSE SAW ~ THE BLADE CAN BE ANGLED.

13. FRET SAW. ~ INTRICATE CURVES AND MODEL MAKING.

14. PIERCING SAW ~ FINE WORK, JEWELLERY AND SILVERSMITHING.

16. TENSION FILE ~ CLIPS HOLD BLADE IN COPING SAW OR HACK-SAW FRAMES. THEY CUT IN ALL DIRECTIONS.

15. BOW SAW ~ CURVES IN THICK SECTIONS.

6.5 SHAPING TOOLS

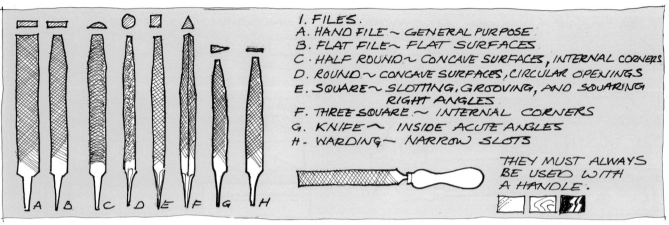

1. FILES.
A. HAND FILE ~ GENERAL PURPOSE.
B. FLAT FILE ~ FLAT SURFACES.
C. HALF ROUND ~ CONCAVE SURFACES, INTERNAL CORNERS.
D. ROUND ~ CONCAVE SURFACES, CIRCULAR OPENINGS
E. SQUARE ~ SLOTTING, GROOVING, AND SQUARING RIGHT ANGLES
F. THREE SQUARE ~ INTERNAL CORNERS
G. KNIFE ~ INSIDE ACUTE ANGLES
H. WARDING ~ NARROW SLOTS

THEY MUST ALWAYS BE USED WITH A HANDLE.

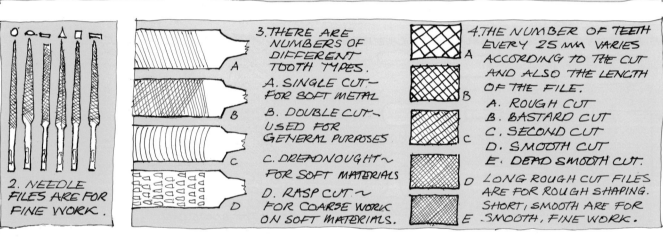

2. NEEDLE FILES ARE FOR FINE WORK.

3. THERE ARE NUMBERS OF DIFFERENT TOOTH TYPES.
A. SINGLE CUT ~ FOR SOFT METAL
B. DOUBLE CUT ~ USED FOR GENERAL PURPOSES
C. DREADNOUGHT ~ FOR SOFT MATERIALS
D. RASP CUT ~ FOR COARSE WORK ON SOFT MATERIALS.

4. THE NUMBER OF TEETH EVERY 25 mm VARIES ACCORDING TO THE CUT AND ALSO THE LENGTH OF THE FILE.
A. ROUGH CUT
B. BASTARD CUT
C. SECOND CUT
D. SMOOTH CUT
E. DEAD SMOOTH CUT.
LONG ROUGH CUT FILES ARE FOR ROUGH SHAPING. SHORT, SMOOTH ARE FOR SMOOTH, FINE WORK.

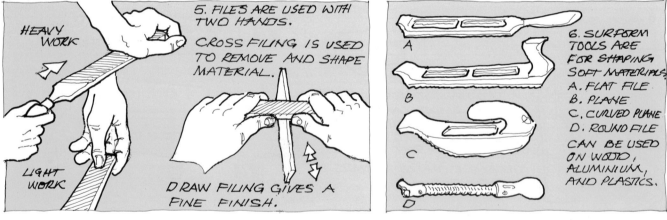

5. FILES ARE USED WITH TWO HANDS.

CROSS FILING IS USED TO REMOVE AND SHAPE MATERIAL.

HEAVY WORK

LIGHT WORK

DRAW FILING GIVES A FINE FINISH.

6. SURFORM TOOLS ARE FOR SHAPING SOFT MATERIALS.
A. FLAT FILE
B. PLANE
C. CURVED PLANE
D. ROUND FILE
CAN BE USED ON WOOD, ALUMINIUM, AND PLASTICS.

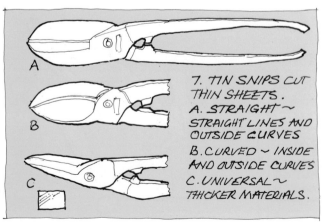

7. TIN SNIPS CUT THIN SHEETS.
A. STRAIGHT ~ STRAIGHT LINES AND OUTSIDE CURVES
B. CURVED ~ INSIDE AND OUTSIDE CURVES
C. UNIVERSAL ~ THICKER MATERIALS.

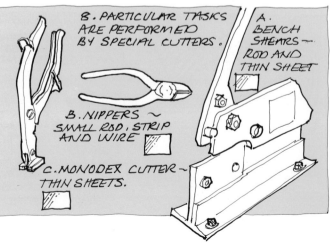

8. PARTICULAR TASKS ARE PERFORMED BY SPECIAL CUTTERS.
A. BENCH SHEARS ~ ROD AND THIN SHEET
B. NIPPERS ~ SMALL ROD, STRIP AND WIRE
C. MONODEX CUTTER ~ THIN SHEETS.

6.6 PLANES

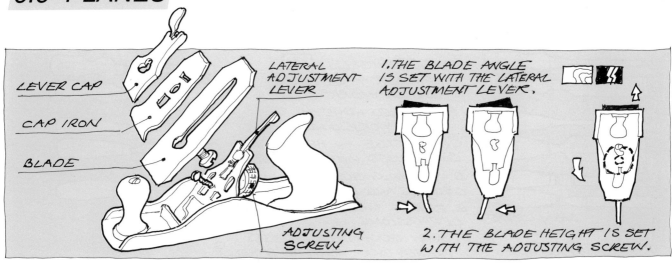

LEVER CAP

CAP IRON

BLADE

LATERAL ADJUSTMENT LEVER

ADJUSTING SCREW

1. THE BLADE ANGLE IS SET WITH THE LATERAL ADJUSTMENT LEVER.

2. THE BLADE HEIGHT IS SET WITH THE ADJUSTING SCREW.

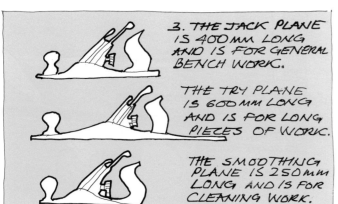

3. THE JACK PLANE IS 400mm LONG AND IS FOR GENERAL BENCH WORK.

THE TRY PLANE IS 600mm LONG AND IS FOR LONG PIECES OF WORK.

THE SMOOTHING PLANE IS 250mm LONG AND IS FOR CLEANING WORK.

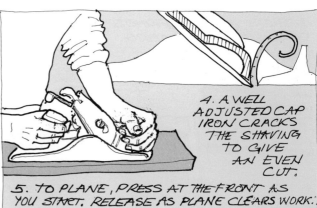

4. A WELL ADJUSTED CAP IRON CRACKS THE SHAVING TO GIVE AN EVEN CUT.

5. TO PLANE, PRESS AT THE FRONT AS YOU START. RELEASE AS PLANE CLEARS WORK.

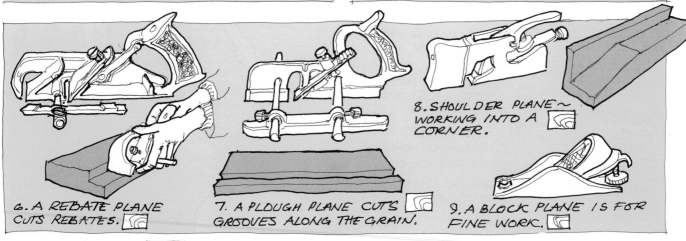

6. A REBATE PLANE CUTS REBATES.

7. A PLOUGH PLANE CUTS GROOVES ALONG THE GRAIN.

8. SHOULDER PLANE ~ WORKING INTO A CORNER.

9. A BLOCK PLANE IS FOR FINE WORK.

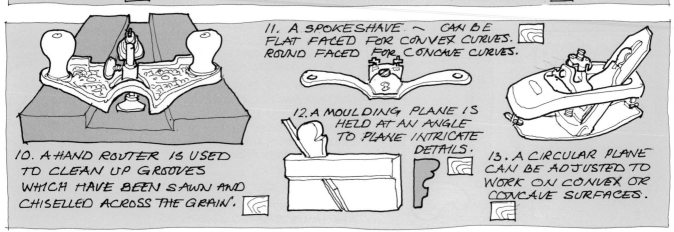

10. A HAND ROUTER IS USED TO CLEAN UP GROOVES WHICH HAVE BEEN SAWN AND CHISELLED ACROSS THE GRAIN.

11. A SPOKESHAVE ~ CAN BE FLAT FACED FOR CONVEX CURVES. ROUND FACED FOR CONCAVE CURVES.

12. A MOULDING PLANE IS HELD AT AN ANGLE TO PLANE INTRICATE DETAILS.

13. A CIRCULAR PLANE CAN BE ADJUSTED TO WORK ON CONVEX OR CONCAVE SURFACES.

6.7 CHISELS AND SCRAPERS

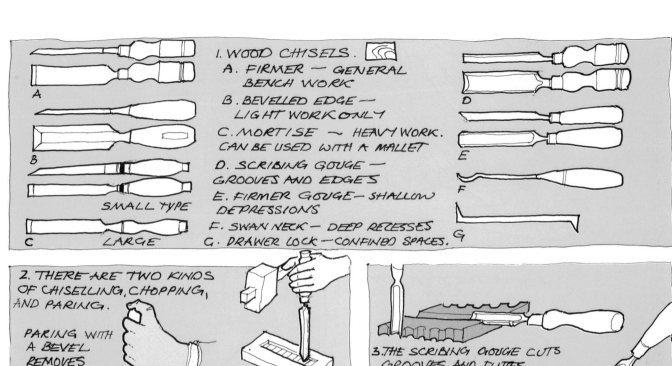

1. WOOD CHISELS.
 A. FIRMER — GENERAL BENCH WORK
 B. BEVELLED EDGE — LIGHT WORK ONLY
 C. MORTISE — HEAVY WORK. CAN BE USED WITH A MALLET
 D. SCRIBING GOUGE — GROOVES AND EDGES
 E. FIRMER GOUGE — SHALLOW DEPRESSIONS
 F. SWAN NECK — DEEP RECESSES
 G. DRAWER LOCK — CONFINED SPACES.

A

B

C SMALL TYPE LARGE

D

E

F

G

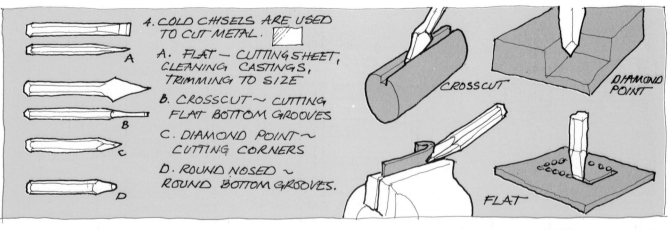

2. THERE ARE TWO KINDS OF CHISELLING, CHOPPING, AND PARING.

PARING WITH A BEVEL REMOVES SMALL SHAVINGS..

..CHOPPING WITH A MORTISE CHISEL REMOVES LARGE CHIPS.

3. THE SCRIBING GOUGE CUTS GROOVES AND FLUTES.

THE FIRMER GOUGE WILL CUT SHALLOW DEPRESSIONS.

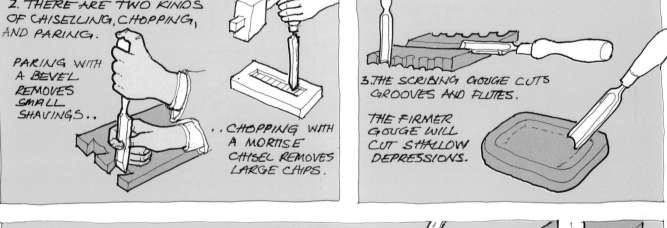

4. COLD CHISELS ARE USED TO CUT METAL.

A. FLAT — CUTTING SHEET, CLEANING CASTINGS, TRIMMING TO SIZE

B. CROSSCUT — CUTTING FLAT BOTTOM GROOVES

C. DIAMOND POINT — CUTTING CORNERS

D. ROUND NOSED — ROUND BOTTOM GROOVES.

A

B

C

D

CROSSCUT DIAMOND POINT

FLAT

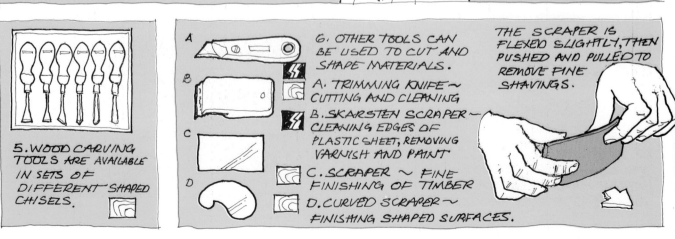

5. WOOD CARVING TOOLS ARE AVAILABLE IN SETS OF DIFFERENT SHAPED CHISELS.

6. OTHER TOOLS CAN BE USED TO CUT AND SHAPE MATERIALS.

A. TRIMMING KNIFE — CUTTING AND CLEANING

B. SKARSTEN SCRAPER — CLEANING EDGES OF PLASTIC SHEET, REMOVING VARNISH AND PAINT

C. SCRAPER — FINE FINISHING OF TIMBER

D. CURVED SCRAPER — FINISHING SHAPED SURFACES.

THE SCRAPER IS FLEXED SLIGHTLY, THEN PUSHED AND PULLED TO REMOVE FINE SHAVINGS.

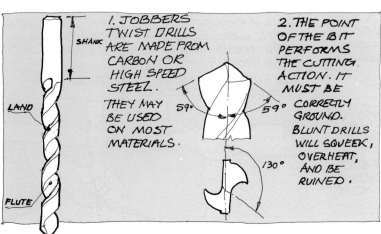

1. JOBBERS TWIST DRILLS ARE MADE FROM CARBON OR HIGH SPEED STEEL.

THEY MAY BE USED ON MOST MATERIALS.

SHANK

LAND

FLUTE

2. THE POINT OF THE BIT PERFORMS THE CUTTING ACTION. IT MUST BE CORRECTLY GROUND. BLUNT DRILLS WILL SQUEEK, OVERHEAT, AND BE RUINED.

59° 59°

130°

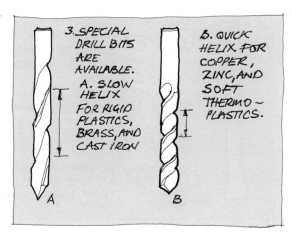

3. SPECIAL DRILL BITS ARE AVAILABLE.

A. SLOW HELIX FOR RIGID PLASTICS, BRASS, AND CAST IRON

B. QUICK HELIX FOR COPPER, ZINC, AND SOFT THERMO~ PLASTICS.

A B

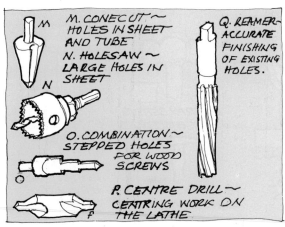

4. BITS FOR BORING TIMBER HAVE AN OPEN FLUTE.

A. AUGER BIT ~ DEEP HOLES IN GREEN TIMBER

B. JENNINGS PATTERN ~ FOR DOWEL HOLES

C. SOLID NOSED ~ HEAVY WORK AND DRILLING AT AN ANGLE

A B C SPUR POINT

CENTRE BITS~ FOR SHALLOW HOLES

D. SCREW POINTED

E. FLAT OR BRAD POINTED

D E F

F. FORSTNER~ FLAT BOTTOMED HOLES

G. EXPANSIVE ~ VARIOUS SIZED HOLES IN THIN MATERIAL

G H

H. FLAT BIT HIGH SPEEDS ONLY

I J

COUNTERSINKS
I. SNAILHORN ~ SOFTWOODS
J. ROSEHEAD ~ METAL HARDWOOD, PLASTICS

K. SHELL AUGER BIT ~ SMALL AND TAPERED HOLES

L. DOWEL BIT ~ CHAMFERING DOWELS

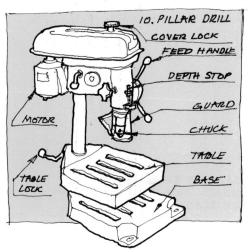

M. CONECUT ~ HOLES IN SHEET AND TUBE

N. HOLESAW ~ LARGE HOLES IN SHEET

O. COMBINATION ~ STEPPED HOLES FOR WOOD SCREWS

P. CENTRE DRILL ~ CENTRING WORK ON THE LATHE

Q. REAMER~ ACCURATE FINISHING OF EXISTING HOLES.

M N O P Q

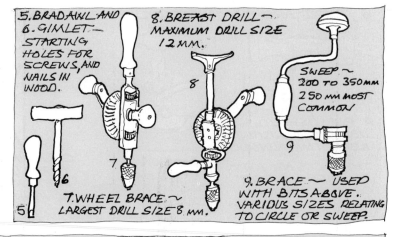

5. BRADAWL AND
6. GIMLET ~ STARTING HOLES FOR SCREWS, AND NAILS IN WOOD.

5 6 7 8 9

T. WHEEL BRACE ~ LARGEST DRILL SIZE 8 MM.

8. BREAST DRILL ~ MAXIMUM DRILL SIZE 12 MM.

SWEEP ~ 200 TO 350MM 250 MM MOST COMMON

9. BRACE ~ USED WITH BITS ABOVE. VARIOUS SIZES RELATING TO CIRCLE OR SWEEP.

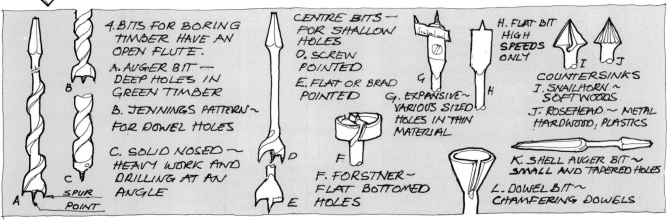

10. PILLAR DRILL

COVER LOCK
FEED HANDLE
DEPTH STOP
GUARD
CHUCK
TABLE
BASE
MOTOR
TABLE LOCK

11. DRILLING RULES~

A. THE CENTRE OF THE HOLE MUST BE CLEARLY MARKED

B. THEN THE WORK SECURELY CLAMPED IN PLACE

C. THE CORRECT SPEED MUST BE USED (SEE OPPOSITE)

D. CUTTING FLUID USED WHEN NECESSARY (SEE PAGE 137).

MATERIAL	DRILL DIAMETER IN MM.					
	1·5	3	6	8	10	12
MILD STEEL	5200	2600	1300	975	775	650
HIGH CARBON STEEL	2600	1300	650	485	385	325
ALUMINIUM ALLOYS	6500	3250	1625	1200	975	800
BRASS	6500	3250	1625	1200	975	800
GREY CAST IRON	5200	2600	1300	975	775	650
ACYLIC	7000	3720	1800	1400	1110	900

APPROXIMATE DRILL SPEED IN R.P.M. FOR HIGH SPEED STEEL DRILL BITS.

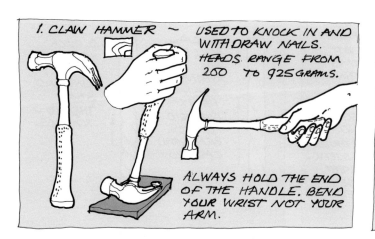

1. CLAW HAMMER ~ USED TO KNOCK IN AND WITH DRAW NAILS. HEADS RANGE FROM 200 TO 925 GRAMS.

ALWAYS HOLD THE END OF THE HANDLE. BEND YOUR WRIST NOT YOUR ARM.

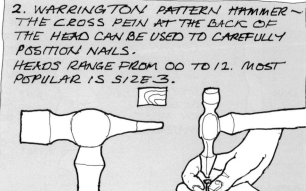

2. WARRINGTON PATTERN HAMMER ~ THE CROSS PEIN AT THE BACK OF THE HEAD CAN BE USED TO CAREFULLY POSITION NAILS.
HEADS RANGE FROM 00 TO 12. MOST POPULAR IS SIZE 3.

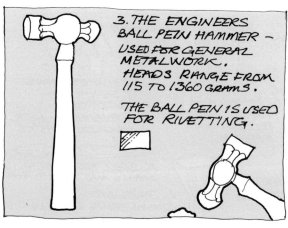

3. THE ENGINEERS BALL PEIN HAMMER ~ USED FOR GENERAL METALWORK. HEADS RANGE FROM 115 TO 1360 GRAMS.

THE BALL PEIN IS USED FOR RIVETTING.

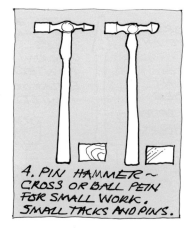

4. PIN HAMMER ~ CROSS OR BALL PEIN FOR SMALL WORK. SMALL TACKS AND PINS.

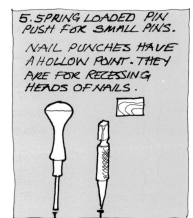

5. SPRING LOADED PIN PUSH FOR SMALL PINS.

NAIL PUNCHES HAVE A HOLLOW POINT. THEY ARE FOR RECESSING HEADS OF NAILS.

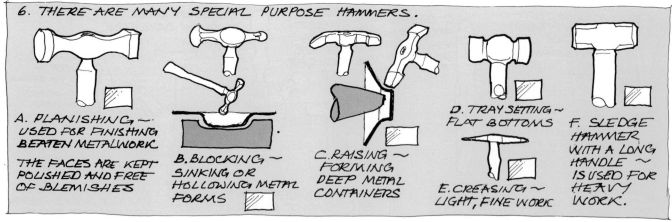

6. THERE ARE MANY SPECIAL PURPOSE HAMMERS.

A. PLANISHING ~ USED FOR FINISHING BEATEN METALWORK.

THE FACES ARE KEPT POLISHED AND FREE OF BLEMISHES

B. BLOCKING ~ SINKING OR HOLLOWING METAL FORMS

C. RAISING ~ FORMING DEEP METAL CONTAINERS

D. TRAY SETTING ~ FLAT BOTTOMS

E. CREASING ~ LIGHT, FINE WORK

F. SLEDGE HAMMER WITH A LONG HANDLE ~ IS USED FOR HEAVY WORK.

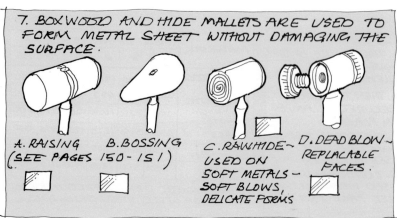

7. BOXWOOD AND HIDE MALLETS ARE USED TO FORM METAL SHEET WITHOUT DAMAGING THE SURFACE.

A. RAISING (SEE PAGES 150-151)

B. BOSSING

C. RAWHIDE ~ USED ON SOFT METALS ~ SOFT BLOWS, DELICATE FORMS

D. DEAD BLOW ~ REPLACABLE FACES.

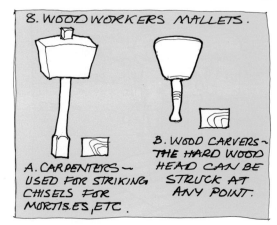

8. WOODWORKERS MALLETS.

A. CARPENTERS ~ USED FOR STRIKING CHISELS FOR MORTISES, ETC.

B. WOOD CARVERS ~ THE HARD WOOD HEAD CAN BE STRUCK AT ANY POINT.

6.10 ASSEMBLY TOOLS

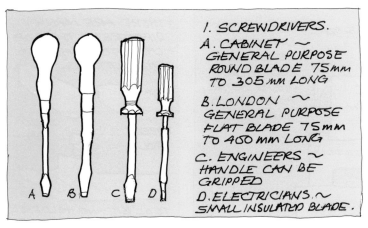

1. SCREWDRIVERS.
A. CABINET ~ GENERAL PURPOSE ROUND BLADE 75mm TO 305 mm LONG

B. LONDON ~ GENERAL PURPOSE FLAT BLADE 75mm TO 450 mm LONG

C. ENGINEERS ~ HANDLE CAN BE GRIPPED

D. ELECTRICIANS ~ SMALL INSULATED BLADE.

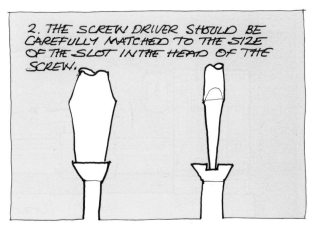

2. THE SCREW DRIVER SHOULD BE CAREFULLY MATCHED TO THE SIZE OF THE SLOT IN THE HEAD OF THE SCREW.

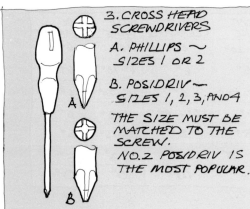

3. CROSS HEAD SCREWDRIVERS

A. PHILLIPS ~ SIZES 1 OR 2

B. POSIDRIV ~ SIZES 1, 2, 3, AND 4

THE SIZE MUST BE MATCHED TO THE SCREW.
NO. 2 POSIDRIV IS THE MOST POPULAR.

4. BOTH SLOT AND CROSSHEAD SCREW DRIVERS ARE AVAILABLE IN SPECIAL FORMS.
A. YANKEE (SPIRAL RACHET) PUMP ACTION TIGHTENS AND UNTIGHTENS SCREWS
B. RACHET ~ HEAD STAYS IN CONTACT WITH THE SCREW
C. STUBBY ~ SMALL SPACES
D. OFFSET ~ AWKWARD SPOTS
E. OFFSET RACHET ~ EXTENSION ARMS AND VARIOUS BITS AVAILABLE.

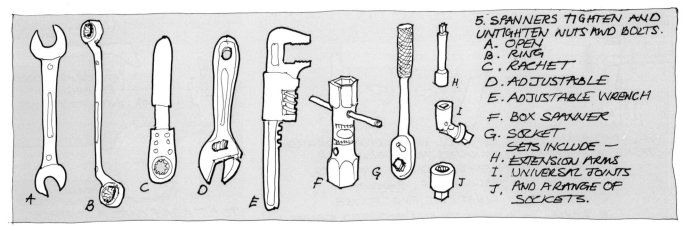

5. SPANNERS TIGHTEN AND UNTIGHTEN NUTS AND BOLTS.
A. OPEN
B. RING
C. RACHET
D. ADJUSTABLE
E. ADJUSTABLE WRENCH
F. BOX SPANNER
G. SOCKET SETS INCLUDE ~
H. EXTENSION ARMS
I. UNIVERSAL JOINTS
J. AND A RANGE OF SOCKETS.

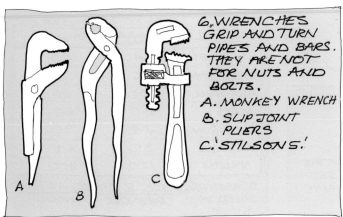

6. WRENCHES GRIP AND TURN PIPES AND BARS. THEY ARE NOT FOR NUTS AND BOLTS.
A. MONKEY WRENCH
B. SLIP JOINT PLIERS
C. 'STILSONS.'

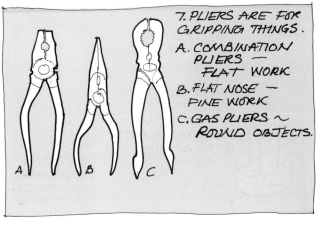

7. PLIERS ARE FOR GRIPPING THINGS.

A. COMBINATION PLIERS ~ FLAT WORK

B. FLAT NOSE ~ FINE WORK

C. GAS PLIERS ~ ROUND OBJECTS.

6.11 CENTRE LATHE

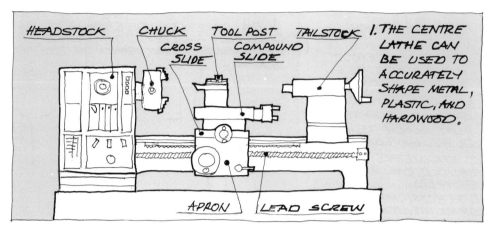

HEADSTOCK CHUCK TOOL POST TAILSTOCK
CROSS SLIDE COMPOUND SLIDE

1. THE CENTRE LATHE CAN BE USED TO ACCURATELY SHAPE METAL, PLASTIC, AND HARDWOOD.

APRON LEAD SCREW

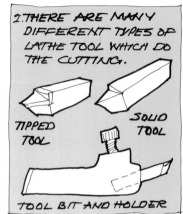

2. THERE ARE MANY DIFFERENT TYPES OF LATHE TOOL WHICH DO THE CUTTING.

TIPPED TOOL SOLID TOOL

TOOL BIT AND HOLDER

3. THEY MUST BE GROUND TO A SHAPE SUITED TO THE MATERIAL BEING WORKED.

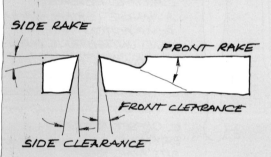

SIDE RAKE

FRONT RAKE

FRONT CLEARANCE

SIDE CLEARANCE

MATERIAL	FRONT RAKE	FRONT CLEARANCE	SIDE RAKE	SIDE CLEARANCE
MILD STEEL	15°–20°	8°	15°	6°
CARBON STEEL	5°	6°	6°–10°	6°
ALUMINIUM	35°–55°	6°	10°–20°	6°
BRASS	0°	6°–8°	0°–3°	6°
CAST IRON	8°	8°	10°–15°	6°
ACRYLIC	0°–3°	15°	0°–3°	6°
NYLON	5°	10°	0°	10°

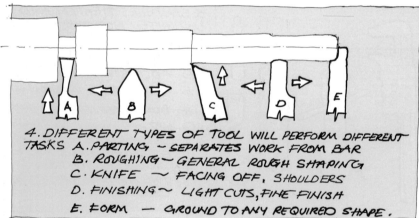

4. DIFFERENT TYPES OF TOOL WILL PERFORM DIFFERENT TASKS A. PARTING ~ SEPARATES WORK FROM BAR
B. ROUGHING ~ GENERAL ROUGH SHAPING
C. KNIFE ~ FACING OFF, SHOULDERS
D. FINISHING ~ LIGHT CUTS, FINE FINISH
E. FORM ~ GROUND TO ANY REQUIRED SHAPE.

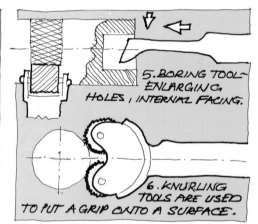

5. BORING TOOL~ ENLARGING HOLES, INTERNAL FACING.

6. KNURLING TOOLS ARE USED TO PUT A GRIP ONTO A SURFACE.

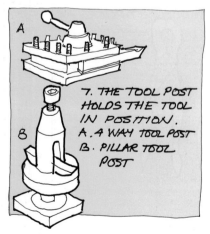

7. THE TOOL POST HOLDS THE TOOL IN POSITION.
A. 4 WAY TOOL POST
B. PILLAR TOOL POST

8. THE POINT OF THE TOOL MUST BE SET ON THE CENTRE LINE OF THE WORK.

MATERIAL	SPEED IN METRES PER MIN.	
	TURNING AND FACING	FINISHING
MILD STEEL	24	30
CARBON STEEL	12	18
ALUMINIUM	30	60
BRASS	30	60
CAST IRON	24	30
ACRYLIC	35	60
NYLON	120	300

9. MACHINE SPEED IN R.P.M.
$$= \frac{320 \times SPEED \text{ AS ABOVE}}{DIAMETER \text{ OF WORK}}$$

10. LUBRICANTS AND COOLING FLUIDS ARE USED TO ~
1. KEEP WORK COOL
2. REDUCE TOOL WEAR
3. GIVE A BETTER FINISH.

ALUMINIUM ~ PARAFFIN
BRASS ~ NONE
MILD STEEL ~ SOLUBLE OIL
CAST IRON ~ NONE
ACRYLIC ~ SOLUBLE OIL OR PARAFFIN
NYLON ~ NONE
TOOL STEEL ~ SOLUBLE OIL

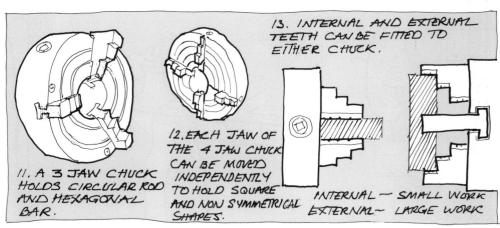

11. A 3 JAW CHUCK HOLDS CIRCULAR ROD AND HEXAGONAL BAR.

12. EACH JAW OF THE 4 JAW CHUCK CAN BE MOVED INDEPENDENTLY TO HOLD SQUARE AND NON SYMMETRICAL SHAPES.

13. INTERNAL AND EXTERNAL TEETH CAN BE FITTED TO EITHER CHUCK.

INTERNAL ~ SMALL WORK
EXTERNAL ~ LARGE WORK

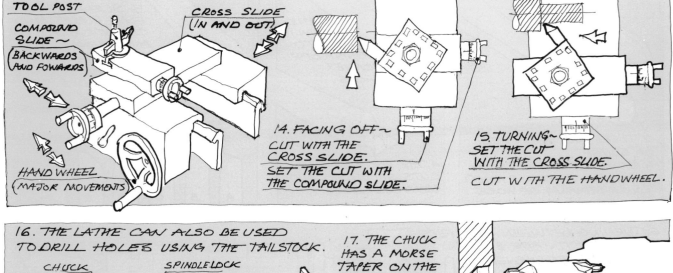

TOOL POST
COMPOUND SLIDE ~ (BACKWARDS AND FOWARDS)
CROSS SLIDE (IN AND OUT)
HAND WHEEL (MAJOR MOVEMENTS)

14. FACING OFF ~ CUT WITH THE CROSS SLIDE. SET THE CUT WITH THE COMPOUND SLIDE.

15. TURNING ~ SET THE CUT WITH THE CROSS SLIDE. CUT WITH THE HANDWHEEL.

16. THE LATHE CAN ALSO BE USED TO DRILL HOLES USING THE TAILSTOCK.

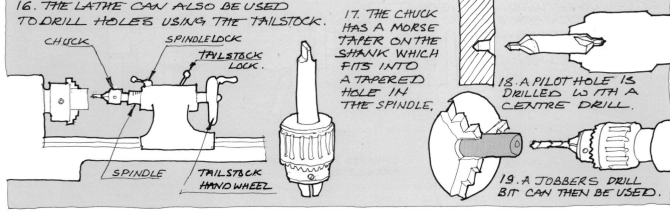

CHUCK
SPINDLE LOCK
TAILSTOCK LOCK.
SPINDLE
TAILSTOCK HAND WHEEL

17. THE CHUCK HAS A MORSE TAPER ON THE SHANK WHICH FITS INTO A TAPERED HOLE IN THE SPINDLE.

18. A PILOT HOLE IS DRILLED WITH A CENTRE DRILL.

19. A JOBBERS DRILL BIT CAN THEN BE USED.

20. THE COMPOUND SLIDE CAN BE ROTATED AND LOCKED INTO PLACE TO TURN TAPERED SHAPES.

21. LONGER SHAPES MUST BE SUPPORTED WITH A REVOLVING CENTRE WHICH IS HELD IN THE TAILSTOCK.

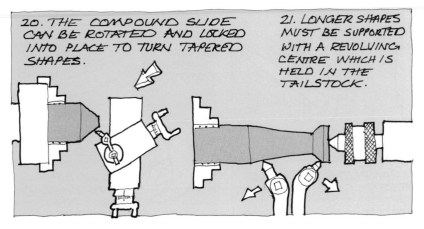

A. BORING TOOL
B. BORING BAR
C. LARGE BORING BAR

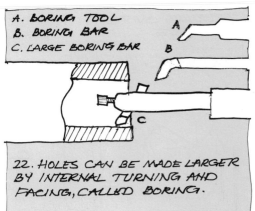

22. HOLES CAN BE MADE LARGER BY INTERNAL TURNING AND FACING, CALLED BORING.

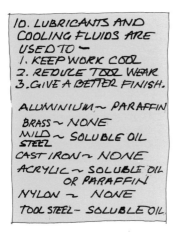

6.12 WOODTURNING LATHE

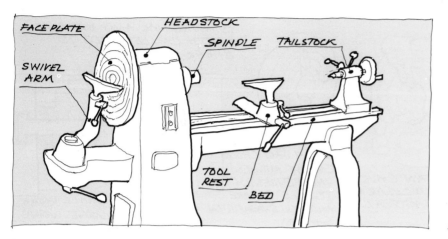

FACE PLATE
HEADSTOCK
SPINDLE
TAILSTOCK
SWIVEL ARM
TOOL REST
BED

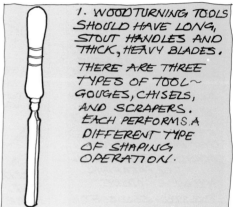

1. WOODTURNING TOOLS SHOULD HAVE LONG, STOUT HANDLES AND THICK, HEAVY BLADES.

THERE ARE THREE TYPES OF TOOL~ GOUGES, CHISELS, AND SCRAPERS. EACH PERFORMS A DIFFERENT TYPE OF SHAPING OPERATION.

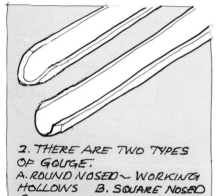

2. THERE ARE TWO TYPES OF GOUGE.
A. ROUND NOSED~ WORKING HOLLOWS B. SQUARE NOSED ROUGH SHAPING OF WORK.

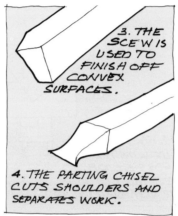

3. THE SCEW IS USED TO FINISH OFF CONVEX SURFACES.

4. THE PARTING CHISEL CUTS SHOULDERS AND SEPARATES WORK.

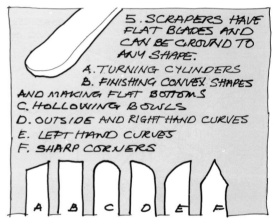

5. SCRAPERS HAVE FLAT BLADES AND CAN BE GROUND TO ANY SHAPE.
A. TURNING CYLINDERS
B. FINISHING CONVEX SHAPES AND MAKING FLAT BOTTOMS
C. HOLLOWING BOWLS
D. OUTSIDE AND RIGHT HAND CURVES
E. LEFT HAND CURVES
F. SHARP CORNERS

A B C D E F

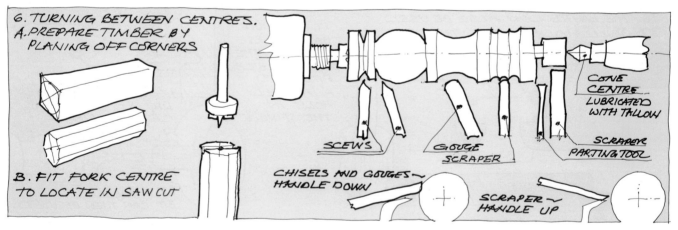

6. TURNING BETWEEN CENTRES.
A. PREPARE TIMBER BY PLANING OFF CORNERS

B. FIT FORK CENTRE TO LOCATE IN SAW CUT

SCEWS
GOUGE SCRAPER
CONE CENTRE LUBRICATED WITH TALLOW
SCRAPER PARTING TOOL

CHISELS AND GOUGES~ HANDLE DOWN

SCRAPER~ HANDLE UP

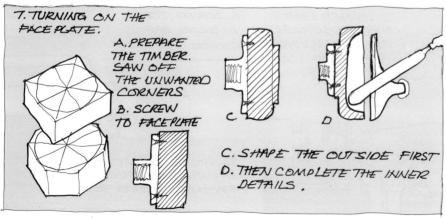

7. TURNING ON THE FACE PLATE.
A. PREPARE THE TIMBER. SAW OFF THE UNWANTED CORNERS
B. SCREW TO FACE PLATE

C
D

C. SHAPE THE OUTSIDE FIRST
D. THEN COMPLETE THE INNER DETAILS.

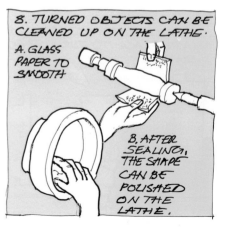

8. TURNED OBJECTS CAN BE CLEANED UP ON THE LATHE.
A. GLASS PAPER TO SMOOTH

B. AFTER SEALING, THE SHAPE CAN BE POLISHED ON THE LATHE.

1. ABRASIVES ARE AVAILABLE IN MANY FORMS. SHEETS, DISCS, COILS, ROLLS, AND BELTS, AS WELL AS POLISHES AND SOAPS.

TYPE	COLOUR	USE
GLASS	SANDY	GENERAL WOODWORK
GARNET	RED	CLEANER CUT ON WOOD
ALUMINIUM OXIDE	GREY, BROWN	MACHINE SANDING ON METAL + WOOD
SILICON CARBIDE WET OR DRY	GREY	USED WET WITH WATER ON PLASTICS, METALS, AND PAINTWORK
EMERY	BLACK	DRY ON METAL, OR WET WITH PARAFFIN FOR FINE WORK

2. THE GRITS USED ARE FOR PARTICULAR TASKS.

	VERY FINE						FINE				SMOOTHING			COARSE			
GLASS	~	~	~	~	~	00	O	1	1½	f2	M2	≤2	2½	3	~	~	
GARNET	~	~	9/0	8/0	7/0	6/0	~	5/0	3/0	2/0	~	~	1½	2	2½	3	
WET + DRY	650	400	320	280	240	220	~	180	120	100	~	60	~	40	36	30	24
EMERY	~	~	~	~	~	O	~	~	F	~	1½	2	2½	3	~	4	4½

3. EACH MATERIAL IS GRADED EITHER IN THE EUROPEAN OR ENGLISH SYSTEM. THE GRADE NUMBER IS PRINTED ON THE BACK OF THE SHEET.

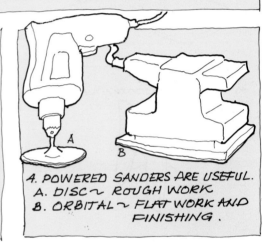

4. POWERED SANDERS ARE USEFUL.
A. DISC ~ ROUGH WORK
B. ORBITAL ~ FLAT WORK AND FINISHING.

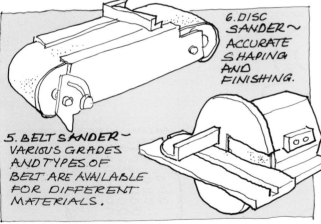

6. DISC SANDER ~ ACCURATE SHAPING AND FINISHING.

5. BELT SANDER ~ VARIOUS GRADES AND TYPES OF BELT ARE AVAILABLE FOR DIFFERENT MATERIALS.

7. A BUFFING MACHINE CAN BE FITTED WITH WIRE BRUSHES FOR CLEANING METALS. POLISHING MOPS CAN ALSO BE FITTED FOR FINISHING METALS AND PLASTICS.

MOPS
A. FINE WORK.
B. HEAVY WORK
C. FLAT BOTTOMS
D. FELT FINGERS AND
E. CONES ~ FINE WORK

8. THERE ARE VARIOUS GRADES OF BUFFING SOAP.
HYFIN ~ MILD AND STAINLESS STEEL
TRIPOLI ~ NON FERROUS METAL
ROUGE ~ GOLD AND SILVER
POLASTIC ~ PLASTIC

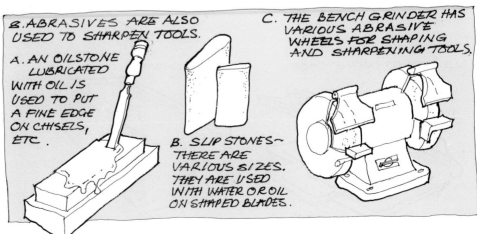

8. ABRASIVES ARE ALSO USED TO SHARPEN TOOLS.

A. AN OILSTONE LUBRICATED WITH OIL IS USED TO PUT A FINE EDGE ON CHISELS, ETC.

B. SLIP STONES ~ THERE ARE VARIOUS SIZES. THEY ARE USED WITH WATER OR OIL ON SHAPED BLADES.

C. THE BENCH GRINDER HAS VARIOUS ABRASIVE WHEELS FOR SHAPING AND SHARPENING TOOLS.

6.14 ACTIVITIES FOR TOOLS AND MACHINES

These activities should be attempted, one product at a time, over a number of sessions.

List the tools and machines you would use for the manufacture of the items illustrated below. Explain your choice and state the task each tool or machine would perform.

Think about the whole manufacturing process:

marking out
cutting and drilling
shaping
assembling, if necessary
cleaning and/or finishing.

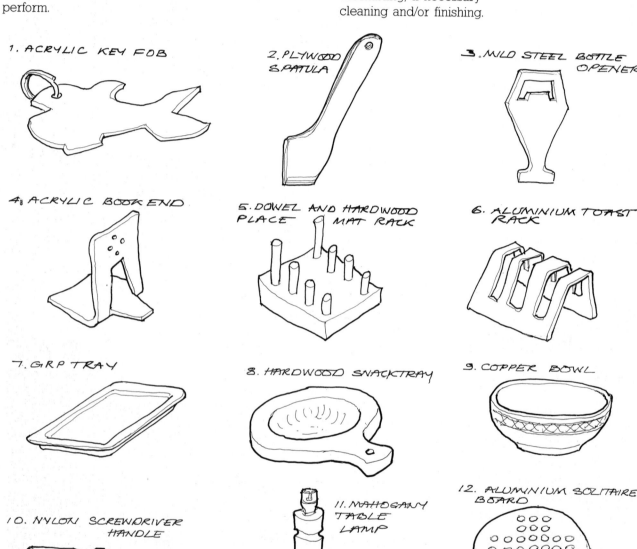

1. ACRYLIC KEY FOB

2. PLYWOOD SPATULA

3. MILD STEEL BOTTLE OPENER

4. ACRYLIC BOOK END

5. DOWEL AND HARDWOOD PLACE MAT RACK

6. ALUMINIUM TOAST RACK

7. GRP TRAY

8. HARDWOOD SNACKTRAY

9. COPPER BOWL

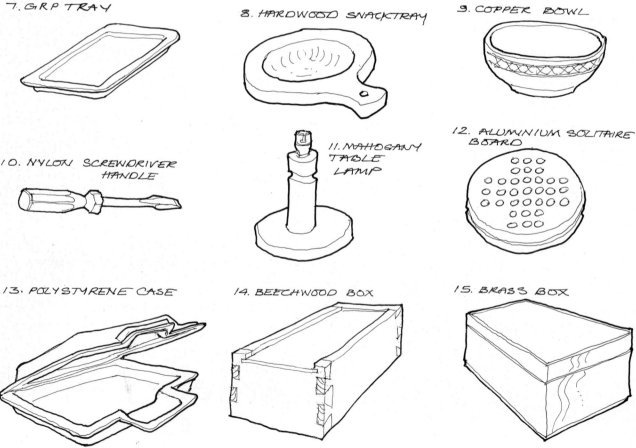

10. NYLON SCREWDRIVER HANDLE

11. MAHOGANY TABLE LAMP

12. ALUMINIUM SOLITAIRE BOARD

13. POLYSTYRENE CASE

14. BEECHWOOD BOX

15. BRASS BOX

SECTION 7
PROCESSES

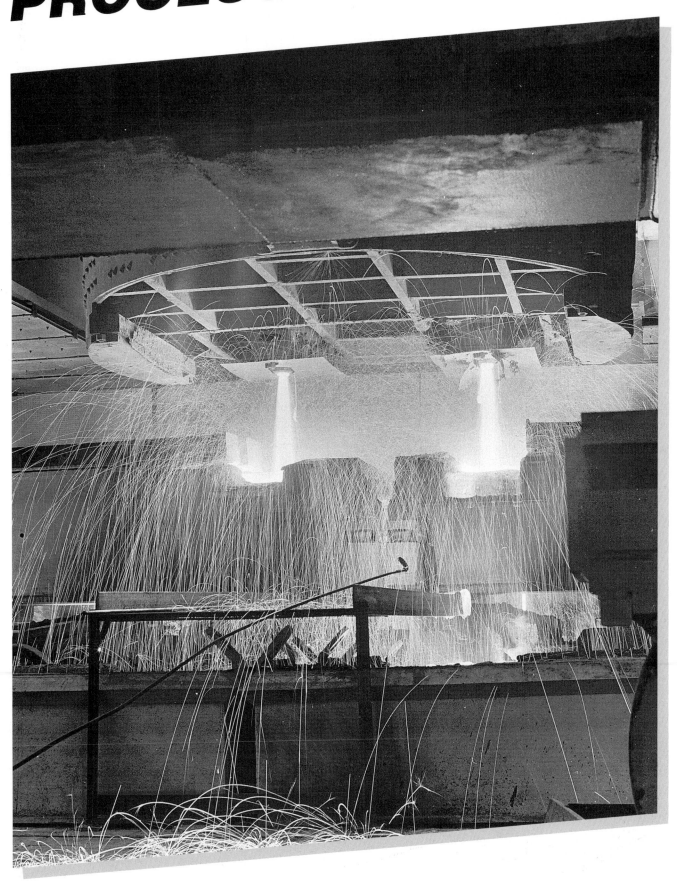

7.1 FLAT SHAPES

Flat shapes are either geometric or organic.
To draw them you need a rule, a pencil, a set square, and compasses.

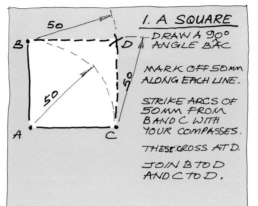

1. A SQUARE

DRAW A 90° ANGLE BAC

MARK OFF 50MM ALONG EACH LINE.

STRIKE ARCS OF 50MM FROM B AND C WITH YOUR COMPASSES.

THESE CROSS AT D.

JOIN B TO D AND C TO D.

2. A RECTANGLE

DRAW A 90° ANGLE BAC.

MARK OFF SIDES OF 50 AND 70 MM TO FIND B+C,

FROM B AND C DRAW ARCS OF 50 AND 70 MM.

THEY CROSS AT D. JOIN B TO D AND C TO D.

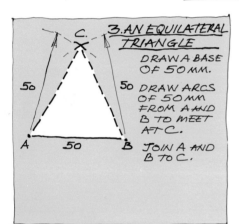

3. AN EQUILATERAL TRIANGLE

DRAW A BASE OF 50 MM.

DRAW ARCS OF 50 MM FROM A AND B TO MEET AT C.

JOIN A AND B TO C.

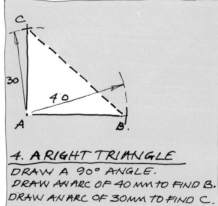

4. A RIGHT TRIANGLE

DRAW A 90° ANGLE.
DRAW AN ARC OF 40 MM TO FIND B.
DRAW AN ARC OF 30 MM TO FIND C.

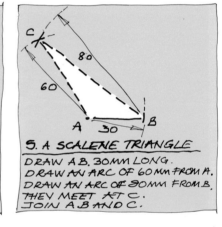

5. A SCALENE TRIANGLE

DRAW A B. 30MM LONG.
DRAW AN ARC OF 60 MM FROM A.
DRAW AN ARC OF 90 MM FROM B.
THEY MEET AT C.
JOIN A, B AND C.

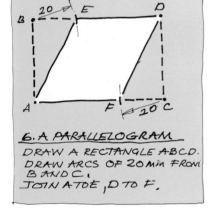

6. A PARALLELOGRAM

DRAW A RECTANGLE ABCD.
DRAW ARCS OF 20 mm FROM B AND C.
JOIN A TO E, D TO F.

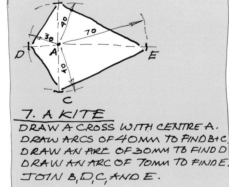

7. A KITE

DRAW A CROSS WITH CENTRE A.
DRAW ARCS OF 40MM TO FIND B+C.
DRAW AN ARC OF 30MM TO FIND D.
DRAW AN ARC OF 70MM TO FIND E.
JOIN B, D, C, AND E.

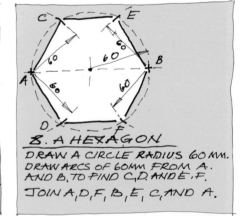

8. A HEXAGON

DRAW A CIRCLE RADIUS 60 MM.
DRAW ARCS OF 60MM FROM A. AND B, TO FIND C, D, AND E, F.
JOIN A, D, F, B, E, C, AND A.

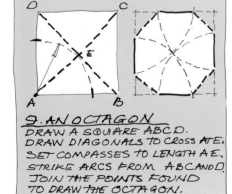

9. AN OCTAGON

DRAW A SQUARE ABCD.
DRAW DIAGONALS TO CROSS AT E.
SET COMPASSES TO LENGTH A E.
STRIKE ARCS FROM A B C AND D.
JOIN THE POINTS FOUND TO DRAW THE OCTAGON.

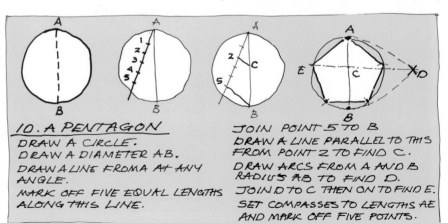

10. A PENTAGON

DRAW A CIRCLE.
DRAW A DIAMETER AB.
DRAW A LINE FROM A AT ANY ANGLE.
MARK OFF FIVE EQUAL LENGTHS ALONG THIS LINE.

JOIN POINT 5 TO B
DRAW A LINE PARALLEL TO THIS FROM POINT 2 TO FIND C.
DRAW ARCS FROM A AND B RADIUS AB TO FIND D.
JOIN D TO C THEN ON TO FIND E.
SET COMPASSES TO LENGTHS AE AND MARK OFF FIVE POINTS.

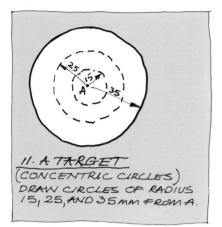

11. A TARGET
(CONCENTRIC CIRCLES)
DRAW CIRCLES OF RADIUS
15, 25, AND 35mm FROM A.

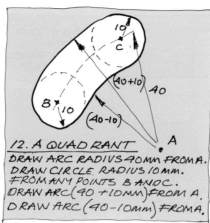

12. A QUADRANT
DRAW ARC RADIUS 40MM FROM A.
DRAW CIRCLE RADIUS 10MM.
FROM ANY POINTS B AND C.
DRAW ARC (40+10mm) FROM A.
DRAW ARC (40-10mm) FROM A.

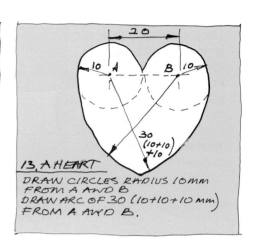

13. A HEART
DRAW CIRCLES RADIUS 10MM
FROM A AND B
DRAW ARC OF 30 (10+10+10mm)
FROM A AND B.

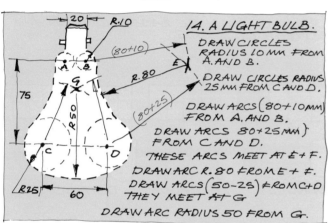

14. A LIGHT BULB.
DRAW CIRCLES
RADIUS 10MM FROM
A. AND B.
DRAW CIRCLES RADIUS
25MM FROM C AND D.
DRAW ARCS (80+10mm)
FROM A. AND B.
DRAW ARCS 80+25mm)
FROM C AND D.
THESE ARCS MEET AT E+F.
DRAW ARC R.80 FROM E+F.
DRAW ARCS (50-25) FROM C+D
THEY MEET AT G
DRAW ARC RADIUS 50 FROM G.

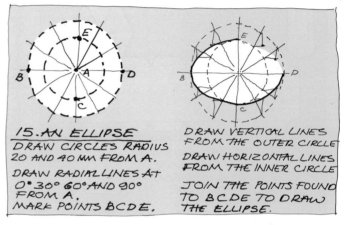

15. AN ELLIPSE
DRAW CIRCLES RADIUS
20 AND 40 MM FROM A.
DRAW RADIAL LINES AT
0° 30° 60° AND 90°
FROM A.
MARK POINTS B C D E.

DRAW VERTICAL LINES
FROM THE OUTER CIRCLE
DRAW HORIZONTAL LINES
FROM THE INNER CIRCLE
JOIN THE POINTS FOUND
TO B C D E TO DRAW
THE ELLIPSE.

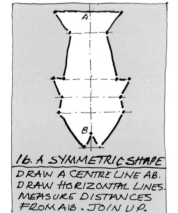

16. A SYMMETRIC SHAPE
DRAW A CENTRE LINE AB.
DRAW HORIZONTAL LINES.
MEASURE DISTANCES
FROM AB. JOIN UP.

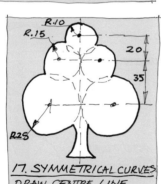

17. SYMMETRICAL CURVES
DRAW CENTRE LINE.
DRAW HORIZONTAL GUIDE
LINES.
MARK OFF CENTRES.
DRAW CIRCLES.

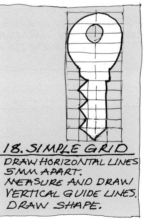

18. SIMPLE GRID
DRAW HORIZONTAL LINES
5MM APART.
MEASURE AND DRAW
VERTICAL GUIDE LINES.
DRAW SHAPE.

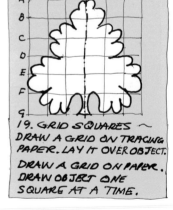

19. GRID SQUARES ~
DRAW A GRID ON TRACING
PAPER. LAY IT OVER OBJECT.
DRAW A GRID ON PAPER.
DRAW OBJECT ONE
SQUARE AT A TIME.

20. LINE SIMPLIFYING
TRACE SHAPE FROM
PHOTOGRAPH. USE
STRAIGHT LINES TO
MAKE SHAPE SIMPLER.

21. SHAPE SIMPLIFYING ~
TRACE OBJECT. DECIDE ON
SHAPE TO BE USED.
SIMPLIFY OBJECT USING
SHAPE.

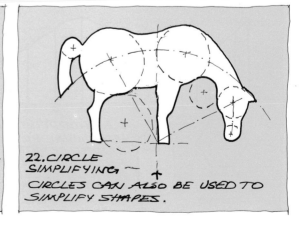

22. CIRCLE SIMPLIFYING ~
CIRCLES CAN ALSO BE USED TO
SIMPLIFY SHAPES.

7.2 FOLDED SHAPES

Metal and plastic sheet can be cut and formed into three dimensional forms by folding. The unfolded shapes are called developments. These can be constructed from a plan view and a front elevation of the shape required.

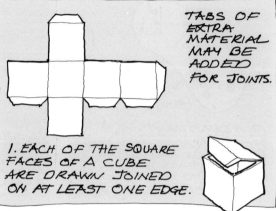

TABS OF EXTRA MATERIAL MAY BE ADDED FOR JOINTS.

1. EACH OF THE SQUARE FACES OF A CUBE ARE DRAWN JOINED ON AT LEAST ONE EDGE.

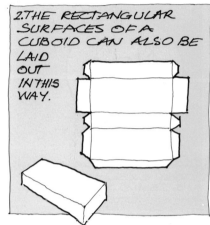

2. THE RECTANGULAR SURFACES OF A CUBOID CAN ALSO BE LAID OUT IN THIS WAY.

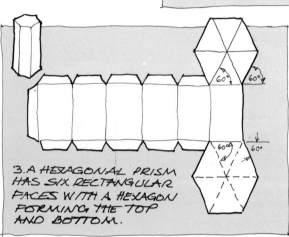

3. A HEXAGONAL PRISM HAS SIX RECTANGULAR FACES WITH A HEXAGON FORMING THE TOP AND BOTTOM.

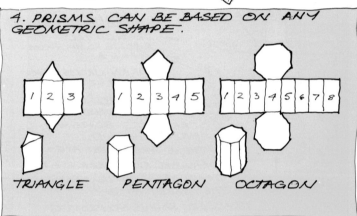

4. PRISMS CAN BE BASED ON ANY GEOMETRIC SHAPE.

TRIANGLE PENTAGON OCTAGON

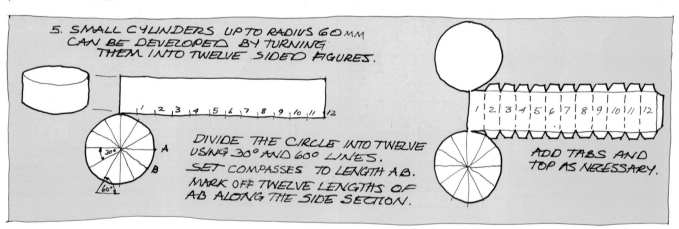

5. SMALL CYLINDERS UP TO RADIUS 60 MM CAN BE DEVELOPED BY TURNING THEM INTO TWELVE SIDED FIGURES.

DIVIDE THE CIRCLE INTO TWELVE USING 30° AND 60° LINES. SET COMPASSES TO LENGTH A.B. MARK OFF TWELVE LENGTHS OF A.B ALONG THE SIDE SECTION.

ADD TABS AND TOP AS NECESSARY.

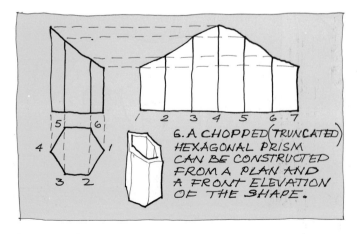

6. A CHOPPED (TRUNCATED) HEXAGONAL PRISM CAN BE CONSTRUCTED FROM A PLAN AND A FRONT ELEVATION OF THE SHAPE.

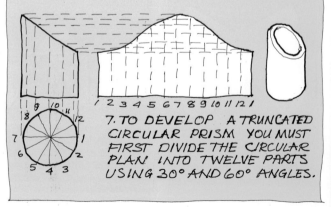

7. TO DEVELOP A TRUNCATED CIRCULAR PRISM YOU MUST FIRST DIVIDE THE CIRCULAR PLAN INTO TWELVE PARTS USING 30° AND 60° ANGLES.

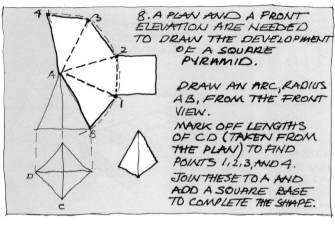

8. A PLAN AND A FRONT ELEVATION ARE NEEDED TO DRAW THE DEVELOPMENT OF A SQUARE PYRAMID.

DRAW AN ARC, RADIUS AB, FROM THE FRONT VIEW.

MARK OFF LENGTHS OF CD (TAKEN FROM THE PLAN) TO FIND POINTS 1, 2, 3, AND 4.

JOIN THESE TO A AND ADD A SQUARE BASE TO COMPLETE THE SHAPE.

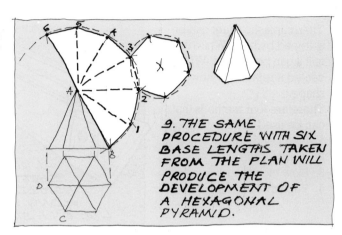

9. THE SAME PROCEDURE WITH SIX BASE LENGTHS TAKEN FROM THE PLAN WILL PRODUCE THE DEVELOPMENT OF A HEXAGONAL PYRAMID.

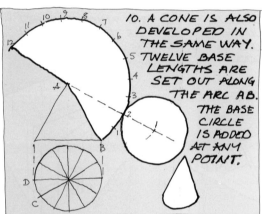

10. A CONE IS ALSO DEVELOPED IN THE SAME WAY. TWELVE BASE LENGTHS ARE SET OUT ALONG THE ARC AB. THE BASE CIRCLE IS ADDED AT ANY POINT.

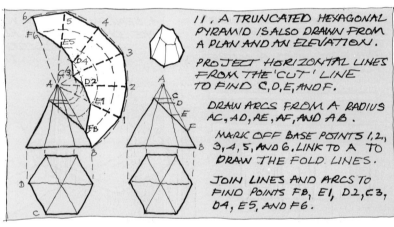

11. A TRUNCATED HEXAGONAL PYRAMID IS ALSO DRAWN FROM A PLAN AND AN ELEVATION.

PROJECT HORIZONTAL LINES FROM THE 'CUT' LINE TO FIND C, D, E, AND F.

DRAW ARCS FROM A RADIUS AC, AD, AE, AF, AND AB.

MARK OFF BASE POINTS 1, 2, 3, 4, 5, AND 6. LINK TO A TO DRAW THE FOLD LINES.

JOIN LINES AND ARCS TO FIND POINTS FB, E1, D2, C3, D4, E5, AND F6.

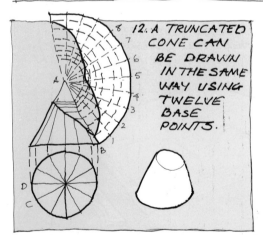

12. A TRUNCATED CONE CAN BE DRAWN IN THE SAME WAY USING TWELVE BASE POINTS.

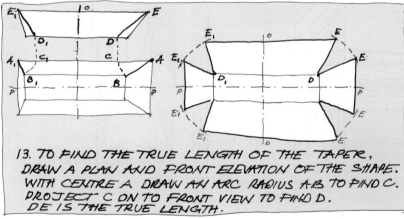

13. TO FIND THE TRUE LENGTH OF THE TAPER, DRAW A PLAN AND FRONT ELEVATION OF THE SHAPE. WITH CENTRE A DRAW AN ARC RADIUS AB TO FIND C. PROJECT C ON TO FRONT VIEW TO FIND D. DE IS THE TRUE LENGTH.

14. EQUILATERAL TRIANGLES CAN BE LINKED TO FORM A NUMBER OF THREE DIMENSIONAL SOLIDS (POLYHEDRA).

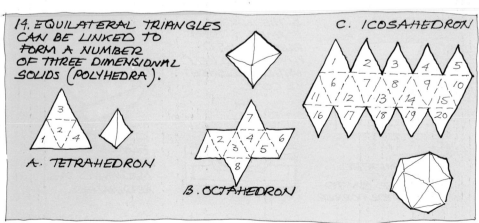

A. TETRAHEDRON

B. OCTAHEDRON

C. ICOSAHEDRON

15. A DODECAHEDRON HAS TWELVE PENTAGONAL SIDES.

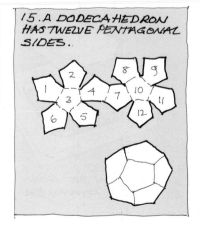

145

7.3 FORMING PLASTICS

Thermoplastic sheet can be softened by heat. While it is soft it can be formed. When cooled it retains the new shape.

There are four methods that can be used in the workshop:
1. Line bending
2. Press forming
3. Blow moulding
4. Vacuum forming

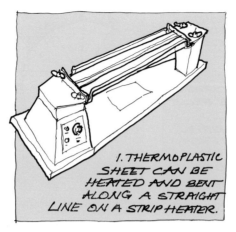

1. THERMOPLASTIC SHEET CAN BE HEATED AND BENT ALONG A STRAIGHT LINE ON A STRIP HEATER.

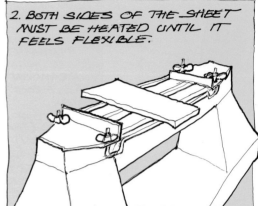

2. BOTH SIDES OF THE SHEET MUST BE HEATED UNTIL IT FEELS FLEXIBLE.

3. THE HIGHER THE GUIDE BARS ARE SET THE WIDER THE SOFTENED ZONE. THIS PRODUCES A MORE ROUNDED BEND.

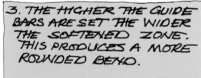
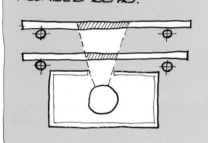

4. BENDING JIGS WILL HOLD THE SHEET IN THE REQUIRED POSITION UNTIL IT COOLS.

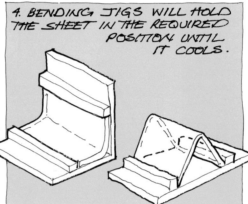

5. THE WHOLE SHEET CAN BE HEATED IN AN OVEN.

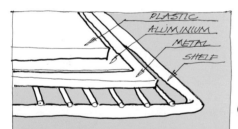

PLASTIC
ALUMINIUM
METAL
SHELF

6. TO STOP THE SHEET FROM SAGGING WHEN IT IS HOT IT IS BEST SUPPORTED ON A METAL SHEET COVERED IN ALUMINIUM FOIL.

7. GLOVES SHOULD BE WORN TO HANDLE THE SHEET.

8. FORMERS MUST BE WELL FINISHED (FELT COVERING IS BEST). THEY HOLD THE HOT SHEET IN PLACE WHILE IT COOLS.

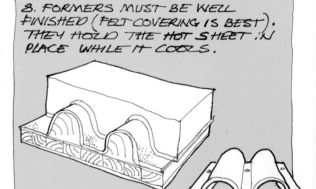

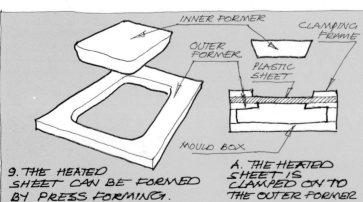

INNER FORMER
OUTER FORMER
CLAMPING FRAME
PLASTIC SHEET
MOULD BOX

9. THE HEATED SHEET CAN BE FORMED BY PRESS FORMING.

A. THE HEATED SHEET IS CLAMPED ON TO THE OUTER FORMER

B. THE INNER FORMER IS THEN PRESSED INTO PLACE AND HELD UNTIL THE SHEET IS COOL.

C. THE OUTER FLANGE CAN THEN BE REMOVED OR MODIFIED AS REQUIRED.

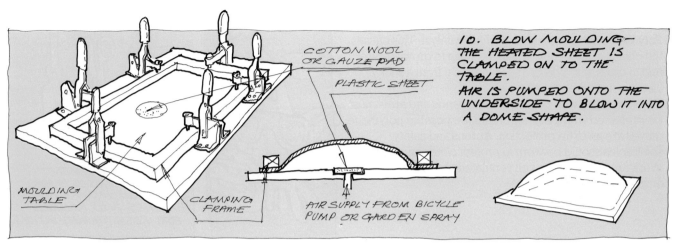

COTTON WOOL OR GAUZE PAD

PLASTIC SHEET

MOULDING TABLE

CLAMPING FRAME

AIR SUPPLY FROM BICYCLE PUMP OR GARDEN SPRAY

10. BLOW MOULDING — THE HEATED SHEET IS CLAMPED ON TO THE TABLE.
AIR IS PUMPED ONTO THE UNDERSIDE TO BLOW IT INTO A DOME SHAPE.

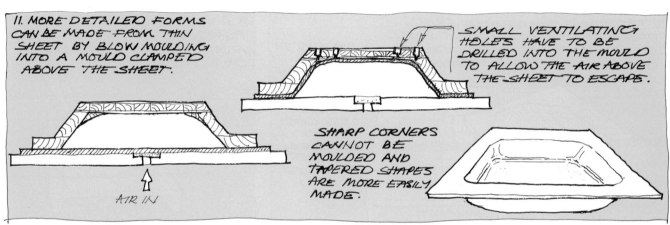

11. MORE DETAILED FORMS CAN BE MADE FROM THIN SHEET BY BLOW MOULDING INTO A MOULD CLAMPED ABOVE THE SHEET.

AIR IN

SMALL VENTILATING HOLES HAVE TO BE DRILLED INTO THE MOULD TO ALLOW THE AIR ABOVE THE SHEET TO ESCAPE.

SHARP CORNERS CANNOT BE MOULDED AND TAPERED SHAPES ARE MORE EASILY MADE.

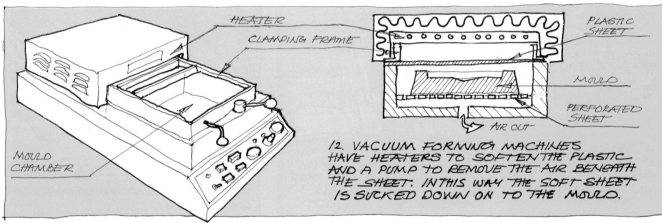

HEATER

CLAMPING FRAME

MOULD CHAMBER

PLASTIC SHEET

MOULD

PERFORATED SHEET

AIR OUT

12. VACUUM FORMING MACHINES HAVE HEATERS TO SOFTEN THE PLASTIC AND A PUMP TO REMOVE THE AIR BENEATH THE SHEET. IN THIS WAY THE SOFT SHEET IS SUCKED DOWN ON TO THE MOULD.

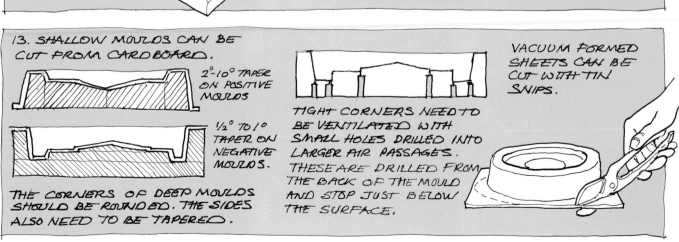

13. SHALLOW MOULDS CAN BE CUT FROM CARDBOARD.

2°–10° TAPER ON POSITIVE MOULDS

½° TO 1° TAPER ON NEGATIVE MOULDS.

THE CORNERS OF DEEP MOULDS SHOULD BE ROUNDED. THE SIDES ALSO NEED TO BE TAPERED.

TIGHT CORNERS NEED TO BE VENTILATED WITH SMALL HOLES DRILLED INTO LARGER AIR PASSAGES. THESE ARE DRILLED FROM THE BACK OF THE MOULD AND STOP JUST BELOW THE SURFACE.

VACUUM FORMED SHEETS CAN BE CUT WITH TIN SNIPS.

7.4 MOULDING GRP

Polyester resin can be mixed with a catalyst. This causes the chains of molecules within the resin to grow longer and to cross link. This changes the resin from a sticky liquid to a solid brittle material.

When working with polyester resin *hands and arms must be protected* with a barrier cream. Disposable polythene gloves are an extra protection. Aprons and safety spectacles should be worn to *protect clothes and eyes.* Work areas should be well ventilated. A fume cupboard is an ideal environment.

1. SPECIAL EQUIPMENT INCLUDES WAXED PAPER, CUPS FOR MIXING RESIN, BRUSHES AND ROLLERS FOR RESIN IMPREGNATION.

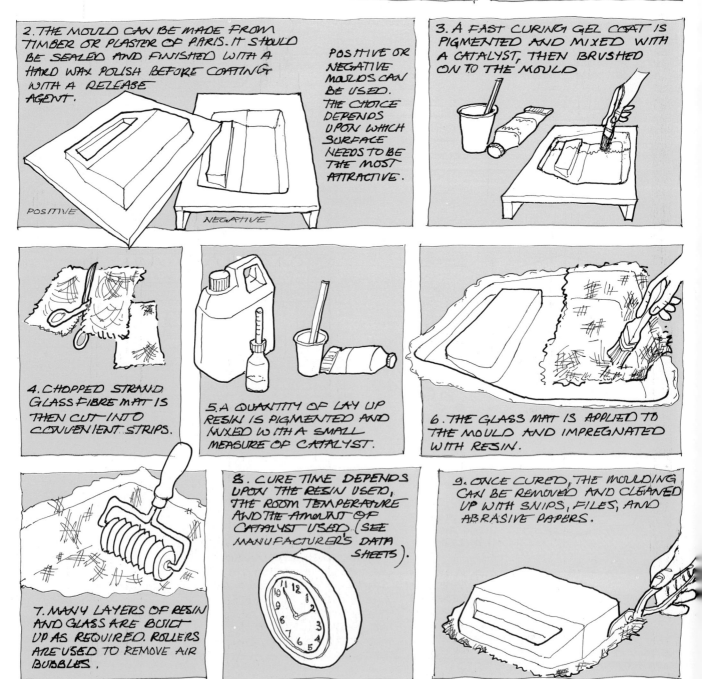

2. THE MOULD CAN BE MADE FROM TIMBER OR PLASTER OF PARIS. IT SHOULD BE SEALED AND FINISHED WITH A HARD WAX POLISH BEFORE COATING WITH A RELEASE AGENT.

POSITIVE

NEGATIVE

POSITIVE OR NEGATIVE MOULDS CAN BE USED. THE CHOICE DEPENDS UPON WHICH SURFACE NEEDS TO BE THE MOST ATTRACTIVE.

3. A FAST CURING GEL COAT IS PIGMENTED AND MIXED WITH A CATALYST, THEN BRUSHED ON TO THE MOULD

4. CHOPPED STRAND GLASS FIBRE MAT IS THEN CUT INTO CONVENIENT STRIPS.

5. A QUANTITY OF LAY UP RESIN IS PIGMENTED AND MIXED WITH A SMALL MEASURE OF CATALYST.

6. THE GLASS MAT IS APPLIED TO THE MOULD AND IMPREGNATED WITH RESIN.

7. MANY LAYERS OF RESIN AND GLASS ARE BUILT UP AS REQUIRED. ROLLERS ARE USED TO REMOVE AIR BUBBLES.

8. CURE TIME DEPENDS UPON THE RESIN USED, THE ROOM TEMPERATURE AND THE AMOUNT OF CATALYST USED. (SEE MANUFACTURER'S DATA SHEETS).

9. ONCE CURED, THE MOULDING CAN BE REMOVED AND CLEANED UP WITH SNIPS, FILES, AND ABRASIVE PAPERS.

7.5 · CASTING METALS

Aluminium can be melted and cast into complex forms in the school foundry.
The mould is made of sand built up around a pattern. When the mould is completed, the pattern is removed and hot metal poured in to take its place.

1. A PATTERN CAN BE MADE FROM TIMBER. IT IS AN EXACT REPLICA OF THE FINAL MOULDING AND SHOULD BE CAREFULLY FINISHED AND SEALED WITH SHELLAC.

THE SIDES OF THE PATTERN SHOULD BE TAPERED. EXTERNAL TAPERS 1°. INTERNAL TAPERS 5°. SHARP CORNERS SHOULD BE ROUNDED WITH A FILLER.

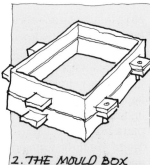

2. THE MOULD BOX IS MADE OF TWO PARTS THE TOP HALF IS THE COPE. THE BOTTOM IS THE DRAG.

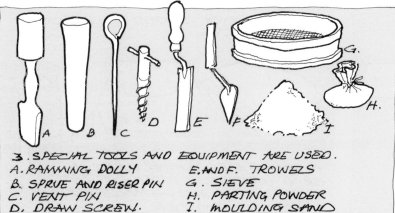

3. SPECIAL TOOLS AND EQUIPMENT ARE USED.
A. RAMMING DOLLY
B. SPRUE AND RISER PIN
C. VENT PIN
D. DRAW SCREW.
E. AND F. TROWELS
G. SIEVE
H. PARTING POWDER
I. MOULDING SAND

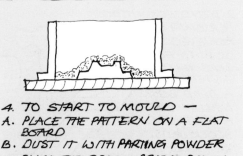

4. TO START TO MOULD —
A. PLACE THE PATTERN ON A FLAT BOARD
B. DUST IT WITH PARTING POWDER
C. PLACE THE DRAG UPSIDE DOWN TO ENCLOSE THE PATTERN
D. COVER THE PATTERN WITH A THICK LAYER OF SIEVED SAND.

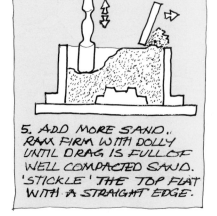

5. ADD MORE SAND. RAM FIRM WITH DOLLY UNTIL DRAG IS FULL OF WELL COMPACTED SAND. 'STICKLE' THE TOP FLAT WITH A STRAIGHT EDGE.

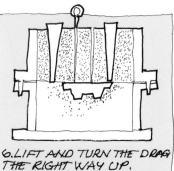

6. LIFT AND TURN THE DRAG THE RIGHT WAY UP. FIT THE COPE. FILL WITH WELL RAMMED SAND. ADD THE SPRUE AND RISER AS NECESSARY.

7. CUT A POURING BASIN AROUND THE SPRUE. TAP AND REMOVE SPRUE AND RISER PINS.

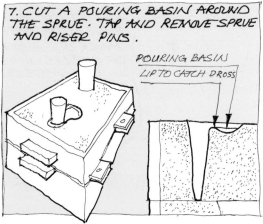

POURING BASIN LIP TO CATCH DROSS

8. REMOVE THE COPE. CUT A GATE TO JOIN THE BASE OF THE SPRUE TO THE PATTERN.

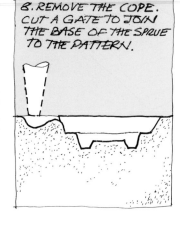

9. FIT THE DRAW SCREW INTO THE PATTERN, TAP IT. THEN WITHDRAW THE PATTERN.

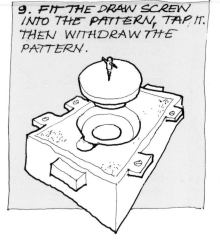

10. BLOW AWAY UNWANTED SAND AND REASSEMBLE THE MOULD.

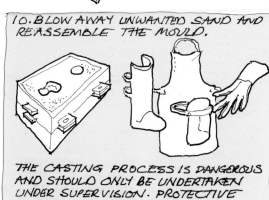

THE CASTING PROCESS IS DANGEROUS AND SHOULD ONLY BE UNDERTAKEN UNDER SUPERVISION. PROTECTIVE CLOTHING MUST BE WORN.

7.6 FORMING METALS

Most thin metal sheets can be cut and folded into the forms shown on pages 144 and 145. They can be seamed and joined as on pages 112 and 113. Copper, gilding metal, brass, and aluminium can be formed into more complex objects by beating them with a hammer or a mallet. All but aluminium will need to be annealed before and during the shaping operation (see page 152).

There are three forming processes: hollowing, sinking, and raising. Objects produced in these ways have to be finished by planishing.

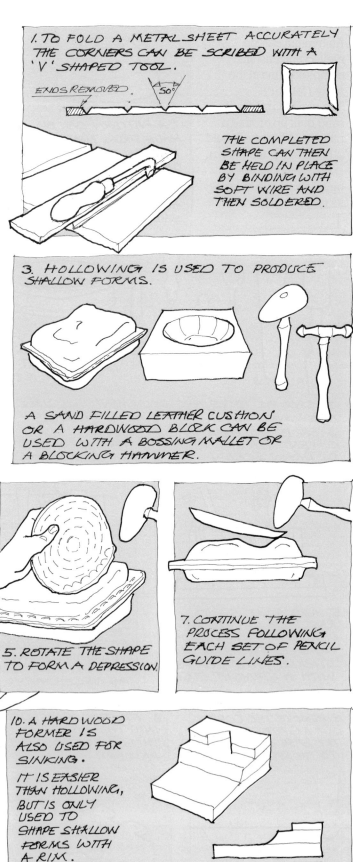

1. TO FOLD A METAL SHEET ACCURATELY THE CORNERS CAN BE SCRIBED WITH A 'V' SHAPED TOOL.

ENDS REMOVED.

THE COMPLETED SHAPE CAN THEN BE HELD IN PLACE BY BINDING WITH SOFT WIRE AND THEN SOLDERED.

2. BENDING WITHOUT SCRIBING CAN BE ACHIEVED IN A VICE OR WITH FOLDING BARS HELD IN A VICE.
A DEAD BLOW MALLET OR A HARDWOOD BLOCK MUST BE USED TO PROTECT THE SURFACE FROM DAMAGE.

3. HOLLOWING IS USED TO PRODUCE SHALLOW FORMS.

A SAND FILLED LEATHER CUSHION OR A HARDWOOD BLOCK CAN BE USED WITH A BOSSING MALLET OR A BLOCKING HAMMER.

4. FIRST CUT AND ANNEAL THE SHEET. MARK OUT A SERIES OF CIRCLES WITH SOME COMPASSES.

SUPPORT THE EDGE OF THE SHEET AND STRIKE IT JUST BEYOND THE POINT OF SUPPORT.

5. ROTATE THE SHAPE TO FORM A DEPRESSION.

7. CONTINUE THE PROCESS FOLLOWING EACH SET OF PENCIL GUIDE LINES.

8. BY WORKING AROUND EACH RING, A ROUGH BOWL SHAPE CAN BE MADE THIS CAN BE SMOOTHED BY PLANISHING.

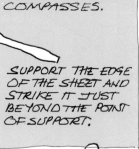

9. A BLOCKING HAMMER WILL SHAPE METAL MORE QUICKLY, BUT MORE SKILL IS NEEDED TO USE IT.

10. A HARDWOOD FORMER IS ALSO USED FOR SINKING.
IT IS EASIER THAN HOLLOWING, BUT IS ONLY USED TO SHAPE SHALLOW FORMS WITH A RIM.

VARIOUS SHAPES ARE POSSIBLE.

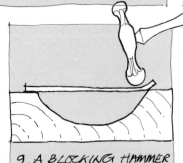

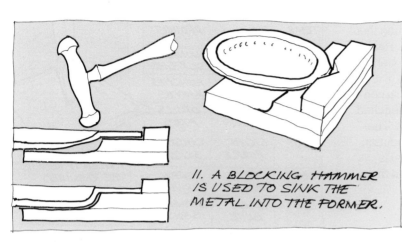

11. A BLOCKING HAMMER IS USED TO SINK THE METAL INTO THE FORMER.

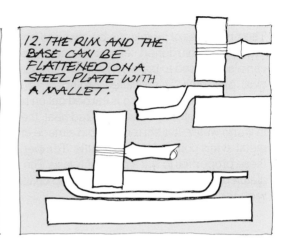

12. THE RIM AND THE BASE CAN BE FLATTENED ON A STEEL PLATE WITH A MALLET.

13. THERE ARE MANY DIFFERENT TYPES OF STAKE ON WHICH METAL CAN BE RAISED.

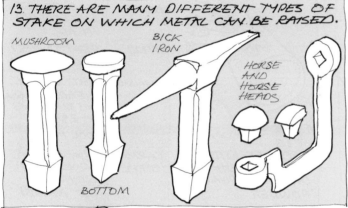

MUSHROOM

BICK IRON

HORSE AND HORSE HEADS

BOTTOM

14. WORK OUT THE SIZE OF THE BLANK. ADD THE DIAMETER A TO THE HEIGHT B.

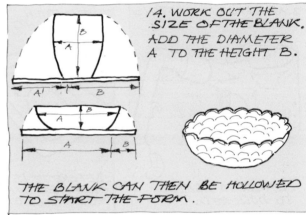

THE BLANK CAN THEN BE HOLLOWED TO START THE FORM.

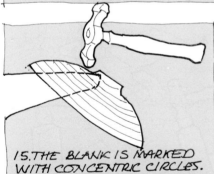

15. THE BLANK IS MARKED WITH CONCENTRIC CIRCLES. A RAISING HAMMER IS USED TO START SHAPING THE OBJECT FROM THE CENTRE WORKING OUT TO THE RIM.

16. BY WORKING AROUND THE STAKE A NUMBER OF TIMES A DEEP SHAPE CAN BE MADE. A FLAT BASE IS CREATED ON A BOTTOM STAKE.

17. FEET AND DECORATIONS CAN BE FORMED ON A DOMING BLOCK WITH A PUNCH.

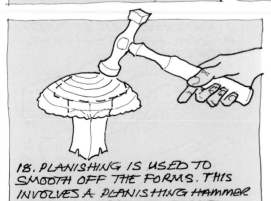

18. PLANISHING IS USED TO SMOOTH OFF THE FORMS. THIS INVOLVES A PLANISHING HAMMER USED ON A RAISING STAKE.

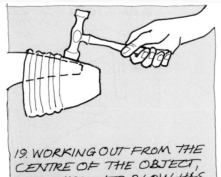

19. WORKING OUT FROM THE CENTRE OF THE OBJECT, EACH HAMMER BLOW HAS TO OVERLAP THE PREVIOUS ONE.

20. ONCE SMOOTH THEY CAN BE CLEANED AND FINISHED WITH ABRASIVES BEFORE THEY ARE POLISHED.

7.7 HEAT TREATMENT OF METALS

The properties of metals can be changed by heating them. They can be hardened, tempered, and annealed. Heat can also be used to make ferrous metals easier to bend, twist, or stretch. This is called forging.

Hardening and tempering is carried out on high carbon steels. The material is heated to red heat, then quenched in warm water. It is stirred to avoid surface cracks. The metal at this point is hard but brittle. Tempering adjusts these properties to suit a particular task. The metal is cleaned then slowly heated until the tip changes to the required colour.

TEMP	TIP COLOUR	PRODUCT
230°	PALE STRAW	HAMMERS SCRIBERS
245°	DARK STRAW	PUNCHES KNIVES
260°	RED BROWN	DRILLS AXES
270°	LIGHT PURPLE	CHISELS SCISSORS
280°	DARK PURPLE	SCREW DRIVERS
300°	DARK BLUE	SPANNERS SAWS

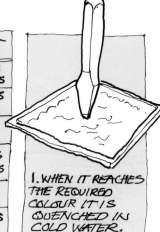

1. WHEN IT REACHES THE REQUIRED COLOUR IT IS QUENCHED IN COLD WATER.

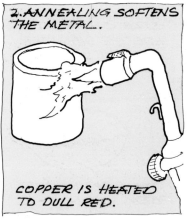

2. ANNEALING SOFTENS THE METAL.

COPPER IS HEATED TO DULL RED.

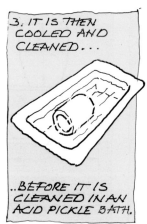

3. IT IS THEN COOLED AND CLEANED...

..BEFORE IT IS CLEANED IN AN ACID PICKLE BATH.

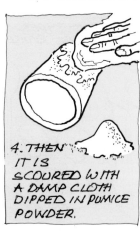

4. THEN IT IS SCOURED WITH A DAMP CLOTH DIPPED IN PUMICE POWDER.

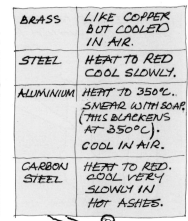

BRASS	LIKE COPPER BUT COOLED IN AIR.
STEEL	HEAT TO RED COOL SLOWLY.
ALUMINIUM	HEAT TO 350°C. SMEAR WITH SOAP. (THIS BLACKENS AT 350°C). COOL IN AIR.
CARBON STEEL	HEAT TO RED. COOL VERY SLOWLY IN HOT ASHES.

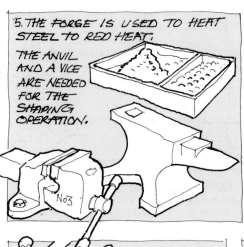

5. THE FORGE IS USED TO HEAT STEEL TO RED HEAT.

THE ANVIL AND A VICE ARE NEEDED FOR THE SHAPING OPERATION.

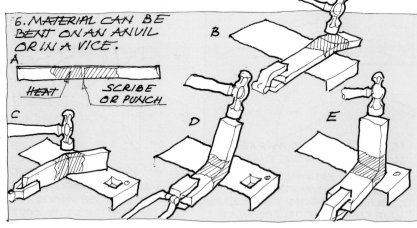

6. MATERIAL CAN BE BENT ON AN ANVIL OR IN A VICE.

HEAT SCRIBE OR PUNCH

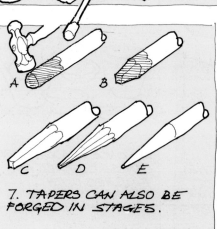

7. TAPERS CAN ALSO BE FORGED IN STAGES.

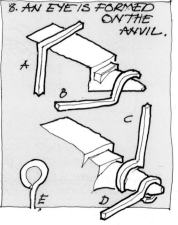

8. AN EYE IS FORMED ON THE ANVIL.

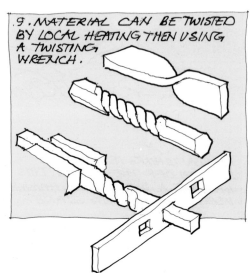

9. MATERIAL CAN BE TWISTED BY LOCAL HEATING THEN USING A TWISTING WRENCH.

7.8 FORMING TIMBERS

1. APART FROM JOINTING, SHAPING AND TURNING TIMBER CAN ALSO BE FORMED BY BENDING IT IN ONE DIRECTION.

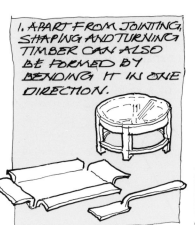

2. LOCAL BENDS, PARTICULARLY IN PLYWOOD, CAN BE MADE FROM PARALLEL SAW CUTS. GLUE IS APPLIED AND THE CURVE CLAMPED UNTIL IT DRIES.

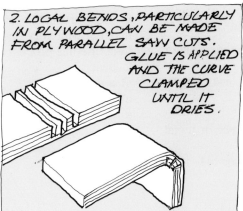

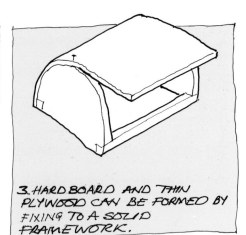

3. HARDBOARD AND THIN PLYWOOD CAN BE FORMED BY FIXING TO A SOLID FRAMEWORK.

4. BENDING IS EASIER IF THE REVERSE SIDE OF THE HARDBOARD IS WETTED.

5. THESE MATERIALS CAN BE FORMED INTO QUITE COMPLICATED FORMS BEFORE THEY ARE BOLTED OR SCREWED TOGETHER.

6. COMPLICATED RIGID FORMS CAN BE BUILT UP BY LAMINATION. TWO OR MORE LAYERS ARE FORMED THEN GLUED TOGETHER.

7. SMALL OBJECTS CAN ALSO BE BUILT UP BY LAMINATION.

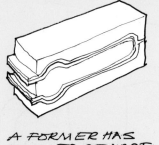

A FORMER HAS FIRST TO BE MADE.

8. THE SURFACES OF THE FORMER ARE OFTEN COVERED IN CORK OR RUBBER SHEET.

9. VARIOUS TIMBERS CAN BE USED. THEY ARE USUALLY CUT INTO STRIPS 25 MM TO 75 MM LONGER THAN IS REQUIRED TO ALLOW FOR MOVEMENT.

MATERIAL	MAXIMUM THICKNESS
DECORATIVE VENEERS	1·5 MM
CONSTRUCTIONAL VENEERS	3·0 MM
PLYWOOD	3·0 MM
SOLID TIMBER ASH, ELM, OAK, AND BEECH.	3·0 MM

10. THE FORMER IS PROTECTED WITH A LAYER OF POLYTHENE FILM. EACH LAYER OF TIMBER IS THEN GLUED INTO PLACE.

11. ONCE SET THE FORM CAN BE SHAPED TO GIVE THE REQUIRED PRODUCT.

12. A FLEXIBLE FORMER CAN BE RE-USED. BRACKETS ARE POSITIONED ON A BASE BOARD TO GIVE THE SHAPE. TIMBER STRIPS ARE THEN GLUED AND CLAMPED BETWEEN TWO FLEXIBLE STEEL STRIPS.

7.9 ACTIVITIES FOR PROCESSES

1 Design a set of badges, one for each of your school's sports teams.

They are to be made from a flat shape, cut from either acrylic or brass sheet.

Draw each of them accurately, using instruments. (Pages 142–143.)

2 Sketch three designs for a lamp.

The shade is to be made from folded acrylic or metal sheet.

Draw the development of each shade. (Pages 144–145.)

3 Sketch some designs for a set of display dishes, or snack trays, to be formed from plastic sheet.

Describe the method you would use to manufacture them. (Pages 146–147.)

4 Glass reinforced polyester resin is very light, tough, and colourful.

Design a case to be made from this material.

Explain the preparation and manufacturing procedures you would use. (Page 148.)

5 Aluminium can be melted in the foundry, and cast in a sand mould.

This moulding can be left either rough cast, or filed smooth and then polished.

Design a decorative paper weight to use both of these finishes.

Describe the ways in which you would prepare for, and manufacture, the object. (Page 149.)

6 Design a trophy to be formed from metal sheet.

Describe, with the aid of sketches, the manufacturing processes you would use. (Pages 150–151.)

7 Mild steel can be shaped by forging.

Design a set of traditionally styled fire irons (poker, shovel, tongs, and brush).

Describe the various stages of manufacture. (Page 152.)

8 Heat treatment of carbon steel can produce a material with very specific properties. (Page 152.)

Describe this process and explain how to produce the following:

a) a screwdriver b) a knife

c) a hammer head d) a saw blade

e) a drill bit

9 Design a tray to be formed from timber.

Describe the method by which you would manufacture your product. (Page 153.)

SECTION 8
TECHNOLOGY

8.1 TECHNOLOGY

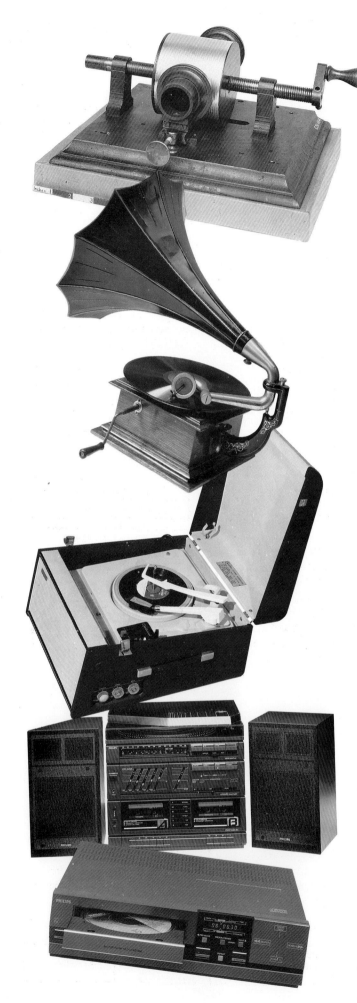

Without technologists like Thomas Edison, Henry Ford, and Jack Kilby, the world would be very different. You have probably heard of them. Edison designed and developed one of the first electric light bulbs and the phonograph. The phonograph was the forerunner of the modern record player, and where would we be without that!

Henry Ford was the first to mass produce cars, changing them from luxury items into something which could be purchased by millions of people. This gave more of us the freedom to travel and the chance to broaden our view of the world.

Jack Kilby had the simple idea of combining a number of electronic components on to one crystal of silicon. This led to the development of the integrated circuit, or microchip, as it is popularly known. Computers, calculators, space craft, televisions, washing machines, and digital watches all use the microchip.

Inventor-technologists apply scientific principles to the design and development of everyday objects. Your own projects may not be as significant as theirs. Like them, however, you need to understand certain technological principles if you are to build any new structure or machine.

AN INTRODUCTION

This section of the book introduces you to some of these ideas. **Sequence diagrams** will help you to analyse and solve your technological problems and to plan your projects. **Systems and circuits** will enable you to see how technological processes are organized and controlled, and will introduce you to some circuits and their components.

The sources of **energy** are also discussed, as are the forms in which the designer can find and use it. **Mechanisms**, such as levers, linkages, pulleys, and gears are explained. There are also some structural principles which should help you to understand forces and to build reliable **structures**.

TECHNOLOGY IN PRACTICE

Although technology is having a major effect upon the world around us, it should be remembered that it is not magical. In fact, it is often the simple, logical principle that achieves the most effective results.

Technologists, therefore, need to analyse problems, to generate alternative ideas, and to formulate practical plans. They should be able to sketch and make models, so that they can produce worthwhile solutions.

We could say of technology what Thomas Edison said about genius, that it is *one per cent inspiration, and ninety nine per cent perspiration.*

8.2 SEQUENCE DIAGRAMS

The technological elements of design projects usually require careful analysis, creative problem solving, and detailed planning.

Sequence diagrams can be used for each of these activities to help clarify and organize ideas. The three most useful are **process flow charts, block diagrams**, and **project networks**.

PROCESS FLOW CHARTS

Process flow charts were developed by computer programmers. Their main function is to separate the various activities involved in any process, and to set them down in a logical sequence. Each type of activity is given a particular shaped box which stands for the kind of action being carried out.

For example, you could be given a project brief, such as 'design a hand-operated apple picking device so that the fruit can be picked and collected without climbing the tree.' Part of your analysis could be to draw up a process flow chart of the complete operation, listing each stage.

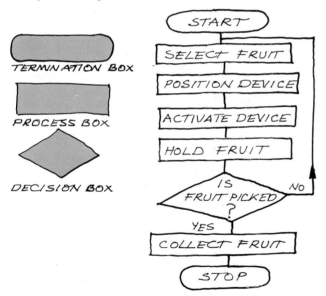

BLOCK DIAGRAMS

Once the various stages of the process have been established, each can be explored. Then alternative solutions can be considered, using a block diagram. The chief operations from the process flow chart can become the subject of this system. It is sometimes given the grand title of *morphological analysis*, but is relatively simple. It can increase your chances of finding an original solution.

First, draw up a block for each activity.

Then, identify as many methods as you can for solving each part of the operation.

When you have established these possibilities you can explore each in your sketch book.

Ideas from the first list can then be combined with any from the second list. These can be linked with ideas from the third to give, in this case, 5 × 6 × 5 or 175 possible solutions. One of these should be worthwhile.

PROJECT NETWORKS

Technological design solutions tend to have a number of different parts. So, time spent planning could save manufacturing effort. To plan the manufacture of your object it is advisable to use a project network. Each activity is drawn along an arrow joining two circles. The circles are called nodes. These diagrams are best drawn to scale. The distance between nodes represents a period of time.

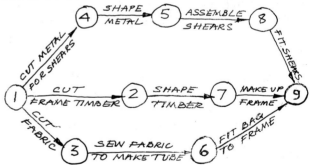

By visualizing the planning operations in this way, you will be able to see which parts of the programme you should start first and how long the project might take.

QUESTIONS

1 What effect have Thomas Edison, Henry Ford, and Jack Kilby had on our world?

2 What do you think Thomas Edison meant when he said 'one per cent inspiration, and ninety nine per cent perspiration'?

3 What is the function of a process flow chart?

4 How can a block diagram help to solve a technological problem?

8.3 SYSTEMS AND CIRCUITS

A **system**, to a technologist, is an organized way of performing an activity. Some of the most common systems are **circuits**, where components are linked in a loop. Electricity and water systems are commonly arranged in the form of a circuit.

INPUT

To perform the function, the system has to be activated. The simplest activating device is a **switch** in an electric circuit or a **valve** in a water system.

These items might differ in appearance, but the principle by which they operate is much the same. Both switches and valves can prevent any flow within the circuit.

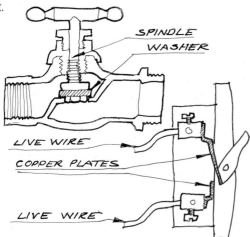

When the tap is turned off, the spindle is wound down. The washer seals the valve and stops any water from passing through it. Once it is turned on, the seal is broken and the water can flow.

In the case of the switch, the flow of electricity around the circuit is prevented by an air gap inside it. In the 'on' position the copper plates are brought into contact to allow the current to flow around the circuit.

Control technologists call switches and valves **input** devices. These start systems working.

POWER

In a domestic central heating system a pump provides the **power**, which is a measure of how quickly energy is being transferred. The pump causes pressure inside the circuit, and, once the radiator valves are opened, it pushes the water around the system. The power in a lighting circuit is provided by a generator. The potential difference across the generator leads causes the current to flow. Once the switch is turned on, power is then developed in the circuit.

PROCESS

The **process** is the means by which the required result is achieved. A central heating system uses hot water to transfer heat from the boiler to the air in a room. The hot water circuit is the process by which this is achieved.

OUTPUT

All systems and circuits are designed to perform activities. An electric circuit might be designed to provide lighting for a room, or power for a cooker. The light from the bulb or the heat from the cooker is the **output** from each system.

All systems have these four elements, **input**, **power**, **process**, and **output**.

MANUAL CONTROL

An electric hot plate relies on *you* to turn it on, to turn it up or down, and to turn it off. This is **manual control**.

The disadvantage of manual control, when boiling a saucepan of milk for instance, is that the hot plate has to be watched continually and adjusted when necessary.

In control technology terms, the hot plate is an **open loop** system.

OPEN LOOP

Water, running from a tap, to fill a washing up bowl, is another example of an open loop system. There is nothing to tell the tap when to turn off. A diagram to

represent this shows both ends of the chain unconnected, so forming an open loop.

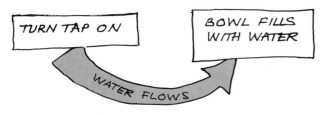

CLOSED LOOP

If you control the tap, turning it off when the bowl is full, then *you* become part of the system and complete the loop. There is now a link between the output and the input. The system has become continuous or closed, and is called a **closed loop** system.

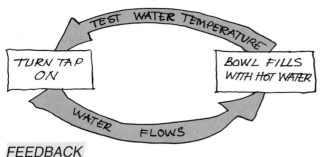

FEEDBACK

By continually testing the temperature of the water with your hand, the control in a closed loop system can become more versatile.

If the water is too hot, then you turn on the cold. If it is not hot enough, you increase the flow from the hot tap. Your hand, touching the water, is feeding back information to you. Further action can then be taken to control the system. This information is called **feedback** and is an important part of a closed loop system.

AUTOMATIC CONTROL

When the system itself registers the feedback from the output and controls the input, you have **automatic control**.

Electric cookers often have thermostats which register the heat of the oven. They switch the circuit on and off to keep the oven at the required temperature. The thermostat is a **sensor**. This enables the circuit to check itself to become an **automatic closed loop** system.

SENSORS AND SWITCHES

There are many sensors and switches which can be used to switch systems on and to check conditions.

Thermostats, like the one in the oven, sense the air temperature. They can also be used to register changes of heat in most solid, liquid, and gaseous materials.

Pressure pads sense weight. For example, when you tread on them, they activate a circuit which automatically opens supermarket doors.

Floats will register liquid levels. **Microphones** will monitor sound. Light beams and jets of air, if interrupted, help us to detect movement.

When these circuits are needed for specific periods, **time switches** are used to turn them on and off, as required.

There are many other devices which wait, look, listen, and feel for particular responses. There are also many different types of processing circuit. These act upon input information, and bring about some form of output activity.

PROCESSING CIRCUITS

Some of these systems are **mechanical** and use mechanisms, such as the springs, levers, and gears inside a set of kitchen scales.

An **hydraulic** system uses liquid to convert the input into the required output. An example of this would be the braking system of a car. This activates all four brakes, once the pedal is pushed.

Pneumatic systems use air in processing circuits. Many schools and most factories have an air line. Compressed air is piped through this to various output devices. These are pneumatically operated.

Processing circuits can also be **electrical**. They use electricity to provide energy, whether this is for a conveyor belt in a factory or for the lighting in a house.

A low voltage electrical supply can provide power for an **electronic** circuit. In such circuits, a range of components act upon and amplify small electrical impulses from a wide variety of sensing and switching devices.

COMPUTER CONTROL

Systems and circuits are widely used in our industrial society. In recent years, the degree of possible control of these has been increased by the introduction of the computer. This can monitor, analyse, record, and select information. Unlike people, the computer can do this for twenty-four hours a day. It therefore brings a whole new meaning to automatic control.

QUESTIONS

1 What is meant by the terms input, power, process, and output?

2 Why is an open loop system so named?

3 What part does feedback play in a closed loop system?

4 How do manual and automatic control differ?

5 What functions do sensors perform?

6 Name the six different types of processing circuit. Give an example of each to explain how it works.

7 How is our thinking about control being affected by the introduction of computers?

8.4 SIMPLE ELECTRICAL CIRCUITS

Electric and electronic components are arranged in circuits. Sensors act as input devices. Process components monitor or magnify the signals from these devices. The process components then relay them to actors which are the output devices.

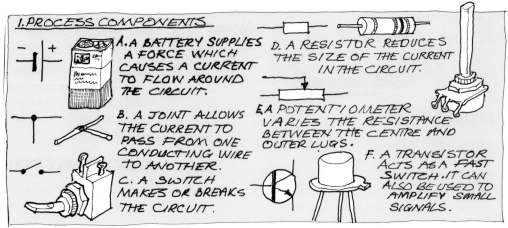

1. PROCESS COMPONENTS

A. A BATTERY SUPPLIES A FORCE WHICH CAUSES A CURRENT TO FLOW AROUND THE CIRCUIT.

B. A JOINT ALLOWS THE CURRENT TO PASS FROM ONE CONDUCTING WIRE TO ANOTHER.

C. A SWITCH MAKES OR BREAKS THE CIRCUIT.

D. A RESISTOR REDUCES THE SIZE OF THE CURRENT IN THE CIRCUIT.

E. A POTENTIOMETER VARIES THE RESISTANCE BETWEEN THE CENTRE AND OUTER LUGS.

F. A TRANSISTOR ACTS AS A FAST SWITCH. IT CAN ALSO BE USED TO AMPLIFY SMALL SIGNALS.

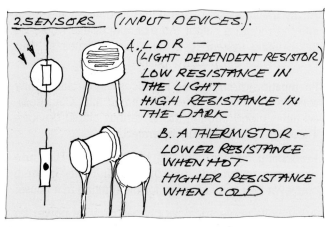

2. SENSORS (INPUT DEVICES).

A. L.D.R — (LIGHT DEPENDENT RESISTOR) LOW RESISTANCE IN THE LIGHT HIGH RESISTANCE IN THE DARK

B. A THERMISTOR — LOWER RESISTANCE WHEN HOT HIGHER RESISTANCE WHEN COLD

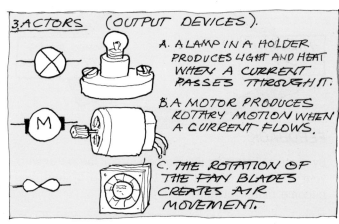

3. ACTORS (OUTPUT DEVICES).

A. A LAMP IN A HOLDER PRODUCES LIGHT AND HEAT WHEN A CURRENT PASSES THROUGH IT.

B. A MOTOR PRODUCES ROTARY MOTION WHEN A CURRENT FLOWS.

C. THE ROTATION OF THE FAN BLADES CREATES AIR MOVEMENT.

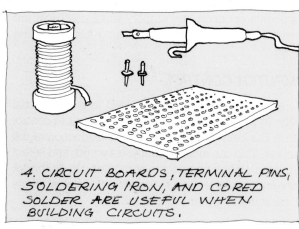

4. CIRCUIT BOARDS, TERMINAL PINS, SOLDERING IRON, AND CORED SOLDER ARE USEFUL WHEN BUILDING CIRCUITS.

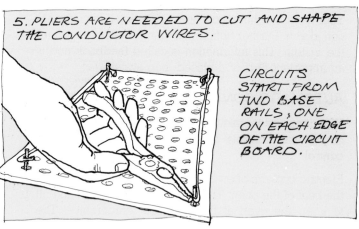

5. PLIERS ARE NEEDED TO CUT AND SHAPE THE CONDUCTOR WIRES.

CIRCUITS START FROM TWO BASE RAILS, ONE ON EACH EDGE OF THE CIRCUIT BOARD.

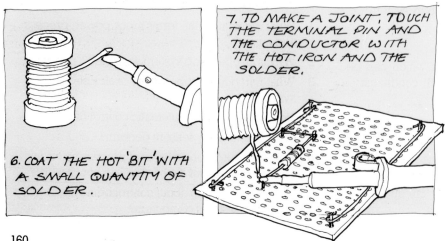

6. COAT THE HOT 'BIT' WITH A SMALL QUANTITY OF SOLDER.

7. TO MAKE A JOINT, TOUCH THE TERMINAL PIN AND THE CONDUCTOR WITH THE HOT IRON AND THE SOLDER.

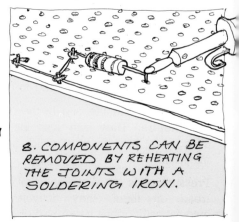

8. COMPONENTS CAN BE REMOVED BY REHEATING THE JOINTS WITH A SOLDERING IRON.

9. THE SIZE OF EACH COMPONENT IN A CIRCUIT HAS TO BE CAREFULLY CALCULATED TO MAKE SURE THAT THE CIRCUIT WILL WORK.

10. THE RESISTANCE OF A RESISTOR IS MEASURED IN OHMS.

1 OHM IS WRITTEN 1 Ω
1000 OHMS IS WRITTEN 1 KΩ
3300 OHMS IS WRITTEN 3·3 KΩ

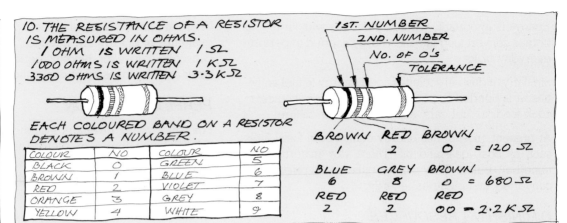

EACH COLOURED BAND ON A RESISTOR DENOTES A NUMBER.

COLOUR	NO	COLOUR	NO
BLACK	0	GREEN	5
BROWN	1	BLUE	6
RED	2	VIOLET	7
ORANGE	3	GREY	8
YELLOW	4	WHITE	9

1ST. NUMBER
2ND. NUMBER
No. OF 0's
TOLERANCE

BROWN RED BROWN
1 2 0 = 120 Ω

BLUE GREY BROWN
6 8 0 = 680 Ω

RED RED RED
2 2 00 = 2·2 KΩ

11. THE THREE LEADS ON A TRANSISTOR MUST BE TREATED WITH CARE.

A SHORT LENGTH OF PLASTIC SLEEVE WILL PREVENT CONTACT.

THE CORRECT LEAD MUST BE CONNECTED TO THE REQUIRED TERMINAL.
c = COLLECTOR
b = BASE
e = EMITTER.

PLAN VIEW.

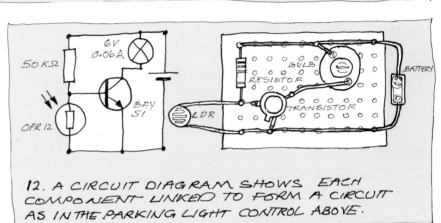

12. A CIRCUIT DIAGRAM SHOWS EACH COMPONENT LINKED TO FORM A CIRCUIT AS IN THE PARKING LIGHT CONTROL ABOVE.

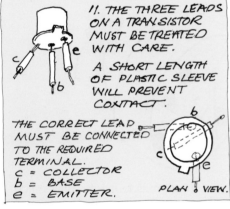

13. BY MOVING THE LDR AND CHANGING THE SIZE OF THE RESISTOR THE LAMP WILL LIGHT WHEN THE ROOM IS BRIGHT.

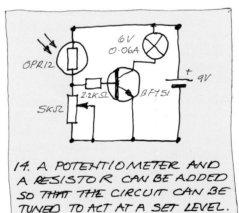

14. A POTENTIOMETER AND A RESISTOR CAN BE ADDED SO THAT THE CIRCUIT CAN BE TUNED TO ACT AT A SET LEVEL.

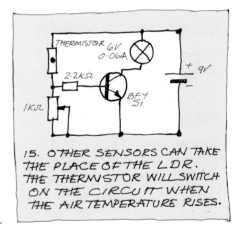

15. OTHER SENSORS CAN TAKE THE PLACE OF THE LDR. THE THERMISTOR WILL SWITCH ON THE CIRCUIT WHEN THE AIR TEMPERATURE RISES.

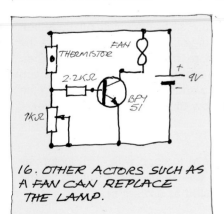

16. OTHER ACTORS SUCH AS A FAN CAN REPLACE THE LAMP.

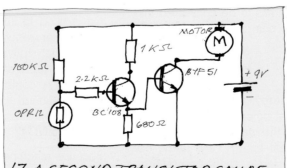

17. A SECOND TRANSISTOR CAN BE USED TO MAKE THE CIRCUIT MORE SENSITIVE.

Activity

Using either a thermistor or an LDR as a sensor, design a circuit and the necessary output machinery to ventilate a car which is to be left locked in the summer sun.

8.5 ENERGY

Energy is important. We could not live without it. Our bodies convert food into the energy needed to perform everyday tasks.

Similarly, industrial societies need energy to fuel activities. It is needed to power factories, to heat homes, to cook food, to fuel cars, and even for agriculture.

At present, most of this energy comes from fossil fuels such as coal, gas, and oil. These raw materials are mined or drilled. They can be either used directly, or converted into electrical energy.

DIMINISHING RESOURCES

Fossil fuels have taken millions of years to form beneath the surface of the earth. However, they can only provide us with energy for a limited period.

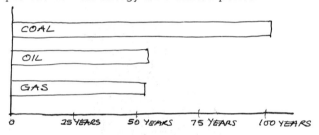

RESERVES OF FOSSIL FUELS.

The demand for energy is huge *and* growing. Therefore, other sources are needed to meet this demand.

HYDRO-ELECTRIC POWER

Hydro-electric power is one such source. Electricity is generated by channelling large amounts of water from lakes, through dams, to drive turbines.

NUCLEAR ENERGY

Nuclear energy is also used to generate electricity. Atoms of uranium are split to release huge quantities of energy.

One kilogram of uranium 235 could supply one million times more energy than the same weight of coal. However, the process uses highly radioactive materials, and so nuclear energy has to be converted into electricity under carefully controlled conditions in nuclear power stations.

OTHER SOURCES

Because of the need for energy, scientists and technologists have also looked at other new sources. The movement of the wind and the waves, as well as the heat of the earth (geothermal energy) are being explored. Work is also progressing to tap the energy from the sun (solar energy), either by using it directly to heat solar panels, or, indirectly, by growing plants which can be converted into fuel.

There are limited signs of success. However, very large quantities of energy are needed. These other sources can only help after lengthy periods of development work and the investment of significant sums of money.

PERPETUAL MOTION

For many years, inventors searched for an alternative solution to the energy problem. Attempts were made to design perpetual motion machines. It was hoped that these machines, once set in motion, would continue to function without the need for additional energy input.

Great minds battled with notions such as the one below, proposed by the Marquis of Worcester in 1663.

As the wheel rotates, a ball rolls to the circumference creating a turning force which moves the wheel and sets the next ball in motion. There were many variations on this theme, but although they appeared convincing on paper, none of them actually worked in practice. This is because all machines are affected by **friction**.

FRICTION

Friction is a force which prevents one surface from sliding over another. Without it, we would not be able to walk along the road, as our feet would be unable to grip. It is also the force which slows a bicycle down once pedalling has stopped, and it would certainly help to bring the perpetual motion machine to a halt.

LUBRICATION

Oil is used to lubricate surfaces which rub together. Lubrication reduces the effects of friction. It allows the surfaces to move more freely against one another. Although lubrication could help the perpetual motion machine to continue working, it would not reduce the friction enough to allow the wheel to rotate forever.

EFFICIENCY

Because machines have to cope with such factors as friction, they cannot use all the input energy. Some energy is always wasted as useless heat.

Some machines, because of their design, lose more

energy than others. Therefore, there is a need to measure how effective each is. This can be done by calculating their efficiency.

$$\text{Efficiency} = \frac{\text{energy output}}{\text{energy input}} \times 100\%$$

James Watt's steam engine of about 1776 was only 1% efficient. This means that only one part in a hundred of the input energy was being used to produce the required work. The petrol engine of a car is a little more efficient. Even so, it only uses a quarter of the energy in the petrol to drive the car. The rest of the energy is converted to heat and other forms of energy.

All machines convert energy from one or more forms into other forms. So, it is important for designers to know about the different forms of energy.

FORMS OF ENERGY

There are two kinds of **mechanical** energy: potential and kinetic.

Kinetic energy is energy due to movement. If you drop a heavy weight on to your foot, you will soon discover how much kinetic energy a short fall will produce. A moving weight can be used to perform work. For example, water flowing down a mountain side can be used to drive a waterwheel.

Potential energy is energy due to position, or energy 'stored up', ready to be used. A weight, before it falls, has potential energy. A compressed spring and a twisted piece of elastic also have potential energy.

Heat is another form of energy. It can often be used to perform a function, such as converting water into steam to drive a steam engine.

Fuel, such as petrol, contains **chemical** energy. This is converted into kinetic energy inside the engine of a car.

A battery also stores chemical energy and releases it in the form of electrical energy.

Electrical energy is produced by the flow of an electric current around a circuit. An electric motor uses electrical energy to turn a fan or rotate a drill.

Light energy can be used to switch electronic circuits on. In the form of a laser beam, light can cut through metal.

Sound can be converted into electrical energy by a microphone. It can also be used to determine the depth of water by using a sonar device which bounces sound waves.

ENERGY IN ACTION

All these forms of energy can be used to power circuits and switch on systems in a variety of situations. However, a single form rarely appears by itself. In fact, one machine can use many types of energy.

Imagine a ball in a pin ball machine. When the plunger is pulled back it compresses a spring, creating **potential** energy. When released, the **kinetic** energy in the plunger is transferred to the ball. This races around the machine, transferring kinetic energy to the pins as it collides with them. The impact switches on an electric circuit. Here, **electrical** energy is converted into **light** and **sound** energy. The ball loses energy to the walls and floor of the machine because of friction. This produces small amounts of **heat** energy.

QUESTIONS

1 What are fossil fuels?

2 What other sources of energy are being investigated as alternatives to fossil fuels?

3 What is friction, and how is it affected by lubrication?

4 How can the effectiveness of two machines be compared?

5 How do the two forms of mechanical energy differ?

6 What other forms of energy are there?

8.6 ENERGY SOURCES AND USES

Designers use energy to create movement. There are many ways in which this can be achieved. The most available sources of movement are air, gravity, heat, flexible materials, electricity, and, of course, human beings.

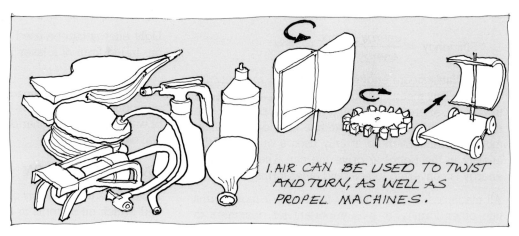

1. AIR CAN BE USED TO TWIST AND TURN, AS WELL AS PROPEL MACHINES.

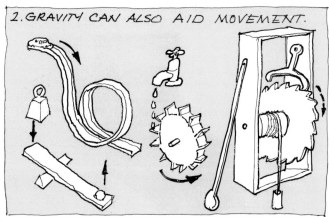

2. GRAVITY CAN ALSO AID MOVEMENT.

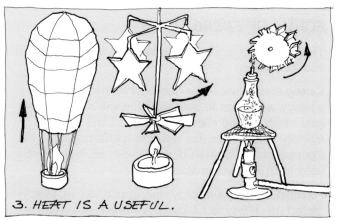

3. HEAT IS A USEFUL.

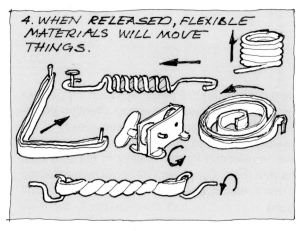

4. WHEN RELEASED, FLEXIBLE MATERIALS WILL MOVE THINGS.

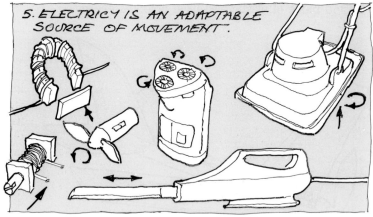

5. ELECTRICY IS AN ADAPTABLE SOURCE OF MOVEMENT.

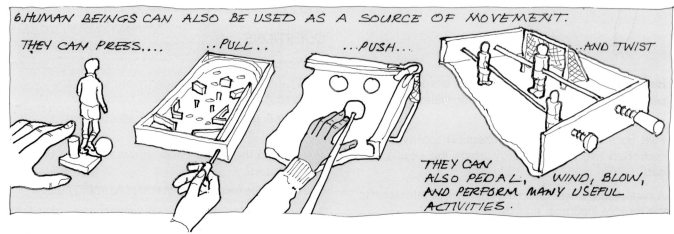

6. HUMAN BEINGS CAN ALSO BE USED AS A SOURCE OF MOVEMENT.

THEY CAN PRESS.... ..PULL.. ...PUSH... ...AND TWIST

THEY CAN ALSO PEDAL, WIND, BLOW, AND PERFORM MANY USEFUL ACTIVITIES.

7. THESE ENERGY SOURCES CAN BE USED IN MANY DIFFERENT WAYS.

BRIEF.
DESIGN A WAY OF PROPELLING A TENNIS BALL ACROSS AN OPEN SPACE SO THAT IT WILL TRAVEL THE FURTHEST DISTANCE. IT MUST REMAIN IN CONTACT WITH THE GROUND AT ALL TIMES.

8. THE BALL COULD BE PUSHED BY HAND...

9. ...OR ROLLED DOWN A RAMP.

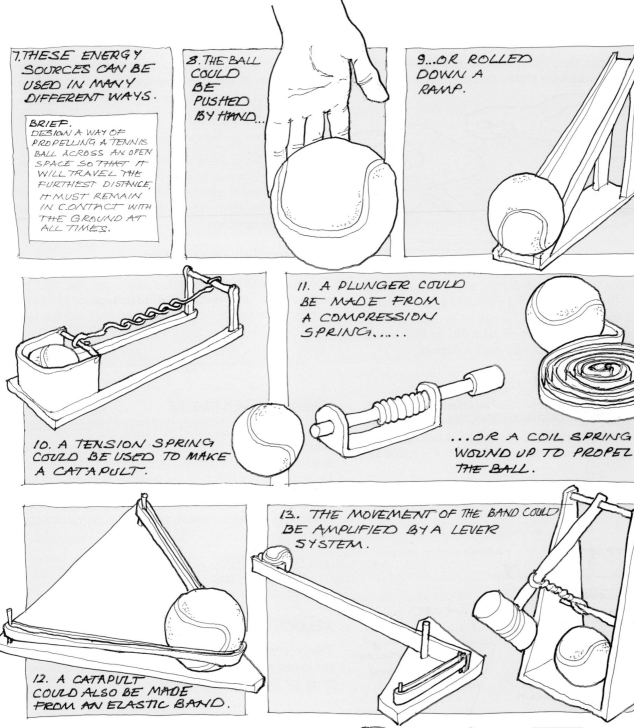

10. A TENSION SPRING COULD BE USED TO MAKE A CATAPULT.

11. A PLUNGER COULD BE MADE FROM A COMPRESSION SPRING......

...OR A COIL SPRING WOUND UP TO PROPEL THE BALL.

12. A CATAPULT COULD ALSO BE MADE FROM AN ELASTIC BAND.

13. THE MOVEMENT OF THE BAND COULD BE AMPLIFIED BY A LEVER SYSTEM.

14. THE BALL MIGHT BE DRIVEN BY AN ELECTRIC MOTOR.

15. IT MIGHT ALSO BE PROPELLED BY AIR.

Activity

Design a board game of skill. This should include a glass marble which is to be propelled around the board by some readily available source of energy.

8.7 LEVERS

Many common tools incorporate **levers**. Three every-day lever systems are shown below.

FULCRUM

Levers can be constructed from any reasonably stiff material. The selection of the material for the lever will depend upon its function. This can be to apply a **force**, or to transfer a **movement**, or both. To do this, levers have to pivot about a point called a **fulcrum**.

EFFORT AND LOAD

We need to apply a force called an **effort** for these tools to function. The effort moves the lever about the fulcrum, and so it performs the required task. This task also applies a force on the lever. This force is called the **load**.

THREE ORDERS OF LEVER

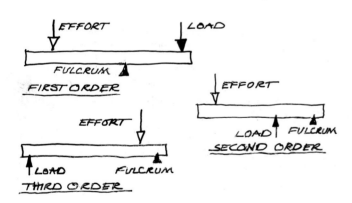

The positions of the fulcrum, effort, and load can be seen in the force diagram on page 167 opposite.

These diagrams show the three orders of lever. The pliers are made up of first order levers. The hole punch incorporates a second order. And the tweezers combine two third order levers. All levers can be placed in one of these three orders.

LIFTING LOADS

When designing a lever to lift a load you will need to know the positions of the fulcrum, the effort, and the load in order to work out how long it should be, or how much effort is needed. To do this you should calculate the **moments** in the lever system.

A moment of a force can be calculated as follows:

moment of a force
= force × distance of force from the fulcrum.

In a simple lever there are two moments acting about the fulcrum. If one is created by the load with a turning force in an anticlockwise direction, then the other is created by the effort, which produces a turning force in a clockwise direction.

MECHANICAL ADVANTAGE

The relationship between the effort and the load is recorded as the **mechanical advantage** of a lever system. It is calculated by dividing the load by the effort.

$$\text{mechanical advantage} = \frac{\text{load}}{\text{effort}}$$

CREATING MOVEMENT

Levers can also be used to create movement. The effort, in this case, is called the input movement. The load is the output movement. A movement diagram can be drawn using two new symbols shown opposite.

The formula for calculating the unknown factors in this situation is similar to the one used for loads. You should use:

$$\frac{\text{input movement}}{\text{distance of input from fulcrum}} = \frac{\text{output movement}}{\text{distance of output from fulcrum}}$$

VELOCITY RATIO

The velocity ratio is the relationship of these two movements. It is calculated by dividing the input movement by the output movement.

$$\text{velocity ratio} = \frac{\text{input movement}}{\text{output movement}}$$

QUESTIONS

1 What is the fulcrum of a lever system?
2 What is the difference between effort and load?
3 How do first, second, and third order levers differ?
4 What is a moment?
5 How are moments used to calculate lever sizes?
6 What is mechanical advantages?
7 What are the two movements in a lever system called?
8 How is velocity ratio calculated?

8.8 DESIGNING LEVERS

Levers can be used to lift loads or to create movement or to do both. To design a lever system, first draw a diagram using symbols to represent the various elements.

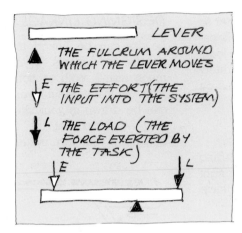

LEVER

THE FULCRUM AROUND WHICH THE LEVER MOVES

E THE EFFORT (THE INPUT INTO THE SYSTEM)

L THE LOAD (THE FORCE EXERTED BY THE TASK)

2. SOME OF THE INFORMATION ABOUT THIS LEVER CAN BE FOUND FROM EXPERIMENTS...

LOAD = 6 NEWTONS

3..OR FROM MEASUREMENTS TAKEN FROM AVAILABLE MATERIALS.

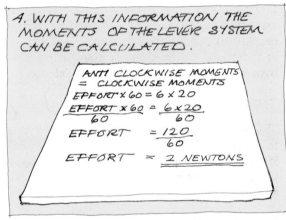

4. WITH THIS INFORMATION THE MOMENTS OF THE LEVER SYSTEM CAN BE CALCULATED.

ANTI CLOCKWISE MOMENTS = CLOCKWISE MOMENTS

$EFFORT \times 60 = 6 \times 20$

$\dfrac{EFFORT \times 60}{60} = \dfrac{6 \times 20}{60}$

$EFFORT = \dfrac{120}{60}$

$EFFORT = \underline{2\ NEWTONS}$

5. WHEN THE LEVER IS TO CREATE MOVEMENT A SIMILAR SYMBOL DIAGRAM CAN BE DRAWN.

LEVER

I INPUT MOVEMENT

O OUTPUT MOVEMENT

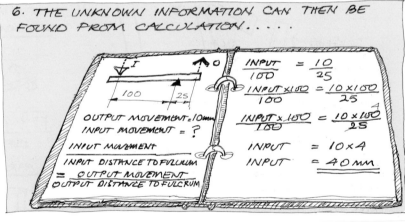

6. THE UNKNOWN INFORMATION CAN THEN BE FOUND FROM CALCULATION.....

OUTPUT MOVEMENT = 10 mm
INPUT MOVEMENT = ?

$\dfrac{INPUT\ MOVEMENT}{INPUT\ DISTANCE\ TO\ FULCRUM} = \dfrac{OUTPUT\ MOVEMENT}{OUTPUT\ DISTANCE\ TO\ FULCRUM}$

$\dfrac{INPUT}{100} = \dfrac{10}{25}$

$\dfrac{INPUT \times 100}{100} = \dfrac{10 \times 100}{25}$

$\dfrac{INPUT \times 100}{100} = \dfrac{10 \times 100}{25}$

$INPUT = 10 \times 4$

$INPUT = \underline{40\ mm}$

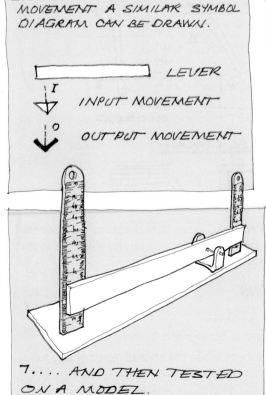

7.... AND THEN TESTED ON A MODEL.

Activity

Design a lever system that could be used as a weighing machine. This should be capable of accurately measuring loads up to 3 kg.

8.9 LINKAGES

Linkages are collections of levers grouped together so that one input movement may give a number of separate outputs, or the effort may move more than one load. Each lever in the linkage can be worked out separately using either the movement or the load equations on pages 166–167.

A WORKING LINKAGE

The design of a linkage system can be a very engaging task. If you look closely at the mechanism of the upright piano you will see how ingenious some designers have been.

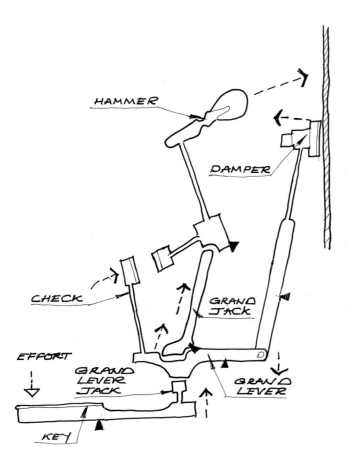

The key itself is a first order lever. When pressed, it transmits an output movement to the grand lever. This is the most interesting component in the whole system because it does three jobs.

Firstly it acts as a first order lever to move the damper away from the string. It can then vibrate when it is struck. It also acts as a second order lever when it moves the grand jack up to strike the hammer. Finally, it becomes a third order lever when it moves up to lift the check. This holds the hammer just clear of the string and prevents it from returning to its original position until the key is released.

DESIGNING LINKAGES

Levers can be linked to create very intricate and precise movements. If you look at various tools and mechanisms, both at home and at school, you will discover many useful lever and linkage systems. These can be drawn in your sketch book for later use. You may also find that the linkages below help when designing your own system.

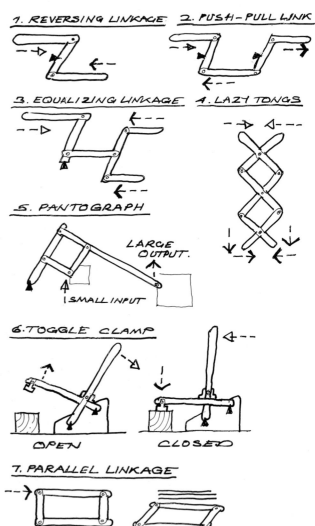

At the design stage, movement diagrams are essential and card models, if made accurately, will help to sort out your ideas.

QUESTIONS

1 What is a linkage?
2 What does a pantograph linkage do?
3 What happens when the ends of a pair of lazy tongs are pushed together?
4 What steps do you need to go through to design a linkage system?

8.10 DESIGNING LINKAGES

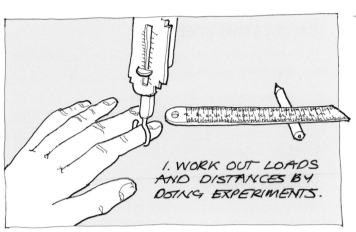

1. WORK OUT LOADS AND DISTANCES BY DOING EXPERIMENTS.

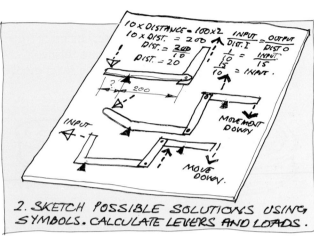

2. SKETCH POSSIBLE SOLUTIONS USING SYMBOLS. CALCULATE LEVERS AND LOADS.

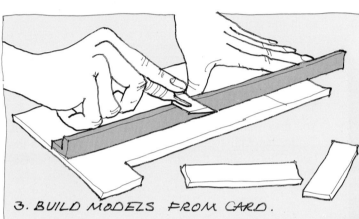

3. BUILD MODELS FROM CARD.

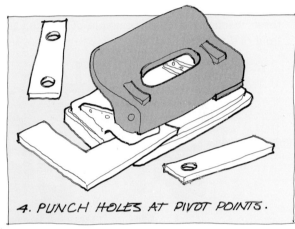

4. PUNCH HOLES AT PIVOT POINTS.

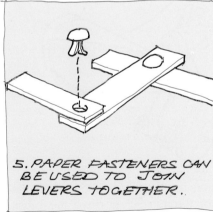

5. PAPER FASTENERS CAN BE USED TO JOIN LEVERS TOGETHER.

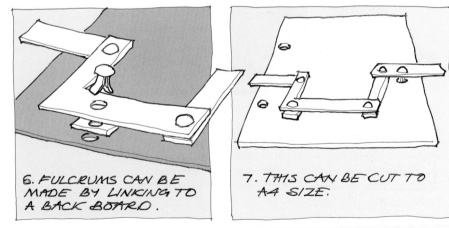

6. FULCRUMS CAN BE MADE BY LINKING TO A BACK BOARD.

7. THIS CAN BE CUT TO A4 SIZE.

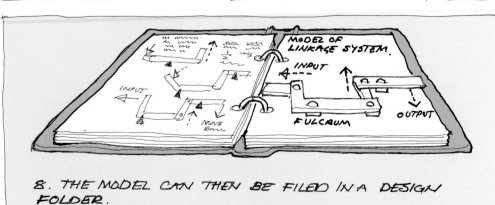

8. THE MODEL CAN THEN BE FILED IN A DESIGN FOLDER.

Activity

Design a linkage system that could be used as the framework of a folding chair.

This should be able to support the user in two positions, as well as packing flat for storage and transport.

Pulley systems are used to drive many different sorts of machine. They have many uses and are relatively easy to design and install. Usually, they are a set of grooved wheels linked by a belt.

The pillar drill in the school workshop is driven by a pulley system, as are most record turntables. Both of these machines use the principle of the belt moving from one pulley to another.

CONE PULLEYS

Switch off the power supply and remove the cover from the drilling machine. In most cases, you will see that the electric motor at the back is connected to a set of cone pulleys, with the smallest at the bottom. The belt connects these to another set mounted the other way up on top of the shaft. This is linked to the chuck into which the drill bit is fitted.

DRIVER AND DRIVEN

As the motor does the driving, the pulley fixed to it is called the **driver**. The chuck pulley is being turned by the driver, so this is called the **driven** pulley.

When the belt is at the bottom of the cone the driver is smaller than the driven pulley. So, the chuck revolves more slowly than the motor. When the belt is at the top, the reverse is true. The driver is larger than the driven pulley. So, the output speed is greater than the input speed.

CALCULATING SPEED

The relationship of the speeds of the two spindles can be calculated, as below.

driver speed × driver diameter
= driven speed × driven diameter

Once any three of these are known, the fourth can be found by calculation.

VELOCITY RATIO

When you have completed the calculation you can find the velocity ratio of a pulley system. This can be done by comparing the diameters of the two pulley wheels, as in the equation below.

$$\text{velocity ratio} = \frac{\text{diameter of driven}}{\text{diameter of driver}}$$

DIFFERENT DIRECTIONS

You may want to reverse the direction of your output. To do this with a pulley system, you simply cross the belt. This rotates the driven pulley in the opposite direction.

Some vacuum cleaners use a round belt to transmit the rotation of the motor through 90° to drive the brush roller. In this case the driver pulley has been specially designed to keep the twisted belt in place.

QUESTIONS

1 What is a pulley system?
2 What is the difference between a driver and a driven pulley?
3 What is the formula used for calculating pulley speeds?
4 How is the velocity ratio of a pulley system calculated?
5 What effect does crossing the drive belt have on a pulley system?

8.12 MODELLING PULLEYS

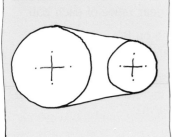

1. THE DRAWING SYMBOL FOR A PULLEY IS A CIRCLE. THE BELT IS SHOWN AS A LINE.

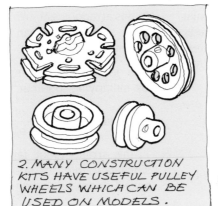

2. MANY CONSTRUCTION KITS HAVE USEFUL PULLEY WHEELS WHICH CAN BE USED ON MODELS.

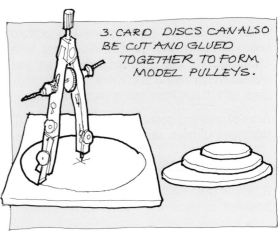

3. CARD DISCS CAN ALSO BE CUT AND GLUED TOGETHER TO FORM MODEL PULLEYS.

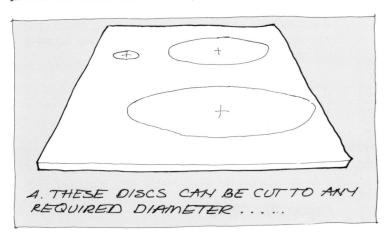

4. THESE DISCS CAN BE CUT TO ANY REQUIRED DIAMETER

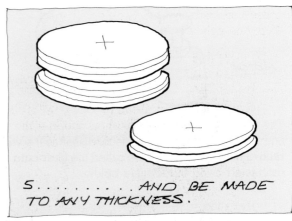

5. AND BE MADE TO ANY THICKNESS.

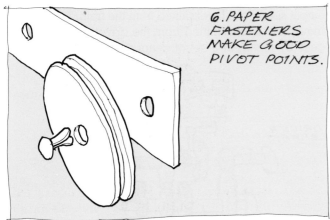

6. PAPER FASTENERS MAKE GOOD PIVOT POINTS.

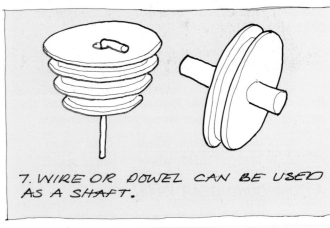

7. WIRE OR DOWEL CAN BE USED AS A SHAFT.

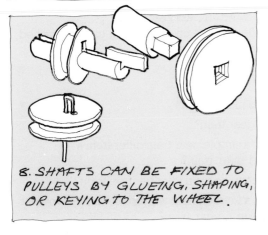

8. SHAFTS CAN BE FIXED TO PULLEYS BY GLUEING, SHAPING, OR KEYING TO THE WHEEL.

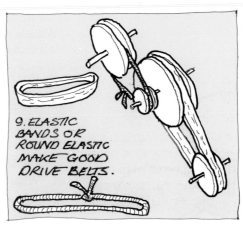

9. ELASTIC BANDS OR ROUND ELASTIC MAKE GOOD DRIVE BELTS.

Activity

Design a pulley system to transfer the twisting motion of a wound up elastic band to the wheels of the cardboard car so that it will travel the furthest distance without stopping.

8.13 GEARS

Gears and pulleys are often used to perform similar tasks. However, pulleys may slip under heavy loads. Gears will not slip. This is because they are toothed wheels which interlock or **mesh**. This transmits a movement or a force from one wheel to another.

A set of meshing gears is called a **gear train**. There are two types of train: **simple** or **compound**.

A SIMPLE GEAR TRAIN

A simple gear train is one in which one gear wheel is mounted on each of the shafts to be linked.

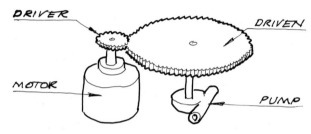

The relationship between the input speed of the motor and the output speed of the second shaft is the **velocity ratio** of the train. This can be called the **gear ratio** and is calculated using the formula below.

$$\text{gear ratio} = \frac{\text{input speed}}{\text{output speed}}$$

The gear ratio can also be found from the number of teeth on each wheel.

$$\text{gear ratio} = \frac{\text{number of teeth on driven wheel}}{\text{number of teeth on driver wheel}}$$

By combining these two formulae, you can relate the number of teeth on each wheel with their speeds.

$$\frac{\text{no. of teeth on driven wheel}}{\text{no. of teeth on driver wheel}} = \frac{\text{input speed}}{\text{output speed}}$$

A COMPOUND GEAR TRAIN

Greater speed difference between the input and output wheels can be obtained from a **compound gear train**.

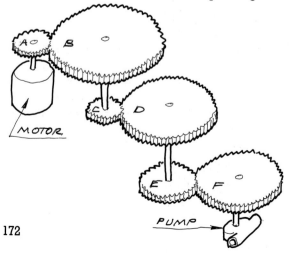

In this arrangement, two or more gears are mounted on each shaft. More than one pair of wheels mesh to transmit movement.

The gear ratio of a compound gear train can be found by multipying together the gear ratios of each pair.

$$\text{gear ratio} = \frac{\text{no. of teeth on B}}{\text{no. of teeth on A}} \times \frac{D}{C} \times \frac{F}{E}$$

In this arrangement, fairly small gears will give very significant rates of speed increase (gearing up) or speed decrease (gearing down).

CHANGING DIRECTION

If you need to change the direction of an output gear you should introduce an **idler** gear. This sits between the driver and the driven wheels.

The idler can be of any convenient size, because it does not change the gear ratio of the train in any way.

CHANGING GEAR

Gears can also be arranged so that more than one output speed can be obtained from the train. To do this, movement is transmitted from the driver to the driven gear by means of a set of gears on a **layshaft**.

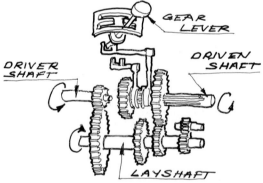

Wheels of different size on the layshaft can be meshed to produce various speeds.

QUESTIONS

1 What does mesh mean?
2 What is a gear train?
3 How does a simple gear train differ from a compound gear train?
4 What function does an idler gear perform?
5 How does a layshaft help to produce different output speeds from a gear train?

8.14 MODELLING GEARS

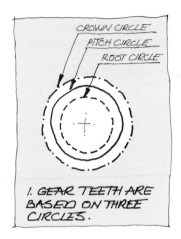

1. GEAR TEETH ARE BASED ON THREE CIRCLES.

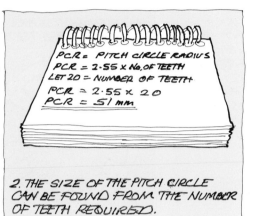

2. THE SIZE OF THE PITCH CIRCLE CAN BE FOUND FROM THE NUMBER OF TEETH REQUIRED.

PCR = PITCH CIRCLE RADIUS
PCR = 2·55 × No. OF TEETH
LET 20 = NUMBER OF TEETH
PCR = 2·55 × 20
PCR = 51 mm

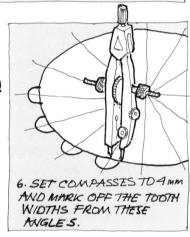

3. DRAW THE PITCH CIRCLE ON A PIECE OF CARD.

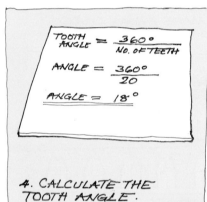

$$\text{TOOTH ANGLE} = \frac{360°}{\text{No. OF TEETH}}$$

$$\text{ANGLE} = \frac{360°}{20}$$

$$\text{ANGLE} = 18°$$

4. CALCULATE THE TOOTH ANGLE.

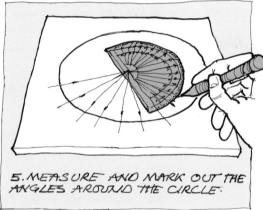

5. MEASURE AND MARK OUT THE ANGLES AROUND THE CIRCLE.

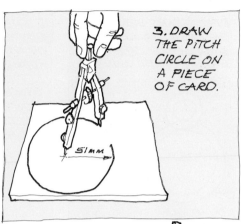

6. SET COMPASSES TO 4mm AND MARK OFF THE TOOTH WIDTHS FROM THESE ANGLES.

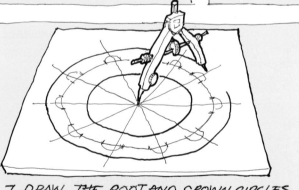

7. DRAW THE ROOT AND CROWN CIRCLES 5mm LARGER AND SMALLER THAN THE PITCH CIRCLE.

8. JOIN THE TOOTH WIDTHS TO THE CENTRE OF THE CIRCLE AND OUTLINE THE TEETH.

9. CUT OUT THE CROWN CIRCLE.

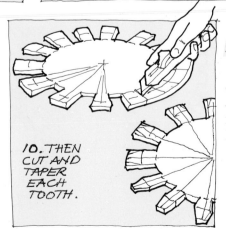

10. THEN CUT AND TAPER EACH TOOTH.

Activity

Design a gear train that will change the output speed of an electric motor from 4500 rpm to 60 rpm, so that it can be used as a timing device.

8.15 GEARS AND OTHER MECHANISMS

1. THE GEARS DESCRIBED ON PAGE 173 ARE FLAT SPUR GEARS. THEY ARE SHOWN ON DRAWINGS AS TWO CIRCLES.

FRONT VIEW END VIEW

2. THERE ARE DIFFERENT FORMS OF GEAR. EACH IS REPRESENTED BY A DIFFERENT SYMBOL AND PERFORMS A PARTICULAR TYPE OF ACTIVITY.

3. INTERNAL GEARS WILL TAKE HIGHER LOADS AND THE TEETH ARE GUARDED INSIDE THE WHEEL.

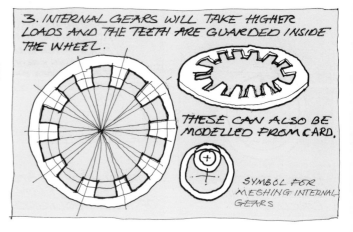

THESE CAN ALSO BE MODELLED FROM CARD.

SYMBOL FOR MESHING INTERNAL GEARS

4. A RACK AND PINION CHANGES CIRCULAR MOTION INTO A LINEAR ONE OR VICE VERSA.

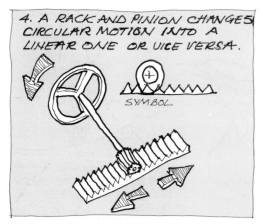

SYMBOL

5. A MODEL RACK CAN BE MADE FROM CARD.

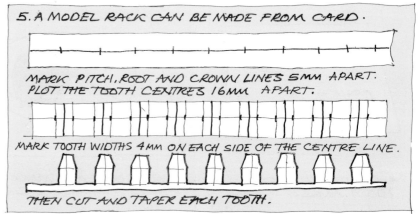

MARK PITCH, ROOT AND CROWN LINES 5MM APART. PLOT THE TOOTH CENTRES 16MM APART.

MARK TOOTH WIDTHS 4MM ON EACH SIDE OF THE CENTRE LINE.

THEN CUT AND TAPER EACH TOOTH.

6. BEVEL GEARS TRANSMIT ROTATION THROUGH 90°.

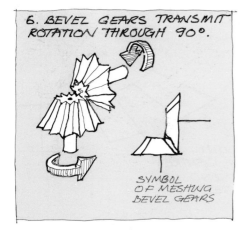

SYMBOL OF MESHING BEVEL GEARS

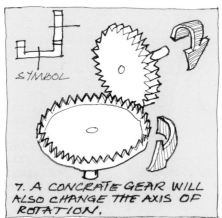

SYMBOL

7. A CONCRATE GEAR WILL ALSO CHANGE THE AXIS OF ROTATION.

8. A WORM AND WORMWHEEL ARE OFTEN USED TO CONNECT A MOTOR TO A GEAR TRAIN.

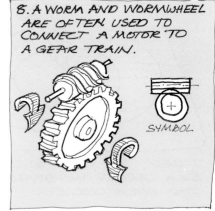

SYMBOL

9. ON SIMPLE MODELS CARD SPUR GEARS CAN BE MESHED AT 90° TO EACH OTHER.

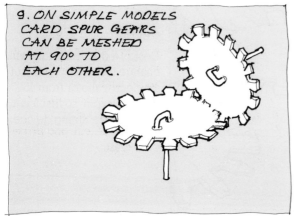

10. RACHET WHEELS WILL ONLY ROTATE IN ONE DIRECTION. THE 'PAWL' PREVENTS RETURN.

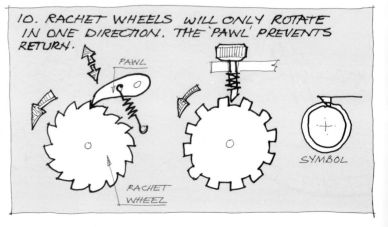

PAWL

RACHET WHEEL

SYMBOL

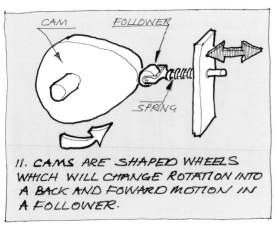

11. CAMS ARE SHAPED WHEELS WHICH WILL CHANGE ROTATION INTO A BACK AND FOWARD MOTION IN A FOLLOWER.

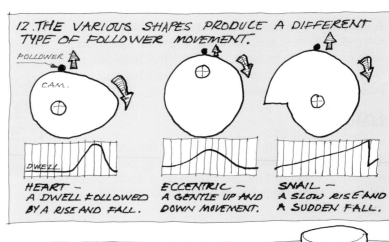

12. THE VARIOUS SHAPES PRODUCE A DIFFERENT TYPE OF FOLLOWER MOVEMENT.

HEART — A DWELL FOLLOWED BY A RISE AND FALL.

ECCENTRIC — A GENTLE UP AND DOWN MOVEMENT.

SNAIL — A SLOW RISE AND A SUDDEN FALL.

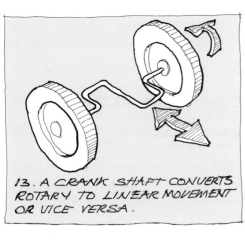

13. A CRANK SHAFT CONVERTS ROTARY TO LINEAR MOVEMENT OR VICE VERSA.

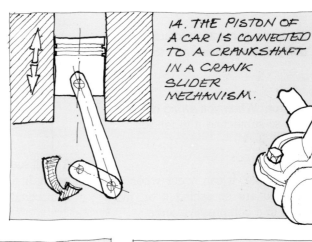

14. THE PISTON OF A CAR IS CONNECTED TO A CRANKSHAFT IN A CRANK SLIDER MECHANISM.

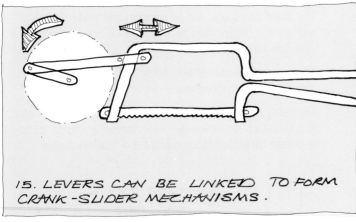

15. LEVERS CAN BE LINKED TO FORM CRANK-SLIDER MECHANISMS.

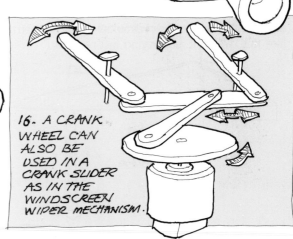

16. A CRANK WHEEL CAN ALSO BE USED IN A CRANK SLIDER AS IN THE WINDSCREEN WIPER MECHANISM.

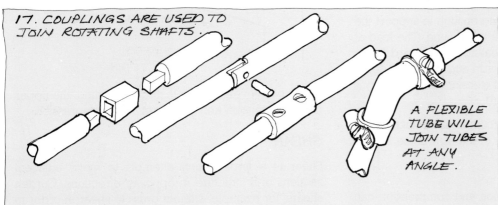

17. COUPLINGS ARE USED TO JOIN ROTATING SHAFTS.

A FLEXIBLE TUBE WILL JOIN TUBES AT ANY ANGLE.

Activity

Design a machine that could be used to make your breakfast when you pull a starter chord.
This might make a cup of tea, pour a bowl of breakfast cereal, and make some toast.

8.16 STRUCTURES

A matchbox is as much a structure as a bridge over a river. Both have to keep their shape or form and stand up to normal loads on them. To achieve this, their designers have had to understand how structures can be built to resist these loads.

LOADS

There are two main types of load on any structure. These are either **static** or **dynamic**. A lorry, parked on a bridge, is subjecting the bridge to a static load. However, once the lorry starts to move it is then a dynamic load.

FORCES

Static and dynamic loads subject structures to the forces of **tension**, **compression**, **shear**, and **torsion**.

TENSION

Tension is a pulling force. When you swing on a rope you are pulling it and so subjecting it to tension.

COMPRESSION

Compression is the opposite. It can occur when you stand on something. You are squashing it or, more correctly, subjecting it to a compressive force.

Imagine a tower crane on a building site. Both tension and compression can act simultaneously on a structure like this, whilst it is carrying just one load.

Assume that the tower is strong enough to support the arm and is anchored firmly to the ground. The load at the end of the arm is then creating a downward force. This is being resisted by the arm and the tie. In doing this the tie is being stretched (tension) and the arm is being squashed (compression).

Structural engineers call a compression member a **strut**. So, in this instance, the crane arm is the strut.

BENDING

The same two forces of tension and compression can be found together when an object bends.

A pile of books or magazines, standing on a shelf, causes it to bend.

A line through the centre of the shelf, called the **neutral axis**, does not change it length.

However, above the centre line the shelf is being squashed, and so reduces in length. Below the neutral axis, the shelf is being stretched, and so increases in length.

A shelf such as this, supported at either end, is called a **beam**. In a beam subjected to bending, the upper part is in compression and the lower is in tension.

CANTILEVERS

The shelf brackets, which support the shelf, are themselves only supported at the wall. In structural terms they are **cantilevers**.

When cantilevers bend, they too are subjected to tension and compression.

If a heavy load were hung from the end of the bracket, it would bend downwards. This forms a curve in the opposite direction from that of the loaded beam.

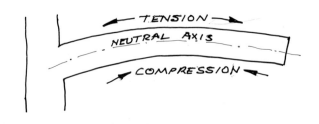

When cantilevers are subjected to bending, the upper part is in tension and the lower is in compression.

SHEAR

Shear is a force which attempts to move adjacent sections of a structure in opposite directions. Garden shears, for example, subject grass to shear in order to cut it.

Shear is also present along the whole length of a loaded beam or cantilever.

TORSION

Torsion is a twisting force. The elastic band in a toy plane is being twisted as it is wound up. The band is therefore being subjected to torsion.

STRUCTURAL DESIGN

Designers need to know about the structural properties of materials. String, for example, has **tensile** strength, which means that it can resist tension, but it can easily be compressed. A ceramic wall tile has **compressive** strength and so will resist compression, but it will not bend.

REINFORCEMENT

Concrete has excellent compressive strength, but it is rarely subjected to this type of force alone.

However, it is widely used as a building material, where it is subjected to bending, and therefore to both compressive and tensile forces. To help it to resist these forces it has to be **reinforced**.

A concrete lintel above a door, for instance, has steel inside it. This makes the lintel much less brittle and less likely to crack.

The concrete itself can resist the compressive force above the neutral axis. So, a steel bar is introduced into the lower part of the beam to resist tension. The steel bar is twisted. The ends are often curled up to increase the grip between the two materials. This helps them to act as one material.

SHAPE

The ways in which materials are shaped also affect their structural properties.

The three timber beams all have the same cross sectional area, but it is the deeper of the three that will resist bending most.

Shaped sections (T, I, U and L beams) are also fairly lightweight. By placing material on the outer edges, the sections effectively resist tension and compression.

Hollow sections help to make structures rigid and light. Material is removed from around the neutral axis of a beam. The rigidity of the section is hardly changed by this.

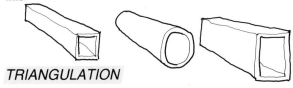

TRIANGULATION

Structures like tower cranes and electricity pylons, in which all the members are visible, use triangles in their construction. This is because triangles are rigid shapes. If the joints at the corners are very strong, then triangles cannot change shape.

The corners of rectangular structures can be made rigid by bracing them with short members, so creating triangles. These bracing pieces can be solid panels called **gusset plates**. (See page 179).

SHELL STRUCTURES

Materials can be moulded into **shell structures**.

GUSSET PLATE
BEAM TO RESIST BENDING
BEAM TO RESIST TORSION

The plastic chair seat is an example of a shell structure which incorporates various structural elements. The seat is a beam, the back is a cantilever. Inverted U beams form both sides. And these are joined by integral gusset plates.

These shapes and forms have been introduced to structures to help resist the dynamic and static loads that are placed on them, and to stand up to the forces of tension, compression, shear, and torsion.

QUESTIONS

1 How do the forces of tension and compression differ?
2 What is a tie and how does it differ from a strut?
3 What part do tension and compression play in bending?
4 What is the difference between a cantilever and a beam?
5 How does the depth of a beam affect its resistance to bending?
6 Why are triangles widely used in structures?
7 What is a shell structure?

8.17 MODELLING STRUCTURES

Models of structures in card paper and balsa wood pose the same problems to the designer as do full size structures made from timber, steel, and concrete. Model structures have to be light but strong, with carefully constructed joints.

1. THIN DEEP SECTIONS MAKE LIGHT, STRONG BEAMS.

2. BUT THEY BEND AND BUCKLE EASILY.

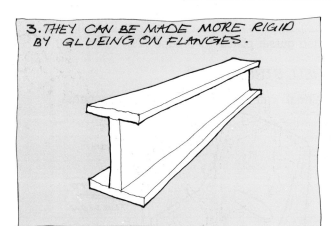

3. THEY CAN BE MADE MORE RIGID BY GLUEING ON FLANGES.

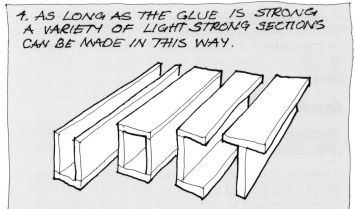

4. AS LONG AS THE GLUE IS STRONG A VARIETY OF LIGHT STRONG SECTIONS CAN BE MADE IN THIS WAY.

4. THIN SHEETS CAN BE FORMED INTO RIGID PANELS BY GLUEING THEM INTO HONEYCOMB STRUCTURES.

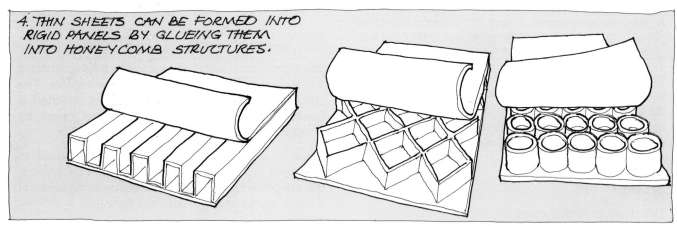

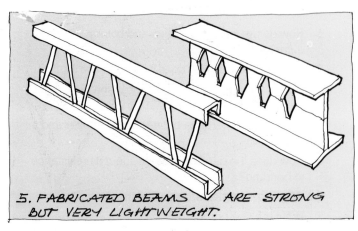

5. FABRICATED BEAMS ARE STRONG BUT VERY LIGHTWEIGHT.

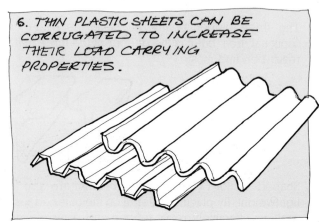

6. THIN PLASTIC SHEETS CAN BE CORRUGATED TO INCREASE THEIR LOAD CARRYING PROPERTIES.

7. JOINTS ARE USUALLY THE WEAK POINTS IN MOST STRUCTURES. CARE MUST THEREFORE BE TAKEN TO MAKE SURE THAT THEY ARE STRONG.

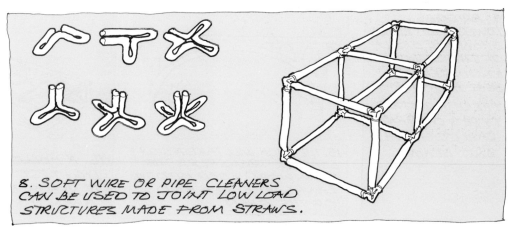

8. SOFT WIRE OR PIPE CLEANERS CAN BE USED TO JOINT LOW LOAD STRUCTURES MADE FROM STRAWS.

9. THESE CORNERS CAN BE STRENGTHENED BY LASHING THEM WITH COTTON OR TAPE.

10. GLUE WILL PREVENT THESE LASHINGS FROM MOVING UNDER A LOAD.

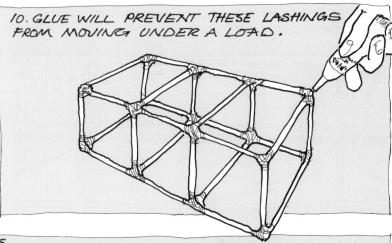

11. TRIANGULAR GUSSET PLATES ARE OFTEN USED TO STRENGTHEN CORNER JOINTS.

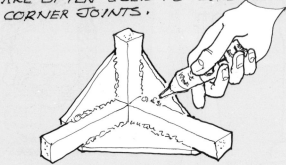

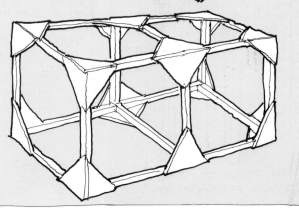

12. THE SHAPES USED IN A STRUCTURE ARE IMPORTANT. RECTANGLES CAN EASILY COLLAPSE.

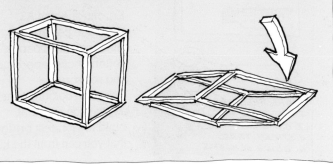

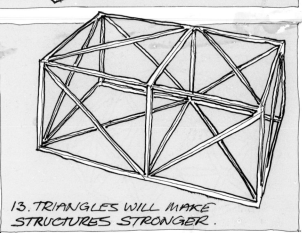

13. TRIANGLES WILL MAKE STRUCTURES STRONGER.

14. BRIDGES, TOWERS, AND DOMES SHOW THE SKILLS OF THE STRUCTURAL ENGINEER TO BEST ADVANTAGE.

THERE ARE TWO TYPES OF BRIDGE, CALLED ARCH, AND BEAM.

15. THE ARCH WILL TAKE A HIGH LOAD. IT TRANSFERS THE DOWNWARD LOAD INTO THE BANKS AT EITHER END OF THE SPAN.

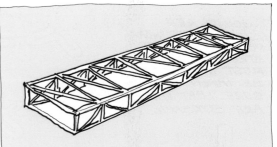

16. A HOLLOW BEAM IS THE LIGHTEST KIND OF BRIDGE. IT NEEDS EXTRA SUPPORT TO SPAN LONG DISTANCES.

17. THIS SUPPORT MAY COME FROM RIGID STRUTS IN A TRUSSED BRIDGE,

OR FROM TIES IN A SUSPENSION BRIDGE.

18. A CANTILEVER BRIDGE IS MADE OF TWO BEAMS MEETING AT THE CENTRE OF THE SPAN. EACH BEAM IS SUPPORTED FROM A TOWER NEAR ITS END.

BUILDING
GROUND LEVEL
RAFT
PILES

19. TALL TOWERS NEED STRONG FOUNDATIONS.

20. A WIDE BASE TAPERING TO A LIGHTWEIGHT TOP IS NEEDED FOR VERY TALL STRUCTURES.

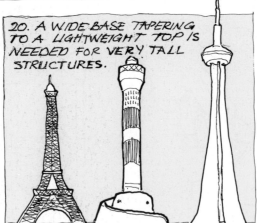

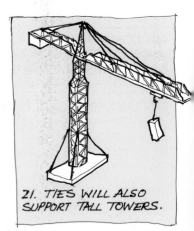

21. TIES WILL ALSO SUPPORT TALL TOWERS.

22. GEODESIC DOMES ARE LIGHTWEIGHT, THEY NEED SMALL FOUNDATIONS AND CAN COVER LARGE AREAS.

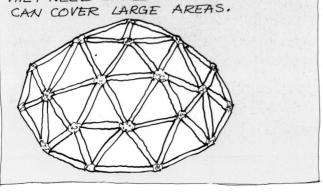

KIT
1. ONE SHEET A3 CARTRIDGE
2. ONE SHEET A3 COLOURED
3. COTTON
4. STICKY TAPE
5. GLUE + SCISSORS

Activity

Kit: one sheet of A3 cartridge paper, one sheet coloured paper, cotton, sticky tape, glue, and scissors.
Using the coloured sheet as practice material, build the longest bridge that you can from the kit.

COURSEWORK AND EXAMINATIONS

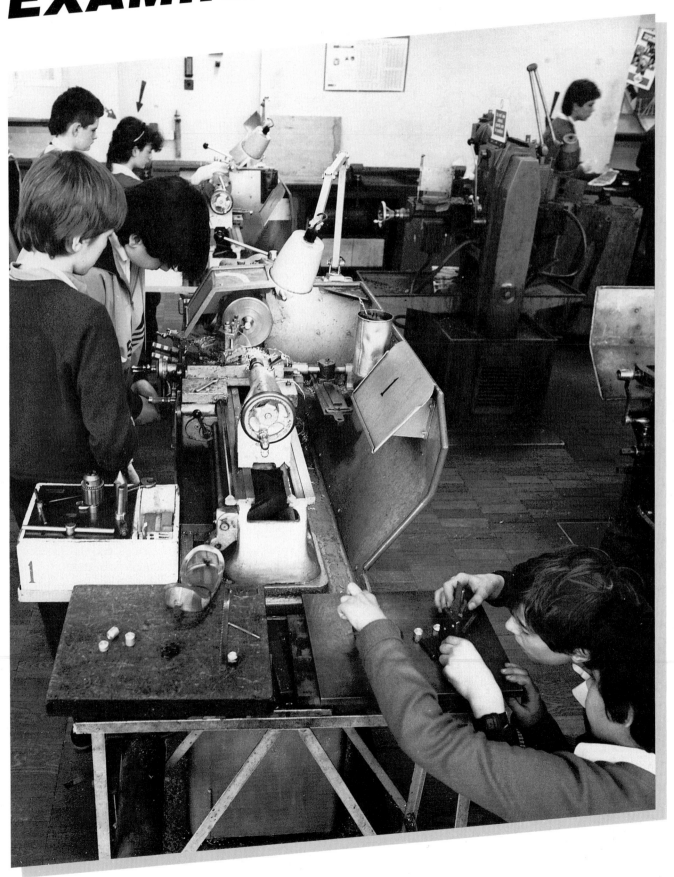

COURSEWORK BRIEFS

Up to 50% of GCSE examination marks are awarded for coursework. These marks will be given for your design folder and for the object you produce.

On this page you will find 20 design briefs. These are graded from easy ■ to hard ■■■■.

■

1 Desks and work tables can become cluttered with writing equipment.
Design a desk tidy to keep these implements in place.

2 Design a system to store a number of letters until they can be answered.

3 Taking notes, when using the telephone, can be difficult.
Design a pad to allow the user to make notes with one hand, whilst telephoning.
Your design should include a means of storing the writing implement.

4 Stationery shops sell rolls of paper for adding machines.
Devise a system by which one of these rolls can be used on a wall-mounted memo-pad.

5 Needles, pins, cotton reels, and other items of sewing equipment are often needed for quick mending jobs.
Design a small carrier to keep them safely to hand.

■■

6 Necklaces, rings, brooches, and bracelets need to be stored in such a way as to prevent them from becoming entangled.
Design a rack or container to achieve this.

7 It is often difficult to find the end of a roll of adhesive tape and to cut it to the required length.
Design a simple holder to solve both of these problems.

8 Screw-top jars and fizzy drinks bottles can be difficult to open.
Design a device which will make this task easier.

9 Devise a rack or container that will help to transport a small selection of DIY tools around the house.
This should incorporate some method of retaining and uncoiling an electric cable.

10 Devise a portable lighting system to be used when camping.

■■■

11 Design a compact and attractive storage system for medical and toilet requisites, to be used in a bathroom.

12 Design a lighting system to be powered from a car battery.
This should enable the user's hands to be free and allow light to reach awkward spaces when the car is being repaired.

13 Plants can be grown in various positions around the house.
Design a display system which will allow them to be watered and tended without disruption.

14 Design a collapsable racking system to allow a small selection of clothes to be hung and dried in the bathroom.

15 Design a constructional toy, based on simple components, which can be assembled into a variety of forms.

■■■■

16 Design a picnic table and seating system to be used in a garden during the summer, and folded away for winter storage.

17 Design a draughting station which is transportable. It should allow for the accurate production of sketches and working drawings, and should also provide storage for draughting equipment.

18 Design a bird scarer which would be cheap to run and would keep birds away from newly planted seeds and ripening fruit.

19 Water play is popular with young children.
Devise a range of water play equipment to stimulate and educate.

20 Design a collapsable stool or ladder system to allow the user to reach high shelves, light fittings, ceilings, and other high spots around the house.

EXAMINATION QUESTIONS

There are three types of GCSE examination:

1 Open examinations in which a design problem is set during the final year of the course.

2 Design examinations which consist in a number of questions to be answered in a set time.

3 Knowledge examinations which are usually short questions related to the materials, tools, and techniques used in the school workshop.

OPEN EXAMINATION QUESTIONS

1 A parent keeps all the mending materials for various fabrics in a large flat box in a sideboard drawer (pins, needles, cottons, silks, knitting needles, scissors, etc). It is necessary to keep the sewing needles in a separate container inside the large box. Assume two needles of every size are needed.
On one sheet of A3 paper, show as clearly as possible all the considerations you would take into account if you were designing such a container.

(Northern)

2 The sketch below shows a handled magnifying glass. You are required to design a stand to hold the glass so that the user may have both hands free to do intricate work. At a later stage you will make the stand you design and for this you will have a maximum of 5 hours workshop time.

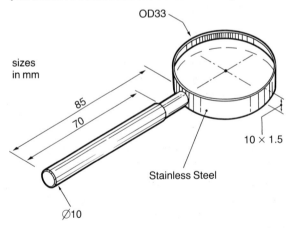

OD33

sizes in mm

85
70

10 × 1.5

Stainless Steel

Ø10

To focus the magnifying glass on the work both vertical and horizontal adjustment must be provided. The vertical adjustment should be from 150 mm to 200 mm above the surface on which the viewed object rests.

Vertical Adjustment

Horizontal Adjustment

You may design the stand to be made in any single material or in a combination of materials.

(London/East Anglian)

3 Traditionally, trophies have tended to take the form of cups, shields or medallions made either from precious metals or from cheaper alloys with a precious metal plating. Other forms are possible.
Design a trophy to be presented to an orienteering team consisting of three young people. Rather than present an expensive trophy to be collected in again in due course, three identical pieces are required which can be retained by the winners. The trophies must be inexpensive, relying for their appeal on your skill as a designer and maker. The total material cost for the three trophies should not exceed £6. You will be required at a later date to make one of the three trophies in a period of not more than five hours in your school workshop. You may employ materials and processes available in your school workshop.

(London/East Anglian)

4 People today use many more pills and tablets than ever before. We all need to keep tablets away from children who may harm themselves by eating them as sweets. Find a container for tablets which has some means of making access difficult for children, or other unfamiliar users.
Using one sheet of A3 paper, make a good drawing of the container and, separately if necessary, show clearly the way in which the container works. Add a short set of instructions or symbols which could be printed on the container describing how it may be opened.

(Northern)

5 Many householders do much of their own home maintenance, using a variety of sizes and types of nails and pins. A container is required which:
(a) will keep different sizes and types separate;
(b) can be carried easily to wherever the job is in house or garden;
(c) allows easy access to nails and pins.
On an A3 sheet sketch two of the design ideas you may have for each of the requirements (i), (ii) and (iii).

(Northern)

6 A collection of 20 dress rings requires an arrangement to keep the rings together on a dressing table top or in a dressing table drawer. Draw such an arrangement. Indicate the materials, sizes and construction fully.

(Northern)

7 Very little furniture is now made from solid wood. By laminating thin strips of wood e.g. 1 mm or 2 mm thick, it is possible to produce shapes that are impossible by conventional construction methods. 'Modular furniture' is also popular, that is where a number of units or components can be put together in different ways.
Figure 1 shows two shapes that can be made easily by laminating. Design and build two formers that will produce these or similar shapes.
Experiment by altering the length, width and thickness of the laminations and by using different timbers or thin

Figure 1

acrylic sheet. Try sculpting the laminated forms once they have been removed from the formers.

As a result of what you learn from your experimentation, design a series of small pieces of furniture using the laminated forms e.g. book ends, lamp, foot stool, occasional table, storage units, mirror stand. These should be as original as possible and not copied from mail order or sales catalogues. The furniture should all follow a similar theme.

Make *two* of the items that you have designed.

(Welsh)

8 There are many disabled people who can be helped considerably by simple, custom-built aids which are tailored to their specific needs.
 (a) By following the advice of your teacher, contact a local disabled person and with his/her help design and build a piece of equipment that will improve their quality of life.
 or
 (b) By following the advice of your teacher contact a local day centre, home for the disabled or similar institution and with the help of the person in charge design and build a piece of equipment that can be used by the residents or disabled visitors.
 Your design folio should show how you used expert advice to determine the nature of the aid that you designed and how you worked with the disabled person(s) to develop the aid so that it was completely suited to their individual needs.

(Welsh)

9 Design and make a small pull-along toy. The design must emit noise and incorporate movement which creates visual interest.

(Southern)

10 Candidates are expected to complete a major project. They will be expected to work from the identification of a need or problem through the various stages of the design process to realisation, testing and evaluation. Candidates must present for assessment a design folder (20 marks), a completed piece of work (25 marks) and a written report (5 marks).

The design folder must contain relevant information — written and graphic — models and trial materials which lead to the making of the end product.

The theme this year is 'Storage'.

(Midland)

DESIGN EXAMINATION QUESTIONS

1 The basic frame of a narrow writing table, together with the main sizes, is shown.

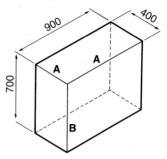

 (a) Name a material from which the table frame could be made.
 (b) Draw suitable cross-sections (full size) for the parts A and the part B.
 (c) Show, using notes and sketches, how parts A can be joined to part B to make this table frame.
 (d) Give details of a suitable top for this table.
 (e) Draw details of how the top would be fixed to the frame.
 (f) It is intended to change the use of the table from a writing table to a table to hold an aquarium, which when full, weighs 150kg. (*This is equal to the weight of two average people.*) The overall sizes stay the same.
 Show what change(s) you would make to the design. Add reasons for the change(s) you intend.

(London/East Anglian)

2 (a) Copy and complete the following sentence.
 Gears in toys, models and kits are often made from by the following process
 ..
 (b) What is the purpose of the types of gears shown in the drawing below?

 (c) Draw the tooth shapes for two gear-wheels in mesh.

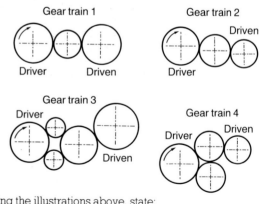

Using the illustrations above, state:
 (i) a train that will not rotate,
 (ii) a train that gives no change in rotation direction,
 (iii) a train that increases speed,
 (iv) a train that decreases speed,
 (v) a train that does not alter speed.

(e) The drawing above shows a winder for a simple rubber-band motor used for model aircraft. The winder also has a device which prevents the winder unwinding if the handle is released.
Draw the internal mechanism necessary to give six clockwise rotations of the winder to match one clockwise rotation of the handle.

(f) Draw a suitable device which prevents the winder unwinding when released.

(London/East Anglian)

3 Your have been asked to design a rack to hold 6 eggs.
(a) Sketch two solutions considering carefully both the design and the material you would choose.
(b) Name the material(s) chosen and describe briefly its characteristic(s).
(c) Indicate the main forms in which this material can be purchased.
(d) Describs, using notes and sketches, how you would make your design.

(Midland)

Figure 1

4 The sketch in figure 1 represents the section through a tomato. A piece of costume jewellery is required, the design of which is to be influenced by this natural form.
(a) Explore this form through a range of sketches and develop ideas for two solutions which meet this need.
(b) Select one of your solutions stating its purpose and explain the main processes you would use in making it, paying particular attention to any methods of linking and fixing you might use.
(c) Name all the materials you would require for your piece of jewellery, indicating why you would choose them.

(Midland)

5 (a) The dimensions of a tube of "Smarties" are given below.
The tube is made from card and has one plastic end. The name is printed once as shown. The manufacturers want to give to shopkeepers, free of charge, a small dispenser which will bring 'Smarties' to the attention of customers. It will hold twelve tubes.

∅23 × 120 long
sizes in mm

(b) (10 minutes)
Imagine you are the manufacturer. Write down a list of the things the dispenser should do.

(8 marks)

(c) (10 minutes)
Suppose the manufacturer decided to use acrylic for the making of the dispenser. What advantages would this material have?

(9 marks)

(d) (10 minutes)
Suppose the manufacturer decided to use card as the only material for the dispenser. What advantage would this material have?

(9 marks)

(e) (10 minutes)
After one month of use the shopkeeper thought the dispenser was very successful in every way. If you were the shopkeeper, write down a list of the things you would mention to the manufacturer if he came to ask you about it.

(9 marks)

(f) (20 minutes)
Using quick sketches, draw as clearly as possible three different ideas for holding and displaying the twelve tubes of 'Smarties'. Make clear which materials might be involved.

(20 marks)

(Northern)

6 When suitably re-ground and sharpened, the metal from old hacksaw blades can be used to made blades to cut card, paper, balsawood and similar materials.
Design a modelling knife that uses part of a used hacksaw blade. You may use any suitable material or combination of materials for the handle and any processes normally used in a school workshop.
Your design should include the following: —
(a) Details of the size of the blade and the shape of the cutting edge.
(b) Details of how the blade is removed and replaced in the handle.
(c) Sketches and notes to show how you decided on the shape and size of the handle. Use your own hand as a guide, the knife should be safe and comfortable for *you* to use.

(Welsh)

7 Figure 1 shows the outline shape of the skids for a small sledge. Figure 2 shows the anthropometric data (body measurement) for a 10 year old child.
Complete the design of the sledge so that the child can use it in reasonable safety. You may use any suitable material, or combination of materials.
Your design should include the following:
(a) A seat or platform of a suitable size.
(b) All constructional details, including a method of supporting the seat above the skids.
(c) Details of the materials used — for the skids and other parts of the sledge. This should include any jigs or formers you think are necessary.
(d) Details of any additional features you have included in the design.

Figure 1

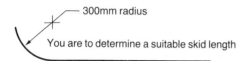

— 300mm radius

You are to determine a suitable skid length

Figure 2
boys and girls of
10 years old are
1.325 metres tall

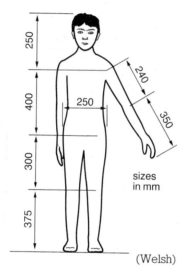

250
400
300
375
240
250
350

sizes
in mm

(Welsh)

8 Your Headteacher would like a small, visually interesting sculpture to be placed on a coffee table in the school reception area. Visitors are to be encouraged to touch the sculpture so parts of it should move. Magnets move in interesting ways when they come close together.
(Opposite poles attract, like poles repel)
Figure 1 shows a small bar magnet. These are also available in the following sizes: — 20 mm long × 5 mm dia, 30 mm long × 10 mm dia.

25mm
bar magnet
diameter
8mm

Figure 1

Design a stimulating or amusing table sculpture. Your sculpture design should include the following: —
(a) At least two different materials used in the school workshop.
(b) Two or more moving magnets.
(c) All constructional details.
Interesting effects can be achieved by attaching the magnets to items such as small coil springs (like those in ball point pens), or to fine chain (like that used to join a plug to a sink). You may use these or similar ideas in your design.

9 Attempt **all** parts of this question.
(a) Several control devices are shown in the picture. Make **two** lists of those illustrated, sorting them into non-variable (i.e. on or off) and variable devices.

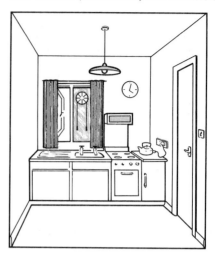

(b) A diagram illustrating the sequence in supplying water and flushing a w.c. is shown below. Translate the diagram into a drawing(s) which show the necessary components.

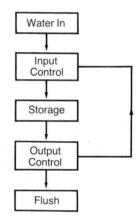

Water In

Input Control

Storage

Output Control

Flush

(c) The diagram shows the cross-section of a dispenser for liquids.

Depress

Cap
(To be screwed
on to a bottle)

(i) Copy and draw, on the diagram, a spring in a position which will cause the tap to return to the top of its stroke
(ii) Mark on your diagram the positions of the two control valves.
(iii) Make sketches to show clear details of the valves.

(d) A domestic dishwasher requires water at a constant temperature of 70°C. The machine has two inputs — cold water at mains supply temperature, and hot water at a temperature which varies between 60°C and 90°C. The machine contains sensor valves, a water heater and pump within its system. Make a flow diagram for the above system so that the sequence, and the necessary monitoring, will provide the required output.

(London/East Anglian)

10 As the result of industrial or other accidents, some people have the use of only one hand. This makes simple tasks much more difficult — for example, opening containers and preparing food.
Using the baseboard in figure 1 as a starting point, design a device that is easy to operate and that enables a one handed person to:
(a) Open screwtop jam jars.
(b) Keep a slice of bread in position while the jam is being spread.
You may change the baseboard in any way you think appropriate. You may also add other components. Decide on the overall size of the board and give all other relevant details. You may use any appropriate material.
Use the following information to design the device: —
Jam jars are normally 120 mm tall. They can be any diameter between 60 mm and 80 mm.
Bread from the largest slice loaf is 140 mm × 110 mm, the average slice is 8 mm thick.

Figure 1

(Welsh)

11 The drawings show four battery-powered lights.
NOTE: The illustrations shown are not to the same scale.

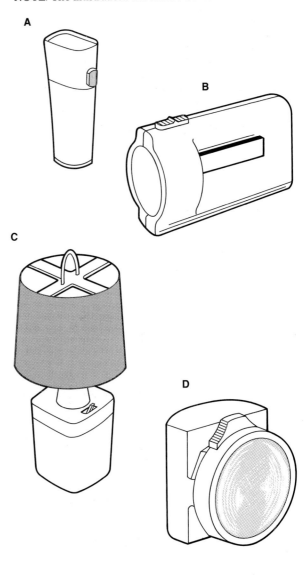

(a) Give a situation in which each light would be used.
(4 marks)

(b) For each light state two factors which make it suitable for the situation you have given in (a).
(8 marks)

(c) Describe two design features important to the working of all four lights.
(2 marks)
(Southern)

1 (a) Name a non-ferrous metal.
 (b) Name a common thermoplastic.
 (c) Name one adhesive that will join acrylic sheet.
 (d) The sketches below show two manufactured boards. Name the boards.

 (i)

 (ii)

 (e) What would you use to clean a paint brush which has just been used for:
 (i) emulsion paint?
 (ii) gloss paint (oil based)?
 (f) What do the initials GRP stand for?
 (g) Name one piece of equipment used for holding metal when drilling on a vertical drilling machine.
 (h) Saws are sometimes used for cutting curves in metal. From the list below, find the saw you would use for cutting 22 SWG copper sheet.
 Hacksaw — 'Abrafile' — Junior Hacksaw — Piercing Saw — Power Hacksaw.
 (i) What prompt action should be taken if acid is splashed on to the skin?
 (j) Metals can be heated to red heat and then quenched. Name a metal that would be left hard by this process.
 (k) Why should lead based paint *not* be used to finish a child's toy?
 (l) Soft solder is an alloy of tin and what other substance?
 (m) In which order should the taps shown below be used to thread a blind hole?

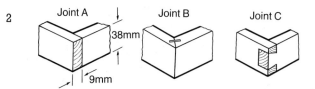

 (n) Sketch a vee belt in the position which will give the fastest speed to the drill spindle.

 Motor

 Drill
 spindle

188

(o) Name the parts at A and B that have been removed.

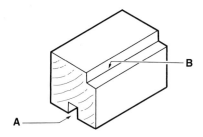

(p) Which joint would be strongest in preventing A being pulled from B?
 (i) Glued butt joint.
 (ii) Dowel.
 (iii) Wedged mortise and tenon.
 (iv) Stepped mortise and tenon.
 (v) Halving.

(Midland)

2

Joint A Joint B Joint C

(a) The three corner joints shown above, made from the same timber, can be used for small containers.

 Name each joint.

 (3 marks)

(b) Place the joints in part (a) in order of strength, strongest first. You should assume that they have all been properly glued.

 (3 marks)

(c) Name a suitable adhesive for such a joint if the container were to be used as follows:
 (i) Always indoors
 (ii) outdoors when the owner went fishing

 (2 marks)

(d) The joints A, B and C shown in the drawing above are made from timber of 36 × 9 mm cross-section.

 Imagine the drawing show the corner of a small box which is to hold nails. The overall size of the box is 200 mm × 100 mm × 38 mm. Which of the following materials would be the most suitable for the bottom of such a box?
 Hardboard 4 mm thick
 Plywood 9 mm thick
 Blockboard 12 mm thick
 Solid timber of the same kind as the box, but 6 mm thick
 Place the materials in order of suitability, from most suitable to least suitable.

 (4 marks)

(e) Sketch a cross-section through each of the materials montioned in part (d) on the previous page to show the way the material is made up. Add a few words of explanation if necessary.

 (8 marks)

(f) The box must have a bottom in order to keep the nails in; the bottom also makes the box very strong. Explain carefully in what ways the bottom makes the box strong. Use sketches if necessary.

(5 marks)

(Northern)

3 **Answer** all twenty-five **questions**. (Full marks can be gained for correct answers to twenty questions).

1 Name the part A.

2 Which one of the following is a softwood: oak, mahogany, parana pine?

3 What preservative is used to stop a softwood fencepost rotting in the ground?

4 State one advantage of plywood over natural timber.

5 Draw the head of a countersunk-head woodscrew.

6 Name the file section shown in the diagram.

7 Name one ferrous metal.

8 State one method of joining the two pieces of mild steel shown.

9 Name the cutting tool used to cut an internal M6 thread.

10 Draw a parting-off tool for metal.

11 State the approximate melting point, in degrees centigrade, of aluminium alloy.

12 Write in full, what is meant by BDMS.

13 Which of the gearwheels A, B, or C, will rotate the fastest?

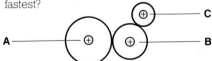

14 The diagram shows an open three-pin plug.

The three terminals of the plug are:
Live; Neutral; Earth.
Which of these are A, B, and C?

15 Using the formula? power = voltage × current, calculate the current for a 480 watt motor, run from 240 volt mains supply.

16 State the type of force acting on the body of the jack.

17 What does the symbol represent?

18 Which one of the following is a thermosetting plastics material: polythene, nylon, epoxy resin?

19 In what way do thermoplastics differ from thermosetting plastics?

20 Why is gel-coat resin used?

21 Why is a catalyst added to polyester resin?

22 Name a plastics-moulding process which uses heat.

23 Put in the value of the missing dimension.

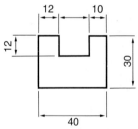

24 Draw a centre line.

25 What projection is the cube drawn in?

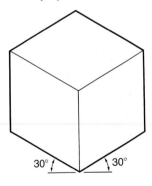

(Southern)

189

SQUARE GRID

TWO POINT PERSPECTIVE GRID

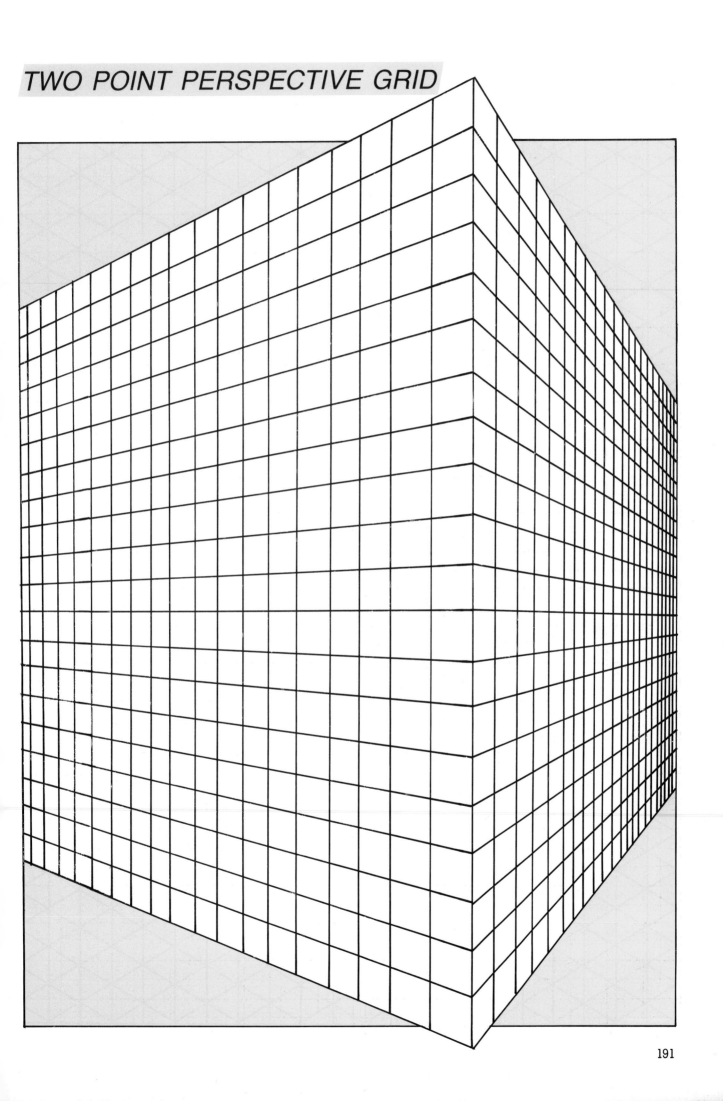

ISOMETRIC GRID

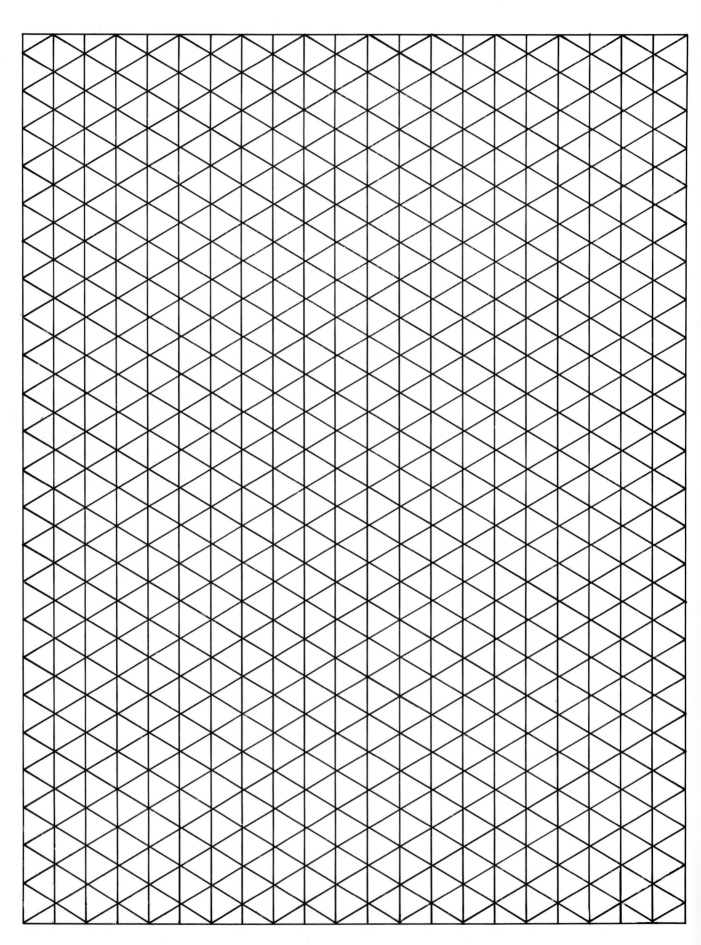

ELLIPSES

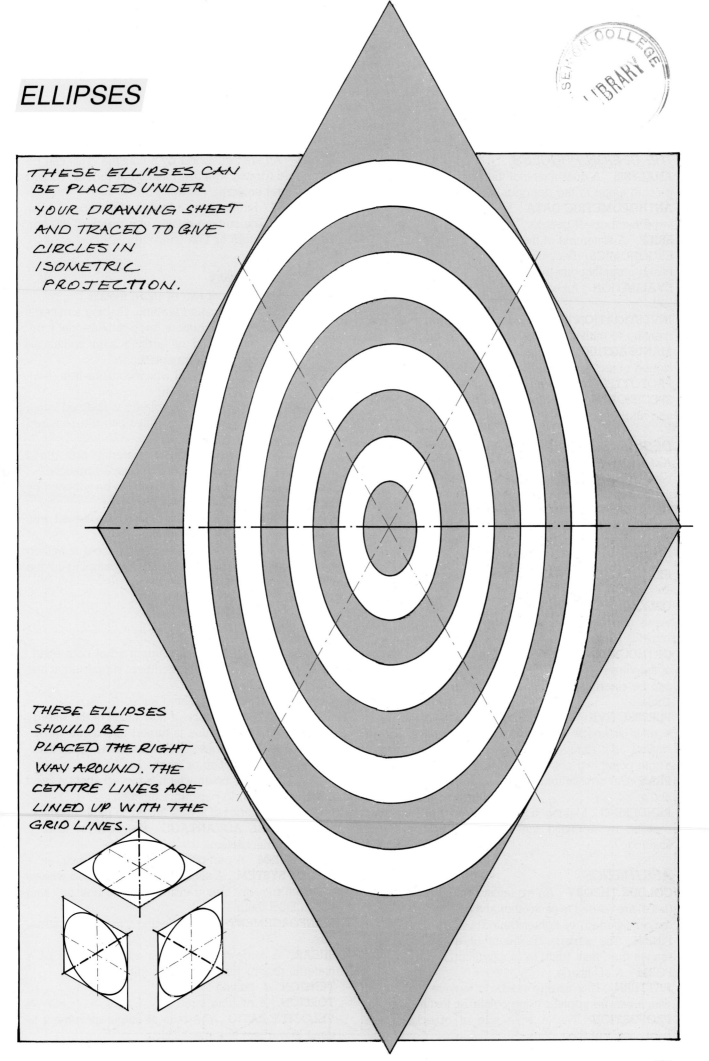

THESE ELLIPSES CAN BE PLACED UNDER YOUR DRAWING SHEET AND TRACED TO GIVE CIRCLES IN ISOMETRIC PROJECTION.

THESE ELLIPSES SHOULD BE PLACED THE RIGHT WAY AROUND. THE CENTRE LINES ARE LINED UP WITH THE GRID LINES.

GLOSSARY

THE DESIGN PROCESS

ANALYSIS A questioning of the brief to find out what it could mean to the designer.

ANTHOPOMETRIC DATA Measurements taken from large numbers of people.

BRIEF A statement of the design problem.

ERGONOMICS Recommended dimensions of objects based on anthopometric data.

EVALUATION An assessment of the completed project.

INVESTIGATION/RESEARCH Reading and experimenting to gather information about the problem.

MANUFACTURE The process of making the designed object.

PROTOTYPING Making models to test design ideas.

SPECIFICATION A statement of the design problem and all the factors that might be linked to it.

DESIGN GRAPHICS

AXONOMETRIC PROJECTION A 3D drawing system based on three sets of parallel lines, in which no face of the object is seen as a true shape.

CUTAWAY DRAWING A drawing in which a part is removed to show the inner detail.

ELEVATION An orthographic view of the front, rear, or end of an object.

EXPLODED DRAWING A drawing in which the parts are separated so that each can be clearly seen.

OBLIQUE PROJECTION A 3D drawing system which views one face of the object as a 'true shape' and projects parallel lines from it to suggest solidity.

ORTHOGRAPHIC PROJECTION An organized series of flat views of an object, drawn so that all the details can be clearly seen. There are two types 1st and 3rd angle.

PERSPECTIVE A 3D drawing system which produces a realistic image of the object. This appears to get smaller as it recedes into the picture space. 3 types, single point, two point, and three point.

PLAN An orthographic view of the object seen from above.

RENDERING Making a line drawing appear more realistic by applying tone, line, texture, or colour shading.

AESTHETICS

COLOUR THEORY An explanation as to how colours (hues) are related to each other and how they are made darker (shaded) or lighter (tinted)

FINISH The surface treatment of a material. This ranges from matt (dull) to glossy (shiny).

FORM A 3D shape.

PATTERN This usually refers to surface decoration which can be applied using colour or texture.

PROPORTION The relative size of objects or the relationship of their parts.

SHAPE An area enclosed by an outline. This can be geometric (drawn with instruments) or organic (based on a natural object).

STYLIZING Emphasizing a feature of a shape or form.

TEXTURE The surface quality of a material, this can be coarse (rough) or fine (smooth).

MANUFACTURING

ALLOY A mixture of two or more metals.

DEFORMING Also called forming, shaping a material by pushing or pulling it into a three dimensional form.

EXTRUSION A method of forming long continuous sections of metal and thermoplastic.

FERROUS METAL A metal which contains iron (Non-ferrous metals contain no iron).

INJECTION MOULDING Hot plastic is injected into a mould where it cools and solidifies into the required shape.

LAMINATING Thin strips of material are glued together to form thick sections or shaped objects.

THERMOPLASTICS A plastic that can be softened by heat.

THERMOSET A plastic that cannot be softened with heat.

VACUUM FORMING A themoplastic sheet is heated until soft then sucked onto a mould by pumping out the air from the mould chamber.

VENEER A thin sheet of timber.

TECHNOLOGY

BEAMS Stuctural members supported at both ends.

CANTILEVERS Structural members supported at one end.

COMPRESSION A squashing force.

EFFICIENCY A measure of how much of the energy that is put into a machine is turned into useful work.

GEAR TRAIN A series of toothed wheels which interlock to transmit motion or force.

LEVER A bar or beam which is moved about a fixed point (a fulcrum) to perform a function.

LINKAGE a series of levers 'linked' to perform a task.

MECHANICAL ADVANTAGE The ratio of load to effort in a mechanism.

MECHANISM A part of a machine (lever, gear, etc.)

PULLEY SYSTEM A set of grooved or toothed wheels in which movement is transmitted by a belt or chain which links them.

REINFORCEMENT Strengthening a material or structure.

SHEAR A force which pushes adjacent parts of a material or structure in opposite directions.

TENSION A pulling force.

TORSION A twisting force.

VELOCITY RATIO The ratio of output movement to input movement in a mechanism.

INDEX